W9-AOX-339

WITHDRAWN

EX LIBRIS

RITTER LIBRARY

BALDWIN-WALLACE COLLEGE · BEREA, OHIO

MANET AND MODERN PARIS

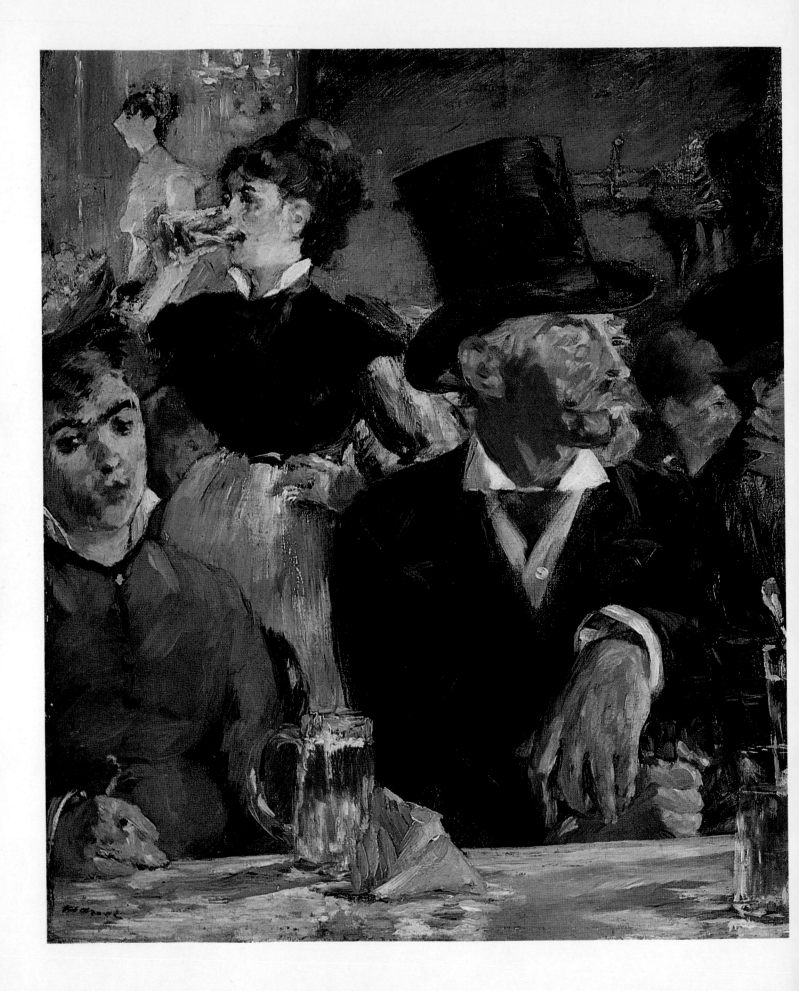

N 6853 .M233 A4 1982
Reff, Theodore.
Manet and modern Paris :

MANET
and Modern Paris

❦

One Hundred Paintings, Drawings, Prints, and
Photographs by Manet and His Contemporaries

❦

THEODORE REFF

WITHDRAWN
RITTER LIBRARY
BALDWIN WALLACE COLLEGE

National Gallery of Art, Washington

Copyright © 1982 Board of Trustees, National Gallery of Art, Washington. All rights reserved. No part of this book may be reproduced without written permission of the National Gallery of Art, Washington, D.C. 20565.

This catalogue was produced by the Editors Office, National Gallery of Art, Washington. Printed by Eastern Press, New Haven, Connecticut. The type is Fairfield, set by Composition Systems Inc., Arlington, Virginia. The text paper is eighty-pound Warren Lustro Offset Enamel Dull, with matching cover.
Edited by Mei Su Teng
Designed by Melanie B. Ness

Published in conjunction with the exhibition *Manet and Modern Paris* held at the National Gallery of Art, 5 December 1982-6 March 1983.

Cover: Edouard Manet. *The Gare Saint-Lazare,* 1873. Cat. 10, detail.
Frontispiece: Plate 1. Edouard Manet. *The Café-Concert,* 1878. Cat. 21.

Library of Congress Cataloging in Publication Data
Reff, Theodore.
 Manet and modern Paris.
 Bibliography: p. 272 ff.
 1. Manet, Edouard, 1832-1883—Exhibitions 2. Paris (France) in art—Exhibitions. I. National Gallery of Art (U.S.) II. Title.
N6853.M233A4 1982 760′.092′4 82-18965
ISBN 0-89468-060-9 (paper) ISBN 0-226-70720-2 (cloth)

The clothbound edition of this catalogue is published by the University of Chicago Press, 5801 Ellis Avenue, Chicago, Illinois 60637 in association with the National Gallery of Art.

© SPADEM 1982. SPADEM, Paris, asserts copyright in works by the following artists: Bernard, Bonnard, Degas, Luce, Monet, and Vuillard.

For dimensions given in this catalogue, height precedes width. References to Manet oeuvre catalogues are shortened to "R-W" for Rouart and Wildenstein and "H" for Harris.

CONTENTS

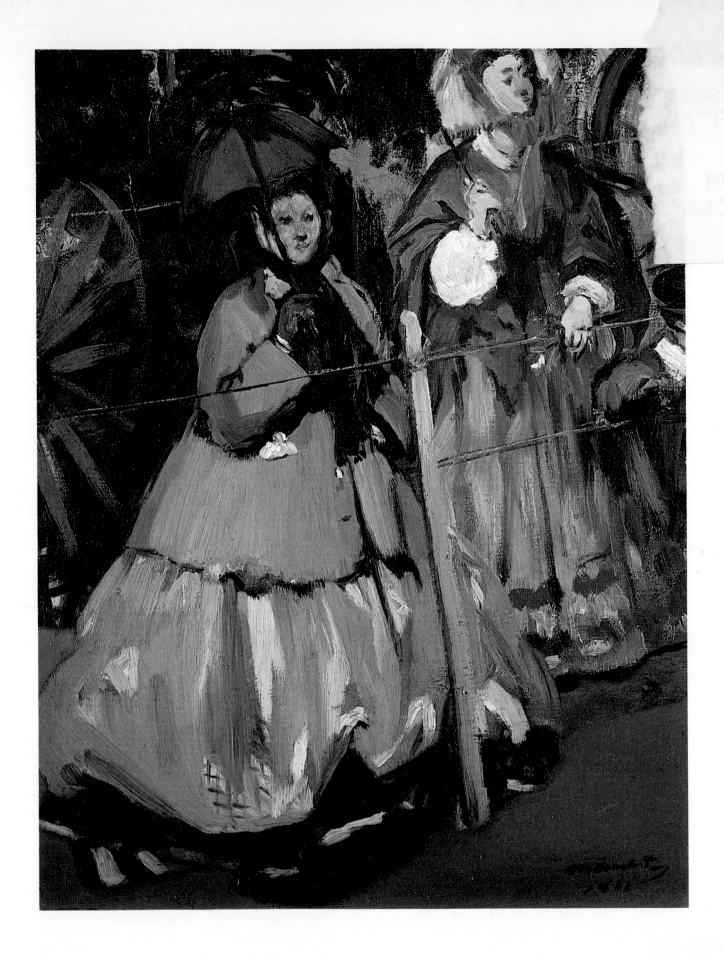

FOREWORD

WHEN EDOUARD MANET died one hundred years ago, the newspaper *Paris* repeated in its obituary what had become by then a familiar maxim: "Manet was the Parisian *par excellence*; witty, subtle in his pleasures, enjoying all the refinements of life." That assessment remains valid today: in his art we find a definitive expression of the form and content of Parisian life in the two decades of his artistic maturity, the 1860s and 1870s. These were also the years, and not by coincidence, in which Paris became what has aptly been called "the capital of the nineteenth century" and indeed a model for capital cities throughout the world for almost a century thereafter.

In *Manet and Modern Paris* we have collected representations of the city's appearance in a period of momentous change. The images included depict characteristic forms of its social life—on the boulevards, in the public gardens, railroad stations, cafés, and *cafés-concerts*, and at the theater and opera — as well as familiar aspects of its nearby racetracks and beaches. We have tried to capture the mood of nineteenth-century Paris by means of those primary social documents that are great works of art: paintings, drawings, and prints by the impressionist artists who made Parisian life a central theme of their work and, to complete the picture, those of their immediate predecessors and followers. Thus we have included images of Paris not only by Manet, Degas, Renoir, Pissarro, and other artists of their group, but also by Daumier, Bonvin, Boudin, and others in the previous generation and by Forain, Toulouse-Lautrec, Bonnard, and others in the succeeding generation.

Although the works by Manet himself, roughly half those in the exhibition, inevitably provide an overview of his artistic development, the primary purpose of *Manet and Modern Paris* is not to offer yet another survey of his art, but rather to focus on the most characteristic aspects of his vision of his native city in relation to that of his contemporaries. To this end, we have organized the material thematically rather than chronologically, dividing it into nine sections, each centered on a key work by Manet. Since the National Gallery's collection is especially strong in French art of the nineteenth century and indeed contains several of those key works—among others, *The Old Musician, The Tragic Actor, The Gare Saint-Lazare,* and *The Plum*—we have naturally drawn on it wherever possible. We have also relied heavily on the generosity of Mr. and Mrs. Paul Mellon in lending important works from their justly famous collection. Many other collectors and museums in this country and abroad, whose names appear in this catalogue, have also been generous lenders, none more so than the Musée du Louvre and the Art Institute of Chicago. We are grateful to all of them for their willingness to part temporarily with extremely valuable works of art, without which our presentation would have been far less exciting and meaningful.

Manet and Modern Paris was conceived and organized by Theodore Reff, professor of art history at Columbia University and author of many books and articles on Manet, Degas, Cézanne, and other artists; he has also written this scholarly and fully illustrated catalogue. At every stage in the organization of the exhibition, he worked closely with David E. Rust and Florence E. Coman of the Gallery's Department of French Painting, and in the technical examination of Manet's works with Sarah L. Fisher of the Department of Conservation, assisted by Molly Faries, a senior fellow in the Center for Advanced Study in the Visual Arts at the Gallery in

Plate 2. Edouard Manet. *Women at the Races,* 1865. Cat. 42.

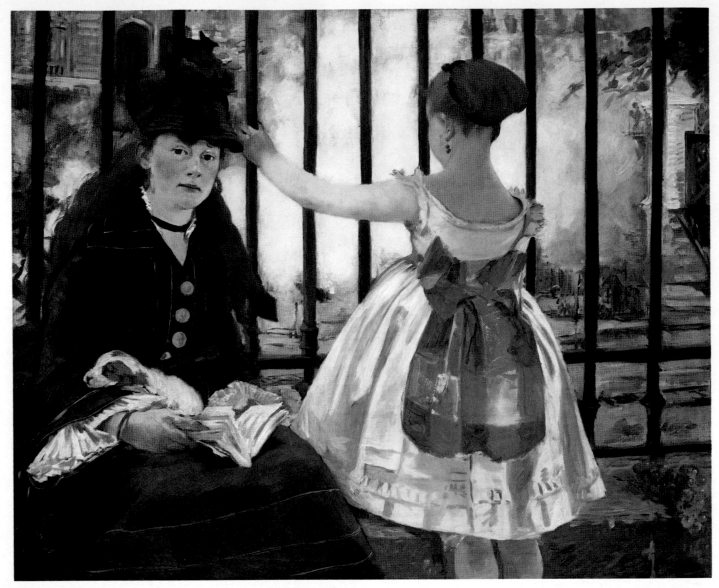

Plate 3. Edouard Manet. *The Gare Saint-Lazare*, 1872-1873. Cat. 10.

1981-1982. In the installation of the exhibition, Professor Reff worked with Gaillard Ravenel and Mark Leithauser of the Department of Installation and Design; and in the publication of the catalogue, with Frances Smyth, Melanie Ness, and Mei Su Teng of the Editors Office. Many other members of the Gallery's staff and colleagues at other institutions have made valuable contributions to the realization of this project, which is a tribute both to the genius of Manet on the centenary of his death and to the city in which he worked and found his inspiration.

J. CARTER BROWN
Director

LENDERS TO THE EXHIBITION

The Art Institute of Chicago

Cabinet des Dessins, Musée du Louvre, Paris

The Cincinnati Art Museum

Richard M. Cohen, Holmby Hills, California

Corcoran Gallery of Art, Washington

David Daniels, New York

The Detroit Institute of Arts

Durand-Ruel & Co., Paris

Folkwang Museum, Essen

Hamburger Kunsthalle, Hamburg

The Armand Hammer Collection, Los Angeles

Dr. John E. Larkin, Jr., White Bear Lake,
Minnesota

The Library of Congress, Washington

The Maryland Institute, College of Art, Courtesy of
The Baltimore Museum of Art

Mr. and Mrs. Paul Mellon, Upperville, Virginia

The Metropolitan Museum of Art, New York

Mr. and Mrs. Irving Moskovitz, New York

Musée Carnavalet, Paris

Musée National d'Art Moderne, Centre Georges
Pompidou, Paris

Musée d'Orsay, Paris

Musée du Petit Palais, Paris

Museum of Fine Arts, Boston

Muséum National d'Histoire Naturelle, Paris

Nasjonalgalleriet, Oslo

The National Gallery, London

The New York Public Library, Astor, Lenox, and
Tilden Foundations

Petit Palais, Geneva

The Phillips Collection, Washington

Santa Barbara Museum of Art

Szépmüvézeti Múzeum, Budapest

Mr. and Mrs. Joseph M. Tanenbaum, Toronto

The Walters Art Gallery, Baltimore

Mrs. John Hay Whitney, New York

Yale University Art Gallery, New Haven,
Connecticut

Private collections

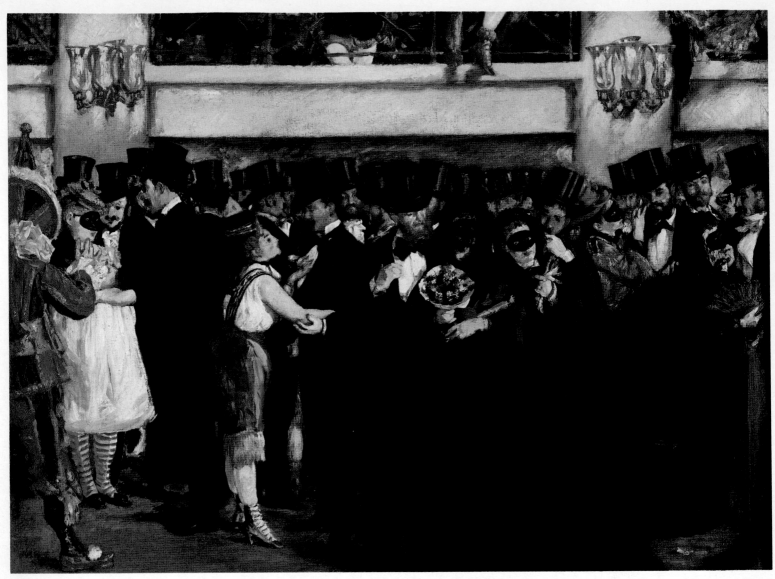

Plate 4. Edouard Manet. *The Ball of the Opera*, 1873. Cat. 39.

ACKNOWLEDGMENTS

ONE OF the pleasures in working on this exhibition and its catalogue has been the opportunity to collaborate with the highly professional staff of the National Gallery, where everyone, beginning with the director, J. Carter Brown, has been most cooperative and supportive. Colleagues at many other museums, both here and abroad, were also very helpful; I would particularly like to thank Richard Brettell at the Art Institute of Chicago, Bernice Davidson at the Frick Collection, Charles Moffett and Charles Stuckey at the Metropolitan Museum of Art, Françoise Cachin and Geneviève Lacambre at the Musée d'Orsay, and Werner Hofmann and Gisela Hopp at the Hamburger Kunsthalle.

For providing photographs and information, I am grateful to Gerald Ackerman, Arthur G. Altschul, William Acquavella, Beverly Carter, Timothy J. Clark, Hermine Chivian-Cobb, Alan Fern, Donald Gordon, John and Paul Herring, Harry Parker III, Joseph Rishel, Kirk Varnedoe, and Robert N. Whittemore in this country and Hortense Anda-Bührle, Huguette Berès, Philippe Brame, Charles Durand-Ruel, Bernard Tabah, and Daniel Wildenstein in Europe. In addition, Barbara Coeyman and Kirsten Keen undertook research in Paris, Joel Isaacson read the manuscript with his usual critical acumen, and Arlene G. Reff edited it with great patience and care.

Throughout the entire project, John Klein was a dedicated and resourceful research assistant and Arlene Reff an unfailing source of advice and encouragement. Without their help the exhibition and the catalogue would never have been completed in time.

THEODORE REFF

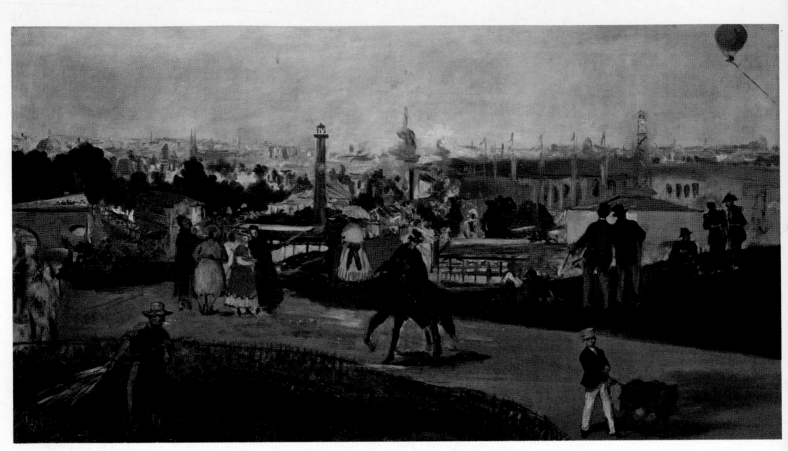

Plate 5. Edouard Manet. *The World's Fair of 1867*, 1867. Cat. 2.

Manet and the Paris
of Haussmann and Baudelaire

❧

EDOUARD MANET's paintings, drawings, and prints of Parisian subjects, which are shown in this exhibition alongside those of his contemporaries, have become so familiar through frequent reproduction that we tend to forget what a remarkable innovation they were in their time. Inseparable from two of the most popular aspects of our culture, impressionist art and modern Paris, they seem as "familiar, foreign, and near" as the Tuileries Gardens, the Folies-Bergère, and the Pantheon, each of which Manet painted. But like all authentic works of art, they are the product of a unique personality working in a unique milieu; they cannot be understood fully without first understanding certain aspects of Manet himself and the Paris of his time. For he was in background, manners, and taste the most thoroughly Parisian of the impressionist artists, at home only there, and even there only in an elite society centered on the fashionable cafés of the boulevards and the artists' cafés of Montmartre. At the same time, he was influenced by two developments that began in the 1850s and continued in the following decade, when he produced his first images of Paris. One was the transformation of the city both physically and socially into the first truly modern metropolis, with a monumental grandeur and scale and a richness of cultural life that made it a model for capital cities throughout the world. The other was the development of modernism itself as the highest value of avantgarde and eventually of popular culture and of the urban milieu as the source of that modernism for over a century. The one achievement was largely due to Baron Georges Haussmann, Napoleon III's master planner in the rebuilding and expansion of Paris in the Second Empire; the other to Charles Baudelaire, Manet's guide in the discovery of modern urban life as a source of subject matter and stylistic innovation. To understand what made Manet's images of Paris specifically modern, rather than merely contemporary like those of his prede-

cessors, we must understand how they were shaped by his own vision and values, as well as by the modernization effected by Haussmann and the modernism advocated by Baudelaire.

❧

ALL THOSE who knew him agreed that Manet was more than a resident of Paris; he "personified the sentiments and customs of Parisians, raised to their highest power" (Duret, 158). Unlike many of his fellow citizens, moreover, he was "comfortable only in Paris," and despite his fascination with Spain and Spanish art, he found the cuisine of Madrid so inferior to that at home that he cut short his trip in 1865 and hurried back (Duret, 47). He did stay longer at Boulogne, where the food was presumably better, on a summer vacation in 1868, but toward the end he admitted, "I think only of returning to Paris, for I do nothing here" (Moreau-Nélaton 1926, 1:103). Born and bred a Parisian, he came from a prominent, well-to-do family in which the traditions and social graces of the old bourgeoisie of the July Monarchy were still valued. On his father's side, his ancestors had been wealthy landowners and local officials at Gennevilliers and respected magistrates in Paris for several generations; on his mother's, they had been equally distinguished diplomats and army officers. From them Manet acquired a taste for fashionable society and, equally important, the means to satisfy it. "He confessed to me," wrote Zola in his first essay on the artist, "that he adored society and discovered secret pleasures in the perfumed and brilliant delights of evening parties" (Zola 1867, 86). Fantin-Latour's well-known portrait (fig. 1), painted in the same year, shows Manet wearing elegantly cut clothing and a tall silk hat, with a gold chain in his vest and a walking stick in his gloved hands, a costume we are told he always wore, in the country as well as the city. Even at the end of his life, when he was very ill, he

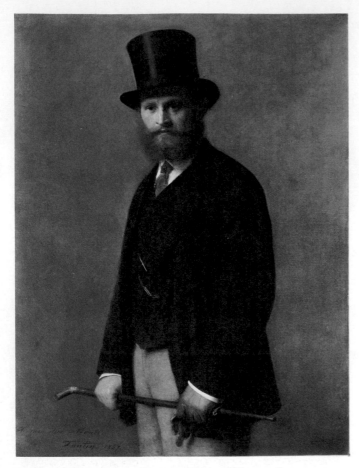

1. Henri Fantin-Latour. *Portrait of Edouard Manet,* oil on canvas, 1867. The Art Institute of Chicago, Stickney Fund.

"dressed like a clubman" and, preserving "a smiling demeanor, welcomed many friends in his studio . . . now that he was unable to walk along the boulevards" (Blanche, 9-10).

The boulevards, from the Porte Saint-Denis to the Madeleine, and especially the few hundred yards between the rue de Richelieu and the Chaussée d'Antin comprising the boulevard des Italiens, had been the center of Manet's social life since the late 1850s, as indeed they had been for several generations of worldly and talented Parisians for twenty years before that. Here were concentrated the most fashionable theaters, restaurants, and cafés—above all the Café Tortoni on the corner of the rue Taitbout (fig. 2), the very heart of boulevard society and of Manet's as well. "The Café Tortoni was the restaurant where he had lunch before going to the Tuileries Gardens," his friend Antonin Proust recalled, "and when he returned to the same café from five to six o'clock, people vied with each other in

complimenting him on his studies" (Proust, 42). Here, on the boulevard, were edited and published the ephemeral newspapers, with names like *Le Nain jaune, La Vie parisienne,* and *Le Boulevard* itself, devoted to chronicling the activities and gossip of that elite society, and in a witty, sophisticated style that summed up its urbane spirit perfectly. Among the topics treated in their columns and abundant illustrations were the theater, the racetrack, the beaches and spas, the public concerts and festivals, and the lives of the fashionable courtesans—all subjects Manet too treated in the 1860s. Among the contributors were Banville, Champfleury, Baudelaire, and Gautier, all friends of his; indeed Baudelaire's only essay on him appeared in *Le Boulevard,* edited by the socially prominent photographer and satirist Carjat, and Manet in turn contributed a satirical print to Carjat's previous publication, *Le Diogène* (Farwell 1973, 82-83, 120-124).

It was also on the boulevard des Italiens, in the enterprising Galerie Martinet, a forerunner of those which later supported impressionism, that Manet had his first one-man exhibition in March 1863. Among the pictures he showed was the one in which, for the first time, he portrayed himself amid this boulevard society and made its elegant, allusive style his own—the *Concert in the Tuileries* (fig. 3). Some of those who have been identified in it were indeed among the leaders of that society: Gautier, the bohemian turned court writer and entertainer; Offenbach, the composer of lighthearted operettas; Aurélien Scholl, the journalist admired for his

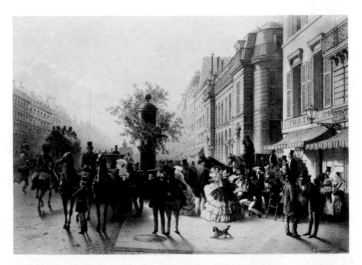

2. Eugène Guérard. *The Boulevard des Italiens,* lithograph, 1856. Bibliothèque Nationale, Paris.

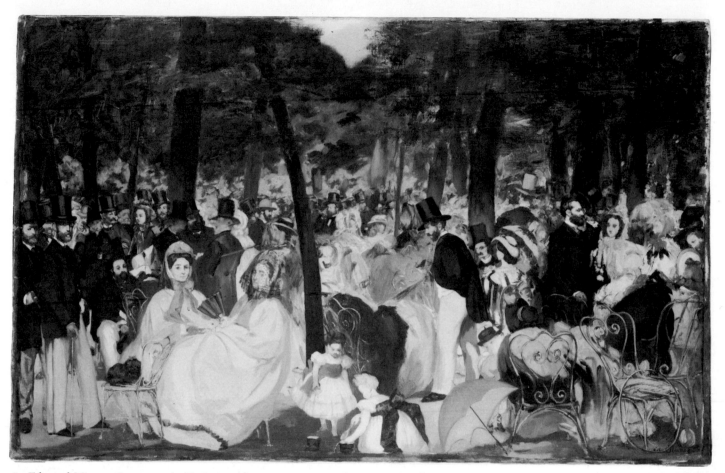

3. Edouard Manet. *Concert in the Tuileries,* oil on canvas, 1862. The National Gallery, London.

wit; Baudelaire, the poet and self-styled dandy; and Manet himself, the unofficial painter of this elite circle (Davies, 91-92). Unofficial but not unacknowledged, for in depicting himself and a fellow artist at the left edge of his composition, he imitated the poses and positions of figures then thought to represent Velázquez and Murillo, in a picture in the Louvre then attributed to Velázquez, thus implying that he was to this new aristocracy what his idol had been to the old aristocracy of Madrid (Sandblad, 37-39). For the fulfillment of this fantasy, at once serious and playful, the public gardens adjacent to the Palais des Tuileries provided a suitably courtlike setting, just as the band concerts given there biweekly provided a suitably fashionable and animated atmosphere.

Contemporary observers were by no means agreed, however, on the value of such an atmosphere or setting. If in the politically neutral *La Vie parisienne* a society draftsman like Crafty could describe a concert in the Tuileries with coy amusement (fig. 4), in the republican paper *L'Evénement* an opposition writer like Jules Vallès could only find it ridiculous: "It is the worn-out and the idle who sit there under the tall chestnut trees, proper gentlemen and charming ladies," he remarked, bitterly regretting that in creating a new street Haussmann had not "mutilated" the Tuileries Gardens, rather than the Luxembourg Gardens dear to the Latin Quarter (Vallès, 36). It was indeed in defiance of publications like Carjat's *Le Boulevard* that Vallès chose as the running title of his columns "La Rue," a term with a lower-class connotation: "I am of the people and my column too," he announced (Vallès, 8-9). Manet, for all his well-known republican views, was of course a friend of Carjat and not of Vallès, an habitué of the boulevard and not of the street. Yet he was more complex than such a simple opposition implies; for if, as a later admirer of Vallès noted, the street suggests "the pavement or, better yet, the barricade" (Vallès, 8-9), Manet too could represent

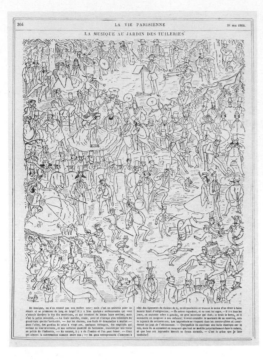

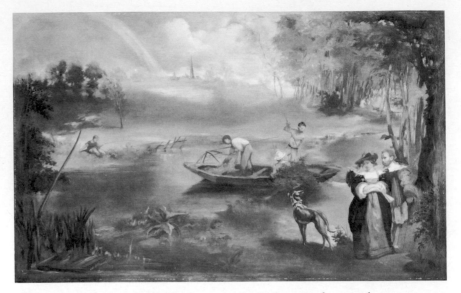

Left: 4. Crafty [Victor Geruzez]. *Concert in the Tuileries Gardens*, wood engraving from *La Vie parisienne*, 28 May 1864. Bibliothèque Nationale, Paris.
Right: 5. Edouard Manet. *Fishing,* oil on canvas, c. 1860. The Metropolitan Museum of Art, New York, Purchase, Mr. and Mrs. Richard J. Bernhard Gift, 1957.

the barricade with power and compassion, as he did twice during the Commune (cat. 73, 76). He could also represent the street itself and the streetwise inhabitants of its slums, as he did in the *Old Musician* (cat. 59), painted in the same year as the *Concert in the Tuileries* and shown with it in the same exhibition at the Galerie Martinet—an extraordinary confrontation between *le boulevard* and *la rue,* to which we shall return.

Nor was it the only such confrontation his work of the early 1860s provided: in contrast to *Fishing* (fig. 5), based on a print after Rubens' *Landscape with the Castle Steen* and depicting himself and his future wife in the guises of the aristocratic Rubens and his wife, stands the *Gypsies* (see fig. 97), based on a print after Louis Le Nain's *Harvesters* and perhaps on his *Forge* in the Louvre, models of lower-class rural life appropriate for this image of dispossessed, wandering gypsies. And in contrast to the *Women at the Races* (cat. 42), a group of elegant spectators at the Longchamp racetrack, stands the *Street Singer* (fig. 86), an itinerant performer emerging from a low tavern. These too were aspects of contemporary Parisian society to which Manet, an artist keenly aware of his society, could not help responding.

In the kind of company he himself chose, however, he remained to the end the *boulevardier* he had been from the beginning, "one of those for whom the frequentation of the boulevard was a habit all his life" and even, as its

character became increasingly cosmopolitan and commercial, "one of the last representatives of that form of existence" (Duret, 159). In the 1870s, after having established the Café Guerbois and then the Café de la Nouvelle-Athènes in Montmartre as the meeting place of his circle of artists and writers, he continued to return to the Café Tortoni and the Café de Bade—the only one in that circle who did so, indeed the only one, except perhaps for Degas, who *could* do so. Manet's work was received at Tortoni's, once his closest friends were gone, with indifference and even with hostility, yet "he came back every day simply as a Parisian, driven by the need to tread the select ground of the true Parisian" (Duret, 160). And when his failing health prevented him from going there, he recreated the boulevard milieu in his studio, filling it every afternoon with friends and acquaintances, even setting out beer and apéritifs for them; it became, as his wife remarked, "an annex of the Café de Bade" (Schneider, 135). He also invited society ladies and well-known cocottes to sit for their portraits, executed in the lighter medium of pastel; among them were Méry Laurent and Valtesse de la Bigne (fig. 6), demimondaines who brought with them "a circle of fashionable artists, financiers, and wealthy foreigners" (Blanche, 52).

Valtesse was one of the many links between Manet's present society and that of the Second Empire: she had

begun her career singing in Offenbach's operettas and had been a model for Zola's and perhaps for Manet's treatment of Nana (fig. 11), the very type of the wealthy courtesan of the Empire (Hofmann 1973a, 90). Henriette Hauser, the actress who actually posed for Manet's painting, was another link; she too had performed in boulevard comedies and achieved her greatest notoriety toward the end of the Empire. And Léontine Massin, who starred in the stage version of *Nana* in 1881, was another of those whom Manet portrayed at this time (R-W 2:54).

Several of his recent pastel portraits, including that of Valtesse de la Bigne, figured in the exhibition Manet held in April 1880 in the galleries of *La Vie moderne,* an illustrated weekly founded the year before, which now played much the same role in his life as *Le Boulevard* had in the previous decade. Its offices and galleries were in fact on the boulevard, and its pages were filled with articles of topical interest for polite society, avoiding politics and stressing social and cultural activities, of the kind that the previous publication had featured; although it appealed to a broader middle-class audience, its articles were written in a similarly sophisticated and witty style. The editor of *La Vie moderne,* Emile Bergerat, was a friend of Manet and persuaded him to contribute several drawings—Renoir and Forain were more regular con-

tributors—and to participate in a few benefit shows. About his own exhibition the journal carried a long and predictably favorable review, assuring its readers that Manet was a man of "perfect education, excellent manners, cultivated spirit, and amiable character, a Parisian by race" (Hanson 1977, 132). He was, in short, both the painter of modern Paris and the embodiment of its spirit, at least that side of its spirit valued by *La Vie moderne* and *Le Boulevard.*

What they valued was precisely what characterizes Manet's own style: allusive, elegant, subtle, effortless, it is the style of the boulevard society to which he remained loyal throughout his life. In his youth it had still been the self-contained society of whose domain Musset noted with satisfaction, "It is only a few steps from one end to the other; nevertheless they contain the whole world" (Kracauer, 75). In such a closed milieu, subtle allusions could be made with the assurance that they would be appreciated: allusions to well-known figures in one's circle, like those in the *Concert in the Tuileries,* or even to oneself in an historical guise, like that in *Fishing;* but also quotations from famous works of art, like that of Titian's *Venus of Urbino* in *Olympia* (fig. 7), though it was scarcely noted by contemporary reviewers.

If the design of *Olympia* is patterned on Titian's *Venus,* its style is altogether modern, closer to that of the boule-

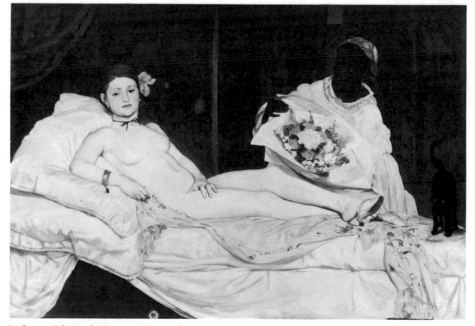

Left: 6. Edouard Manet. *Valtesse de la Bigne,* pastel, 1879. The Metropolitan Museum of Art, New York, Bequest of Mrs. H. O. Havemeyer, The H. O. Havemeyer Collection, 1929. Right: 7. Edouard Manet. *Olympia,* oil on canvas, 1862-1863. Musée d'Orsay (Galerie du Jeu de Paume), Paris.

vard writers in its elegance and concision. As Zola astutely observed, "that elegant austerity" marks "the personal savor" of works like *Olympia,* while "certain exquisite lines, certain slender and lovely attitudes," reveal Manet's "fondness for high society" (Zola 1867, 91, 97). Much the same concision, a form of visual wit, characterizes the svelte drawing and simplified modeling in the *Balcony* (fig. 10) and the *Gare Saint-Lazare* (cat. 10). In, their color harmonies, dominated by relatively neutral tones with accents of brighter hue, these pictures reveal a refined feeling for nuance, for subtlety and understatement, that was also a familiar feature of the boulevard style. Even in an intrinsically colorful subject like the *Ball of the Opera* (cat. 39), Mallarmé could "only marvel at the exquisite nuances in the blacks: in the dress coats and dominoes, in the hats and masks . . ." (Hamilton, 183). The same could be said of the subtly varied shades of black, olive green, and white in the *Dead Toreador* (cat. 77). For all their apparent simplicity and ease, both pictures were, as we know, the result of a long struggle; and in this effort to make them seem effortless, Manet reveals still another feature of his boulevard style. It was the natural expression of a society that disdained hard work as bourgeois or plebeian and admired the virtuoso performance. All those who watched him paint have remarked that "he labored greatly on the pictures he sent to the Salon, yet they looked like sketches," and that he reworked a portrait "again and again, [yet] every time it came out brighter and fresher" (Hanson 1977, 160).

To match the style of a social group with that of a single artist is always somewhat arbitrary; and in this case to isolate four qualities, while ignoring others which may characterize the group better than the artist—the amusing banter, witty repartée, and ephemeral journalism said to express the spirit of the boulevard (Roz, 206-211)—or the artist better than the group—the "harmony, clarity, economy, and concentration on essentials" said to distinguish Manet's finest pictures (Richardson, 29)—may seem particularly arbitrary. But in its allusivenesss, elegance, subtlety, and virtuosity, Manet's style does reflect that of the milieu whose values had formed his own and continued to inform them throughout his life. Zola, the first to hint at such a connection, noted that Manet's art is "intelligent, witty, spirited" and "could only have developed in Paris; it has the slender grace of our women, made pale by gaslight; it is truly the child of an artist who loved high society and exhausted

himself determining to conquer it" (Zola 1884, 261). In the twenty years it took him to do so, however, that society changed and the city itself changed dramatically, thanks largely to the ambitious program of renovation and expansion undertaken in the Second Empire and completed early in the Third Republic.

❧

NAPOLEON III's grandiose plans for the modernization of Paris, formulated before he became emperor in 1851 and amplified by Haussmann, his Prefect of the Seine, were a response to many urgent problems. The most obvious was demographic: in the two decades preceding 1851, the city's population had doubled, rising from 576,000 to 1,053,000; in the three decades following, the population doubled again, reaching 2,270,000; thus within Manet's lifetime it increased fourfold. The new railroads that led directly to the capital, the annexation by the city of its suburbs in 1860, and the influx of workers from rural areas, partly drawn by Haussmann's construction projects, all contributed to the demographic explosion. In addition to overcrowding, there were other serious problems: the housing in many of the oldest and poorest quarters was dangerously decrepit; the narrow streets made circulation difficult within neighborhoods and impossible between them; the outmoded sewage system was a threat to public health and was polluting the Seine; and both the central markets and the public parks were inadequate for the increased population.

To these problems the emperor and his prefect, for all the ruthlessness of their methods and the political bias of their motives, which favored above all "the new class of daring financiers, large scale building contractors, big department store owners, hotel operators, and the rest of the *nouveau riche* commercial breed" (Saalman, 113), brought energetic and farsighted solutions. They demolished many slums in the central and eastern parts of the city and promoted construction of new housing there and in the recently developed areas to the north and west; they cut through wide boulevards to provide access to railroad stations and commercial centers and to link the separate neighborhoods; they so greatly improved the sewage and drainage systems that Napoleon could be complimented on having "found Paris stinking and [having] left it sweet" (Pinkney, 127); and they built modern markets at Les Halles and large parks at Boulogne, Vincennes, and elsewhere in the city.

The results were impressive, but so were the costs, not only the 2.5 billion francs that Haussmann estimated having spent, much of it borrowed through the irregular schemes that eventually brought him down, but also the less easily quantified costs that critics such as Victor Fournel added up: the destruction of old buildings and streets of great historic value and charm; the ruthless insistence on broad, straight boulevards of monotonously uniform design; and the imposition everywhere, on private as well as public buildings, of a pompous, banal, official style (Fournel 1865, 218-229). And those other costs, more social than aesthetic, that Zola listed in a scathing attack on the brutal demolition of entire neighborhoods, the cynical indifference to those who were evicted—those urban vagabonds for whom Haussmann expressed hatred even as he increased their numbers—and the masking of new slums by new façades; in short, "an immense hypocrisy, a colossal Jesuitical lie" (Zola 1872, 78). And though these critics did not mention it, others pointed out that the broad boulevards were also a "strategic embellishment" that would facilitate the movement of troops and the razing of barricades in any future insurrection, which indeed they did in 1871 (Benjamin 1968, 87).

Manet's reaction to the drastic changes taking place around him is hard to assess. The only direct evidence is Proust's memoir of their stroll one day—it must have been in 1860-1861—through a ghetto being demolished to make way for the new boulevard Malesherbes, one of Haussmann's major projects and the subject of many prints like the one by Martial illustrated here (fig. 8). The memoir focuses exclusively on Manet's delight in the novel visual effects provided by a tree left standing in a destroyed garden and by the whiteness of a workman's clothing against a white plaster wall: "'There it is,' he exclaimed, 'the symphony in white that Gautier speaks of'" (Proust, 39-40). But this purely aesthetic response could not have been his only one; for he could hardly ignore the moral and social implications of the demolitions, any more than Daumier did in depicting the bewilderment of suddenly dispossessed tenants and the glee of suddenly enriched landlords in prints of the 1850s, or than Baudelaire did in revealing "how the modernization of the city at once inspires and enforces the modernization of its citizens' souls" in prose poems of the 1860s (Berman, 147).

If Manet was fascinated by the visual aspects of the

rebuilding, the way draftsmen like Martial and photographers like Marville were, he did not record them in his art; whereas he did represent, in a picture of haunting, melancholy power, the displaced inhabitants of Petite Pologne, the once notorious area of decrepit slums whose destruction he had witnessed that day. This picture, his first of modern Paris on a monumental scale, is of course the *Old Musician* (cat. 59), painted in his new studio on the rue Guyot, a street recently opened in a still undeveloped area west of the boulevard Malesherbes, not far from Petite Pologne. In it he describes sympathetically not only those undesirable types Haussmann wished would go away—an itinerant musician, a quack peddler, a chronic alcoholic, an orphan girl—but also a street urchin whose incongruous, Pierrot-like costume alludes

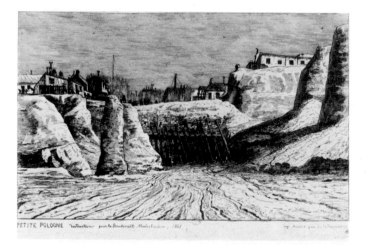

8. A. P. Martial [Adolphe Potémont]. *Petite Pologne*, etching, 1861. Bibliothèque Nationale, Paris.

to the Parisian home of the commedia dell'arte, the Théâtre des Funambules, itself a victim of urban renewal; along with other popular theaters on the boulevard du Temple, it was about to be destroyed (Mauner, 55). Thus the *Old Musician*, far from being "Manet's last portrayal of peasant life in a more romantic manner" before he turned to modern urban subjects later in 1862 (Sandblad, 28), is actually his first portrayal of lower-class street life in manner half romantic and half realist.

He had, it is true, already painted the alcoholic whom he repeats in the *Old Musician* three or four years earlier; but this *Absinthe Drinker* (fig. 94), although posed by a rag-picker and iron-monger Manet had met in the Louvre—the slums in its neighborhood, among the worst in Paris, had only recently been cleared—remained a wholly romantic image of pathos and shadowy mystery,

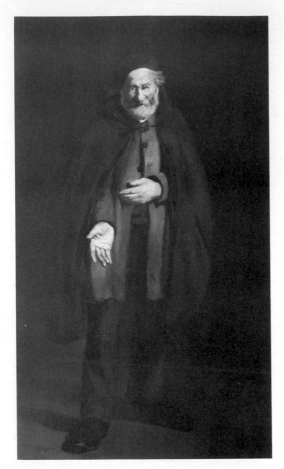

9. Edouard Manet. *The Philosopher (with a Beret)*, oil on canvas, 1865. The Art Institute of Chicago, A. A. Munger Collection

without the roots in a particular time and place of the later work. Much closer to the *Old Musician* in that respect is the *Street Singer* (fig. 86), painted at about the same time. It was in fact inspired by the same exploration of the area occupied by Petite Pologne; for Proust's memoir of their stroll through the area concludes with an account of their chance meeting with just such an itinerant singer: "A woman was leaving a suspicious-looking cabaret, lifting her skirts, holding her guitar. Manet went straight up to her and asked her to come and pose for him" (Proust, 40). She refused, laughing, and he used a model instead; but his immediate interest in the street singer—not as a picturesque genre figure, but as a performer of a certain class, encountered in a certain part of Paris—remains significant. Nor is it the last expression of such an interest in his work: the so-called *Philosophers* (e.g., fig. 9), painted in 1865, were not only traditional types based on Velázquez' *Aesop* and *Menippus*, but also thoroughly contemporary Parisians;

although Haussmann had succeeded in driving them from the new commercial and residential districts, they still flourished in the old ones around the Hôtel de Ville and along the rue Mouffetard (Privat d'Anglemont, 305-306). And the *Rag-Picker* (R-W 1:137), painted in 1869, although by then a familiar type in popular art and literature, was likewise associated with particular parts of the city, above all the bizarre colony called the "Villa des Chiffoniers" near the place d'Italie which, according to a contemporary guide to the Paris underground, contained hundreds of their tiny, tin-roofed hovels, "a city within a city, . . . the capital of poverty lost in the midst of the country of luxury" (Privat d'Anglemont, 218).

However revealing of Manet's social sympathies these pictures of the "capital of poverty" may be, most of those he painted of Parisian subjects represent the "country of luxury," and not only in the last decade of the Empire but also in the first decades of the Republic. In this respect the Republic did not differ from its predecessor, completing all the projects Haussmann had left unfinished and adding a few of its own. The pictures of "luxury," moreover, are often more topical than the others, more deeply rooted in aspects of the city's social life currently in vogue and even in certain places and streets only recently built. Thus the *Concert in the Tuileries* (fig. 3), painted in the spring of 1862, depicts a milieu which, to judge from the attention given it in the illustrated weeklies, of which the drawing in *La Vie parisienne* already cited and an article in *Le Boulevard* exactly contemporary with Manet's painting are examples, was then at the height of its popularity among the men about town and demimondaines who pursued each other there (Isaacson 1982, 115, n. 85; Farwell 1973, 80-82). The *Spanish Ballet* and the portraits of Lola de Valence and Mariano Camprubi (cat. 32-34), which date from the fall of the same year, describe performers who appealed not only to the Hispanophile in Manet but also to the connoisseur of urban entertainment; in the company of Baudelaire, he attended their performances nightly at the Hippodrome, an arena on the place Victor-Hugo that had opened five years earlier. The *Races at Longchamp* (cat. 43), painted in 1864 and repeated several times thereafter, treats a subject which had become one of the major events of the social season and, after the founding of the Grand Prix de Paris the year before, an international sporting event as well; moreover, its setting was the new racetrack in the Bois de Boulogne, completed in 1857 as part of the gran-

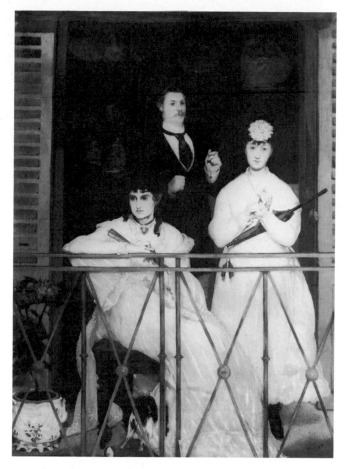

10. Edouard Manet. *The Balcony,* oil on canvas, 1868-1869. Musée d'Orsay (Galerie du Jeu de Paume), Paris.

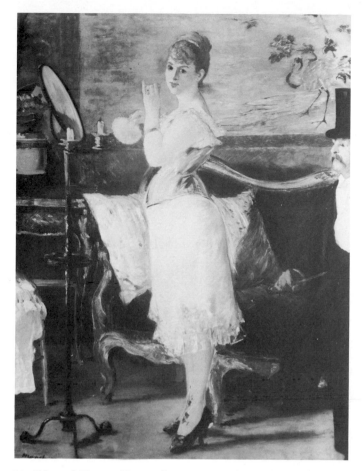

11. Edouard Manet. *Nana,* oil on canvas, 1876-1877. Hamburger Kunsthalle, Hamburg.

diose development of that park. The *World's Fair of 1867* (cat. 2), one of Manet's few panoramic views of Paris, was inspired by a truly topical event, an exhibition open for only seven months, but one of great significance for the Second Empire, which built immense galleries on the Champ de Mars to house it, and for the artist himself, who had a smaller structure built opposite it on the place de l'Alma to house a retrospective exhibition of his own work. The *Balcony* (fig. 10), shown at the Salon two years later, represents an architectural motif which, although not invented by Haussmann's builders, was a standard feature of their new apartment houses, including the one on the rue Saint-Pétersbourg where Manet had his models pose; a feature that afforded the kind of extension of private into public space that he describes here and that the younger impressionists were soon to exploit (fig. 22, 129). The *Gare Saint-Lazare* (cat. 10) and the *Ball of the Opera* (cat. 39), both dating from 1873, show recently built or currently fashionable aspects of

Paris—the one the Saint-Lazare railroad station and yard, enlarged six or seven years earlier, and the Pont de l'Europe, constructed in the same years; the other the traditional carnival ball which, to judge again from the frequency of coverage in the illustrated papers, was especially popular at the time. *Nana* (fig. 11), exhibited amid much notoriety in 1877, portrays the type of wealthy courtesan of the Second Empire who dominates Zola's novel, published two years later, but who also appears in his *L'Assommoir,* issued serially while the picture was in progress; and just as Zola had interviewed a *grande cocotte* of that era, so Manet used as his model an actress and cocotte of his own era (Hofmann 1973a, 21-23, 90-91). The *Rue Mosnier Decorated with Flags* (cat. 86), painted on 30 June 1878, depicts not only a specific occasion, the celebration of the success of the latest world's fair, but a specific location as well, the street Manet saw from his studio windows; opened by Haussmann nine years earlier in the development of the Quartier de l'Europe, it was

not named until three years after the picture was completed. The *Bar at the Folies-Bergère* (fig. 49) of 1882, the last of Manet's large Parisian subjects, is also one of the most topical; although this gaudy music hall on the rue Richer had been noted for its glittering décor and varied spectacles for almost a decade, its greatest vogue came later; witness Forain's picture of 1878 (fig. 50), cartoons in the illustrated press of that year, and Huysmans' description in a prose poem of 1879.

The most ambitious of all Manet's pictures of Haussmann's Paris would have been the murals he proposed to paint in the new Hôtel de Ville but never received permission to execute. The building, almost entirely destroyed during the Commune, was reconstructed between 1873 and 1882 and inaugurated in July of that year; but its decoration dragged on for almost two decades, so that most of the murals were commissioned in the late 1890s, long after Manet's death. Hence his proposal, in a letter to the president of the Municipal Council in April 1879 (Bazire, 142), seems rather premature—until we learn that one month earlier the authority to determine subjects and choose artists, at least for the sculptural decoration, had been shifted from the central administration to the council itself (Vachon, 120) and that its membership included Manet's brother Gustave and the friendly critic Castagnary. Manet's hopes "to paint the life of Paris in the house of Paris" (Proust, 95) were however soon dashed: his letter received no reply. And when the council eventually awarded commissions, it was to artists such as Bonnat, Gervex, and Roll, who could cleverly combine contemporary urban subjects with traditional allegorical motifs; Gervex's ceiling on the theme of music, for example, shows a group of performers and putti floating on clouds and below them a concert in a modern theater strongly reminiscent of scenes by Manet and Degas (d'Hancour, 742-747). What is interesting in the series of subjects Manet proposed on "the public and commercial life" of his day is that every one of them referred to structures, infrastructures, or public amenities created by Haussmann and Napoleon III: "I would have," he explained, "Paris-Markets, Paris-Railroads, Paris-Bridges, Paris-Underground, Paris-Racetracks and Gardens." And four of them were subjects he had already treated in images of the Gare Saint-Lazare (cat. 10), the Pont de l'Europe (fig. 30), the races at Longchamp (cat. 43), and the Bois de Boulogne (fig. 70).

The recently built Pont de l'Europe and rebuilt Gare Saint-Lazare were appropriate symbols of the new city that had emerged, were indeed at the heart of the recently developed Quartier de l'Europe, an upper-middle class residential area west of the administrative and commercial centers. Although laid out in the 1820s, it had remained largely undeveloped until the nearby slums of Petite Pologne were demolished over thirty years later (Hillairet, 1:79, 489). It was the former inhabitants of Petite Pologne, symbols of the old city that had disappeared, whom Manet painted in the *Old Musician* (cat. 59) a decade before painting the *Gare Saint-Lazare* in the same neighborhood. Thus the differences between the two pictures are not only stylistic—a realism tinged with romanticism that leaves the setting vague and evocative versus a full-blown naturalism that defines it explicity—but are also rooted in the urban development of Paris. They parallel the differences in style and urban content between the *Absinthe Drinker* (fig. 94), posed for by a rag-picker who frequented the Louvre in the oldest part of the city, and *At the Café* (fig. 45), set in a tavern near the place de Clichy on the edge of the new quarter; or those between the portrait of Rouvière (cat. 27), a neglected tragedian who played Hamlet on the old boulevard du Temple, and the portrait of Faure (cat. 28), a world-famous baritone who performed *his* Hamlet in the splendid new Opera.

In the earlier period, Manet himself had preferred marginal, somewhat destitute neighborhoods, living in apartments on the rue de l'Hôtel de Ville and the boulevard des Batignolles, in an outlying area only recently annexed by the city, and working in studios on the rue Lavoisier, a street or two away from Petite Pologne, and on the rue Guyot, a remote street behind the still undeveloped Parc Monceau. But in those years he had also frequented the fashionable Café Tortoni, identifying himself with its boulevard clientele, and in that isolated studio, "surrounded by workshops, all sorts of warehouses, courtyards, and huge vacant lots" (Duret, 86), he had painted the Tuileries Gardens, the races of Longchamp, and the elegant courtesan Olympia.

In the later period, such a dichotomy was much less apparent: he lived and worked and often chose his subjects in a relatively restricted area between the place de l'Europe and the place Pigalle, in the western part of the Ninth Arrondissement and the extreme eastern part of the Eighth. For many years his apartment was on the rue

Saint-Pétersbourg and his studio was on the same street or on the rue d'Amsterdam, both of them in the Quartier de l'Europe; his favorite haunts were the Café Guerbois, near the place de Clichy, and the Café de la Nouvelle-Athènes, on the place Pigalle, though he continued to frequent Tortoni's on the boulevard; and his Parisian subjects included, in addition to the Gare Saint-Lazare and the Pont de l'Europe, others in the same *quartier:* the balcony of a building on the rue Saint-Pétersbourg (fig. 10), the celebration of a holiday on the rue Mosnier (cat. 86), and the garden of a friend on the rue de Rome (R-W 1:237). Several of the other sites he painted were clustered around the place de Clichy a few blocks away: the Brasserie de Reichshoffen (cat. 20), the restaurant of Père Lathuille (R-W 1:291), and the bustling traffic of the *place* itself (R-W 1:273); or were not much further away: the ice skating rink on the rue Blanche (R-W 1:260), the old opera house on the rue Lepelletier (cat. 39), and the Folies-Bergère on the rue Richer (fig. 49). Of Manet's other Right Bank subjects, only the world's fair viewed from the Trocadéro (cat. 2) and a *café-concert* on the Champs-Elysées (fig. 39) were further afield, and both clearly had a universal Parisian appeal. As for the Left Bank, he painted only one view—a very impressive one, it is true—of the area around the Pantheon (cat. 4) and a small sketch of the southern suburb of Montrouge (R-W 1:159).

To a large extent, then, Manet's Paris from the late 1860s on was that of the Ninth Arrondissement and contiguous parts of the Eighth and Seventeenth. It was an area of the city in which were crowded together a remarkable number of artists, writers, theater people, newspaper offices, music halls, opera houses, and cafés of every variety, an area of which it could still be said many years later, "Of all the Parisian *arrondissements,* this one is without doubt the most Parisian" (Dauzat and Bournon, 91). It was thus an appropriate setting for the most Parisian of the impressionist painters. But it is doubtful that he would have assimilated its spirit so thoroughly if he had not been convinced that a truly modern art had to be rooted in the experience of modern urban life; and this conviction he owed above all to Baudelaire.

❧

THE EARLY 1860s, when Manet began painting Parisian subjects, after a decade of painting copies and pastiches of Velázquez, Titian, and other old masters, were just the years when he was most closely acquainted with Baudelaire, who had long been an eloquent advocate of such subjects, and also the years when Baudelaire himself was most deeply involved in treating them in both poetry and prose. This double coincidence is something to savor but also something to distrust, for by mid-century Baudelaire was hardly alone in urging that artists and writers "be of their own time." The importance of depicting contemporary scenes and figures rather than historical ones, and in a contemporary language or style rather than a classical one, had already been stressed more than thirty years earlier, when one of the leading romantics had insisted that writers be of their time "before everything and in everything" (Nochlin, 104). Manet himself, while still a *lycée* student in the mid-1840s, had rejected Diderot's dictum, "When a people's clothes are mean, art should disregard costume," by asserting bluntly, "That is really stupid; we must be of our time and paint what we see" (Proust, 7).

Yet Baudelaire's brilliant elaboration of the idea does mark a turning point in its history: he was the first to recognize that "the heroism of modern life" was to be found above all in modern urban life, the first to declare that "the life of our city is rich in poetic and marvellous subjects" (Baudelaire 1846, 119). For the romantics, "being of one's time" had largely been a theoretical demand in their battle against the established rules and canons of correctness and their search for freshness and novelty in contact with nature and everyday life. For the realists, it had a more concrete meaning—that of recording the manners and customs of their own society, especially of its neglected lower classes, in a sincere and serious style—and it had a greater application in practice. But if realist critics like Champfleury called for the imaging of "present-day personalities, the derbies, the black dress-coats, the polished shoes or the peasants' *sabots*" (Nochlin, 28), and artists like Courbet painted them on the monumental scale formerly reserved for the heroic figures of history and myth, these "present-day personalities" were largely drawn from rural and small-town society and thus remained images of its familiar and timeless types. What Baudelaire had discovered, however, and urged Manet to discover, was "the transitory, fleeting beauty of our present life," by which he meant urban life, whose energy and complexity constituted a new source of inspiration (Baudelaire 1863, 40).

It was not the urban-industrial milieu as such that he first claimed for modern art. Gautier had already argued in 1848 that "a modern kind of beauty," different from that of classical art, could be achieved if "we accept civilization as it is, with its railroads, steamboats, English scientific research, central heating, factory chimneys" (Calinescu, 45-46), almost all of which Manet went on to paint. He may indeed have heard his teacher Couture extoll the power of the locomotive, "that grandiose and modern chariot," and the heroism of the engineer, whose "mission has made him grow taller" (Couture, 254), and this too he eventually planned to paint. What he would have learned from Baudelaire, and only from him, was the value of immersing himself in the dynamism of urban life, of "setting up house in the heart of the multitude, amid the ebb and flow of movement" (Baudelaire 1863, 9). This was the writer's prescription for "the perfect *flâneur*" in his essay "Le Peintre de la vie moderne," published in 1863, when he was in almost daily contact with Manet and had recently been "his habitual companion when Manet went to the Tuileries, making studies outdoors," that is, acting like the perfect *flâneur* himself (Proust, 39).

In the painting that emerged from those studies, the *Concert in the Tuileries* (fig. 3), Baudelaire occupies as we have seen a prominent position. That Manet does not hold a corresponding position in Baudelaire's essay, that the painter of modern life is identified instead as Constantin Guys, a relatively minor draftsman, has often been taken as a sign of the writer's failure to appreciate Manet's work sufficiently. And just as often it has been explained as an unavoidable failure, given the date of the essay (1859-1860) and his unadventurous production up to that time. When Manet showed his more recent work in 1862, Baudelaire was quick to acclaim in it evidence of "a vigorous taste for reality, modern reality," as well as of "a lively and abundant imagination" (Baudelaire 1862, 218). He could hardly have spoken of that taste in the earlier essay if indeed he was the one who later stimulated it and had even, as is sometimes stated without proof, suggested the Tuileries concert as a suitably modern subject.

For such a subject, however, Manet had other sources as well, which were equally familiar to Baudelaire. One of them, a wash drawing by Guys of fashionable people gathered in the gardens of the Champs-Elysées, was in fact in the writer's collection; and if it is not quite as "analogous in conception" as has been maintained (Hyslop and Hyslop, 102), it is nevertheless the kind of authentic record of contemporary life that Manet too would have found congenial. The many wood engravings of the Tuileries Gardens and of the concerts given there, which appeared in illustrated newspapers around 1860, would have been equally helpful; this was precisely the kind of imagery, unpretentious yet filled with the flavor of its time, that Baudelaire had been one of the first to appreciate. In "Le Peintre de la vie moderne," while implicitly acknowledging the limitations of Guys' drawings, many of them made for newspapers, he affirms their importance as "precious archives of civilized life," alongside those of Debucourt, Gavarni, and others (Baudelaire 1863, 40), which were likewise precedents or sources for Manet.

But if the *Concert in the Tuileries* is Manet's first important picture of modern life, it is because it transcends those precedents and captures what Baudelaire called the "heroism" of that life, in a medium and on a scale associated with ambitious Salon paintings. Pictures of equally familiar Parisian sites with figures in contemporary dress (e.g., fig. 18) had, it is true, been shown at the Salon earlier in the century; but the figures had been small and the sites rendered in a static, topographic manner. With Manet, not only is the scale larger and the ambition greater, but the merely contemporary becomes truly modern; he conveys the immediacy of the urban *flâneur*'s experience, the force and freshness of his sensations, however mediated by memories of Velázquez. And in this he is indebted to Baudelaire, who affirms in the same essay: "The pleasure which we derive from the representation of the present is due not only to the beauty with which it can be invested, but also to its essential quality of present-ness" (Baudelaire 1863, 1).

The years around 1860, when Baudelaire wrote and sought to publish this essay, were also those when he was most deeply involved in conveying his experience of modern Paris in both his critical and his imaginative writings. The one kind of writing reinforced and may well have influenced the other; for in the art that he discussed, he discovered those aspects of the city's social life and physical fabric that most fascinated him as a poet. In Daumier's lithographs, he saw "parading before [his] eyes all that a great city contains of living monstrosities, in all their fantastic and thrilling reality" (Baudelaire 1857, 177); in Guys' drawings, "all the various types of

fallen womanhood" to be seen in "that vast picture-gallery which is life in London or Paris" (Baudelaire 1863, 37); and both are familiar themes in *Les Fleurs du mal*. Also familiar, at least in the poems of these years, which for the first time bore titles like "Rêve parisien" (dedicated to Guys) and "Paysage parisien," are evocations of what he called, in a memorable passage on Meryon's etchings of old streets and monuments, "the natural solemnity of a great capital" (Baudelaire 1862, 221). This passage first appeared in the "Salon de 1859," where he also discussed for the first time "the landscape of great cities, . . . that collection of grandeurs and beauties which results from a powerful agglomeration of men and monuments" (Baudelaire 1859, 200).

In these years too Baudelaire wrote most of the prose poems—some published during his lifetime, the rest only posthumously—that constitute the *Spleen de Paris,* his most profoundly original meditations on the modern city, and he grouped his recent poems on Parisian subjects with several older ones to create, in the second edition of the *Fleurs du mal* (1861), the section entitled "Tableaux parisiens." One of the new poems, "Le Cygne," is about Haussmann's transformation of Paris: set in the place du Carrousel, the great public space created six years earlier when the old streets and tenements adjacent to the Louvre were demolished, it evokes the bohemian life that once flourished there and laments its disappearance: "The old Paris no longer exists (the form of a city changes more quickly, alas, than the heart of a mortal)" (Baudelaire 1861, 96).

How much of this writing had an impact on Manet, it is hard to say. The poet's somber vision of Paris, summed up in the famous verse in which he calls it "hospital, brothel, purgatory, hell, prison," seems at first to bear little resemblance to the painter's essentially luminous vision. In fact they shared a more complex, ambivalent attitude toward the city, one that revealed itself explicitly in Baudelaire's oscillation between "lyrical celebrations" and "vehement denunciations" of modern life (Berman, 134) and only implicitly in Manet's alternation between themes of middle-class pleasure and lower-class alienation. Two examples of convergence in their treatment of *la vie élégante* have been noted: the *Concert in the Tuileries* (fig. 3) and the picture in "Les Veuves" of a military concert in a public garden, where "shimmering gowns trail on the ground; glances cross each other; idlers, tired of having done nothing, loll about"; and *Olympia* (fig. 7),

the very type of the elegant Parisian courtesan, and the image in "Les Bijoux" of the poet's beloved lying naked before him, wearing "only her sonorous jewels," with "her eyes fixed on [him] like a tamed tigress" (Hyslop and Hyslop, 99-100, 111-112). An example in their treatment of *la vie de bohème* has also been cited: the *Absinthe Drinker* (fig. 94) and the portrait in "Le Vin des chiffoniers" of a solitary rag-picker in an old, decrepit neighborhood, absorbed in his reverie, "intoxicating himself with the splendors of his own virtue" (Hanson 1977, 55); and to it can be added a second example: the *Philosopher* (fig. 9) and the vivid sketch in "La Fausse Monnaie" of a beggar encountered outside a tobacco shop, "holding out his cap with a trembling hand," with "a look of mute eloquence in his pleading eyes" (Baudelaire 1869, 58).

Contrasts of this sort, inspired by a deep awareness of the contradictions in urban society, are familiar in the work of Baudelaire; much less so in that of Manet. Yet it is sufficient to compare his two major paintings of modern life of 1862, the *Concert in the Tuileries* and the *Old Musician* (cat. 59), one set in a formal garden near an imperial palace, the other in a wasteland near a recently demolished ghetto; one summing up "the pageant of fashionable life," the other "the thousands of floating existences" (Baudelaire 1846, 118), to realize how keen his own awareness was. It was indeed, for all his so-called detachment, that of the "perfect *flâneur*" who becomes "one flesh with the crowd," for Manet is present in both pictures—in the one quite literally, as a Baudelairean dandy and *boulevardier;* in the other symbolically, as a Baudelairean beggar and alter ego for the artist. But the two worlds do not come together; whereas in the *Painter's Studio* (fig. 12), exhibited seven years earlier, and long recognized as a source for both of Manet's pictures, Courbet had shown them sharing the same space and himself poised between them. At the right are the writers, musicians, intellectuals, patrons, and other members of his circle, among them the ubiquitous Baudelaire; at the left, the beggar, the poacher, the mountebank, the Wandering Jew, and other disinherited types whom Courbet had also met. But the latter remain anonymous types, while the former are individuals, just as the people in Manet's *Concert* are all individuals, while the old musician and his friends are types (Farwell 1973, 91).

Ultimately, what links Manet's images of modern Paris with Baudelaire's, beyond the social contradictions

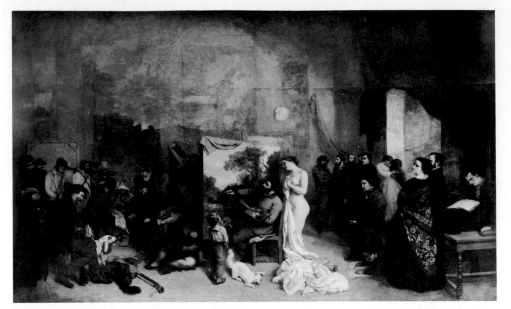

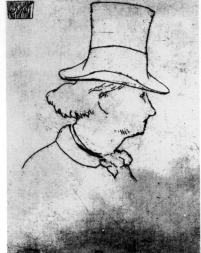

12. Gustave Courbet. *The Painter's Studio*, oil on canvas, 1855, Musée du Louvre, Paris.

13. Edouard Manet. *Portrait of Baudelaire*, etching, second state, 1869. Bibliothèque Nationale, Paris.

implicit in their subject matter, is the depth of their understanding of the distinctly modern forms and content of urban life. This is most evident, in the writer's work, in the prose poems of the late 1850s and 1860s, initially entitled *Spleen de Paris,* more than half of which have a Parisian setting; and in the artist's work, in paintings and pastels of the late 1860s and 1870s, when he had largely abandoned his dialogue with older art and confronted modern Parisian life directly. That he recognized the value of Baudelaire's book and its roots in urban experience is clear from his offer to provide an etched portrait of the author (fig. 13), based on that in the Tuileries picture, "wearing a hat, in fact out for a walk," as a frontispiece for the posthumous edition (Hauptman, 215). To convey the very look and feel of that experience, each of them sought to stretch the limits of his art. For the poet, this meant inventing a new language, "a poetic prose, musical without rhythm and rhyme, supple enough and rugged enough to adapt itself to the soul's lyrical impulses, the undulations of revery, the leaps and jolts of consciousness," a prose derived "above all from the exploration of enormous cities and from the convergence of their innumerable connections" (Baudelaire 1869, ix-x). For the painter, it meant breaking with conventional rules of composition, perspective, and finish to create images of the city in which key figures are placed off-center or cut by the frame, as in the *Ball of the Opera* (cat. 39); space becomes disjunctive and objects within it incommensurable, as in the *World's Fair* (cat. 2); and sensations are recorded in a swift shorthand that gives the appearance of a sketch, as in the *Funeral* (cat. 4). And for both it meant employing a previously spurned vernacular style, whether it was the racy language of the streets or illustrations in the popular press.

It is above all their treatment of certain themes, which "carry a mythic resonance and depth that . . . transform them into archetypes of modern life" (Berman, 148), that reveals the profound affinities in their vision. Three such "primal modern" themes in particular stand out: estrangement in the midst of conviviality, indifference in the presence of death, and suicide, that uniquely modern form of revolt. Baudelaire treats the last of these in "La Corde," which is dedicated to Manet and inspired by an event he had related, the suicide by hanging of a poor, deranged boy whom he had befriended and used as a studio assistant and occasional model (Baudelaire 1869, 64-67). Always said to have taken place some years earlier, it must actually have occurred in 1861-1862 in Manet's studio on the rue Guyot; this is what his widow recalled (Moreau-Nélaton 1906, no. 10; Moreau-Nélaton 1926, 1:38) and what the poem itself suggests: an "out of the way neighborhood . . . where great grassy spaces still separate the houses" (cf. Duret, 86). It was there that he painted the *Old Musician* (cat. 59) early in 1862, in which a poor boy is standing beside the gypsy violinist: does the narrator of "La Corde" have this in

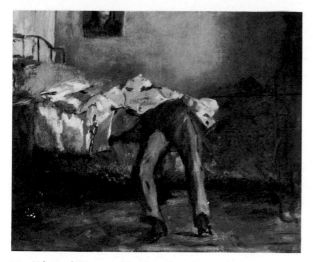

14. Edouard Manet. *The Suicide,* oil on canvas, 1877. E. G. Bührle Foundation, Zürich.

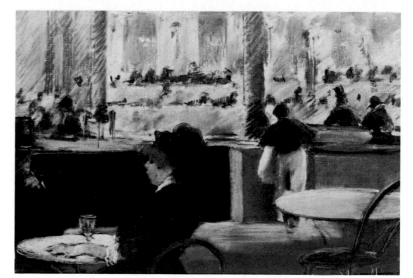

15. Edouard Manet. *A Café in the Place du Théâtre-Français,* oil and pastel, 1881. The Burrell Collection, Glasgow Museums and Art Galleries.

mind when he says, "I would disguise him, sometimes as a little gypsy . . . with the vagrant musician's violin" (cf. Mauner, 18)? And did Manet himself have the poet's conception of suicide as *"the* achievement of modernism in the realm of passions, . . . the only heroic act that remained" (Benjamin 1973, 75) in mind when he painted the victim of a self-inflicted death lying alone in a furnished room, a gun still in his hand (fig. 14)?

Death is also the theme of "Le Tir et le cimetière," published shortly after Baudelaire was buried in the Montparnasse Cemetery and at about the same time Manet painted the *Funeral* (cat. 4), which is set there and may commemorate that event (Mauner, 120). Both works deal with the burial of the dead by stripping it of its earlier meaning—the pathos of a personal tragedy, as in romantic art; the dignity of a communal ceremony, as in realist art—and investing it instead with the familiar modern feelings of indifference, cynicism, and irony. Baudelaire's *flâneur* has come upon a tavern opposite a cemetery, a self-styled "Cemetery View Tavern," and after he has "drunk a glass of beer facing the graves and slowly smoked a cigar," has decided to walk among them; but his thoughts are "interrupted at regular intervals by shots from a nearby shooting gallery" (Baudelaire 1869, 92-93). In short the modern city, in all its vulgarity and violence, has encroached on the once-sacred "sanctuary of Death." In Manet's picture indifference takes a different form: the funeral cortège seems lost amid tall trees

and public buildings, its figures small and blurred; the day is gloomy and the weather threatening, as if nature shared the pervasive malaise. But this detachment too has an ironic twist: the Pantheon, resting place of some of France's most illustrious writers, is not quite aligned with the much maligned poet's hearse.

Not death as such but alienation, a kind of living death, is the theme of "Les Yeux des pauvres," which is set "in front of a new café forming the corner of a new boulevard" (Baudelaire 1869, 52-53), one of those created by Haussmann. It is also the theme of Manet's café pictures, especially the one showing a café on the place du Théâtre-Français (fig. 15), another new establishment in a public space created by Haussmann. Both are depicted as opulent and dazzling, the gas lamps "lighting with all their might the blinding whiteness of the walls, the expanse of mirrors, the gold cornices and moldings," but in both works this luxury only heightens the poverty of human relationships. Baudelaire's couple are doubly estranged—unable to cross the class barrier separating them from the poor family in the street who observe them enviously, and equally unable to reconcile their own differences in facing such a challenge. Manet's café-dwellers may all belong to the same world socially, but it is a world of strangers adrift in a seemingly limitless space, who are cut off severely at its edges, reflected ambiguously in its mirrors, remote from each other even when seated together, and like the man at the left no

more substantial than smoke. In images such as these we rediscover the city of today, the truly modern city in all its fascination and complexity, of which the Paris of Manet and Baudelaire was the first example and for almost a century the last type.

It was, however, much more than a city of alienated classes and individuals, of dreary funerals and disrespect for the dead, of suicides in remote studios and furnished rooms, however "primal" these themes may be for later modernist experience. For it was also a city of theaters, restaurants, and *cafés-concerts,* of international fairs and patriotic celebrations, of masked balls at the Opera and concerts in the Tuileries Gardens, of beggars, rag-pickers, and gypsy musicians, of common streetwalkers and fashionable courtesans, and at times of barricades in the streets and warfare between the classes. These too were Parisian subjects, and as such were also treated by Manet and his contemporaries in the paintings, drawings, and prints shown in this exhibition. They are grouped in nine sections, preceded by a portrait of the artist (cat. 1): The City Viewed (cat. 2-9); The Railroad Station (cat. 10-17); The Café and the *Café-Concert* (cat. 18-26); The Theater and the Opera (cat. 27-41); Outside Paris: The Racetrack (cat. 42-50); Outside Paris: The Beach (cat. 51-58); The Street as Public Theater (cat. 59-71); The Street as Battleground (cat. 72-85); and The Public Holiday (cat. 86-100).

Prologue:
Portrait of the Artist

❦

BOTH HIS personal charm and distinction and his position as a leader of the avant-garde made Manet one of the most frequently portrayed artists of his time. His forceful personality, his elegantly cut figure, his "expressive, irregular face," in which Zola recognized "an indefinable finesse and vigor" (Zola 1867, 85-86), clearly commanded attention; and his acknowledged authority among the future impressionists of the so-called Batignolles School made him an appropriate subject. Two of the most familiar images of that group, painted in 1870 shortly before a war and a revolution disrupted their lives, show him as the dominant personality. In Fantin-Latour's *Studio in the Batignolles* (fig. 16), the studio is that of Manet himself on the rue Guyot, and he alone among the grave young men assembled there—Monet, Renoir, Bazille, and Zola, among others—is seen at work. In Bazille's *The Artist's Studio on the Rue de la Condamine* (ill. Rewald, 235), the central figure examining the picture on the easel, flanked by Monet and Bazille himself, is once again Manet. He had already occupied a leading position six years earlier in Fantin's portrait of the realist circle, the *Homage to Delacroix* (cf. Rewald, 89), in which he and Whistler alone stand beside the effigy of Delacroix, and the others—Baudelaire and Champfleury among the writers, Legros and Bracquemond among the artists—are seated at the sides.

In other portraits of the 1860s, Manet appears in an equally familiar role, that of the man of the world, elegant and supremely at ease. Degas' drawings show him standing at the racetrack, a lithe figure in his well-cut clothing, one hand thrust into his jacket pocket (ill. Rewald, 109), or seated casually on a caned chair, his tall silk hat on the floor beside him; and Degas' remarkably astute double portrait (ill. Rewald, 108) shows him listening to his wife play the piano, while he leans back on a sofa, one leg drawn up beneath him in a pose of

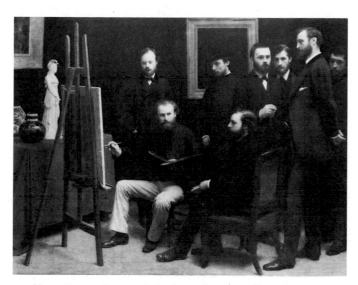

16. Henri Fantin-Latour. *A Studio in the Batignolles*, oil on canvas, 1870. Musée d'Orsay (Galerie du Jeu de Paume), Paris.

studied nonchalance. In Fantin's more formal portrait of 1867 (fig. 1), a work intended for the Salon, he is presented instead as a fashionable Parisian, impeccably dressed in a dark jacket and vest, light trousers, and silk hat, and holding a walking stick and kid gloves rather than a palette and brushes. Only in Monet's portrait, painted seven years later in the younger man's garden at Argenteuil (ill. Rewald, 342), is he shown absorbed in his work, a landscapist like any other in his smock and sun hat; but this is of course Monet's own image of the artist. For in the other portraits of the mid-1870s, it is Manet's forceful personality that emerges: in Desboutin's etching (ill. Rewald, 366) he seems somber and brooding; in Carolus-Duran's (ill. Rewald, 374), more quizzical and amused; but in both works his innate refinement, intelligence, and powerful will are clearly apparent.

Edouard Manet (1832-1883)

1 *Self-Portrait, Half-Length,* 1879

Oil on canvas, 32¹¹⁄₁₆ x 26⅜ in. (83 x 67 cm.)
Not signed or dated
Private collection, New York
R-W 1:276

For all its urbane reticence in contrast, say, to Courbet's or Van Gogh's paintings of themselves, this rare self-portrait is deeply revealing; indeed its very urbanity is a revelation. It is an image of the painter of modern Paris as a modern Parisian—alert, intelligent, skeptical, and fastidious. Dressed in a tan jacket and black bowler, with a stickpin in his black silk cravat, he is the very type of the fashionable *boulevardier* of his day. Such attire may seem unexpected for a painter at work, but in Renoir's portrait of 1875 Monet too wears a jacket and hat while working indoors, and in Fantin-Latour's group portrait of 1870 (fig. 16) Manet himself wears formal dress while working in his studio. It was in fact the only possible attire for an artist whose sophisticated taste all his contemporaries noted. "He loved elegance and frequented society," one of them remarked, "charming people by the distinction of his manners and the finesse of his language" (Bazire, 25). "When Manet went to the Tuileries, making studies outdoors," another recalled, "the strollers looked with curiosity at this elegantly dressed painter" (Proust, 39). He already appears as such in one of his earliest self-portraits, that of the young dandy wearing full morning dress in the picture based on those studies in the Tuileries (fig. 3), and he does so again in one of his latest, a picture contemporary with the one exhibited here (R-W 1:277), where he wears pin-striped trousers and the same jacket, cravat, and pin. That he twice represented himself in 1879 as a stylish and successful Parisian artist becomes more meaningful when we learn that in this very year "Manet, at the height of his career, had achieved the kind of renown that rightfully belonged to him during his lifetime. He was one of those who were most in the public eye in Paris" (Duret, 156). He had, in effect, been recognized at last as the Parisian painter *par excellence.*

In envisaging himself in this role, Manet evidently had in mind that of Velázquez as the supreme painter of Madrid, for his attitude and pose are remarkably like those in the famous self-portrait in the *Maids of Honor* (fig. 17). After seeing it in the Prado, Manet had de-clared it "an extraordinary picture" and its author "the painter of painters," one whom he hoped to match in precisely the kind of sensitivity and swift, confident execution he reveals in this self-portrait (Mauner, 149-150). His identification with Velázquez was a very old one: both in its pose and its position in the whole, the self-portrait in his *Concert in the Tuileries* was based directly on a supposed self-portrait in the *Little Cavaliers,* a picture in the Louvre formerly attributed to the Spanish master, which Manet had copied repeatedly (Sandblad, 37-39). And equally old was his interest in the *Maids of Honor* as an ideal image of the artist in his studio; for in his *Scene in a Spanish Studio* (R-W 1:25), painted twenty years earlier than the self-portrait exhibited here, the artist facing us with his head tilted thoughtfully and his palette in hand is clearly based on the one in Velázquez' masterpiece.

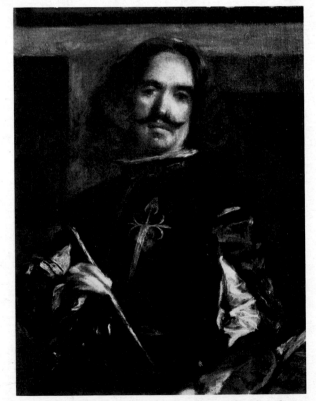

17. Diego Velázquez. *The Maids of Honor* (detail), oil on canvas, 1656. Museo del Prado, Madrid.

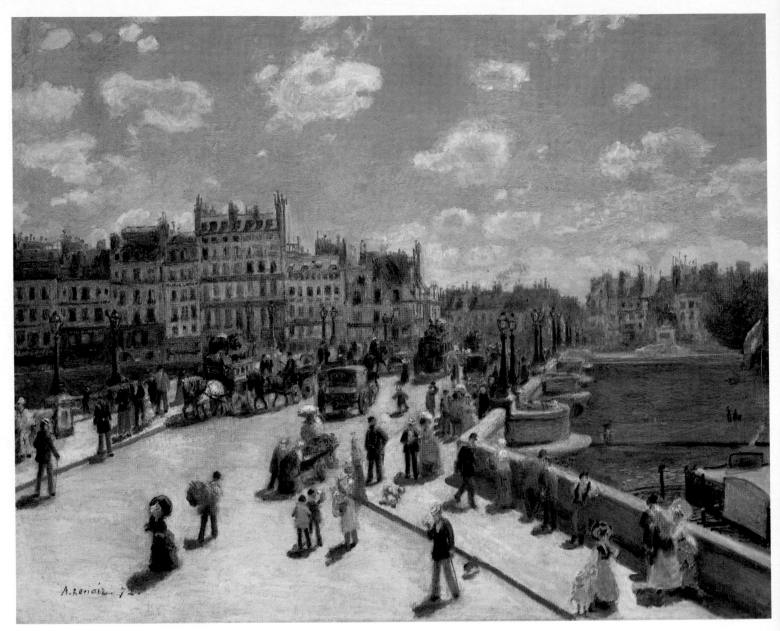

Plate 6. Auguste Renoir. *The Pont Neuf*, 1872. Cat. 5.

1

The City Viewed

❧

IN THE LONG history of the pictorial representation of Paris, Manet and the impressionists played a decisive role: they transformed an imagery that, in previous generations, had largely been the province of topographers and illustrators into a source of inspiration for major artists, and in doing so they established the modern city as one of the most characteristic themes of modern art. But they could play such a role only because the stage had been set by the momentous transformations that occurred in the city itself and in its society and culture. The dramatic expansion of the population and physical fabric of Paris in the mid-nineteenth century produced a large middle-class audience eager to see itself and its world represented in a realistic style. And the rapid development, first of lithography and wood engraving, then of photography and photo-mechanical reproduction, enabled artists and publishers to satisfy this demand efficiently and inexpensively. Hence the appearance of suites of lithographs like Eugène Guérard's *Physionomies de Paris*, of publications like *Le Diable à Paris* with wood-engraved illustrations, and of countless stereoscopic photographs of familiar sites like the Bourse and the Pont Neuf (Wilhelm, 98).

The flood of urban imagery was further swelled by the debate then going on over Haussmann's destruction of old buildings and streets and by the growing nostalgia for *vieux Paris* that emerged in its wake. Hence the production of albums like Laurence's *Les Restes du vieux Paris*, of etchings of the oldest quarters by Meryon, Martial, and Flameng, and the photographic campaigns of Le Secq and Marville sponsored by the city itself (Hambourg 7-11); but also, on the other side of the debate, the publication of lavishly illustrated books proclaiming the glories of the new capital, such as Labédollière's *Le Nouveau Paris* and Audiganne's *Paris dans sa splendeur*. In paintings of the 1860s, the lingering appeal of *vieux Paris* is evident in views of the Seine and the apse of Notre-Dame at sunset by Daubigny and Jongkind, whereas an altogether different vision of the city emerges in the work of Manet and the future impressionists.

Identifying themselves with the dynamic and progressive aspects of urban society, an attitude epitomized in Manet's view of the world's fair of 1867 (cat. 2), these artists depicted Paris as a place of ceaseless movement and change, of animated streets and bridges, seen under equally fleeting conditions of weather and light. Monet and Renoir painted the quays of the Seine in 1867 and the Pont Neuf in 1872 (cat. 5, 6) as vital parts of the modern city, teeming with pedestrians and vehicles and observed from vantage points that imply their own movement; whereas Giuseppe Canella, creator of a series of panoramic views of Paris in the Italian *vedute* tradition, painted the same quays and bridge in 1832 (fig. 18) as familiar historic sites, seen from a fixed and distant vantage point. In their focus and angle of vision, the impressionist pictures are closer to contemporary stereoscopic photographs of the Pont Neuf, such as Hippolyte Jouvin's (fig. 24), and altogether remote from Meryon's etching of the mid-1850s, in which the massive, turreted forms of the seventeenth-century bridge loom up against the sky.

In the same way, Monet and Renoir painted the *grands boulevards* in 1873-1875 (e.g., fig. 19) as the very center of the city's commercial and social life, choosing positions directly above or immersed within the traffic; whereas Thomas Shotter Boys, producer of many views of old and modern Paris in the tradition of Bonington, painted the boulevard des Italiens in 1833 (fig. 20) as a serene and uncongested space, seen from a viewpoint remote enough to suggest stability rather than movement. And when Pissarro, who had previously preferred the traditional forms of rural life but now found the capital and its thoroughfares "so luminous and vital," so "completely modern" (Pissarro, 316), turned late in life to urban

33

Left: 18. Giuseppe Canella. *The Pont Neuf and the Cité*, oil on canvas, 1832. Musée Carnavalet, Paris.

Top right: 19. Auguste Renoir. *The Grands Boulevards*, oil on canvas, 1875. Henry P. McIlhenny, Philadelphia.

Bottom right: 20. Thomas Shotter Boys. *The Boulevard des Italiens, Paris*, watercolor, 1833. The British Museum, London.

themes, he conceived *his* painting of the boulevard des Italiens (cat. 9) as nothing but an image of flux, a field of ceaseless motion in which the carriages, omnibuses, and strollers, and even the restless branches of the trees and the endless windows of the façades, all seem to participate.

Even when they depicted familiar landmarks—something difficult to avoid in a city as rich in history as Paris—the impressionists saw them as embedded in the fabric of the modern metropolis and enveloped in the light and weather of the moment. Moreover, they generally preferred distant views, "in which the very height and range of the artist's vantage point tends to distance the spectator from either involvement in the dramatic anecdote or absorption in minute descriptive detail" (Nochlin, 168-169). In Manet's view of the world's fair (cat. 2), for example, the spires of Sainte-Clotilde, the towers of Notre-Dame, and the domes of the Invalides and the Pantheon are bathed in light and partly obscured by atmosphere, in effect rendered timeless and unhistorical. In his *Funeral* (cat. 4), the domes of the Sorbonne and the Pantheon and the belfry of Saint-Etienne-du-Mont are reduced to barely identifiable silhouettes against the stormy sky; whereas in Meryon's etching of 1852, that church stands forth in all its ornate Renaissance splendor. Very much the same attitude governs Monet's picture of Saint-Germain-l'Auxerrois in 1867

and Renoir's of La Trinité in 1882, despite their closer vantage points. And interestingly, it also governs the many panoramic views of Paris "painted" by Zola in his novels of those years.

The sweeping view of the city stretched out below them at sunset seen by Saccard and Angèle from the heights of Montmartre in *La Curée* (1872), the broad vista of the Seine, the Cité, and the Ile Saint-Louis seen, and also painted, by Claude Lantier in *L'Oeuvre* (1886), and above all the five truly impressionist tableaux of the city seen by Hélène Grandjean from her apartment near the Trocadéro or from a nearby cemetery, in different seasons and at different times of day, in *Une Page d'amour* (1878) are but three examples in Zola's fiction. And since he locates Hélène's apartment on the rue Vineuse, very near the spots from which Manet and Berthe Morisot had painted their views of Paris (cat. 2, 3), his descriptions coincide with theirs in many respects and may even have been influenced by them, just as they seem to have been influenced by Monet's views of the Tuileries Gardens of 1876. By contrast, the first great literary description of this sort, Hugo's vision of medieval Paris as seen from one of the towers of the cathedral in *Notre-Dame de Paris* (1831), provides a vista like that in Meryon's prints of Notre-Dame and the Tour Saint-Jacques, in which the human constructions, the historic buildings and streets, are alone what predominate.

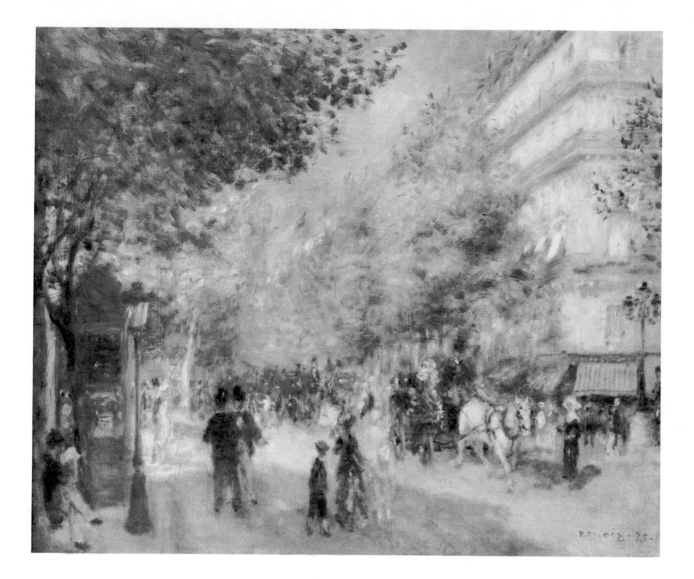

Edouard Manet

2 *The World's Fair of 1867*, 1867

Oil on canvas, 42½ x 77⅜ in. (108 x 196.5 cm.)
Signed, lower right, in Mme Manet's hand: *Ed.
 Manet*
Nasjonalgalleriet, Oslo
R-W 1:123

🐦 In this unusually large and ambitious composition,
Manet's vision of his society and its capital city coincides
with that of the society itself to an unusual extent.
Painted in the summer of 1867, when the Second
Empire's *exposition universelle* on the Champ de Mars
and his own retrospective exhibition across the Seine on
the place de l'Alma were both open and Paris was teem-
ing with visitors from all over the world, it conveys in its
panoramic view of the city and fairground, in its ani-
mated figures of varied background, and even in its
luminous atmosphere and confident execution, a faith in
those values that the exhibition stood for—universality,
progress, and hope (Mainardi, 112-113). This euphoric
mood was not to last for either the artist or his society:
within two months of the opening of both exhibitions,
Manet had left Paris for a badly needed vacation, disillu-
sioned by the almost universal hostility his bold attempt
to reach a large audience had encountered, and news had
reached France of the execution of the Emperor Maximi-
lian in Mexico, the latest and most serious indication of
Napoleon III's inability to resolve his problems at home
and abroad. But in that brief period in June when Manet
chose to celebrate his country's optimistic faith in mate-
rial and cultural progress and in itself as a world power,
and to identify with it his own dream of self-fulfillment
and recognition, such a picture could still be painted, and
in it a symbol of hope and the world—his friend Nadar's
balloon "Le Géant"—could still be shown floating above
the fair (Mainardi, 112).

Even in choosing a position from which to view the
exhibition, Manet was in step with the times. For it was
just this perspective, from the Trocadéro hillside on the
opposite bank of the Seine, that was recommended in
contemporary guidebooks and preferred in popular
orientation and souvenir prints (e.g., fig. 21; cf. Mainar-
di, 110). His exact position has been located at the top of
the hill, at the intersection of the rue Vineuse and the
rue Franklin (Willoch, 108); but as Berthe Morisot's
view of the same scene from that very position (cat. 3)

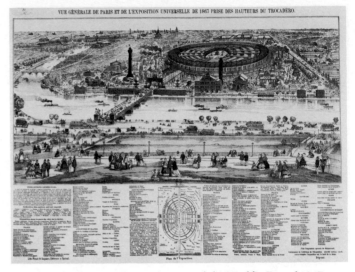

21. Artist unknown. *View of Paris and the World's Fair of 1867*,
Epinal print, 1867. Bibliothèque Nationale, Paris.

makes clear, Manet actually stood halfway down the
hillside, closer to the exhibition that was his real subject.
Like the popular printmakers, he followed a principle of
synecdoche, representing the vast urban panorama by a
few of its most familiar landmarks—from left to right,
the twin spires of Sainte-Clotilde, the twin towers of
Notre-Dame, the dome of Saint-Louis-des-Invalides,
and the dome of the Pantheon—and the mazelike fair-
ground by some of its most distinctive structures—again
from left to right, the columnar French lighthouse, the
immense exhibition hall, and the cagelike English light-
house (Mainardi, 111).

But unlike the printmakers, who employed a bird's-eye
perspective in order to show the fairground and the city
as clearly as possible, sometimes combining this with a
conventional perspective of the Trocadéro gardens and
their sightseers (fig. 21), Manet viewed the whole from a
single, relatively low vantage point; and as a result, his
picture contains more overlapping of forms and hence
more confusion for the eye. In addition, he juxtaposed

Color plate 5

rather abruptly the gardens and figures on the near shore
of the Seine and the trees and exhibition buildings on the
far shore, virtually eliminating the river itself and its
quays. Although this prevented him from conveying
accurate topographic information, which was one of the
popular printmakers' primary objectives, it enabled him
to achieve a plastic strength and solidity altogether for-
eign to them, and also to express more fully than they the
overwhelming abundance and variety of sensations
stimulated by an immense world's fair (Hofmann 1973b,
174-175).

The foreground figures, too, play their parts in con-
veying that sense of cosmopolitan diversity. Apparently
scattered informally, though in fact aligned along diagon-
als intersecting at the *amazone* in the center, they in-
clude, in addition to this female rider, a workman, two
working-class women, a *cocodette* and her companion, a
pair of bourgeois sightseers, two street urchins, two
middle-aged dandies, three imperial guardsmen, and
Manet's adopted son Léon Leenhoff walking his dog.

Berthe Morisot (1841-1895)

3 *View of Paris from the Trocadéro,* 1872

Oil on canvas, 18¹⁄₁₆ x 32¹⁄₁₆ in. (46.1 x 81.5 cm.)
Signed, lower left: *Berthe Morisot*
Santa Barbara Museum of Art, Gift of Mrs.
 Hugh N. Kirkland
Bataille and Wildenstein, no. 23

🦋 Sometimes dated 1866 and cited as a source of inspiration for Manet's view of the same scene (cat. 2), Morisot's was in fact painted five years later than his. But it need not, in its turn, have been inspired by Manet's view; for the two were taken from different positions—his from a point halfway down the Trocadéro hillside, near the edge of the circular lawn shown in Morisot's picture; hers from a point at the top of the hill, where the rue Franklin enters the place du Trocadéro—and they were conceived in a different spirit. Manet's subject is an episode in modern history, an international exhibition and its cosmopolitan audience, and Paris is merely its setting; Morisot's is a modern urban landscape, a panorama of the city and its major monuments, and the figures are merely incidental.

It was, moreover, a perfectly natural place for Morisot to choose, since her house was only two blocks away on the rue Franklin (Morisot, 17); so natural, in fact, that in the same year she painted another view of the same scene (fig. 22), showing her sister Edma Pontillon and her niece Paule Gobillard enjoying that view from the balcony of their house. These must also be the figures who appear, along with Paule's mother Yves Gobillard, in the foreground of the version exhibited here. The panoramas of the city, with the Seine, the Pont d'Iéna, and the Pont de l'Alma in the middle distance, are virtually identical in the two pictures; but since the vantage point is further to the southwest in the *Balcony,* the buildings on the skyline are aligned somewhat differently. In both works the gilded dome of Saint-Louis-des-Invalides appears to the right, and the neo-Gothic spires of Sainte-Clotilde to the left, of center; but in the *View of Paris from the Trocadéro,* the distant towers of Notre-Dame are closer to Sainte-Clotilde, those of Saint-Sulpice are to the left rather than

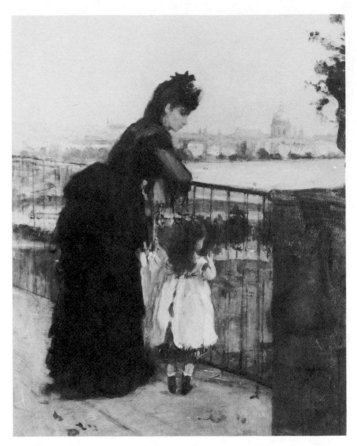

22. Berthe Morisot. *The Balcony,* oil on canvas, 1872. Private collection.

the right of the Invalides, and the still more distant dome of the Pantheon is also visible at the right. Nearer the river, there appear in both pictures the vast open space of the Champ de Mars, now cleared of the buildings erected for the 1867 exhibition, and across the river the gardens of the Trocadéro, not yet transformed for the next one in 1878.

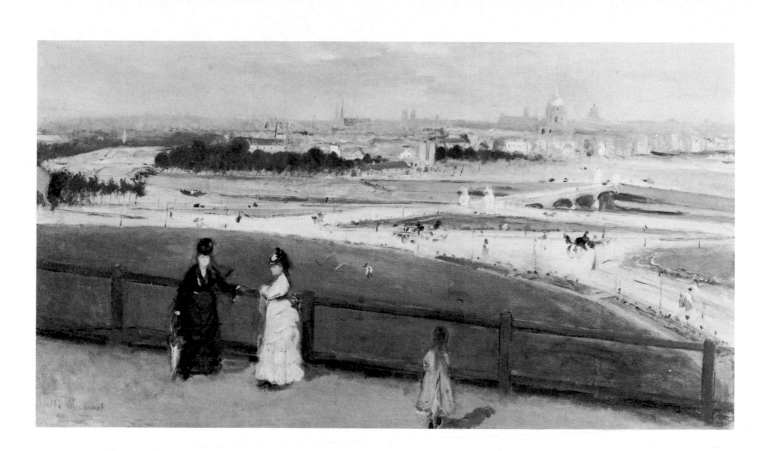

Edouard Manet

4 *The Funeral*, c. 1867

Oil on canvas, 28⅝ x 35⅝ in. (72.7 x 90.4 cm.)
Not signed or dated
The Metropolitan Museum of Art, New York,
 Wolfe Fund, 1909, The Catharine Lorillard
 Wolfe Collection
R-W 1:162

Although it is primarily an expression of a tragic mood which all of nature seems to echo, from the agitated black-green trees to the stormy gray-blue sky, this powerful painting of a funeral procession is also a view of a particular part of Paris. The question is, which part? The buildings dramatically silhouetted against the sky are usually identified, from left to right, as the Observatoire, the Val-de-Grâce, the Pantheon, Saint-Etienne-du-Mont, and the Tour de Clovis, seen from the foot of the Butte Mouffetard (R-W 1:162) or the rue de l'Estrapade (Tabarant 1947, 171) or the rue Monge (Nochlin, 93), that is, from a position on one side or the other of the Montagne Sainte-Geneviève. Actually, even the three buildings at the right cannot be seen in this alignment from the rue Monge; and if they can be seen from the rue de l'Estrapade, the two at the left cannot—not without turning to look in an entirely different direction, southwest rather than north. And if the view is taken from a position much further south, which the presence of those two indeed requires, they cannot be seen aligned in this way with the other three. We must conclude either that Manet, working from memory and perhaps from sketches, though none have survived, represented the five buildings in a manner that is topographically impossible but pictorially varied and interesting or that they have not been identified correctly.

About the Pantheon, the belfry of Saint-Etienne-du-Mont, and the Tour de Clovis, there can hardly be any doubt; but the small cupola could belong to many buildings, both sacred and secular, besides the Observatoire, and the large dome near it could be that of the Sorbonne rather than the Val-de-Grâce, since the two are equally prominent and very similar in design. In two of Monet's views of the Left Bank contemporary with Manet's (e.g., fig. 23), the Sorbonne, the Pantheon, and Saint-Etienne-du-Mont stand out clearly on the skyline, though in the reverse order, since they are seen from the north. If the domed building in the *Funeral* is indeed the

23. Claude Monet. *The Garden of the Princess*, oil on canvas, 1867. Allen Memorial Art Museum, Oberlin College, Oberlin, Ohio. R. T. Miller, Jr., Fund.

Sorbonne, and it is aligned in this way with the other buildings, then the place from which they are all seen is toward the southwest, in the area of the Cimetière de Montparnasse. The only cemetery on the Left Bank, it is obviously an appropriate setting for a funeral procession and would also account for the open green space with large trees surrounding it, as well as for the rather distant look of the buildings silhouetted against the sky.

This identification of the locale may also enable us to specify the occasion. It is most likely the funeral of Baudelaire, one of Manet's closest friends, which took place in the Montparnasse Cemetery on a stormy day in September 1867—Banville's eulogy at the grave was in fact interrupted by rain—and was attended by a small number of the poet's companions, among them Manet (Mauner, 120). It has also been suggested that the gloomy atmosphere of his picture accords well with the long months of hardship he experienced during the Franco-Prussian War, and that its counterparts stylistically are the bleak snow scenes he painted in the winter of 1870-1871 (Richardson, 124). But the imperial guardsman shown in the funeral procession would have been an anachronism after the fall of the Empire in September 1870.

Auguste Renoir (1841-1919)

5 *The Pont Neuf,* 1872

Oil on canvas, 29⅝ x 36⅞ in. (75.3 x 93.7 cm.)
Signed and dated, lower left: *A. Renoir.* 72
National Gallery of Art, Washington, Ailsa
 Mellon Bruce Collection 1970

From the early seventeenth century, when it was completed and lined with shops, the Pont Neuf had been a major traffic artery and center of commerce in the heart of old Paris, and as such had been the subject of countless images, both historical and topographic. Typically, as in an anonymous engraving of c. 1710 (Hillairet, 2:174) and a lithograph by Victor Adam of 1830 (Farwell 1977, no. 70), it was shown crowded with vehicles and pedestrians of all types, though by then the shops had been removed. It is to this long pictorial tradition that Renoir's painting, with its wealth of descriptive detail, ultimately belongs, despite his apparent emphasis on the momentary aspects of light and atmosphere. He was in fact so interested in describing accurately the appearance of the strollers, policemen, delivery boys, and street vendors that he had his brother Edmond stop them briefly, one at a time, on the street below while he painted them from the second-floor window of a café overlooking the bridge (Rewald, 281). Situated on the Right Bank, near the intersection of the rue du Pont Neuf and the quai du Louvre, it afforded a sweeping view of the bridge, the Seine, and the opposite bank. Easily recognizable in Renoir's view

are, at the left, the quai de l'Horloge on the Cité and beyond it the quai des Grands Augustins on the Left Bank; in the center, the Pont Neuf and its continuation into the rue Dauphine on the Left Bank; and at the right, the Vert Galant at the tip of the Cité, with its equestrian statue of Henri IV, and beyond it the quai Conti on the Left Bank.

What is absent from this bare description of the site is precisely what is most valuable in Renoir's vision of it, the feeling of well-being and vitality that pervades every aspect of the picture, from the stylish figures strolling in the bright sunshine to the small clouds floating in the deep blue sky, their light shapes echoing the darker ones formed by the figures and their shadows. It is a radiant vision of a city rich in history and tradition, yet equally rich in its present resources, a city thriving and attractive once again, only a year after having been humiliated by a foreign occupation and partly destroyed by a devastating civil war. The mood was appropriate enough for those times of renewed activity and patriotic pride, even if the picture was not explicitly intended as a comment on them.

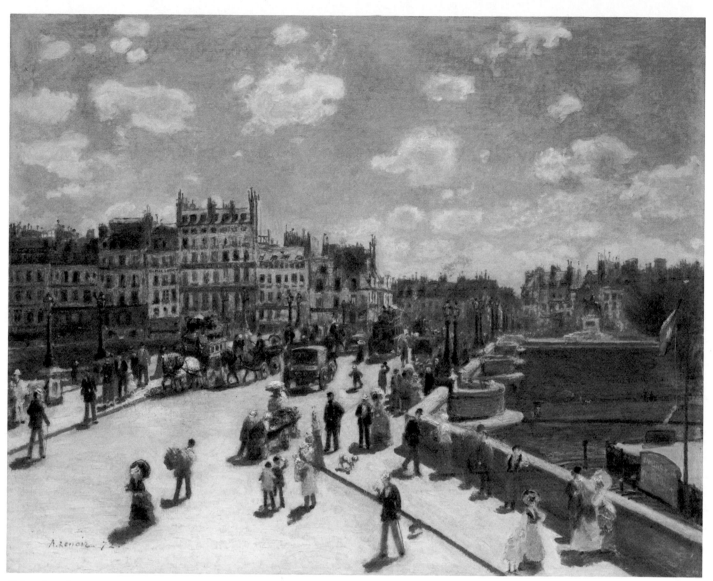

Color plate 6

Claude Monet (1840-1926)

6 *The Pont Neuf, Paris,* 1872

Oil on canvas, 21¹/₁₆ x 28¹⁵/₁₆ in. (53.5 x 73.5
 cm.)
Signed, lower right: *Cl. M.*
Wendy and Emery Reves Foundation
Wildenstein, no. 193

In contrast to Renoir's festive picture of the Pont Neuf (cat. 5), Monet's image of the same site, painted in the same year but in another season and another kind of weather, evokes a more sober, workaday mood. It is a rainy day in autumn with an overcast sky, wet pavements, and umbrellas everywhere; and instead of fleecy white clouds floating in a blue sky, the gray smoke of tugboats rises on both sides of the bridge. Yet there is no less vitality here, despite the absence of sunshine: the streets are as crowded with people and carriages, and the river with ships; and all are rendered in a swift, vigorous style that imparts its own energy and drive. Given the close friendship of the two artists, and the parallel developments in their art, it is remarkable how different Monet's brusque, highly condensed notation is from Renoir's detailed description of the same subject. Monet's canvas, it is true, is roughly one-third smaller in each dimension, but it is hardly a small sketch in relation to Renoir's finished picture; rather, the difference in handling reflects his more forceful, confident personality.

Much has been written about the influence on such paintings of stereoscopic photographs, such as those taken by Hippolyte Jouvin in 1861-1865 and assembled in the album *Vues instantanées de Paris,* which included several of the Pont Neuf (e.g., fig. 24). Inexpensive and extremely popular, they were undoubtedly familiar to Monet; but the features usually singled out as revealing their influence on him—the choice of a high viewpoint and the cutting of forms at the edges (Scharf, 174, 198-201)—can also be found in more traditional cityscapes of the previous generation. In Giuseppe Canella's view of the Pont Neuf (fig. 18), for example, the quay in the foreground, if not the bridge itself, is seen from the same high viewpoint, and at its edges there are figures and carriages cut in the same manner. The real affinity between Jouvin's and Monet's images—and it may be no more than that—lies in their preference for a vantage point close enough to the bridge to enable them to focus on its bustling traffic, rather than the distant point chosen by Canella in order to encompass its entire span. In this they share a distinctly modern taste for movement and the momentary, in contrast to the older artist's taste for stability and the easily identifiable historic structure.

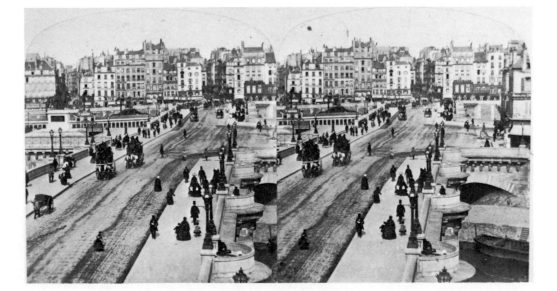

Not in exhibition.

Left: 24. Hippolyte Jouvin. *View of the Point Neuf*, stereoscopic photograph, 1861-1865. Bibliothèque Nationale, Paris.

Stanislas Lépine (1835-1892)

7 *The Pont de la Tournelle*, 1862

Oil on canvas, 15⅞ x 21¾ in. (40.2 x 55.1 cm.)
Signed and dated, lower right: *S. Lépine—62.*
National Gallery of Art, Washington, Ailsa
 Mellon Bruce Collection 1970

Born in 1835, Lépine was of the same generation as the impressionists and participated in their first exhibition in 1874, but he was more conservative both in style and choice of subject matter, closer to such pre-impressionists as Jongkind and Boudin. Among the impressionists, he was friendly with Guillaumin, with whom he shared a taste for views of Paris, especially of its bridges and quays, though Lépine's are generally of more picturesque sites in the older parts of the city and of more tranquil, middle-class activities. After 1874 he exhibited exclusively at the Salon, and the gap between him and the impressionists, who developed a greater boldness of color and execution, while he retained the low-keyed harmonies and relatively smooth touch of his early works, became increasingly apparent. As contemporary critics noted, he remained closest to Corot, whom he acknowledged as his master, in the serenely detached mood, light tonality, and careful rendering of his views of old Paris.

This view of the Pont de la Tournelle, painted early in Lépine's career, illustrates perfectly his debt to the older master, notably to such works as the *Quai des Orfèvres and Pont Saint-Michel* of 1833. In viewpoint and composition, however, Lépine's picture is virtually identical to the one Jongkind painted of the same bridge a decade earlier (fig. 25). Both views are taken from a position on the Left Bank, in what is now the Port de la Tournelle, looking across the Seine at the quai d'Orléans and the quai de Béthune on the Ile Saint-Louis, in the heart of old Paris. The bridge had only recently been reconstructed when Jongkind painted it in 1851; hence the piles of earth and cut stone shown in his version and not in Lépine's (Cunningham, no. 2). The latter is also lighter and more sunny, closer to Corot's picture in its blond tonality; but otherwise the two versions are remarkably similar, even to the inclusion of small figures of working women in the foreground.

25. Johan Barthold Jongkind. *The Pont de la Tournelle, Paris*, oil on canvas, 1851. The Fine Arts Museums of San Francisco, Gift of Count Cecil Pecci-Blunt.

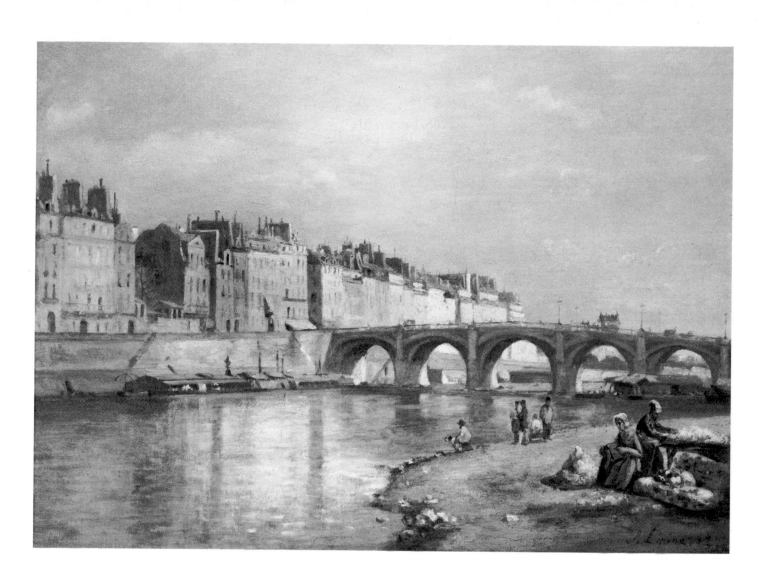

Armand Guillaumin (1841-1927)

8 *The Pont Louis Philippe*, 1875

Oil on canvas, 18 x 23¾ in. (45.8 x 60.5 cm.)
Signed and dated, lower left: *Guillaumin / 75*
National Gallery of Art, Washington, Chester
 Dale Collection 1962
Serret and Fabiani, no. 44

The view shown here is taken from a point on the quai de Bourbon, on the Ile Saint-Louis, looking west along the Seine and the Right Bank—a point rather near the studio on the quai d'Anjou that Guillaumin occupied at the time. Above the central span of the Pont Louis Philippe in the middle-ground appear "les deux malles," the two theaters of identical design built earlier in the century on the place du Châtelet; and directly above the smokestacks to the right of center is the late medieval Tour Saint-Jacques. But these distant signs of the city's cultural and historical importance are dwarfed by the laundry boats and walkways of rough timber construction that loom large in the foreground, reminding us of the city's still greater importance as a place of ongoing life and largely lower-class labor.

The reminder is discreet and almost lost in the subtle play of warm and cool tones used to depict the areas of sunlight and shadow into which the scene is divided. But however small and unobtrusive the laundresses carrying their burdens may be—especially in contrast to the heroic laundresses Daumier had painted on the nearby quai d'Anjou a decade earlier (e.g., fig. 26)—Guillaumin's vision of the modern city is distinctly different from that of the other impressionists. Whereas Monet, Renoir, Degas, even Pissarro late in life (fig. 27) were attracted to the familiar monuments and places of shopping and entertainment—the Louvre and Tuileries Gardens, the Pont Neuf and the quays, the *grands boulevards* and place de la Concorde—Guillaumin preferred the areas of heavy shipping and industry toward the edges of the city. Most of his views are of the unloading of ships and barges on the quai Saint-Bernard and the quai d'Austerlitz and, still further east along the Seine, at Bercy and Charenton, and of the factories at Ivry with their chimneys spewing smoke across the sky.

26. Honoré Daumier. *The Laundress*, oil on wood, c. 1863. The Metropolitan Museum of Art, New York, Bequest of Lizzie P. Bliss, 1931.

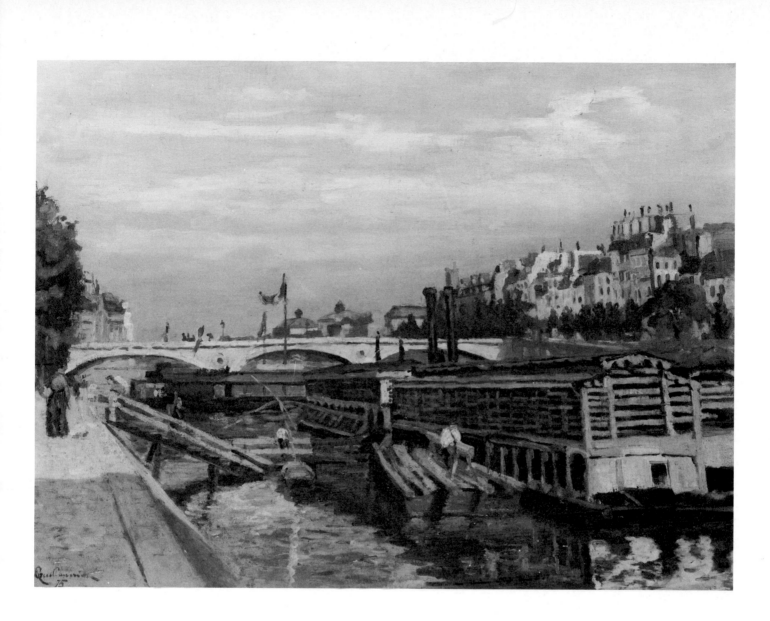

Camille Pissarro (1830-1903)

9 *The Boulevard des Italiens, Morning, Sunlight*, 1897

Oil on canvas, 28⅞ x 36¼ in. (73.2 x 92.1 cm.)
Signed and dated, lower right: *C. Pissarro. 97*
National Gallery of Art, Washington, Chester
 Dale Collection 1962
Pissarro and Venturi, no. 1000

Long a painter of rural life, Pissarro turned to the city as a source of inspiration later than the other impressionists. Apart from a few forlorn views of the outer boulevards dating from 1878-1879 (Pissarro and Venturi, nos. 435, 475), his pictures of Paris belong entirely to the 1890s, by which time his colleagues had long since turned elsewhere. After experimenting with different

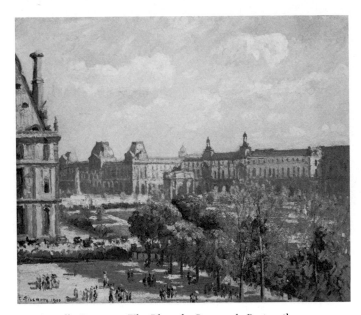

27. Camille Pissarro. *The Place du Carrousel, Paris*, oil on canvas, 1900. National Gallery of Art, Washington, Ailsa Mellon Bruce Collection 1970.

aspects of the urban scene in small paintings of the Gare Saint-Lazare and its adjoining streets in 1893 and 1897 (Pissarro and Venturi, nos. 836-839, 981-985), he undertook three more important series in the last years of the decade. Together they form a kind of extended "triptych," representing familiar features of the modern city and its activities (Coe, 113-114). The views of the boulevard Montmartre and boulevard des Italiens depict the

downtown area already established as a center of commerce and entertainment earlier in the century. Those of the avenue de l'Opéra and place du Théâtre-Français show the wide thoroughfare created in the Second Empire, culminating in its most famous monument, the Opera. And those of the Jardin des Tuileries and the Louvre represent the formal gardens and the national museum that was once a royal palace. Whereas the "gardens" offered a broad, tranquil panorama in which nature and civilization, the seasonally changing and the historically rooted, were held in balance (e.g., fig. 27), and the "avenues" a deep, traditional vista formed by long rows of buildings leading to a landmark almost as famous as the Louvre, the "boulevards" provided a plunging perspective on the most distinctly modern and animated aspect of the urban scene, the movement of pedestrians and vehicles on the heavily used streets.

In a few pictures of this series (e.g., cat. 97), it was an exceptional kind of traffic, the carnival procession and its dense throngs, but in all the others, including the one exhibited here, it was the daily, undistinguished, yet endlessly fascinating kind that Pissarro chose to represent. His angular perspective and radical cutting of forms on all four sides suggest a field of restless activity extending infinitely in all directions; for even the buildings opposite are animated by countless small openings that repeat the pattern of the figures and vehicles. In such pictures, "we sense also the motion of the artist's hand and the intentness of his eye scanning the site for its varied tones and contrasts. His sketchy strokes seem to reenact the intermittent movement of the crowd, the carriages, and buses, halting or advancing in their different directions toward and away from us. It is a freshness and liberty of touch in keeping with the nature of the scene as perceived by Pissarro with enjoyment of its changing face" (Schapiro, 251).

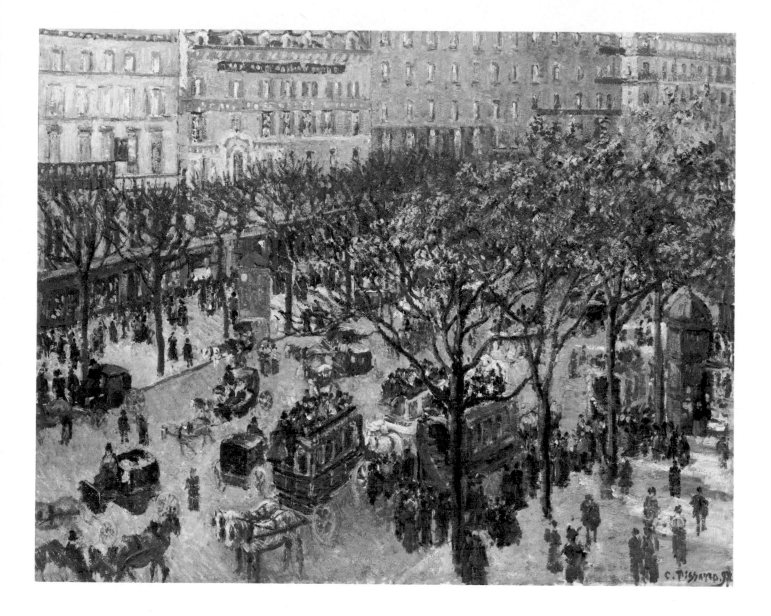

Plate 7. Claude Monet. *The Gare Saint-Lazare*, 1877. Cat. 14.

2

The Railroad Station

❧

O F THE SIX railroad stations serving Paris in Manet's time, the one on the rue Saint-Lazare owned by the Chemin de Fer de l'Ouest was the largest and most important. The terminus of the earliest French line, built in 1837 between Paris and Saint-Germain, it was moved to its present location and enlarged in 1842 and again in 1867 as the railway network rapidly expanded. By then it was serving long distance lines to Normandy and Brittany, heavily used suburban lines to towns west of Paris, and a local line around its periphery; and the suburban traffic alone was more than ten million passengers annually (Walter, 48-55). By then, too, its buildings and yards already occupied the vast area they do

today, bounded on the south by the rue Saint-Lazare, on the east by the rue d'Amsterdam and the rue de Londres, and on the west by the rue de Rome; and its tracks leading toward the Batignolles tunnel to the north were crossed by the recently constructed Pont de l'Europe (fig. 28). A remarkable engineering feat, it consisted of six spans supported by masonry piers and huge iron trellises, carrying six streets over the tracks to their intersection at the place de l'Europe. Although decried by some of Haussmann's enemies as "more odd than handsome, and astonishing in its bizarre form and immense size" (Say, 1661), the bridge was admired by many other writers, who saw in it a symbol of the new Paris. This was clearly

28. A. Lamy. *The Pont de l'Europe and the Gare Saint-Lazare*, wood engraving from *L'Illustration*, 11 April 1868. General Research Division, The New York Public Library, Astor, Lenox, and Tilden Foundations.

29. Camille Pissarro. *Lordship Lane Station, Dulwich*, oil on canvas, 1871. Courtesy Home House Trustees, Courtauld Institute Galleries, London.

the spirit in which the painter Caillebotte saw it a decade later, celebrating its imposing size and strength and brutal directness in pictures (e.g., fig. 34) which simultaneously celebrate the same modern qualities in the broad streets and tall buildings that were created around it as part of Haussmann's ambitious program of urban expansion.

Many other artists and writers found in the new bridge and station an endlessly absorbing spectacle of urban industrial life. *La Bête humaine* (1890), Zola's tragic tale about a railroad engineer, is merely the most familiar in a series of naturalist novels in which the Gare Saint-Lazare or another station is described; in this case, as seen from the engineer's apartment in a tall building on the rue d'Amsterdam directly overlooking the station. A decade earlier, Huysmans had set *Les Soeurs Vatard* (1879) in an apartment near the Gare Montparnasse, subtly adapting to the moods of his characters his portrayal of railroad activities at many times of day and in many kinds of weather—an impressionist program prob-

ably inspired by Monet's Gare Saint-Lazare series of 1877. Still earlier, Jules Claretie, who as a critic was hostile to impressionism, had published *Le Train 17* (1876), a novel whose protagonists are a railroad engineer and a circus performer and whose descriptions of the same station reveal an impressionist interest in the shimmering play of lanterns, headlights, colored signals, and reflections on rails at night. The theme was in fact so much *de rigeur* in naturalist literature that Maupassant, in seeking a dwelling for the impoverished hero of his novel *Bel-Ami* (1885), naturally found a tenement on the rue Boursault, overlooking the Batignolles tunnel and tracks.

From the time of its construction in 1842, the Gare Saint-Lazare was also a popular subject among artists (Chan, 19-27). Before the impressionists discovered it as a theme for ambitious painting, however, these were primarily printmakers catering to the market for realistic views of Paris. Lithographs by Arnout and Lemaître and a drawing by Léon Leymonnerie illustrate this static,

topographic approach. The more imaginative conceptions of the railroad in those years were of the locomotive rather than the station. Although the realist writer Champfleury did envisage around 1860 a series of murals in the stations themselves showing the arrival and departure of trains, he was more excited by the "fantastic" aspect of the "huge machine whose belly sows fire in the countryside at night, flying like the wind with its large red eyes" (Champfleury 1861a, 185). In much the same way, Manet's teacher Couture spoke of the locomotive as a "grandiose and modern chariot, . . . a monster with a bronze shell and a tongue of fire" (Couture, 254-255). If Manet rejected this quasi-mythological imagery, he accepted Couture's notion of the engineer and fireman as heroic figures, ennobled by their labors and responsibilities; and after riding with them from Versailles to Paris in 1880, he spoke admiringly of "their sang-froid, their endurance," and planned to paint them at their work (Jeanniot, 856). He never realized this plan, nor his other, far more ambitious, to paint a series of murals on modern Paris, including its railroad stations, in the rebuilt Hôtel de Ville, which he proposed to the city in 1879

(cf. p. 22, above). But he did paint the Gare Saint-Lazare, and earlier than any of the other impressionists.

That these artists were drawn to the modern station, and this one in particular, seems in retrospect almost inevitable. If Pissarro and Sisley occasionally painted the small suburban station, dwarfed by its landscape setting (e.g., fig. 29), it was the large metropolitan station that attracted their colleagues. None was as large or as active as the Gare Saint-Lazare or indeed as important for their own travels in the 1870s: all the familiar impressionist sites—Louveciennes and Marly, Pontoise and Auvers, Argenteuil and Vernon, Rouen and Le Havre—could be reached by trains departing from it. And for Manet, who was to follow Monet and Renoir to Argenteuil in 1874, it was also a familiar daily sight: in July 1872, shortly before beginning the *Gare Saint-Lazare* (cat. 10), he moved into a studio on the rue Saint-Pétersbourg (now the rue de Moscou) whose windows faced the place de l'Europe and the tracks leading to the Batignolles tunnel. A year later, a visitor noted that "the railroad passes close by, giving off plumes of white smoke which swirl in the air" (Hamilton, 173), exactly as they do in Manet's painting.

Edouard Manet

10 *The Gare Saint-Lazare,* 1872-1873

Oil on canvas, 36¾ x 45⅛ in. (93.3 x 114.5 cm.)
Signed and dated, lower right: *Manet / 1873*
National Gallery of Art, Washington, Gift of
 Horace Havemeyer in memory of his mother,
 Louisine W. Havemeyer, 1956
R-W 1:207

Although inscribed 1873 and first exhibited in 1874, this picture was well advanced by the fall of 1872, when Philippe Burty saw it, "still unfinished," in the artist's studio (Hamilton, 162). The figures were posed by Victorine Meurent, once Manet's favorite model, who had recently returned from America and resumed sitting for him, and the painter Alphonse Hirsch's daughter Suzanne. According to one source (Tabarant 1947, 221-222), Manet painted them outdoors, in the garden behind Hirsch's studio overlooking the station, and the background indoors, using notebook sketches like the one illustrated here (fig. 30). He evidently made no compositional study—at least none is known—and instead sketched the main forms directly on the canvas, using broad liquid strokes, which he then blurred by scraping and overlaid with heavier pigments. This spontaneous approach required only minor revisions, notably in the spacing of the bars and the outlining of Victorine's hair, as a recent laboratory examination (November 1981) has confirmed. For all its naturalness, however, the design is classical in its systematic contrast of the two figures: one is mature and has been reading, the other is young and watching a train go by; one is seated and facing us, the other standing and turned away; one wears a blue dress with a white collar and cuffs, the other a white dress with a blue sash and bow; and if both have reddish brown hair, one wears it down in long tresses, the other swept up and tied with a ribbon.

Their relation to the setting is also more contrived than appears at first. To view the Pont de l'Europe as it appears here, at the right edge, Manet would have had to stand far back in the triangular garden behind Hirsch's building at 58, rue de Rome, near the corner of the rue de Constantinople (see the aerial view and ground plan, figs. 28, 31). But he shows the figures as if they were at the front of the garden, at the very edge of the railroad yard, and he enhances this illusion of immediacy by eliminating the heavy diagonal trellis and vertical fence

30. Edouard Manet. *The Pont de l'Europe*, pencil, 1872. Private collection, Paris.

31. Ground plan of the Pont de l'Europe, wood engraving from *Paris nouveau illustré* (supplement to *L'Illustration*), no. 14, n.d. Bibliothèque Nationale, Paris.

of the bridge on the other side of the rue de Constantinople, and indeed the width of the street itself, including instead only the thin black fence around the garden. When the picture was shown at the Salon of 1874, the critics and caricaturists made much of these black bars, so much like those of a prison (e.g., fig. 32). But above all

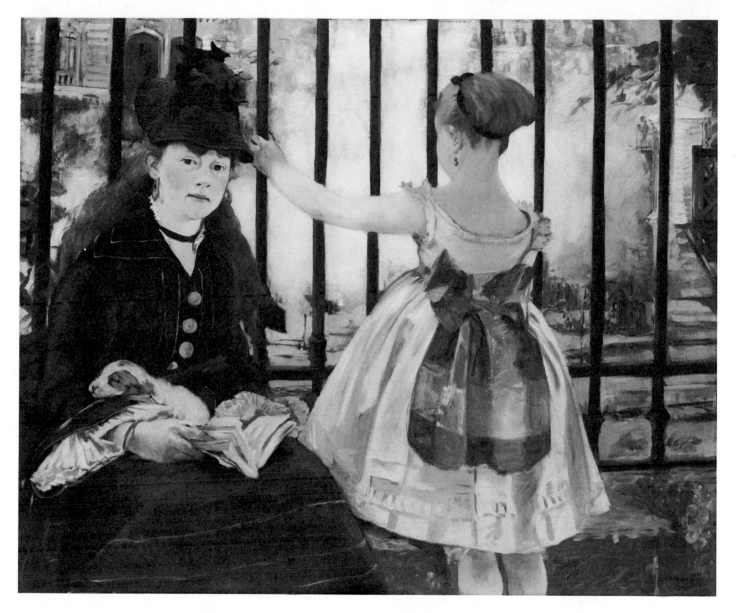

Color plate 3

Right: 32. Cham [Amédée de Noé]. Caricature of Manet's *Gare Saint-Lazare* (cat. 10), wood engraving from *Le Charivari*, 15 May 1874, Bibliothèque Nationale, Paris.

M. MANET.
La dame au phoque.
Ces malheureuses, se voyant peintes de la sorte, ont voulu fuir! Mais lui, prévoyant, a placé une grille qui leur a coupé toute retraite.

they were disturbed by the title, *Le Chemin de fer:* why the railroad? where was the locomotive? where were the passengers? (Bazire, 84). The very elements earlier realists such as Daumier and Couture had stressed—the awesome power of the steam engine, the heroic labor of the engineer, the anxieties of the passengers, all of which gave railroad travel its human significance—seemed suddenly to have vanished behind a cloud of white smoke. Only a few artists and writers could see through the smoke the new image of Paris that Manet had presented, in a remarkably fresh and vigorous manner.

Edouard Manet

11 *The Gare Saint-Lazare,* 1873

Watercolor and gouache on photograph, 7⅜ x 8⅛
in. (18.8 x 22.7 cm.)
Signed on the mount, in Mme Manet's hand: *E.M.*
Durand-Ruel & Co., Paris
R-W 2:322

The ways in which Manet made use of and was influenced by photography, the new medium whose period of greatest development roughly coincided with his own, are still being discovered. Whether he took photographs himself, as his friends Degas and Zola did, is not certain; according to one source (Tabarant 1947, 44-45), he was already photographing his own paintings as early as 1860. In any event, he did have commercial photographers—first Godet, then Lochard—photograph them regularly in both small and large formats, and he mounted the latter in an album to be shown to visitors (Tabarant 1947, 518-519). Manet was thus one of the first artists to recognize the value of photography as a means of recording his production systematically.

The photograph of the Gare Saint-Lazare (cat. 10) exhibited here was taken by Godet, whose dry stamp is on its *verso,* between the time Manet completed the painting late in 1872 or early in 1873 and the time the singer Faure bought it from him in November 1873 (Callen, 163-164). This photograph, too, was no doubt intended as a record, one Manet made more complete than usual by reworking it in watercolor and gouache. But it may also have served as a model for a more public kind of record, a wood engraving by Alphonse Prunaire (Guérin, no. 89); the print is exactly the same size as the photograph and was surely traced directly from it. A specialist in graphic reproductions, Prunaire had done many wood engravings based on Gustave Doré's drawings and a few based on Manet's (Guérin, nos. 87, 90-92). Although this one is known only in a few trial proofs, it was probably intended for mass publication in a magazine article on the Salon of 1874, where the painting was shown.

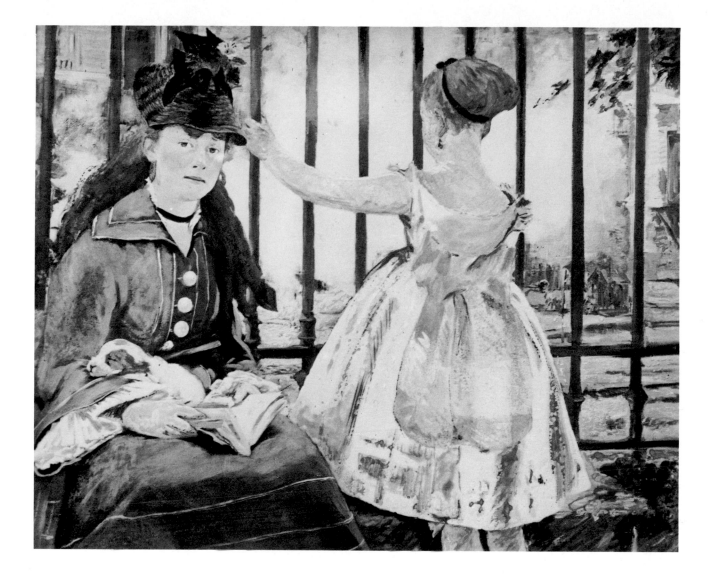

Honoré Daumier

12 *The Departure of the Train,* 1860-1865

Crayon, ink, and watercolor, 5¹¹⁄₁₆ x 9¹³⁄₁₆ in.
 (14.5 x 25 cm.)
Signed, upper right: *h. Daumier*
Private collection
Maison, 2: no. 310

The most important artist to treat railroad subjects between 1840 and 1870, the great age of railroad development and consequently of a new railroad imagery, Daumier was interested above all in the impact of the latest mode of transportation on the lives of the lower- and middle-class people he normally observed. His well-known series of lithographs, "The Railroads" (1843) and "Physiognomies of Railroads" (1852), depict in humorously exaggerated form the hazards and inconveniences of travel on exposed upper decks or in overcrowded carriages, of trains subject to jolting stops or long delays, and of small stations packed with frantic and sometimes eccentric passengers. His equally familiar paintings of people seated in second- and third-class carriages (1864-1865) also concentrate on the panorama of human types they represent, the strangers of different ages, sexes, and backgrounds thrown together in the same confined space for the length of the journey. Only in his watercolors, which he often conceived as finished, independent pictures, does he describe a railroad station in any detail, and even here he focuses on the travelers rather than the

building or the trains. In the *Gare Saint-Lazare* (fig. 33), the station Monet and other impressionists were soon to paint as a place of movement, color, and light, Daumier explored the full range of emotion, from boredom through impatience to anxiety, experienced by people of all classes of society; the station itself appears only as a cavernous space whose piers articulate the various groups and allow a glimpse of the city outside.

In the equally accomplished watercolor exhibited here, Daumier shows a more compact mass of figures moving in a single direction, toward the quay and waiting carriage at the left. Their determination to board it on time is apparent not only in their concentrated expressions, each one individualized yet all sharing the common impulse, but also in their forward-surging bodies. Even the triangular shaft of light, which illuminates and articulates the central group in a masterful way, adds its impetus to this irresistible drive, introducing a diagonal "line of force" pointing to the left. In Daumier's hands, the familiar act of boarding a train becomes a moment of dramatic import.

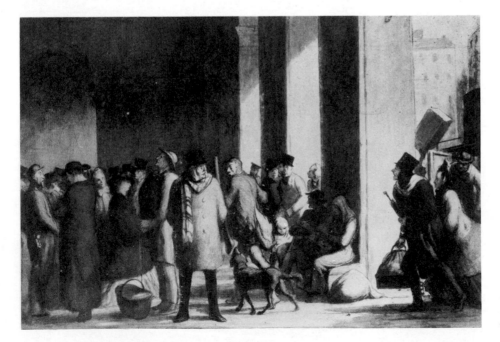

33. Honoré Daumier. *The Gare Saint-Lazare,* crayon, ink, and watercolor, c. 1860. Presumed destroyed.

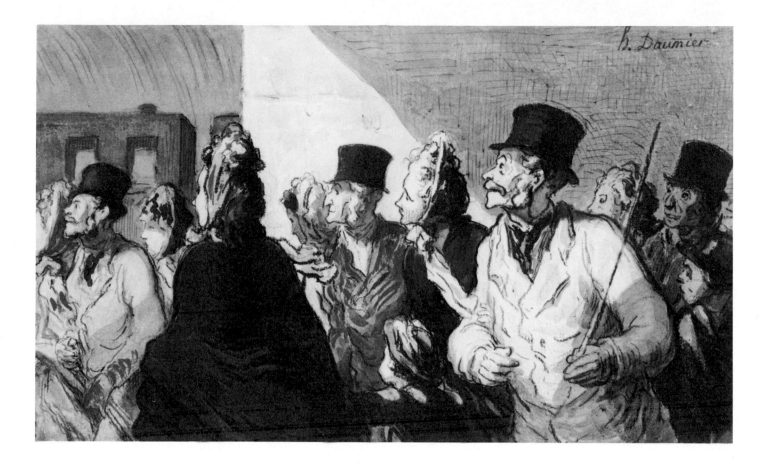

Gustave Caillebotte (1848-1894)

13 *The Pont de l'Europe,* 1876-1877

Oil on canvas, 25¼ x 31½ in. (64 x 80 cm.)
Stamped, lower right: *G. Caillebotte*
Richard M. Cohen, Holmby Hills, California
Berhaut, no. 45

🖎 Painted four years after Manet's view of the same site (cat. 10), Caillebotte's pictures of the Pont de l'Europe and the Gare Saint-Lazare are the earliest examples of its influence on another impressionist artist. The largest, most complex version, painted in 1876 and shown at the impressionist exhibition the following year (fig. 34), depicts a long, swiftly narrowing view down the rue de Vienne, with the place de l'Europe at the left and the railroad yard at the lower right. Looking into the yard is a young worker in a smock, who leans on the parapet in much the same way Léon Leenhoff does in Manet's *Oloron-Saint-Marie* (R-W 1:163), thus forming another link between the two artists (Varnedoe, 41). The version exhibited here is an oil sketch for the larger, more precisely rendered picture in the Kimbell Art Museum (fig. 35), where the site is more fully described; rails and signals can be seen between the girders of the bridge, and a train shed is visible in the triangular blue shape at the upper right. It is this version, rather than the one looking down the rue de Vienne, that most resembles Manet's *Gare Saint-Lazare,* especially in its relatively shallow space dominated by a few large figures and in its planar organization with pronounced horizontal and vertical axes. The two men who have turned away to observe the trains and station below are also reminiscent of the little girl who has done the same in Manet's picture.

Unlike his predecessor, who relegates the railroad yard to the background and includes only a fragment of the Pont de l'Europe, Caillebotte emphasizes the massive iron girders of the bridge, which were in fact some five meters high; his view is of the large central span, seen from a point near its center (Varnedoe, 28). In stressing the powerful geometric forms of the bridge, he reduces the human forms to marginal elements: all three spectators are crowded into less than half the picture surface, intercepted by its edges or by each other more radically than either of Manet's figures is, and turned so completely away as to seem even more impersonal than they do. In its color harmony, too, composed almost entirely of blue, gray, and black, Caillebotte's picture of modern man in his urban-industrial milieu contrasts sharply with Manet's equally new but more optimistic image, painted in balanced warm and cool tones and enlivened by accents of orange, yellow, green, and white.

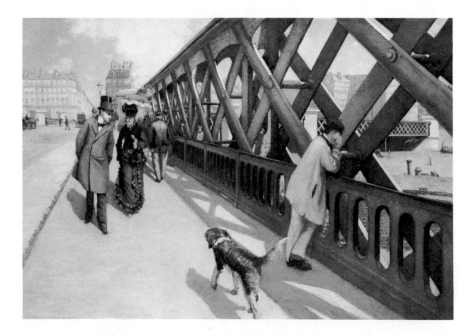

34. Gustave Caillebotte. *The Pont de l'Europe*, oil on canvas, 1876. Petit Palais, Geneva.

35. Gustave Caillebotte. *The Pont de l'Europe*, oil on canvas, 1876-1877. The Kimbell Art Museum, Fort Worth.

THE RAILROAD STATION 63

Claude Monet (1840-1926)

14 *The Gare Saint-Lazare,* 1877

Oil on canvas, 23½ x 31½ in. (59.5 x 80 cm.)
Signed, lower left: *Claude Monet 77*
The Art Institute of Chicago, Mr. and Mrs.
 Martin A. Ryerson Collection
Wildenstein, no. 440

🐦 Unlike Manet and Caillebotte, who painted spectators looking down at the railroad yard from positions some distance away (cat. 10, 13), Monet penetrated the yard and viewed it from within, as indeed he had already done in painting the station at Argenteuil in 1872 and 1875 (Wildenstein, nos. 242, 356). Having obtained permission to work at the Gare Saint-Lazare in January 1877, and having rented with Caillebotte's help a small apartment several blocks away, he completed at least eight pictures within three months and showed them at the impressionist exhibition in April. The one exhibited here, subtitled *The Normandy Train,* was among them. It is one of two pictures, in this series that eventually comprised twelve, painted beneath the canopy of the large train shed at the eastern end of the station, serving long distance lines. Two of the others were painted in the still larger shed used for suburban lines, and the remainder at various points within the yard, on the Pont de l'Europe, or near the Batignolles tunnel (Wildenstein, nos. 438-439, 441-449). The breadth of this panoramic vision of the site has no counterpart in the work of Manet or Caillebotte.

In the version shown here, the Normandy train, its engine already fired and a crowd waiting to board, is standing beneath the canopy, an enormous vault of iron and glass. Like the Pont de l'Europe, seen in the distance here and from a closer position in the Musée Marmottan version (fig. 36), it strikingly demonstrated new possibilities for urban building, to which Monet obviously responded with enthusiasm. In this he resembled the critic Champfleury who, in proposing that Courbet paint murals of modern industry in railroad stations, declared that the latter and the covered markets alone represented the

36. Claude Monet. *The Pont de l'Europe and the Gare Saint-Lazare,* oil on canvas, 1877. Musée Marmottan, Paris.

authentic style of nineteenth-century architecture (Champfleury 1861a, 184). In comparison, the barrel vaults of the freight sheds along the rue de Londres, visible beyond the canopy at the right in Monet's picture, seem modest in scale and traditional in form. It is the vastness of this partly enclosed space, filled with steam and smoke and bustling with movement, yet open to the city and the sky beyond, a space that dwarfs the tiny passengers and workers yet testifies to human achievement, that Monet recreates so vividly. He does so not in spite of his hasty, seemingly careless execution, the subject of much ridicule at the time, but precisely because it alone can reproduce fully that dynamic flux of people and machines, of smoke and atmosphere, which is the essence of his conception.

Color plate 7

Jean-Louis Forain (1852-1931)

15 A *Study of Fog in a Station*, c. 1884

Oil on canvas, 17¾ x 22 in. (45.1 x 55.8 cm.)
Not signed or dated
Mr. and Mrs. Irving Moskovitz, New York

Evidently unique in the work of Forain, who concentrated on scenes of entertainment and sordid pleasure, this desolate picture of a crowd waiting at a railroad station on a foggy day was probably inspired by Monet's Gare Saint-Lazare series of 1877 (e.g., cat. 14) both in its choice of subject and its emphasis on smoke and atmosphere. But unlike Monet, who records the complexity and dynamism of the railroad yard, Forain pays minimal attention to the train shed and even the trains, and stresses instead the yellowish fog pervading the scene, the orange signal glowing in its midst, and the passengers dressed in dark brown and black waiting on the platform. It is, in contrast to Monet's affirmation of urban life, an image of its dreariness, effectively conveyed by the dirty yellow fog mingling with smoke that seems to fill the silent void. In this respect, Forain's picture is closer to the one his friend Huysmans, whose pessimistic view of modern society he shared, paints in *Les Soeurs Vatard* (1879). Looking down at the Gare Montparnasse from an apartment on the rue Vandamme, the sisters are enveloped in "an odor of burnt coal, of castings heating up,

of steam and soot, of smoke from greasy water and oil," and in the distance they see "the station disappearing in a yellow vapor, spangled with orange lights and the white lanterns of tracks left clear" (Huysmans 1879, 119). Later on, they observe once again "the different colors of the engines' smoke, which varies from white to black, from blue to gray, and at times is tinted yellow, the dirty, heavy yellow of sulphur springs" (Huysmans 1879, 236).

For all its interest in the atmosphere of the station, Forain's picture is essentially about the passengers. All of them turn away to watch the train approaching out of the fog—all but one, the young woman who turns toward us, her trunk standing nearby, her eyes lost in reverie, intimating some special motive for her departure but offering no explanation. As a type of young Parisienne in street dress, she is reminiscent of those whom Forain's friend and mentor Degas had depicted around 1880 in his etching *Ellen Andrée* and especially in his pastel *Project for a Frieze of Portraits* (Lemoisne, no. 532), which shows three women in street dress, one with an umbrella, waiting for an omnibus.

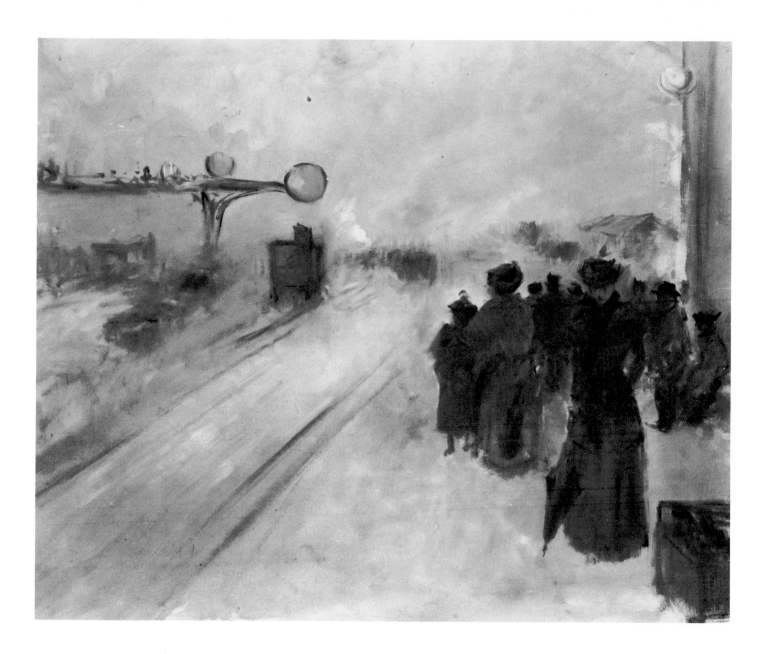

Norbert Goeneutte (1854-1894)

16 *The Pont de l'Europe,* 1887

Oil on canvas, 18⅜ x 21⅞ in. (46.7 x 55.5 cm.)
Signed and dated, lower right: *Norbert Goeneutte
Paris 18[?]7*
The George A. Lucas Collection, the Maryland
Institute, College of Art, Courtesy of the
Baltimore Museum of Art

Goeneutte was one of several younger artists, including his friends Béraud and De Nittis, who began painting contemporary Parisian subjects in the 1870s in imitation of the impressionists but in a style more conventionally realistic and more acceptable to a large public. Early in his career, he became acquainted with artists and writers in the impressionist circle at the Café de la Nouvelle-Athènes, and he appears in several of Renoir's pictures of that period, including the *Moulin de la Galette.* Manet, with whom he was also friendly, is reported by their mutual friend Antonin Proust to have admired Goeneutte's etchings of modern Paris, and Proust himself was planning with him a project on the same theme for the world's fair of 1900, which was to include views of the Gare Saint-Lazare and the Pont Neuf, at the time of Goeneutte's death (*Exposition Goeneutte,* 6-7, 10-11).

The version of the Pont de l'Europe exhibited here reveals the influence of Monet's rather than Manet's paintings of that site, and it does so in its choice of subject and viewpoint rather than its style. Despite the relatively free handling of the foreground and the plumes of smoke, it demonstrates a greater attention to detail than any of Monet's views of the same bridge (fig. 36). Although Goeneutte's picture is inscribed ambiguously and has remained undated in the literature, it must have been painted in 1887. For this unusual view of the Pont de l'Europe, the Gare Saint-Lazare, and the Opera—the tall, gabled building near the center of the skyline (cf. the aerial view, fig. 28)—can only have been taken from an upper floor in a building on the rue de Rome, which runs alongside the railroad yard; and Goeneutte had a studio on that street from 1887 on (Knyff, 89). Moreover, the completed picture was bought directly from the artist by the American collector and art agent George Lucas in March 1888 (Lucas, 1: 666). This was by no means Goeneutte's only image of the subject; fascinated by the railroad station as an embodiment of the vitality of modern Paris, he represented it repeatedly from the bridge, the quays themselves, and more distant vantage points, and in every available medium (Knyff, 85-86). But he probably came closest in this version to capturing the visual charm of the panoramic view, the structures of varied form, and the billowing smoke.

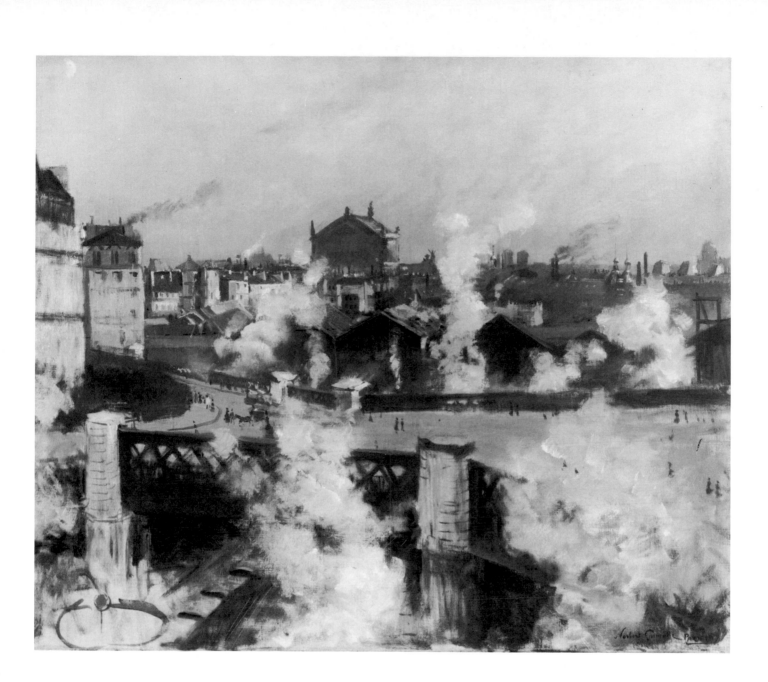

Edouard Vuillard (1868-1940)

17 *On the Pont de l'Europe*, 1899

Color lithograph, 12³⁄₁₆ x 14 in. (31 x 35.5 cm.)
Not signed or dated
National Gallery of Art, Washington, Rosenwald
 Collection 1943
Roger-Marx, no. 40

Published by Ambroise Vollard in the album *Paysages et intérieurs* in 1899, along with other familiar scenes in the public and domestic life of a comfortable Parisian family like his own, Vuillard's lithograph undoubtedly derives from just such an intimate familiarity with its subject: the year before, he and his mother had moved to an apartment on the rue Truffaut in the Batignolles district, very near the Pont de l'Europe. Yet his image of the bridge overlooks entirely the realistic aspects that had appealed to Caillebotte and Monet in the 1870s and to Goeneutte a decade later (cat. 13, 14, 16) and that continued to appeal to printmakers and photographers working in the realist-impressionist tradition to the end of the century. The contrast between Vuillard's image of the Pont de l'Europe and that of a photograph taken in the early 1900s (fig. 37) reveals clearly how much of the massive iron structure and the views it provided of the railroad yard and station he chose to ignore. Even the pattern of the trellis is changed in his print from the forceful diagonals of the actual bridge to calmer horizontals and verticals, which seem barely to emerge as gray shapes against a background of the same opaque gray.

Our attention is focused instead on the two girls crossing the bridge in their delicately patterned pink and blue dresses, the older one carrying an umbrella, the younger one a large doll. But unlike the little girl in Manet's painting of the Gare Saint-Lazare (cat. 10), they are indifferent to the exciting spectacle beyond the bridge and wholly absorbed in themselves. The same can be said of the two young women and the little girl who are shown crossing the Pont de l'Europe—here described correctly with its trellis forming a diagonal grid—in Bonnard's painting *The Promenade* of c. 1894 (Dauberville, no. 57). The quietism and inwardness of the 1890s, and especially of Nabi artists such as Bonnard and Vuillard, is nowhere more apparent than in this contrast with Manet's more dynamic and outwardly oriented image of two female figures sitting or standing before the same bridge.

37. Artist unknown. *The Pont de l'Europe and the Gare Saint-Lazare,* photograph, 1900-1910. Courtesy *La Vie du Rail,* Paris.

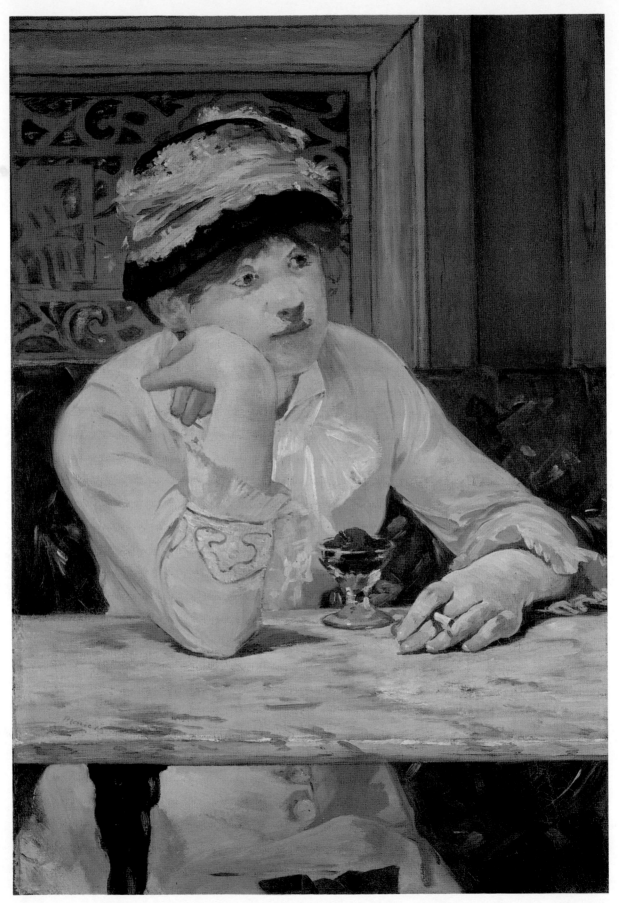

Plate 8. Edouard Manet. *The Plum*, 1877-1878. Cat. 18.

3
The Café and Café-Concert

❧

ALTHOUGH CAFÉS had existed in Paris since the late seventeenth century and had flourished throughout the eighteenth and early nineteenth, it was only in the late nineteenth century that they became the very center of its social and cultural life. If there were already some nine hundred cafés by the end of the *ancien régime*, there were thirty times that number by the end of the more democratic century that followed, and these were of all classes and spread through all parts of the city. As places where people living in increasingly congested urban quarters could relax and converse outside the home, read newspapers and write letters, and also leave and receive messages, meet old friends and make new ones, cafés offered more than refreshment and diversion; they were an essential part of urban life (Ariès, 231-232). Their terraces, overflowing onto the sidewalks of the city's main arteries, became in the Second Empire one of its most characteristic sights. And just as the cafés dominated its night life, so they were at the heart of its artistic and literary activity, providing forums for the exchange of news and gossip and the testing of new ideas. They had of course served that purpose since the days of the Café Procope in the eighteenth century and those of the Divan Lepeletier and the Brasserie des Martyrs in the first half of the nineteenth; but their sheer number, and the number of magazines edited on their tables, is unique in the second half and especially in the last quarter of the century.

Around 1840 a new form of café emerged alongside the *café littéraire*, in which singers and musicians provided a topical, vernacular form of entertainment; and in the following decades this *café-concert* became a familiar feature of Parisian night life, at first outdoors on the Champs-Elysées, then indoors along the principal boulevards. The new streets created in the Second Empire were indeed the *café-concert*'s natural breeding ground: "It occupied, positively invaded, the great spaces Hauss-mann created in the 1850s and 1860s, the sidewalks and squares of a city built for trade [and] traffic" (Clark 1977, 239). Popular café singers like Thérèsa, Bécat, and Demay, all of whom Degas painted in the 1870s (e.g., cat. 25), were among the leading celebrities of the day.

Long before Degas, nineteenth-century artists were recording the pleasures of café life in Paris. From Boilly's paintings of the elegant Palais Royal establishments in the first decades of the century through the countless lithographs of Gavarni and Daumier and the engravings in popular magazines showing more ordinary brasseries, wine shops, and *cafés-concerts* in the following decades, there was a steady stream of such imagery. To it belong such well-known realist images as Courbet's *Brasserie Andler*, Bonvin's *Flemish Tavern* (cf. cat. 19), and Renoir's *Inn of Mother Anthony*, an early, pre-impressionist work set outside Paris. But given this artistic tradition and their own interest in scenes of modern life, why did Manet and the impressionists first turn to café subjects only in 1876-1877? They were all of course familiar with such places, and Manet himself early in his career had frequented the fashionable Café Tortoni and the more literary Café de Bade on the boulevard des Italiens, along with Baudelaire and Duranty. Around 1866 he had changed to the Café Guerbois near the place de Clichy, a more modest establishment, gathering around him Zola, Duranty, and most of the future impressionists (Rewald, 197-207). Yet it was only a decade later, when he changed once more, to the Café de la Nouvelle-Athènes on the place Pigalle, bringing with him the same group of artists and writers, that the café emerged as a major theme in their work. Degas at the Nouvelle-Athènes and the Ambassadeurs, Renoir at the Moulin de la Galette and a Montmartre *bistro*, Forain at the Folies-Bergère and the Jardin de Paris, Manet himself at the Nouvelle-Athènes, the Brasserie de Reichshoffen, and the Folies-Bergère— all were responding to the sudden vogue of café subjects

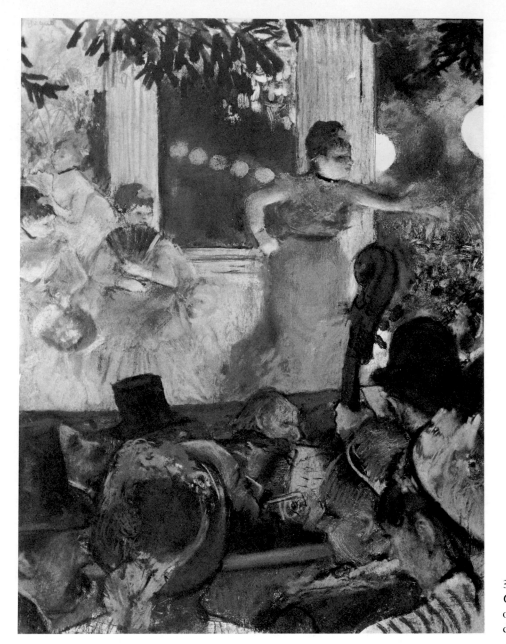

38. Edgar Degas. *At the Café-Concert "Aux Ambassadeurs,"* pastel over monotype, 1876-1877. Musée des Beaux-Arts, Lyon.

in the late 1870s. The question is, why not earlier? Or, to put it another way, why does Manet's *Bon Bock* (R-W 1: 186), painted in 1873, still take a traditional form dependent on Frans Hals' pictures of jolly drinkers in Dutch taverns, while his *Plum* (cat. 18), painted four years later, takes a distinctly modern form, showing a contemporary young woman in a familiar Parisian café?

To some extent, no doubt, because the work on which the *Plum* in its turn depends, Degas' *Absinthe* (fig. 40), had demonstrated the possibility of creating high art from a subject largely confined until then to popular art, to the scenes of café life that appeared in prints and illustrated weeklies, just as Degas' *café-concert* pictures (e.g., fig.

38) had revealed possibilities Manet was quick to exploit (e.g., fig. 39). But Degas' innovations alone can hardly account for so pervasive a trend, which indeed was not confined to painting. Zola's most searching examination of the café and its effect on peoples' lives, and his most graphic descriptions of places like the *père* Colombe's gin mill, occur in *L'Assommoir* (1876-1877), a novel widely discussed in the press and in Manet's circle. In these years, too, Huysmans explored the whole gamut of drinking places in Paris, from a working-class dance hall in Grenelle (*Drageoir aux épices,* 1875) and a prostitutes' bar on the rue de Vaugirard (*Marthe,* 1876) to the glittering music hall of the Folies-Bergère (*Croquis parisiens,* 1880)

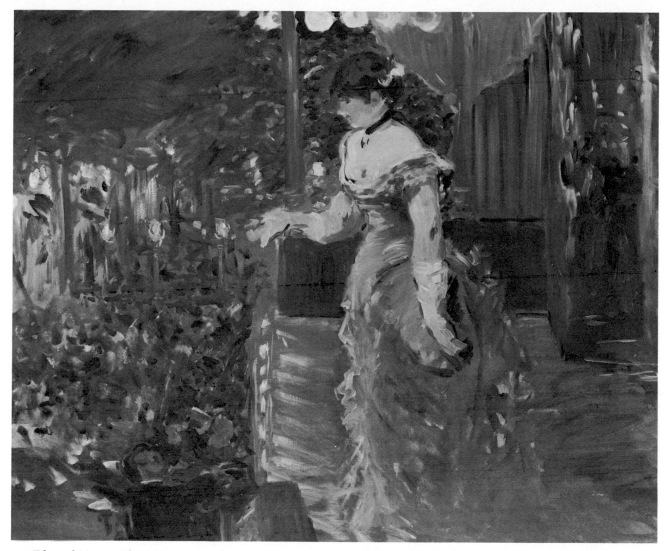

39. Edouard Manet. *The Café-Concert*, oil on canvas, 1879. Private collection, Paris.

and the aristocratic, anglophile Bodéga on the rue Castiglione (*A rebours,* 1884). At the same time, Raffaëlli was urging his fellow artists to make a similar survey of the cafés "in which millions of individuals gather daily," ranging "from the sumptuous café to the den of the suburbs, from the café of the neighborhood tradesmen to the tavern where the politicians hold forth," and he concluded enthusiastically: "What discoveries are there to be made!" (Isaacson 1980, 41).

Ultimately, then, the vogue of the café in art and literature after 1875 reflected its extraordinary vogue in society itself, which in the early years of the Third Republic increasingly sought an animated public life outside the home and traditional social circles. Clearly the measures taken in the very first years of the Republic to regulate and control the cafés, where any unruly behavior was feared as a threat to the regime of moral order that followed the Commune, had proven impossible to enforce and largely ineffective (Pierrot, 10-11), and by the end of the 1870s the café had become more than ever the center of public life, at least for the lower and middle classes. As the hero of *A rebours* came to realize, "The true significance of all these cafés [was] that they corresponded to the state of mind of an entire generation. . . . They offered him a synthesis of the age" (Huysmans 1884, 175).

Edouard Manet

18 *The Plum*, 1877-1878

Oil on canvas, 29 x 19¾ in. (73.6 x 50.2 cm.)
Signed, on the table at the left: *Manet*
National Gallery of Art, Washington, Collection
of Mr. and Mrs. Paul Mellon 1971
R-W 1:282

Eating (and drinking) plums soaked in brandy had been familiar to Parisians at least since 1798, when the Maison de la Mère Moreau opened on the place de l'Ecole and began serving them. Scores of similar establishments followed quickly, though none was as renowned for the beauty of its barmaids or the quality of its plums and other fruits conserved in alcohol (Fournel 1858, 368). By the middle of the nineteenth century, brandy-plums were being served in most cafés, even dreary ones in poor neighborhoods like the *père* Colombe's *assommoir* in Zola's novel. In the first scene set there, Gervaise and Coupeau are "having a brandy-plum together" (Zola 1877, 49-50). In a later scene she sits in the same café, "her elbows on the table" and "gazing into space" as the young woman does in Manet's *Plum,* and after her third drink she "cups her chin in her hands" as his figure does (Zola 1877, 338-339). Was *L'Assommoir,* published serially in 1876 and as a volume early in 1877, Manet's source of inspiration, as it was to some extent for his *Nana* of that year? Not in any literal sense, of course, though it may have stimulated him to undertake such a subject. The wistful attitude of his drinker was familiar enough in the cafés, where Huysmans too observed prostitutes "sitting dejectedly on benches, wearing their elbows out on marble-topped tables . . . with their heads in their hands" (Huysmans 1884, 174). And the setting in which Manet has placed her, the Café de la Nouvelle-Athènes in the Batignolles district, was a very different establishment from the *père* Colombe's gin mill on the rue des Poissonniers in the working-class district of La Chapelle.

If the young woman in the *Plum* is not an impoverished laundress like Gervaise, but rather a well-dressed prostitute, "one of those who wait in cafés for the next assignation" (Duret, 171), with a distinct bittersweet personality, the model who posed for her has thus far remained unidentified. Yet she is clearly the same young woman whom Manet represented, seated beside the artist Henri Guérard, in *At the Café* (fig. 44) and whom he twice

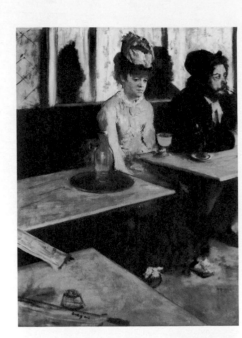

40. Edgar Degas. *Absinthe*, oil on canvas, 1876. Musée d'Orsay (Galerie du Jeu de Paume), Paris.

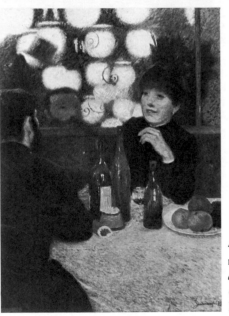

41. Federico Zandomeneghi. *At the Café de la Nouvelle-Athènes,* oil on canvas, 1885. Private collection, Italy.

portrayed in pastel (R-W 2: 8, 9)—the actress and model Ellen Andrée. A *cocodette* well known in the theater and in artists' studios, she also appears in Degas' *Absinthe* (fig. 40), seated beside the painter Desboutin at the Café de la Nouvelle-Athènes. This much-discussed work, shown at the impressionist exhibition of 1876, undoubtedly influenced Manet's; but its somber image of an absinthe drinker slumped down in a stupor makes his image of a wistful prostitute, stylish in her light pink dress and black hat, seem brighter and more sympathetic, more like that of Ellen Andrée when she posed initially for *At the Père Lathuille's,* "young, sweet, amus-

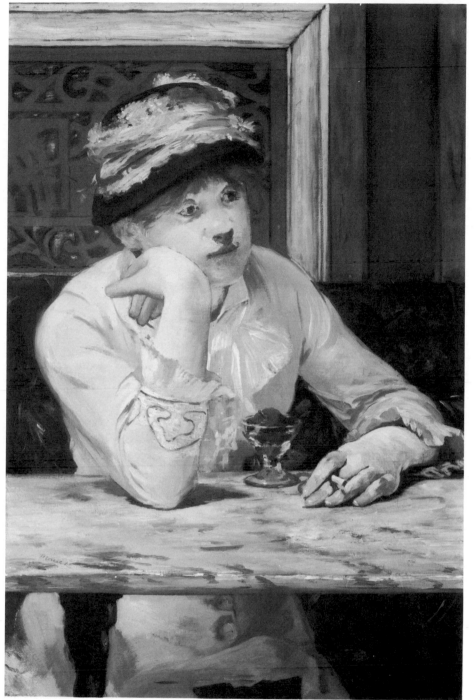

Color plate 8

ing, dressed to kill,'' as a contemporary put it (Richardson, 129). The background of the *Plum* also differs considerably from that of *Absinthe*, though in fact they represent the same place. But since the setting of Zandomeneghi's *At the Café de la Nouvelle-Athènes* (fig. 41) corresponds closely to Degas' in showing a long mirror above an upholstered bench, framed by a narrow molding, it is evident that Manet devised his own for purely pictorial reasons. The wood panel and heavy gold frame define a rectangular pattern, reinforcing that of the bench and marble table and locking the figure in. In contrast to this severity, the panel behind her head, probably an etched mirror, is elaborately ornate; its style has been described as art nouveau, but it was more likely invented by Manet from plant motifs of a type popular in Second Empire decorative art.

François Bonvin (1817-1887)

19 *The Flemish Tavern,* 1867

Oil on wood, 19¾ x 14⅝ in. (50.2 x 37.2 cm.)
Signed and dated, lower right: *F. Bonvin 1867*
The Walters Art Gallery, Baltimore
Weisberg, no. 40 *bis*

The differences between this café scene and Manet's *Waitress Serving Beer* (cat. 20) are not only those between a realist picture of the 1860s and an impressionist picture of the 1870s; they also reveal the extent to which the younger artists broke with a tradition extending back several centuries. The balanced, stable grouping of Bonvin's figures—also a waitress and two men—and their small size relative to the spacious interior; the solid, earthen tones, relieved by red and white; and the smooth, impersonally precise execution are all reminis-

42. Pieter de Hooch. *The Card Players,* oil on canvas, c. 1865. Musée du Louvre, Paris.

cent of traditional genre pictures, especially of Dutch and Flemish café scenes. One in particular has been cited as a precedent and a likely source of inspiration: De Hooch's *Card Players* in the Louvre (fig. 42), which Bonvin must have studied with renewed interest after traveling in Holland for the first time early in 1867, shortly before painting the *Flemish Tavern* (Chu, 40-41). He had been advised to make the trip by the critic Thoré-Bürger, who objected that his earlier *Cabaret Interior*

(Weisberg 1979, no. 28) was not sufficiently Dutch in inspiration.

The later scene, shown at the Salon of 1867, is by no means a mere pastiche of the one by De Hooch. It is, on the contrary, a blend of seventeenth-century Holland and nineteenth-century France; for if the costumes, brass vessels, and clay pipe are reminiscent of the earlier period, the setting clearly belongs to the later one and may in fact be the tavern at Vaugirard operated by Bonvin's father and his half-brother Léon. Scenes such as this one, set in kitchens and servants' quarters as well as in lower-class cabarets, and suffused with the flavor of seventeenth-century Dutch and Spanish art, were a specialty of minor realists like Bonvin and Ribot in the 1860s and formed a link between the rural genre scenes of the previous decade and the urban scenes of the following decade (Chu, 39).

Edouard Manet

20 *A Waitress Serving Beer,* 1877

Oil on canvas, 30½ x 25⁹⁄₁₆ in. (77.5 x 65 cm.)
Signed, lower right, in Mme Manet's hand: *E. Manet*
Musée d'Orsay (Galerie du Jeu de Paume), Paris
R-W 1:312

This picture is closely related to another, larger in format, in the National Gallery, London (fig. 43), which shows the same three customers and waitress but more of the café interior, including the orchestra and dancer in the background. One or the other was once part of a still larger composition, representing the Brasserie de Reichshoffen, a *café-concert* supposedly on the boulevard de Rochechouart (Tabarant 1947, 326) or the boulevard de Clichy (Duret 171), although it is listed at neither address in the *Bottin*. Manet reportedly began the large picture in August 1878 and, before completing it, cut it into two fragments, whose backgrounds he then developed independently. It is generally agreed that one of these fragments is the Reinhart Collection's *At the Café* (fig. 44) and the other the London picture. The contrary view, that the other fragment is the Paris version (Richardson, 128-129), is hard to accept, even if this one and the Reinhart picture are now the same height; for they are stylistically quite different—one rather sketchy, the other more precise—whereas the London version is painted in the same precise style. More important, the London picture shows a table top whose left edge matches perfectly the right edge of the table in the Reinhart version, even to the shadows cast by the glasses (Davies, 98-101). Thus the Reinhart picture must have been cut down to its present height, and its background revised, after the two were separated.

What place did the Paris version occupy in this development? Most likely it was painted after the London picture had been separated from the larger composition and thus was intended as a study for it, to visualize it in its new, autonomous state. It has a more compact design, cut down slightly at the top, more at the left, and still more at the bottom, in order to situate the figures more centrally in the space. But rather than cut down the London version correspondingly, Manet achieved the same result by adding a strip of canvas at the right and extending the original imagery onto it; the join is visible

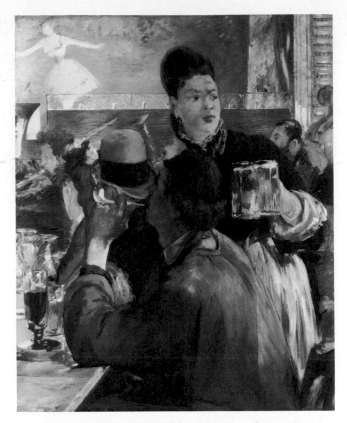

43. Edouard Manet. *A Waitress Serving Beer*, oil on canvas, 1877. The National Gallery, London.

44. Edouard Manet. *At the Café*, oil on canvas, 1878. Oskar Reinhart Collection "Am Römerholz," Winterthur.

even in reproductions. Since the Paris version was painted after the one in London—given the stylistic differences, it is impossible to imagine the reverse—and since it was sold to the singer Faure in 1877 (Callen, 163), the London version, as well as the original *Brasserie de Reichshoffen,* must date from 1877 or earlier, not from 1878-1879 as is usually stated on the basis of the inscribed date on the London picture.

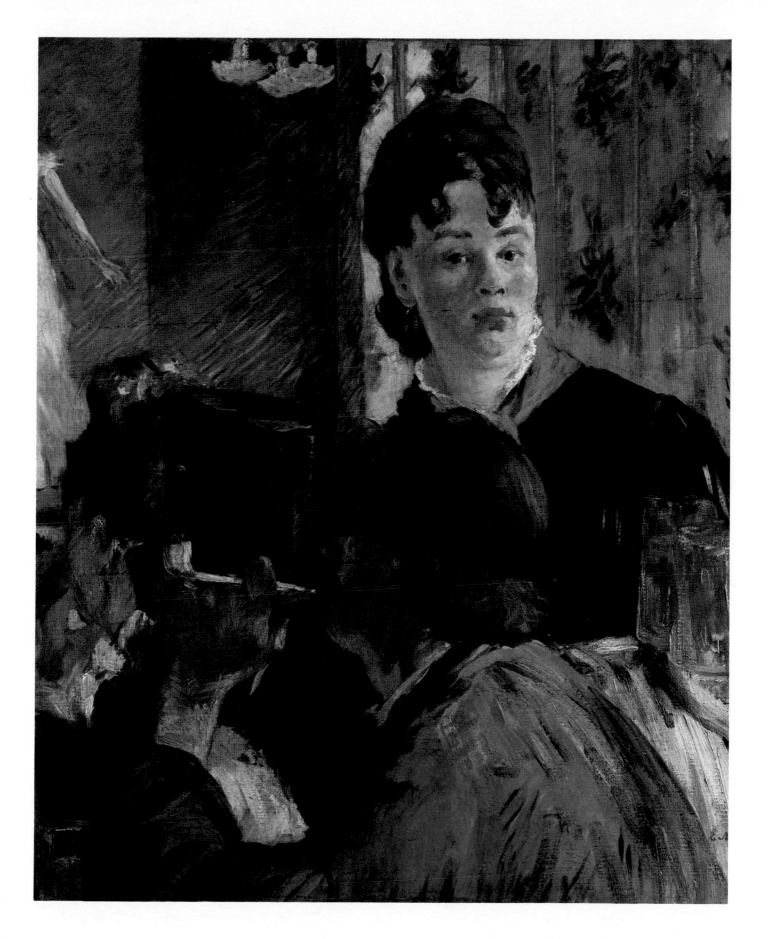

Edouard Manet

21 *The Café-Concert,* 1878

Oil on canvas, 18⅝ x 15⅜ in. (47.3 x 39.1 cm.)
Signed, lower left: *Manet*
The Walters Art Gallery, Baltimore
R-W 1:280

Smaller than most of Manet's café pictures of the late 1870s, but richer in content and more ingeniously composed, this may well be the masterpiece among them. Crowded into the small space are six figures remarkably varied in apparent size and completeness, from three-quarter length to the head alone; each one, moreover, is overlapped by another figure or intercepted by the marble counter or the frame. The three largest form a triangular group, a traditional device and long one of Manet's favorites, but lacking here its usual cohesiveness and stability. Instead, the three figures, described as distinct social types, face in different directions: the old gentleman in a black coat and silk hat, his hands folded on his walking stick, turns proudly to the right; the shop girl lost in reverie, her cigarette and beer forgotten, looks downward to the left; and the waitress behind them, standing with hand on hip and draining a beer herself, faces entirely to the left. Conversely, the couple glimpsed at the far right face entirely to the right. The contrasted colors of the larger figures' clothing—jet black with accents of white in the man's, greenish brown with touches of yellow in the girl's—reinforce the distance between them. Thus Manet's theme is neither amusement nor conviviality, as in so many older café pictures, but estrangement, the inherent isolation of strangers brought together by chance in a public place, perhaps the only place in the Paris of their day where they could come together so easily (Ariès, 231-232).

At the upper left, on the same diagonal as the gentleman and the waitress, but smaller and more distant, is a *café-concert* singer. Wittily characterized by her pointed, upturned "muzzle" and her tiny eye, she has been identified as "la belle Polonaise," a *diseuse* who performed at the Brasserie de Reichshoffen. Her distinctive silhouette also appears in an ink drawing (R-W 2:514) and a transfer lithograph (Wilson, no. 87) of the late 1870s; and the footlights, orchestra, and spectators shown at the bottom edge of those works also occur in another painting set at this Brasserie (fig. 43). In the one exhibited here, however, we see the singer only as a reflection in a mirror, part of whose gold frame is visible above the waitress' head—a prefiguration of the much larger yet also initially ambiguous mirror in the *Bar at the Folies-Bergère* (fig. 49) four or five years later.

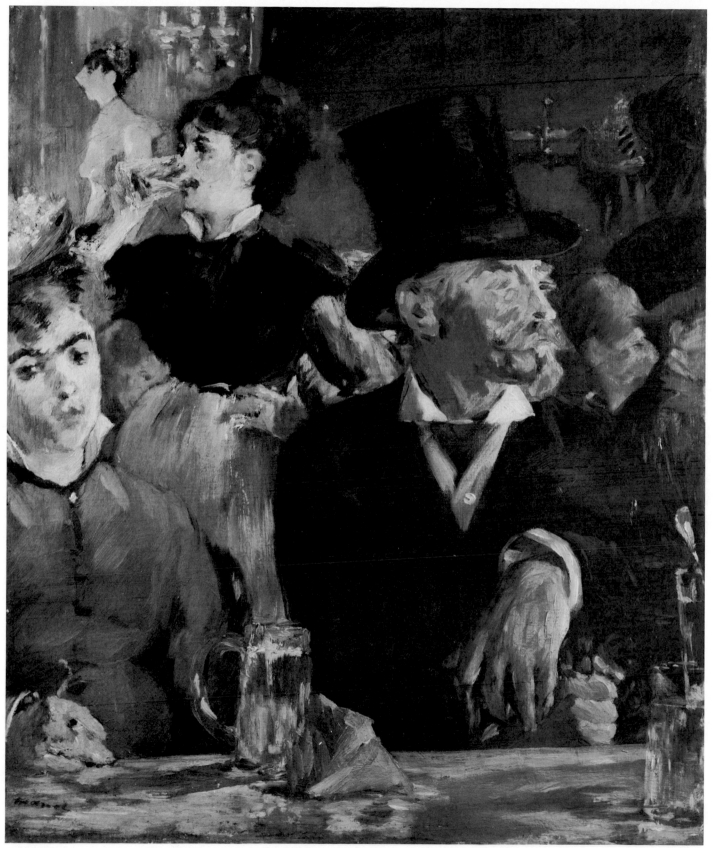

Color plate 1

Edouard Manet

22 *A Woman Reading in a Café,* 1879

Oil on canvas, 24¹⁄₁₆ x 19⁷⁄₈ in. (61.1 x 50.5 cm.)
Signed, lower left: *Manet*
The Art Institute of Chicago, Mr. and Mrs.
 Lewis Larned Coburn Memorial Collection
R-W 1:313

One of the freshest, most freely painted of Manet's café pictures, this is also one of the least explicit in describing the café setting, supposedly the Nouvelle-Athènes on the place Pigalle (Tabarant 1947, 327). The sketchy landscape in the background, perhaps a window view of the café's garden, could as well be a painting or wall hanging in another kind of public place. The young woman herself, stylishly dressed in a black coat with a white tulle collar and wearing her hair on her forehead in the chic style called *à la chien,* is more elegant than Manet's usual café-dwellers and more absorbed in herself, or at least in the magazine she holds in her gloved hands. Only the wooden bar to which the magazine is attached—a familiar feature of café reading racks—and the glimpse of a beer mug beside her suggest the nature of her surroundings. But her nickname offers a witty confirmation: Trognette—not Tronquette, as is often stated—means *petite trogne,* "a little bloated or beery face." It is an apt enough epithet not only for this model but for those in the thematically related pastel *Two Women Drinking Beer* (R-W 2:7), drawn the year before, which shows two stylish, rather bloated young women with tall steins of beer. In neither work, however, is there a suggestion of the dejection that pervades the image of the prostitute drinking alone in a café in the *Plum* (cat. 18).

The term *Illustré* in the French title of this picture—*La Lecture de "L'Illustré"*—must be a generic one: there was no magazine of that name before 1880; and rather than one of the illustrated weeklies of large format, such as *Le Journal illustré,* the magazine the young woman is reading is more likely a smaller one such as *La Vie moderne,* founded in 1879, where Manet's drawings sometimes appeared (Duret, 203). Whichever publication one imagines it to be, the fact that she is shown reading it assumes greater significance when we learn that it was precisely in the pages of such magazines, where prints of café subjects drawn in a lively, informal style abounded in the 1860s and 1870s, that Manet and Renoir found models for their own treatment of the café (Isaacson 1982, 108).

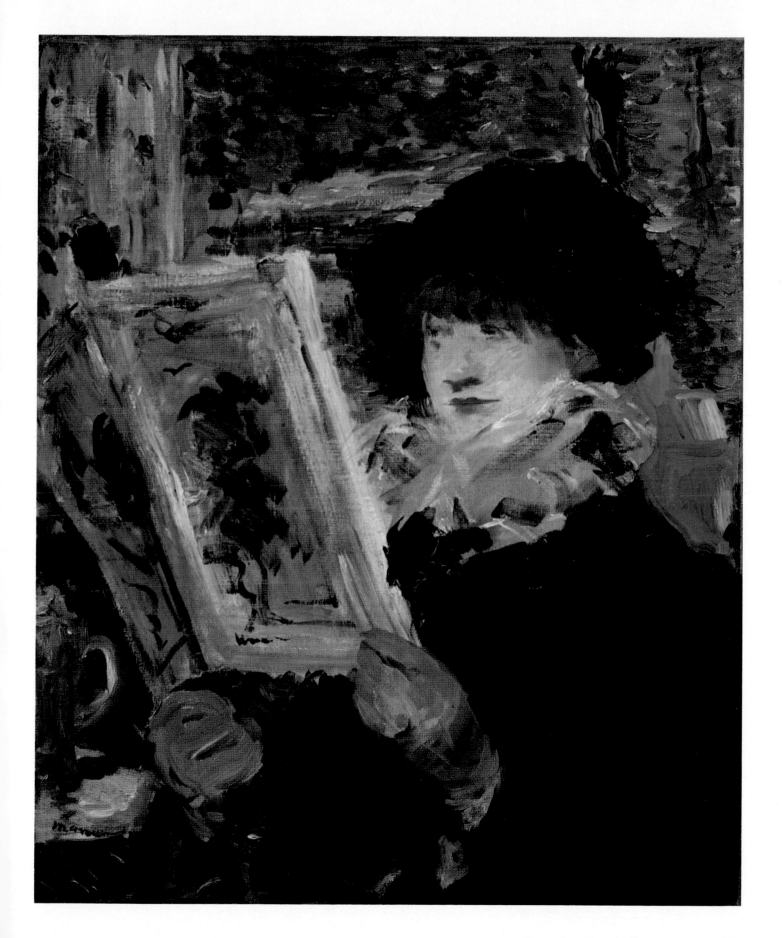

Edouard Manet

23 *At the Café,* 1874

Transfer lithograph, 10⅜ x 13³⁄₁₆ in. (26.3 x 33.4 cm.)
Signed in the stone, lower right: *Manet*
National Gallery of Art, Washington, Rosenwald Collection 1953
H 66, only state

For all its importance in the history of impressionist art and naturalist literature, the Café Guerbois is rarely described in either. Very few of the painters and writers who frequented this neighborhood café near the place de Clichy for almost a decade, some of them almost daily, recorded its appearance, though a few later evoked its special atmosphere (Rewald, 197-207). Even Manet, who had supposedly led them there from the boulevard cafés about 1867 and later, during the siege of Paris, had found in it his "only resource," never used it as a setting for one of his paintings. Hence the significance of this lithograph, which undoubtedly shows the "back room" of the Guerbois and one of those animated discussions, in which the waiters too participated, that reportedly took place there.

In reproducing a drawing he had apparently made on the spot in 1869 (fig. 45), Manet improved its composition in several ways: the spacing of the figures and of the coat and hats is more varied and interesting, and the background is extended at the left to include a view of billiard tables and players. The latter are also mentioned in Duranty's story "La Double Vue de Louis Séguin," which likewise dates from 1869 and contains the only other contemporary description of the Guerbois by someone who frequented it: "At the entrance [to the back room] six squat columns form an aisle that divides it into two spaces like narrow chapels, behind which extends to the rear, like a choir, the area of billiard tables. . . . Five billiard tables, the heavy baptismal fonts of this temple, spread out in false perspective their lawn-like surfaces, which absorb the light" (Petrone, 236). Equally important, however, in situating Manet's image in its historical

45. Edouard Manet. *At the Café*, pen and ink, 1869. Fogg Art Museum, Harvard University, Meta and Paul J. Sachs Bequest.

context are the numerous prints of men drinking, smoking, and conversing in neighborhood cafés that appeared throughout the 1860s and 1870s in illustrated weekly newspapers and in popular illustrated books (Hanson 1972, 153-154).

The print exhibited here is the second of two versions, both of them transfer lithographs; it was drawn with a pen to achieve greater definition of detail, since the first one (H 67) was drawn with a brush and had clearly left Manet dissatisfied with the relative crudeness of the result. Although both have always been dated 1869 on the basis of the drawing, it has recently been discovered that the second version appeared in a newspaper, still unidentified, in February 1874 (Wilson, nos. 84, 85).

Edgar Degas (1834-1917)

24 A Young Woman in a Café, c. 1877

Pastel over monotype, 5⅛ x 6¾ in. (13.1 x 17.2
 cm.)
Signed, at the left: *Degas* and at the lower right:
 Degas
Private collection
Lemoisne, no. 417

Although the café is considered one of Degas' most familiar urban subjects, this is largely because of two works, *Absinthe* (fig. 40) and *Women before a Café in the Evening* (fig. 46), both of which appeared in early impressionist exhibitions and became famous thereafter. Almost all his other café pictures are actually of the *café-concert,* and they focus on the performers rather than the spectators (e.g., cat. 25). The only exception is the one exhibited here—a charming but very small exception, measuring less than five by seven inches. Like many of the other images of such subjects, it is drawn in pastel over a monotype print, the somber yet spontaneous and intimate medium Degas preferred for recording his most boldly unconventional visions of modern life: nude women in poses of unself-conscious abandon, scenes of popular entertainment in restaurants and at *cafés-concerts,* brothel scenes of extraordinarily frank eroticism, and, both here and in the *Women before a Café,* gaudily dressed prostitutes waiting for clients in a café.

The latter was a familiar enough theme at the time, for despite numerous police regulations and supreme court rulings in the 1860s and 1870s strictly prohibiting prostitutes from loitering in or even entering cafés (Pierrot, 10-11), their presence became increasingly conspicuous. A contemporary guidebook warned Anglo-Saxon tourists that "you cannot go into any public place in Paris without meeting one or more women that you will recognize at a glance as belonging to the class known in French society

46. Edgar Degas. *Women before a Café in the Evening,* pastel over monotype, 1877. Musée d'Orsay (Galerie du Jeu de Paume), Paris.

and fiction as the *Demi-Monde.* You will find them at the theaters, in the concert halls, in the cafés . . ." (Janis, no. 15). In *Women before a Café,* the four figures seated on the terrace to attract passers-by seem coarser, more deeply sunk in their empty boredom, and one makes a vulgar gesture with her thumb, whereas here the little lady seems shrewd and alert as she whiles away the time with a game of solitaire. But the vision in both is cynical and unsympathetic, very different from Manet's vision of a virtually identical subject in the *Plum* (cat. 18), painted in the same year.

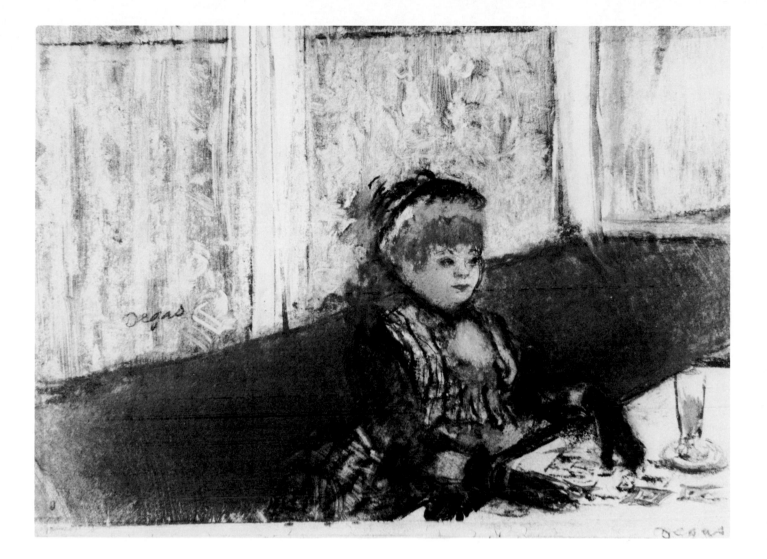

Edgar Degas (1834-1917)

25 *The Café-Concert,* c. 1877

Pastel over monotype, 9½ x 17½ in. (24.2 x 44.5 cm.)
Signed, lower left: *Degas*
Corcoran Gallery of Art, Washington, William A. Clark Collection
Lemoisne, no. 404

If the ordinary café is a relatively rare subject in Degas' oeuvre, the *café-concert* is one of the most familiar. Attracted by the picturesqueness of the gas lamps glowing among the trees at night and the footlights distorting the singers' features, but also by the vivacity of their movements and gestures and the colorfulness of their popular audience, he returned to it frequently in the 1870s. Perhaps because of its nocturnal setting, almost all his images of the *café-concert* are in black and white or began as such: etchings, lithographs, monotypes, and, like the one exhibited here, monotypes reworked in pastel. So extensive was the reworking in this case that the monotype base is visible only at the upper left, and its original format, known from the unretouched cognate (Janis, no. 25), is concealed beneath the chalk strokes applied in order to extend the image above the platemark at the top.

Pastel over monotype is also the medium of the well-known *café-concert* picture at Lyon (fig. 38), which was shown with this one at the impressionist exhibition of 1877 and almost at once established the vogue of this subject among advanced artists; Manet's treatments of it (R-W 1: 309, 310), for example, date from the following year. He may also have drawn on an older iconographic tradition, that of the illustrated book and newspaper, where the *café-concert* had been a familiar subject since its establishment about 1840 (Isaacson 1982, 105). Degas too seems to have found inspiration in that tradition, especially in Daumier's lithographs of the 1850s (e.g., fig. 47); his lower-class audience and musicians display a coarseness reminiscent of the beer-drinking workers in Daumier's print, just as his bold division of the surface into two zones, with a sharply silhouetted hat linking the two, is similar in design (Reff 1976a, 79).

Both of Degas' pastels show the popular *café-concert* "Les Ambassadeurs" on the Champs-Elysées, a classical revival structure built in 1841, whose fluted proscenium columns are visible in the background (Shapiro, 154);

and both show the traditional stage arrangement, with the singer surrounded by half a dozen seated women holding fans or bouquets—the latter a signal of their acceptance of the men who have offered them. In the pastel exhibited here, the orchestra leader who follows the singer closely has been identified as Charles Malo, a popular conductor at *cafés-concerts*, and the singer who leans toward him is probably Victorine Demay, a performer noted for her robustness and cordiality who also figures in several of Degas' monotypes from about 1880 (Shapiro, 154-155, 160-161).

47. Honoré Daumier. *At the Champs-Elysées,* lithograph, 1852. Bibliothèque Nationale, Paris.

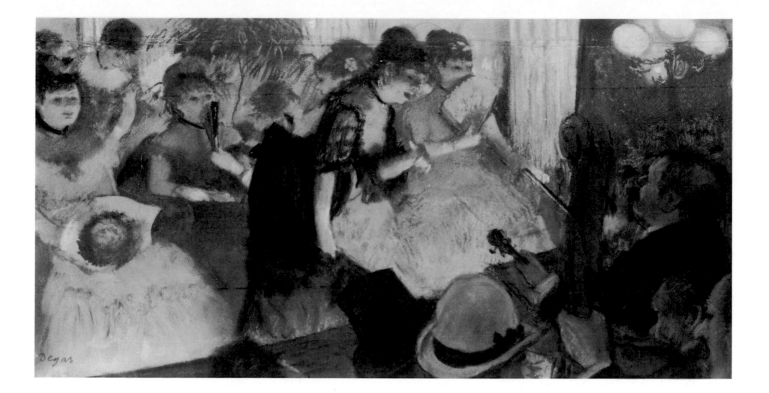

Henri de Toulouse-Lautrec (1864-1901)

26 *At the Bastille, Jeanne Wenz,* 1887

Oil on canvas, 28⅜ x 19⅜ in. (72 x 49 cm.)
Signed, upper right: *H. T. Lautrec*
Mr. and Mrs. Paul Mellon, Upperville, Virginia
Dortu, no. P307

This is one of five pictures of young working-class women that originally hung in a cabaret owned by the *poète-chansonnier* Aristide Bruant, which was for many years Lautrec's favorite haunt. Located on the boulevard Rochechouart at the foot of Montmartre, Le Mirliton was only a few blocks away geographically but miles away socially from the Café de la Nouvelle-Athènes, where the impressionists and other middle-class artists and writers gathered. Bruant, who had spent an impoverished youth in the lowest dives and cheapest eating-houses of the outer boulevards, was the first of the Montmartre *chansonniers* to make the poor, the homeless, and the downtrodden and their peculiar, colorful slang the raw material of his art; and although he and the aristocratic Lautrec were poles apart in their backgrounds, they shared a fascination with the poignancy and vivid realism of such material.

The five pictures that hung in Bruant's café have the titles of some of his most popular ballads: *A Saint-Lazare, A Montrouge, A Batignolles, A Grenelle* (Dortu, nos. P 275, 305, 306, 308), and the one exhibited here, most of them alluding to working-class districts of Paris. Although all but the first are traditionally dated 1888, they are not exactly contemporary; recent research has established that *A Grenelle* dates from 1886 and *At the Bastille* from 1887 (Murray, 412-414). And except for *A Saint-Lazare,* they do not really illustrate the ballads; for if the dreary atmosphere of Lautrec's pictures recalls that of Bruant's bittersweet tales, they have none of their desperate irony and melodramatic contrasts (Mack, 97-100). The subject of *At the Bastille,* Jeanne Wenz, the sister of a friend and fellow artist, seems more gentle and refined than Nini Peau-de-Chien, the splendid and corrupt temptress of Bruant's song; indeed, more like the

48. Henri de Toulouse-Lautrec. *Woman with a Pink Bow—Jeanne Wenz,* oil on canvas, 1886. The Art Institute of Chicago, Mr. and Mrs. Lewis Larned Coburn Memorial Collection.

genteel lady in Lautrec's portrait of her, painted the year before (fig. 48). For all his fascination with the lurid, marginal world Bruant evoked, Lautrec was as an artist closer at this time to the milder, more lyrical world of impressionism, that of Renoir's young girls reading and of Manet's young women sitting in cafés (e.g., cat. 22); and both the softly brushed execution and the muted mixtures of complementary colors in *At the Bastille* testify to this impressionist tendency.

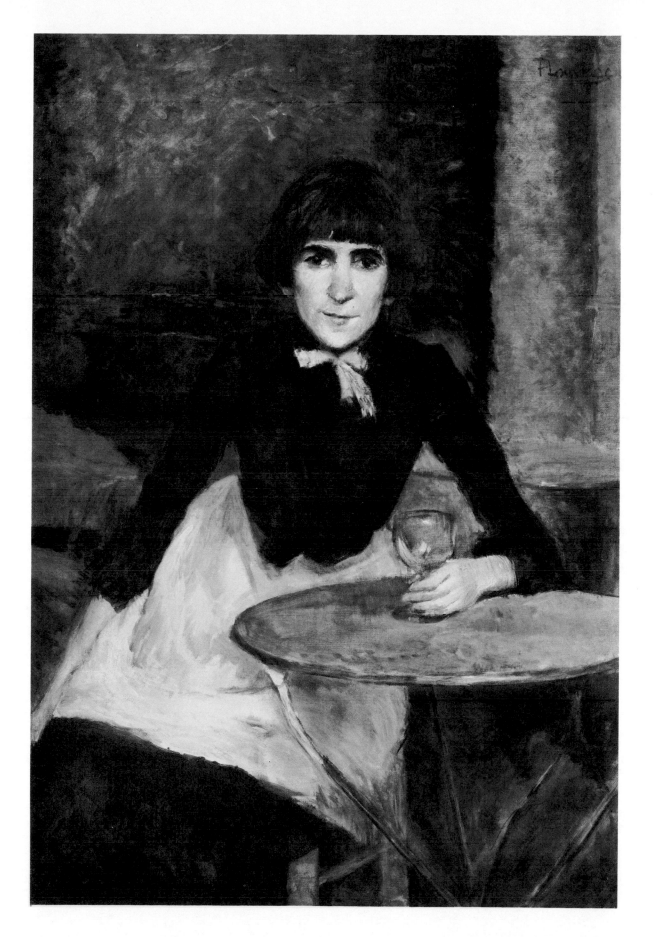

Plate 9.
Edouard Manet.
The Tragic Actor,
1865-1866.
Cat. 27.

4

The Theater and the Opera

❦

THE PERIOD OF Manet's maturity, roughly from 1850 to 1880, was one of the golden ages of the Parisian stage. Not so much in the creation of new operas and plays—Gounod and Offenbach, Dumas *fils* and Halévy were the popular successes; Wagner, Flaubert, and Zola the spectacular failures—as in the number and variety of the theaters then active, the extravagance of their productions, and the brilliance of their performers. From the rhetorical grandeur of Rachel and Mounet-Sully at the Comédie Française to the mute pathos of Deburau's successors at the Funambules, from the ostentation of Garnier's new Opera to the naturalism of Antoine's Théâtre Libre, theaters provided the principal means of entertainment for almost all classes of society except the lowest. They could even attend the same theater; for like the typical apartment house of the time, it was articulated vertically by class, from orchestra seats to remote galleries. How important a place the theater held in that society is evident in the fiction it inspired: hardly a modern novel set in Paris, from *Père Goriot* in 1834 to *Bel-Ami* in 1885, fails to include a scene in which the theater itself is the setting. In Balzac's novel, it is the fashionable Théâtre des Italiens to which Rastignac takes an aristocratic lady; in Maupassant's, it is the Folies-Bergère, a gaudy music hall, in which Duroy makes the acquaintance of a prostitute. Characteristically, Manet chose to paint both places: the Italiens, by then in decline, in a relatively minor work (R-W 2:17), a pastel sketch his student Eva Gonzalès developed further in her *Box at the Italiens* of 1879; the Folies-Bergère, then in its heyday, in one of his greatest works, the *Bar at the Folies-Bergère* of 1882 (fig. 49).

If Maupassant's description of the Folies and its "made-up, slightly soiled" barmaids, enthroned before "tall mirrors [that] reflected their backs and the faces of the passers-by" (Maupassant, 19-20), postdates Manet's and may even depend on it, Huysmans' in "Les Folies-Bergère en 1879" predates it and, though it does not mention the bar, recreates brilliantly the vulgar atmosphere of the place and the kind of entertainment it offered, including a virtuoso trapeze act that explains the tiny legs at the upper left in Manet's picture (Huysmans 1880, 14-18). And Forain's gouache of 1878 (fig. 50), inscribed to Sari, the enterprising director of the Folies, likewise shows the bar with its bottles and compote of fruit and the barmaid reflected in a mirror, along with the theater and its balconies and spectators. In addition to these examples in high art, there were many in the lower art of journalistic illustration that may also have influenced Manet; for as the Folies itself became more popular in the late 1870s, the draftsmen of the illustrated weeklies who chronicled Parisian social life turned to it more frequently; one such drawing, published in the *Journal amusant* in 1878, shows a barmaid and her customer in much the same relationship as in Manet's painting (Isaacson 1982, 110). But as his picture makes clear, he too frequented the place; one of those who accompanied him has in fact left a very brief but amusing account of an evening they spent there with the journalist and *boulevardier* Aurélien Scholl (Jollivet, 254).

It was perhaps not by coincidence that Manet painted both the Théâtre des Italiens and the Folies-Bergère; for throughout the 1870s he found his subjects at the social poles of the world of Parisian entertainment: in the elegant Eva Gonzalès in her box at the Opera and the ragamuffins in their gallery or "paradise" (H 86); in a fancy-dress ball at the Opera (cat. 39) and a *café-concert* at the Brasserie de Reichshoffen (cat. 21). In the previous decade, he had been drawn more often to the popular and even the impromptu performance: a troupe of Spanish dancers and musicians at the Hippodrome (cat. 32), a bear-trainer and acrobats at another circus (R-W 2:562, 563), and a children's puppet theater in the Tuileries Gardens (cat. 98), which in turn provided the

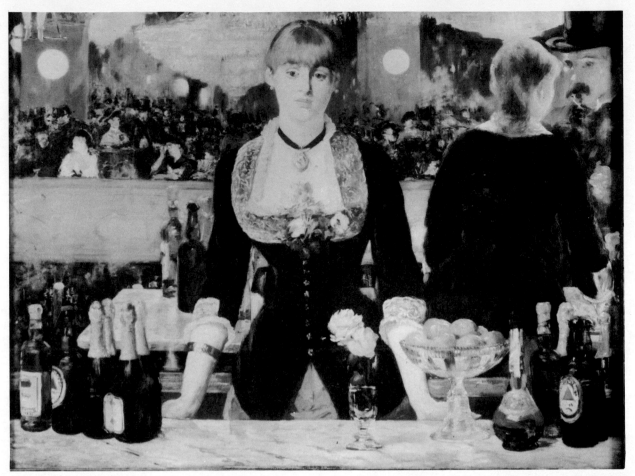

49. Edouard Manet. *The Bar at the Folies-Bergère*, oil on canvas, 1882. Courtesy Home House Trustees, Courtauld Institute Galleries, London.

theatrical metaphor he employed in a frontispiece intended for an album of his etchings (H 38). And since the frontispiece also shows a basket of Spanish clothing he had used in such stagelike costume pieces as the *Young Man in the Costume of a Toreador* and *Victorine Meurent in the Costume of an Espada* (R-W 1: 56, 58), it reveals still another aspect of Manet's fascination with popular entertainment, even if, as in this case, it is one he had only imagined.

At least once in each decade, however, Manet also represented a more conventional theatrical subject in portraying the actor Rouvière and the singer Faure in their roles as Hamlet (cat. 27, 28). Although essentially costume pieces in the tradition of eighteenth-century portraits of actors in familiar roles, these imposing pictures show how strongly Manet could be affected by the famous soliloquy and by the ghost scene in Shakespeare's tragedy, despite his realist aesthetic; whereas Daumier,

precisely because of his, could only find the drama slightly ridiculous, as he did in satirizing the highly emotional scene in which Hamlet forces the queen to acknowledge her guilt (fig. 51); like the other well-known plays that he illustrates in the series "Physionomies tragiques" (1851), *Hamlet* has little meaning for the second-rate actors he shows struggling to perform their histrionic roles. Yet Daumier could also find the theater as such fascinating in ways that Manet could not, commenting shrewdly or sympathetically on the deep engagement of the audience with the unfolding drama and on the poignant contrast between the illusion created on stage and the mundane reality backstage.

And borrowing from Daumier, Degas could do the same in countless paintings and pastels built on the tension between the public and private aspects of the theater and on the human interest of those scenes that take place behind the scenes, in the wings and rehearsal

51. Honoré Daumier. *Hamlet*, lithograph, 1851. National Gallery of Art, Washington, Rosenwald Collection 1958.

50. Jean-Louis Forain. *Café Scene*, gouache, 1878. The Brooklyn Museum, New York, Gift of a Friend.

rooms of the Opera (cat. 36, 37). Again the contrast with Manet reveals how selective and personal his own vision of the theater was; for when he painted the Opera, it was to show a costume ball in which the fashionable people in his circle were gathered in the foyer for sophisticated banter and flirtation (cat. 39). Both are familiar aspects of the contemporary theater, and both belong to traditions of realist iconography that extend back, in Degas' case, to Daumier's prints of backstage scenes and, in Manet's, to Gavarni's carnival lithographs, and that continue into their own day in journalistic and popular book illustrations. But the two artists differ decisively in their notions, both personal and social, of what a realist view of the theater should look like in the first place.

Edouard Manet

27 *The Tragic Actor,* 1865-1866

Oil on canvas, 73¾ x 42½ in. (187.2 x 108.1 cm.)

Signed, lower right: *Manet*

National Gallery of Art, Washington, Gift of Edith Stuyvesant Gerry 1959

R-W 1:106

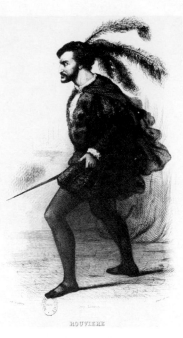

52. Charles Geffroy. *Rouvière*, engraving from *L'Artiste*, ser. 7, vol. 8 (1859), opp. 158. Bibliothèque Nationale, Paris.

The actor Philibert Rouvière is shown here in his most famous role, that of Hamlet in Paul Meurice and Alexandre Dumas' adaptation of the play, a role Rouvière had created at the Théâtre de Saint-Germain in 1846 and continued to perform occasionally at the Théâtre du Cirque as late as 1863. His highly charged interpretation, a product of his Provençal temperament and romantic training, modeled on Delacroix's illustrations of the play (e.g., cat. 29), had won him the admiration of Champfleury, Gautier, and Baudelaire, but little popular acclaim. Despite their support, Rouvière's career was one of insecurity, hardship, and illness; and by January 1865, when his health was already gravely impaired, it came abruptly to an end. To help and encourage him, his friends wrote articles about him, organized a benefit performance, and held a sale of his paintings—for he was also an artist, trained by Gros and strongly influenced by Delacroix—among which were several on subjects taken from *Hamlet,* including a self-portrait in that role, first shown at the Salon of 1864, that may have influenced Manet's work.

It has in fact been argued that Manet's decision to paint Rouvière's portrait was motivated by a similar desire to help the destitute and discouraged actor, perhaps at the suggestion of Baudelaire (Solkin, 707-708). But if it provides a motive and an intellectual context for Manet's decision, this argument rests on the doubtful assumption that the portrait, which was still unfinished at the time of Rouvière's death in October 1865, had been begun eight or nine months earlier, put aside, and taken up again after Manet returned from Spain in September. Doubtful because Manet, unlike, say, Cézanne and Degas, did not normally work that way; because the portrait is clearly based, in conception as well as style, on one by Velázquez that he had seen in Madrid (cat. 31); and because the only historian who claims to know it was begun much earlier (Tabarant 1947, 103, 127) cites no supporting evidence and contradicts his previous state-

ment that it was begun "a few months" before the actor's death (Tabarant 1931, 144). And if "Gautier's description of Rouvière [in February 1865] as a martyr to the indifference of the masses must surely have appealed to Manet at a time when he, too, felt himself persecuted by a hostile public" (Solkin, 708), that time was surely in May or June 1865, when his *Olympia* was the object of unprecedented public and critical scorn.

It is, in any event, unnecessary to interpret Manet's portrait of him so exclusively in terms of Rouvière's condition at the moment, for if he was already seriously ill in January, and no doubt still more so in September, this is not evident in the portrait, where he appears energetic and intensely alert. Not, to be sure, as determined to act as in the only other important image of him as Hamlet, Geoffroy's engraving of 1855 (fig. 52); but that is not so much because he has been "left helpless and defeated by life" (Solkin, 709) as because he is shown in a different aspect of his highly ambivalent role. In Geoffroy's portrait, he is the forceful avenger of his father's death, striding forward sword in hand; in Manet's, he is the brooding melancholic incapable of action, his head exposed, his sword on the floor, his hands crossed in self-abnegation, one finger pointing down ominously. Enveloped in a darkness only slightly warmer and lighter than the jet black of his costume, he is the speaker of the famous soliloquy, who cannot decide whether "to suffer / The slings and arrows of outrageous fortune, / Or to take arms against a sea of troubles" (*Hamlet* III. i), a soliloquy

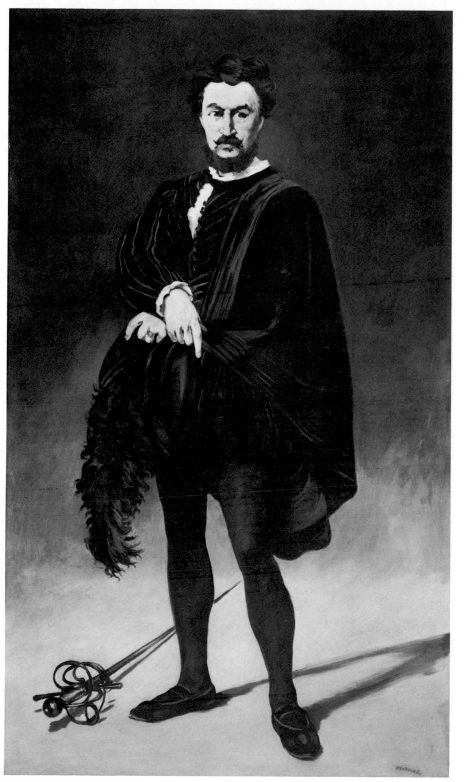

Color plate 9

that Gautier notes was one of Rouvière's rare popular successes. And as the tragic hero surrounded by the shadowy aura of death, Rouvière has a significance for Manet larger than as an expression of the misfortunes either of them experienced in 1865: he is the very embodiment of that obsession with death which pervades Manet's work and, precisely in 1864-1865, manifests itself in such stark and somber images as the dead toreador, the dead Christ with angels, and the monk praying beside a skull (Mauner, 109-148).

Edouard Manet

28 *Portrait of Faure as Hamlet,* 1877

Oil on canvas, 77³⁄₁₆ x 51³⁄₁₆ in. (196 x 130 cm.)
Signed, lower left, in another hand: *Manet*
Hamburger Kunsthalle, Hamburg
R-W 1:256

🐦 The tragic figure of Hamlet, first seen in Manet's
work in a portrait of the actor Rouvière (cat. 27), appears
again twelve years later in this portrait of the singer
Faure and in the more finished work for which it is a
full-size sketch (fig. 53). In both cases, Hamlet is con-
ceived as an awesome presence, all in black and alone on
an empty stage, and in both he is shown life-size, in a
picture clearly intended for the Salon (one was rejected
in 1866, the other accepted but severely criticized in
1877). Both figures, moreover, are based on Velázquez'
Pablillos de Valladolid (fig. 57), which Manet had
admired in the Prado shortly before painting Rouvière
and must have studied again, in a reproduction or his
own copy, before painting Faure, since the latter's stance
and gesture are almost exactly like Pablillos', though
reversed. In all these respects, the later work is a curious
reprise of the earlier one and an anomaly among the
small, animated scenes of café and street life that Manet
was painting in the late 1870s. It was perhaps only in an
overtly theatrical subject such as this one that he could
renew his earlier interests and ambitions.

Jean-Baptiste Faure, the celebrated baritone who was
a friend and an important collector of Manet's work, had
just retired from the Paris Opera when he commissioned
this portrait in 1876. The role he chose was the one he
had also chosen for the farewell performance the picture
was meant to commemorate, the title role in Ambroise
Thomas' opera *Hamlet,* in which he had performed at the
premiere eight years earlier and had subsequently
achieved his greatest fame (Callen, 164). The moment
chosen—whether by Faure or by Manet is not clear—
was that in the first act in which Hamlet meets his
father's ghost on the battlements, a somberly atmospher-
ic scene that even those who were critical of the libretto
and the music agreed was an effective vehicle for Faure's
theatrical and musical talents. After several attempts to
visualize the dramatic encounter, of which there survives
only a pastel sketch on canvas (fig. 54), perhaps inspired
by contemporary illustrations of the opera's production
(Mauner, 146), or by Delacroix's illustration of the cor-

53. Edouard Manet.
*Portrait of Faure as
Hamlet,* oil on canvas,
1877. Museum Folkwang,
Essen.

55. Paul Renouard.
*Faure in Ambroise
Thomas' "Hamlet,"* wood
engraving from *L'Art* 3,
no. 2 (April 1877), 53.
General Research Divi-
sion, The New York Pub-
lic Library, Astor, Lenox,
and Tilden Foundations.

54. Edouard Manet.
*Hamlet and His
Father's Ghost,* pastel,
c. 1877. Burton Agnes
Hall, East Yorkshire,
Marcus Wickham
Boynton Collection.

responding scene in the play (Delteil, no. 105), Manet
decided to concentrate its meaning in the guarded atti-
tude and frightened expression of Hamlet himself. In the
oil sketch exhibited here, he employs the bright coloring
and loose, sketchy stroke of his recent impressionist
works and suggests a stagelike space filled with flickering
points of light. In the more labored painting shown at the

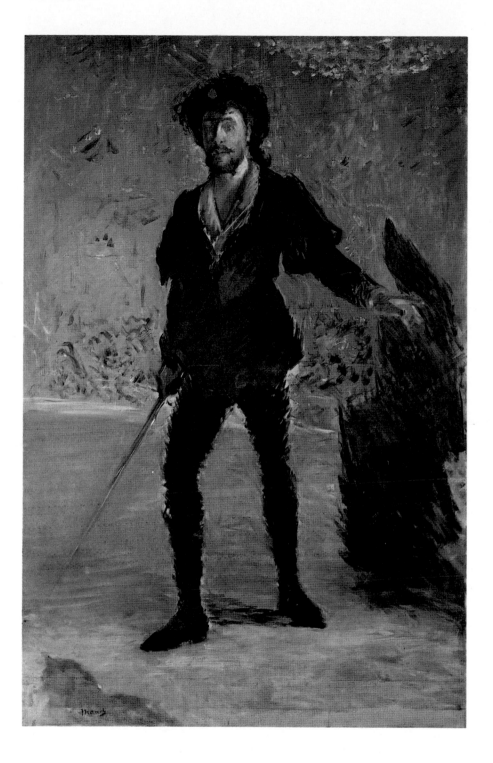

Salon, he reverts to the nearly monochromatic harmony and smoother execution of his earlier works and isolates the sharply silhouetted figure as a deep gray-blue form against a lighter gray void no longer suggestive of a stage.

In addition to the Velázquez discussed previously, a drawing by Paul Renouard showing Faure in the same role and in almost exactly the same pose as in Manet's portrait (fig. 55) may have helped him determine the gesture and stance. Although apparently first published in April 1877, when the portrait was already finished, the drawing may well have been made, and been available to Manet, earlier; or it may have been made from a photograph, which would of course also have been available to him (Hofmann 1973b, 175-179).

Eugène Delacroix (1798-1863)

29 *Hamlet and Horatio before the Gravediggers,* 1843

Lithograph, 11³⁄₁₆ x 8⅜ in. (28.4 x 21.2 cm.)
Signed and dated in the stone, lower left: *Eug.
 Delacroix / 1843.*
National Gallery of Art, Washington, Rosenwald
 Collection 1980
Delteil, no. 116 (1864 restrike)

Of all the authors from whom Delacroix, an artist steeped in world literature, drew inspiration, none was more important to him than Shakespeare; and of all the latter's plays that he read, saw performed, and illustrated, none inspired him as often or stirred him as deeply as *Hamlet*. From his earliest Shakespearean painting, in 1825, of the ghost scene in Act I to his last, in 1859, of the graveyard scene in Act V, the haunted, brooding figure of Hamlet kindled his imagination. The scene in the graveyard in which Hamlet and Horatio contemplate the skull of Yorick was in fact Delacroix's favorite: in addition to the painting just cited (Robaut 1885, no. 1388), it is the subject of three other paintings (Robaut 1885, nos. 576, 694, 711) and two lithographs (Delteil, nos. 75, 116), the second of which is exhibited here. It is one of a suite of sixteen prints drawn between 1834 and 1843, of which thirteen, including this one, were published in the latter year. Among the last to be executed, it reveals the shift "from relative constraint toward expressive freedom," employing "larger forms, more freely and boldly executed," that characterizes the suite as a whole (Trapp, 171).

It is not surprising, then, that Delacroix's prints, which were widely admired at the time, should have served the actor Rouvière as models for the conception and staging, as well as the costume and make-up, in his performances of Hamlet later in the 1840s. His appearance in Geoffroy's engraving of 1855 (fig. 52), for example, resembles in almost every respect that of the tragic hero whom Delacroix had envisaged, as several writers pointed out at the time. "In the exactitude of the costumes, in certain poses, in everything external, one recognized a man nourished by that intense melancholy which has been drawn on stone by the great master,"

Champfleury observed. "He draws Hamlet with his body as Delacroix does with his lithographic crayon," said Gautier more succinctly (Solkin, 706, 708). Given their friendship and mutual esteem—Delacroix greatly admired Rouvière's performances, and the actor, himself a painter at times, was also influenced by the artist in that medium (Solkin, 705, 707)—such a resemblance was perhaps inevitable. And inevitably, too, it affected Manet's conception of his portrait of Rouvière; for "in view of these numerous associations, it does not seem possible that Manet could have failed to realize that the act of painting Rouvière as Hamlet provided a unique opportunity to offer a 'hommage à Delacroix'" (Solkin, 708). An homage similar in inspiration, though very different in form, from the one Fantin-Latour had painted the year before, in which Manet, an equally ardent admirer of Delacroix, played an important role.

Edouard Manet

30 *The Tragic Actor,* 1866

Etching, 14½ x 8¾ in. (36.8 x 22.2 cm.)
Signed in the plate, lower right: *Manet*
National Gallery of Art, Washington, Gift of
 Mrs. Jane C. Carey, 1951, in memory of her
 mother, Mrs. Addie Burr Clark
H 48, second state

If Manet's painting of the actor Rouvière as Hamlet (cat. 27) was largely completed before his death in October 1865, the etching based on it was obviously made afterward, perhaps as a memorial to the deceased. In that case, the large areas of dark gray and black introduced in the second state, the one exhibited here, may be justified in psychological terms. The diagonal division of dark and light in the background, unlike the horizontal division in the painting, which can still suggest a stage, creates a more abstract, mysterious void appropriate for such a memorial content. In purely visual terms, however, the extensive reworking of the brilliantly executed first state (fig. 56) that was required to produce these darker tones seems less justifiable, even regrettable. Rouvière's glance, already lacking in the first state some of the dramatic intensity evident in the painting, becomes still darker and duller in the second state. His costume becomes an almost completely black mass, without the interesting pattern of folds and shadows it had earlier. And the space behind him becomes a uniformly dark plane, closer in tone, it is true, to that in the painting, but lacking its effectiveness as a foil for the head because that too has been toned down through excessive reworking. In the first state, the delicately graded strokes in the background suggest light and air, very much like those in Goya's etched copies after Velázquez' portraits (Solkin, 705, n. 7). In the second state, they suggest simply a dark backdrop of a rather unpleasant, woolly texture. Manet himself may have been dissatisfied with this version, for he never published it; all the known editions are posthumous.

56. Edouard Manet. *The Tragic Actor,* etching, first state, 1866. S. P. Avery Collection, Art, Prints and Photographs Division, The New York Public Library, Astor, Lenox, and Tilden Foundations.

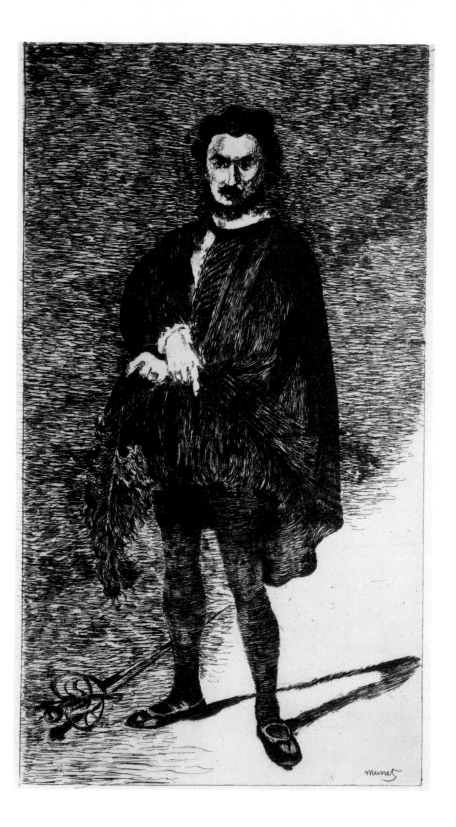

Edouard Manet

32 *The Spanish Ballet*, 1862

Oil on canvas, 24 x 35⅝ in. (61 x 90.5 cm.)
Signed and dated, lower right: *Ed. Manet. 62*
The Phillips Collection, Washington
R-W 1:55

An aficionado of Spanish culture who had achieved his first artistic success with a *Spanish Singer* at the Salon of 1861, Manet was naturally enthusiastic when, "early in the following year, a first-rate company of Spanish dancers appeared in Paris. Headed by the veteran 'master of the bolero,' Mariano Camprubi, they made their first appearance at the Théâtre de l'Odéon on April 27, 1862, in a ballet called *La Flor di Sevilla,* which had been interpolated in the first act of a play, *The Barber of Seville.* The featured dancers were Anita Montez, Lola Melea (later known as Lola de Valence, after Valencia, the province where she was born), and a gentleman whose name appears variously as Alimany, Alemany, and Almancy. Camprubi was both *primer bailarin* and choreographer. . . . After a few days they went off on a tour, but in mid-August of the same year they returned for an engagement at the Hippodrome, a glorified circus where they shared the bill with acrobats and equestrians" until early November (Moore, 24-25). Manet, like his friends and fellow enthusiasts Gautier and Baudelaire, attended their performances frequently and eventually persuaded some of the dancers and musicians to pose for him.

His picture, painted in the studio of Alfred Stevens, since his own was too small for so many figures, shows them as they must actually have appeared in *La Flor di Sevilla:* Lola de Valence is seated at the left, waiting her turn; Alimany stands beside her, accompanying with his castanets; and Anita Montez and Camprubi are in the center, dancing the bolero. By portraying them as if on stage, with an admirer's bouquet at their feet and a "spotlight" illuminating the dancers, while leaving the musicians and onlookers half in shadow, Manet succeeds in making his picture both contemporary and exotic. Its subject is at once a performance at the Hippodrome, as familiar an aspect of modern Paris as the concert in the Tuileries that he painted in the same year (fig. 3), and a performance of the bolero, as traditional an aspect of Spanish culture as the singer with a guitar whom he had painted the year before (R-W 1:32).

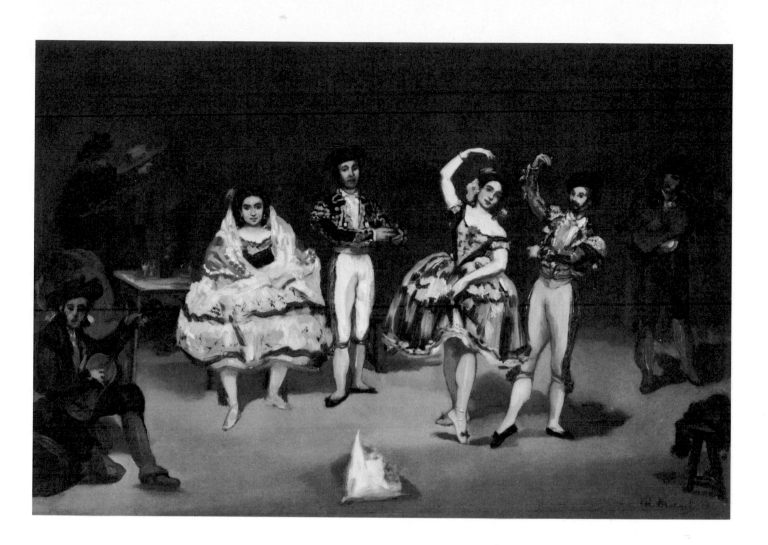

Edouard Manet

33 *Don Mariano Camprubi,* 1862

Oil on canvas, 18½ x 13 in. (47 x 33 cm.)
Signed and dated, lower right: *Ed. Manet 62*
Private collection
R-W 1:54

58. Marie-Alexandre Alophe. *Camprubi and Dolores Serral Dancing the Bolero*, lithograph from *L'Artiste*, ser. 1, vol. 7 (1834), after 60. General Research Division, The New York Public Library, Astor, Lenox, and Tilden Foundations.

Mariano Camprubi was the choreographer and leading male dancer in the troupe of Spanish singers and dancers that performed at the Hippodrome in Paris in the summer and fall of 1862 (cf. cat. 32). Older than the other members of the troupe, he was "first dancer" at the Royal Theater in Madrid, and had already performed in Paris as early as 1834: a lithograph of that year (fig. 58) shows him dancing the bolero with Dolores Serral at a ball at the Opera. His experience and authority are evident in the assertive stance he assumes in Manet's portrait: one hand is on his hip with "a cape thrown over the arm, and one shoulder is lifted with unconscious arrogance. He is not handsome, but his thin face with its high cheekbones and splendid black moustaches is full of insolence and fire" (Moore, 25). If this stance expresses a particular personality, it also reflects a more general image of the performer, as seen for example in ballet posters and prints of famous dancers standing with their feet turned out in the same way. That Manet was familiar with these images is suggested by the inscription below his etched copy of the painting (H 34): "don Mariano Camprubi, primer bailarin del teatro royal de Madrid," it reads, exactly in the manner of such prints and in imperfect Spanish, as if copied from one of them (Wilson, no. 35). In its vigorous execution and above all its brilliant coloring, however, this picture has no equivalent among such prints: the vividness with which the black and white, the fiery red and icy blue of the figure stand out against the yellowish brown and dark reddish brown of the background is equaled only in the intensely Spanish paintings of Goya.

In older print catalogues, the etching of Camprubi is sometimes entitled *The Comic Actor,* in contrast to that of Rouvière as *The Tragic Actor* (cat. 27; cf. Wilson, no. 35).

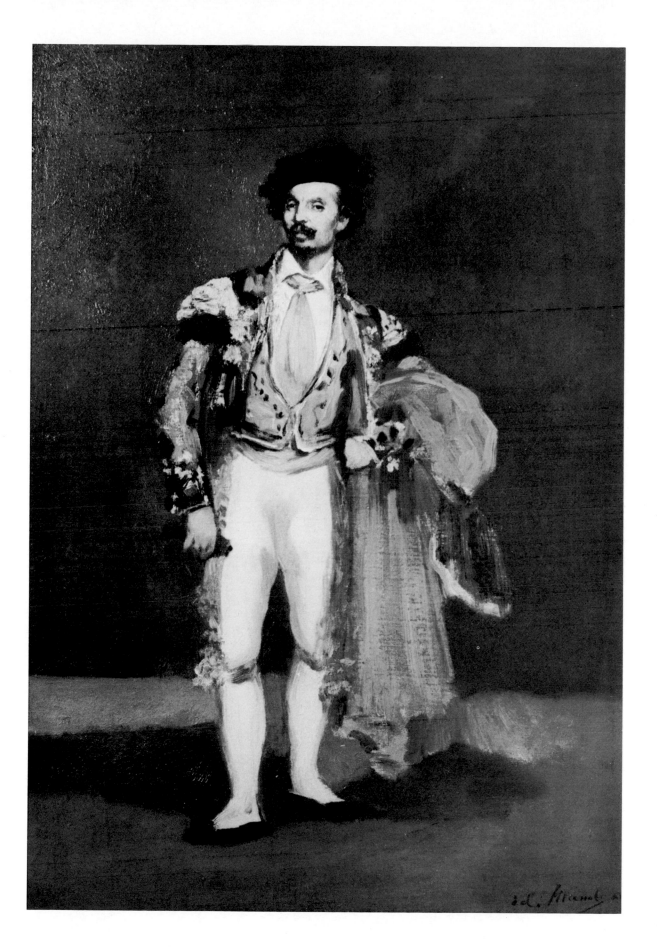

Edouard Manet

34 *Lola de Valence*, 1862

Etching and aquatint, 10⁵⁄₁₆ x 7³⁄₁₆ in. (26.2 x 18.3 cm.)
Signed in the plate, lower left: *éd. Manet*
National Gallery of Art, Washington, Rosenwald Collection 1943
H 33, third state

Lola de Valence (in reality Lola Melea) was the leading female dancer in the troupe of Spanish singers and dancers that performed at the Hippodrome in Paris in the summer and fall of 1862 (cf. cat. 32). Captivated by her dark beauty, Manet portrayed her repeatedly, once with other members of the troupe and several times alone, standing backstage or in a stagelike space in the familiar fourth position of the ballet. In addition to the painting of 1862 (fig. 59), there are four works based on it: this etching, developed in three states and published in October 1863; two drawings made in translating the painting into the print (R-W 2:369, 370); and a lithograph published as a cover for a popular song in March 1863 (H 32; cf. Wilson, no. 73). In reproducing the large painting on a smaller scale, Manet not only simplified the background, supposedly recalling its appearance in an earlier state, when the stage flats and view of the audience, inspired by contemporary theater prints, had not yet been introduced (Isaacson 1982, 114, n. 77); he also made more subtle alterations. Lola stands slightly more erect and turns slightly more toward the viewer in the print; yet the greater directness that might result is canceled by her more reticent expression, which seems pensive rather than provocative. Much of the fascination Lola exerts in the painting clearly derives, like Olympia's in the same year (fig. 7), from the boldness of her stare—one rarely seen in the theatrical posters and souvenir prints of performers on which Manet's image may ultimately depend (Hanson 1977, 79), and made all the more challenging by the slight sneer of her dark eyes and full lips.

In the print as well as the painting, this hint of eroticism is confirmed by the verses Baudelaire composed in

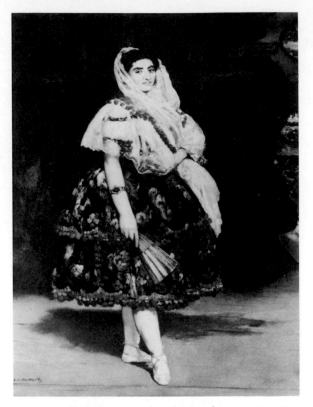

59. Edouard Manet. *Lola de Valence*, oil on canvas, 1862. Musée d'Orsay (Galerie du Jeu de Paume), Paris.

Lola's honor and urged Manet to attach to the one and inscribe beneath the other:

> Entre tant de beautés que partout on peut voir,
> Je comprends bien, amis, que le Désir balance;
> Mais on voit scintiller dans Lola de Valence
> Le charme inattendu d'un bijou rose et noir.
>
> (Baudelaire 1861, supp., 203)

Not only did the last verse suggest "an obscene meaning" to some contemporaries, as Baudelaire himself later admitted (Wilson, no. 34)—and with good reason, since contemporary slang defined a "bijou" in explicitly sexual terms (Delvau 1864, 59-60)—but also his rather lame denial of such a meaning and the changes he later made in reprinting these lines—"désir" for "Désir" in the second verse, "scintiller en Lola" for "scintiller dans Lola" in the fourth—pointed clearly enough to his, and no doubt to Manet's, initial intention.

Entre tant de beautés que partout on peut voir
Je comprends bien, amis, que le Désir balance;
Mais on voit scintiller dans Lola de Valence
Le charme inattendu d'un bijou rose et noir. (Ch. Baudelaire)

Auguste Renoir (1841-1919)

35 *The Dancer*, 1874

Oil on canvas, 56⅛ x 37⅛ in. (142.5 x 94.5 cm.)
Signed and dated, lower right: *A. Renoir. 74*
National Gallery of Art, Washington, Widener
 Collection 1942
Daulte, no. 110

Nearly contemporary with Manet's portrait of Faure (cat. 28) and similar in its use of light tones and sketchy strokes to suggest the space around the figure, Renoir's *Dancer* helps us to realize how much Manet remained outside impressionism even when he came closest to it. His interest in defining forms through their silhouettes—more apparent in the elegant, interlocking shapes of the finished portrait (fig. 53) than in the oil sketch—is altogether different from Renoir's willingness to allow forms to emerge from and recede into the surrounding space. There is a corresponding difference in the two artists' conceptions of their subjects: Manet's costumed performer is wholly absorbed in the dramatic action of an opera based on a Shakespearean tragedy, whereas Renoir's assumes a more formal stance and turns more directly toward the painter, in whose studio she is simply posing, with no thought of a performance or even of a stage. Manet, it is true, could also paint a costumed dancer posing for a portrait, and in a posture so much like Renoir's that his picture, the *Lola de Valence* of 1862 (fig. 59), might be considered a source for Renoir's, where it not that the fourth position pose taken by both dancers is familiar enough in the ballet and already occurs in Courbet's portrait of the Spanish dancer Adela Guerrero in 1851 (Fernier, no. 125). Yet even in giving his figure so formal a stance, Manet characteristically animates it with strong contrasts and sharp accents of color and places it in a specific theatrical milieu, whereas Renoir renders his figure in delicate, pearly tones of pale blue, pink, yellow, and white, relieved only by reddish brown hair and a black choker, and places it in a similarly colored, atmospheric void.

If Renoir's pretty and typically French model lacks the vividness of Manet's Spanish beauty, she is nevertheless a recognizable individual. Although never identified, she is clearly Henriette Henriot, the young actress who often posed for him in 1874-1876, generally as here in an isolated, frontal, standing position and wearing a distinctive costume (Daulte, nos. 102, 109, 123, etc.). In one case she appears in an analogous role, as a circus performer in a short skirt and tights, against a theater curtain.

Edgar Degas (1834-1917)

36 *Dancers at the Old Opera House,*
1873-1874

Pastel, 8⅝ x 6¾ in. (21.8 x 17.1 cm.)
Signed, lower right: *Degas*
National Gallery of Art, Washington, Ailsa
 Mellon Bruce Collection 1970
Lemoisne, no. 432

If the ballet appealed to Degas as the most classical of the theater arts—when asked why he painted it so often, he replied, "Because it is all that is left of the synthesized movements of the Greeks" (Havemeyer, 265)—he nevertheless envisaged it in the most unconventional of pictorial forms. His countless pictures of dance lessons, rehearsals, and performances are remarkable not for their traditional balance or completeness of design, but rather for their audaciously modern obliqueness of viewpoint and cutting of forms. Although in fact carefully contrived, they project a vision in which the accidental and the unstable are highly valued. In the ingeniously composed pastel exhibited here, what would normally appear in the center, the performance or the audience, is compressed around the edges, while the center is a void. This eccentric, lateral view of the stage, in which one looks past the performers and spectators and, guided by the cleverly manipulated perspective, focuses on the blank architecture of the proscenium and boxes, occurs in several of Degas' theater pictures of the 1870s (Lemoisne, nos. 400, 433, 455, etc.), but nowhere in as extreme a form as in this small pastel. As a result, the viewer becomes a performer himself, observing the scene while standing in the wings.

The architectural décor on which so much attention is focused can be identified by means of contemporary images of Parisian theaters, such as those published in the *Paris-Guide* of 1867 (vol. 1, appendix) as aids in seat selection. It is that of the old opera house on the rue Lepeletier, which was destroyed by fire in October 1873, fifteen months before the present one on the place de l'Opéra finally opened. The same proscenium arch, boxes, and balconies appear in the backgrounds of three other pictures, representing a ballet rehearsal on stage,

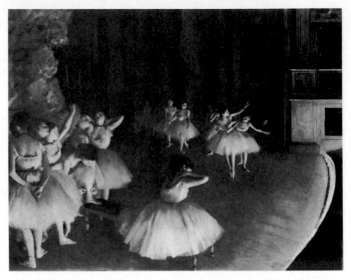

60. Edgar Degas. *Rehearsal of a Ballet on Stage, peinture à l'essence* on canvas, 1874. Musée d'Orsay (Galerie du Jeu de Paume), Paris.

of which one (fig. 60) was exhibited in 1874 and the others can also be dated to around that year (Pickvance 1963, 259-263). In describing them, Degas must have relied for the architectural details on a sketch he had made in a notebook of the early 1870s (Reff 1976b, Nb. 24, pp. 26-27). Thus it is likely that this pastel, which is generally dated c. 1877, but which in its highly refined treatment of the medium seems earlier, was also made in 1873-1874, before or shortly after the old opera house burned.

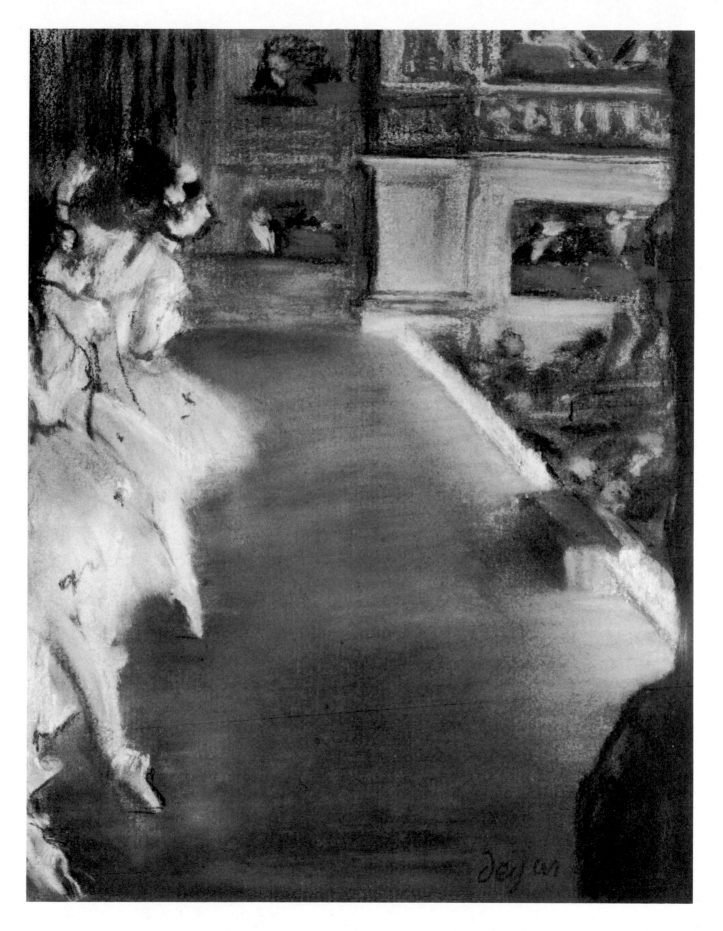

Edgar Degas (1834-1917)

37 *Ballet Dancers,* c. 1877

Pastel and gouache over monotype, 11¾ x 10⅝
 in. (29.7 x 26.9 cm.)
Signed, lower left: *Degas* and lower right: *Degas*
National Gallery of Art, Washington, Ailsa
 Mellon Bruce Collection 1970
Lemoisne, no. 481

For all his disdain of contemporary academic practice, Degas followed it in basing the figures in his dance pictures on drawings made from models in his studio; they provided a repertory of poses that could be used in endless combinations. Even in pictures like the one exhibited here, whose spontaneous handling of pastel and gouache belies the notion of such careful preparation, the principal figures are based on preparatory studies. The dancer at the right who flexes her leg appears with another dancer in a charcoal and pastel drawing (Lemoisne, no. 480) and with several others in the more complex painting *Dancers Resting* (Lemoisne, no. 479). Similarly, the dancer at the left who adjusts her slipper appears alone in a charcoal and pencil drawing (Boggs, no. 71) and with one other in the small painting *Two Dancers Resting* (Lemoisne, no. 343). Although two of these works can be dated 1873-1874, and the other two 1874-1876 (Pickvance 1963, 259), it seems unlikely on stylistic grounds that the one shown here dates from those years; rather, it is an example of Degas' use of figure types created several years earlier.

If the figures in this picture also occur in other ballet scenes, the setting is unique to this one. The curiously agitated forms of the stage flats that loom above and enclose the graceful little dancers, partially obscuring them, are not repeated elsewhere in his work. But the use of such strikingly silhouetted flats both to animate the surface and to define space through parallel planes does recur, and precisely in pictures contemporary with this one. In the *Yellow Dancer* and the *Red Dancers* (Lemoisne, nos. 483, 486), as in these *Ballet Dancers,* the huge painted trees also play a more metaphorical role, projecting the rhythms of the figures' arms and legs on a larger scale, and thus mediating between the human and the inorganic. This imaginative use of the stage scenery culminates about 1880 in a series of fans that Degas decorated with theatrical subjects (e.g., Lemoisne, nos. 564, 567). And there his source of inspiration in Japanese art, especially in folding screens of the Momoyama and Edo periods, with their strongly silhouetted clouds, half abstract and half fantastic, becomes more explicit (Gerstein, 115-116).

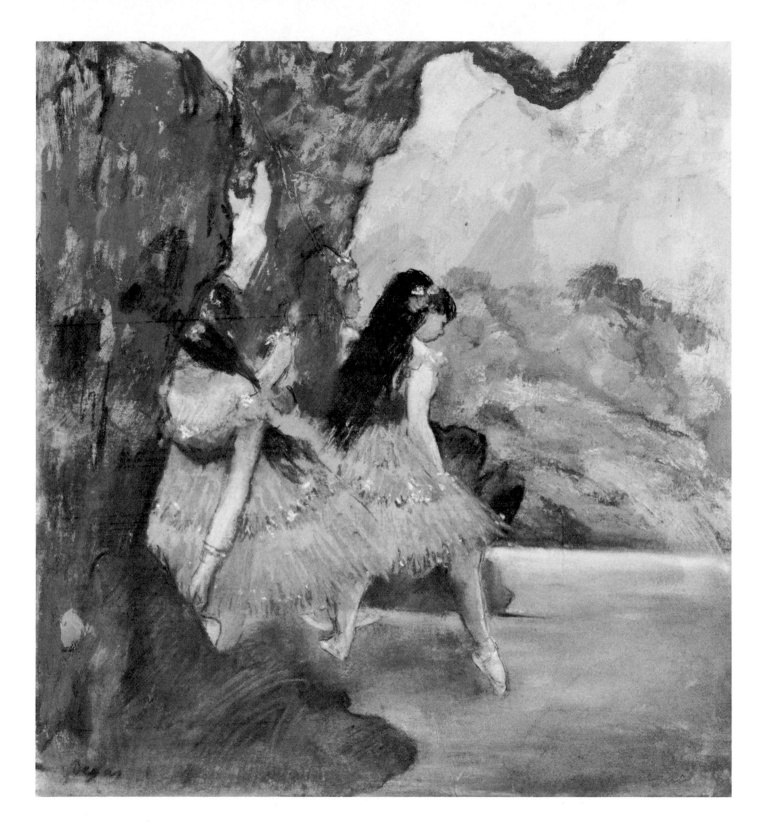

Jean-Louis Forain (1852-1931)

38 *Behind the Scenes,* c. 1880

Oil on canvas, 18¼ x 15⅛ in. (46.4 x 38.4 cm.)
Signed, lower left: *Forain*
National Gallery of Art, Washington, Rosenwald
 Collection 1943

🦢 The theme of the *rat,* or ballet chorus girl, who allows herself to be wooed backstage at the Opera by a wealthy gentleman far older than herself, whom she in turn hopes to win as a protector, has a long history in nineteenth-century art and literature. It is already treated in popular prints and illustrated books of the 1840s (Farwell 1977, nos. 59, 60) and is explored more fully thirty years later in Ludovic Halévy's *La Famille Cardinal,* sophisticated stories about two sisters seeking rich husbands at the Opera, which Degas illustrated in a series of monotypes in 1878-1880 (Janis, nos. 195-231). Given his equally disillusioned view of society, it was inevitable that Forain too would treat this theme; and indeed it is one of his earliest, first appearing in the *Old Gentleman* (Browse, pl. 1) of c. 1876 and in several other paintings and drawings of that period. The version exhibited here apparently dates from some years later, to judge from the form of the signature and the style in which the figures and costumes are rendered; it is particularly close in that respect to the *Buffet* (Browse, pl. 15) of 1883-1884.

As in the earlier examples, the influence of Degas, Forain's acknowledged master, is unmistakable here not only in the choice of subject, but in the way it is conceived and executed. The image of the dancer standing in the wings, turning away from the gentleman beside her yet clearly very much aware of him, occurs in such earlier works by Degas as the pastel *Two Dancers Going Onstage* (Lemoisne, no. 448) and the painting *Dancers Backstage* (fig. 61). Although previously assumed to have been painted much later, the latter has recently been redated to the early 1870s (Reff 1981, 127), and thus might well have provided Forain with an appropriate model. If it did, however, he was able to transform it entirely to suit his own personality: the chance encounter to which Degas alludes, glimpsing it as part of a larger

backstage scene in which a second dancer and several stage flats also appear, becomes for Forain a subject of psychological analysis in which the actors' subtly contrasted roles—the one interested yet apparently indifferent, the other indifferent yet clearly interested—is alone what counts.

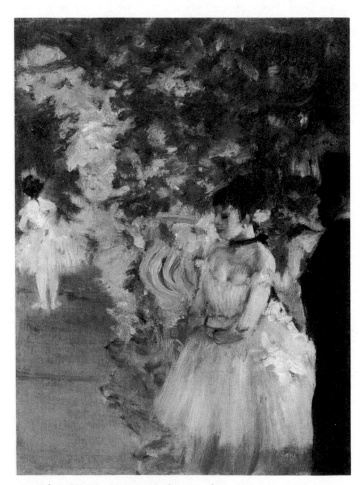

61. Edgar Degas. *Dancers Backstage,* oil on canvas, c. 1872. National Gallery of Art, Washington, Ailsa Mellon Bruce Collection 1970.

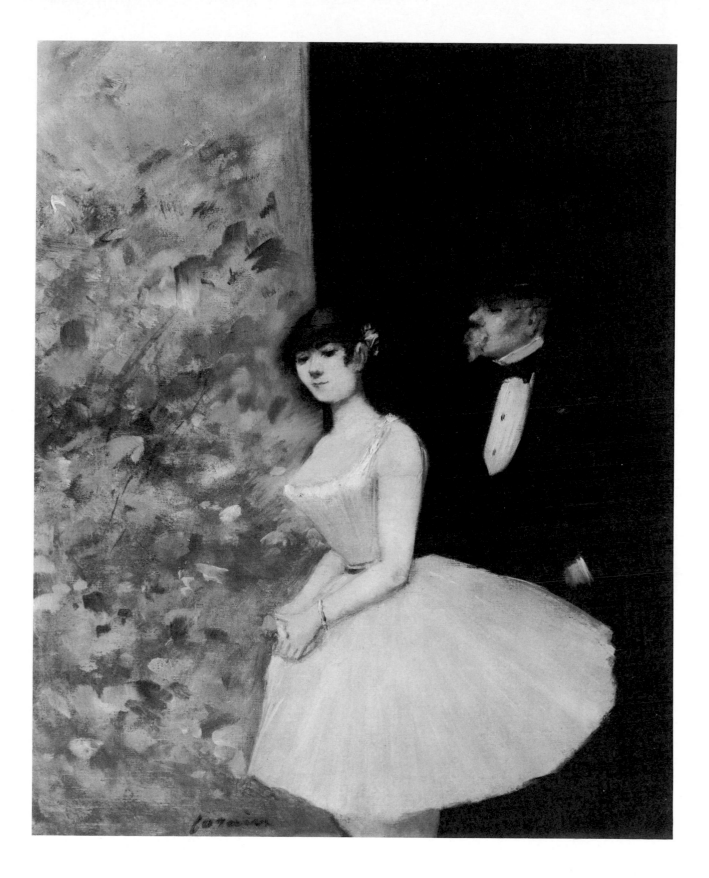

Edouard Manet

39 *The Ball of the Opera,* 1873

Oil on canvas, 23⅝ x 28¾ in. (60 x 73 cm.)
Signed, lower right: *Manet*
National Gallery of Art, Washington, Gift of
Mrs. Horace Havemeyer in memory of her
mother-in-law, Louisine W. Havemeyer, 1982
R-W 1:216

The masked balls given every Saturday night during the carnival season at the old opera house on the rue Lepeletier were, in the words of a contemporary guidebook, "the choicest pleasures known to the Parisian" (McCabe, 739). As such they had already been a popular subject for chroniclers of modern life like Gavarni in the 1840s, and twenty years later they continued to be treated regularly in newspaper illustrations like the one by Grévin published in 1873 (fig. 62), the same year as the painting by Manet exhibited here (Isaacson 1982, 105). Although different in medium and intention, the two images comment with a similar sophisticated amusement on the dense crowd of gentlemen in evening dress flirting with women—no doubt demimondaines—wearing masks and fancy costumes in the foyer of the Opera. The fire that destroyed it in October of that year, however, also marked the end of such intimate and animated revels. "I attended them [afterward] and above all I left them, and for good," a well-known chronicler recalled, "not for having been, as on the rue Lepeletier, crowded together, packed in like sardines, but for just the opposite reason" (Jollivet, 163). The new theater that opened in 1875 was indeed too grandiose to preserve that kind of intimacy; and the banal formality of the balls given there is conveyed perfectly in a painting by Forain of c. 1880 (Browse, pl. 9). Thus Manet's picture, begun in the spring of 1873 but completed only in November, supposedly in direct response to the fire (Tabarant 1947, 232), can be seen as a tribute to the fashionable society that had created and supported the old opera house and to which he still belonged.

Both in this aspect and in its composition, a friezelike alignment of figures, the *Ball of the Opera* resembles Manet's first picture of that society, the *Concert in the Tuileries* (fig. 3). And as his earliest biographers noted, this one too contains recognizable portraits of his friends (Bazire 139; Duret, 110-111); among them, the composer Chabrier, the painters Guillaudin and André, the banker

62. Alfred Grévin. *The Ball of the Opera,* wood engraving from *Petit Journal pour rire,* no. 176 (1873), 1. Bibliothèque Nationale, Paris.

Hecht, and Duret himself, most of whom Manet also portrayed individually. On the basis of these portraits, the man standing before the pillar at the left, facing us, can be identified as Chabrier, and the one turning toward the woman with a bouquet, in the center, as Guillaudin. André is presumably the Polichinelle at the far left, wittily cut by the frame—a role he also played in posing for several pictures and a print (cat. 40) at this time. And as has recently been observed, the man standing at the far right, the only one conspicuously facing us, is Manet himself, and on the floor directly below him is a discarded *carnet de bal* bearing his signature, which is also that of the painting (De Leiris 1980, 98).

Color plate 4

Edouard Manet

40 *Polichinelle,* 1874

Color lithograph, 17⅞ x 11¹⁵⁄₁₆ in. (45.4 x 30.4 cm.)
Signed in the stone, lower right: *Manet*
National Gallery of Art, Washington, Rosenwald Collection 1947
H 80, third state

🐸 The Polichinelle who appears here and in several other works of 1873-1874 resembles the Pulcinella of the commedia dell'arte but is a distinctly French type. Already seen on the Parisian stage in the early seventeenth century, he was especially popular in children's puppet theaters. His prominence in one such theater in the Tuileries Gardens, directed by the realist writer Duranty, would explain his presence and that of his cat in etchings Manet designed as frontispieces for an album of his prints in 1862 (H 37, 38; cf. Fried, 37-40), just as his traditional role in carnival celebrations would explain his appearance in the *Ball of the Opera* in 1873 (cat. 39). But other than as postscripts to the latter work, the four images of Polichinelle dating from the same period—the color lithograph exhibited here, the watercolor study for it of December 1873 (R-W 2:563), and the oil sketch and finished painting showing him in a different pose (R-W 1: 212, 213)—are more difficult to explain. Yet their number, and Manet's insistence that the lithograph be printed in time to be shown at the Salon of 1874 (it was not, and he showed the watercolor instead; cf. Wilson, no. 83), suggest that the image had a special meaning for him.

Evidently this meaning was political; for the printer's assistant later recalled that some fifteen hundred examples of the lithograph, part of a larger edition to be distributed to subscribers to the republican newspaper *Le Temps,* were destroyed by the police because Polichinelle resembled Marshal MacMahon, who had been elected president of the Republic in May 1873 (Tabarant 1923, 368-369). Since Manet's actual model was Edmond André, a neighbor and fellow artist, the resemblance to MacMahon has been minimized and the caricatural aspect denied (Farwell 1977, no. 11). But the confirmation provided by photographs of MacMahon cannot be ignored, any more than the antipathy that Manet, a staunch patriot and radical republican, must

63. Etienne Bocourt. *Monsieur Polichinelle* (after Ernest Meissonier), wood engraving from *Gazette des Beaux-Arts* 5 (1860), 203. Avery Library, Columbia University, New York.

have felt toward the marshal who had led an entire French army to defeat at Sédan and had directed the brutal repression of the Paris Commune (Ruggiero, 36-37). An early biographer may indeed have had this in mind in writing that, despite "the costume or disguise, . . . the model is among us, that is incontestable; [the figure] has his brutality and his insolence" (Bazire, 85), an odd characterization if applied to the traditional Polichinelle, but a very apt one for the scornful individual shown here. His stance is indeed that of a general inspecting his troops, and the bat he holds behind his back may allude to "Maréchal Bâton," MacMahon's nickname, just as the bicorned hat he wears *en bataillon* may have a Napoleonic connotation.

That Manet apparently used as a pictorial model for this version of Polichinelle a painting by Meissonier, a political and artistic reactionary under whom he had served in the Franco-Prussian War, seems paradoxical; but the resemblance to Meissonier's *Polichinelle,* exhibited in 1860 and reproduced in an etching (fig. 63), is unmistakable and may even hint at a further political irony (Dorival, 223-226).

Although it was previously thought that the first edition of this print was in 1874 and the second in 1876 (H 80), or even that one was in 1876 and the other posthumous (Guérin, no. 79), it has recently been established that both date from June 1874 (Wilson, no. 83).

Color plate 15

Henri de Toulouse-Lautrec (1864-1901)

41 *Maxime Dethomas at the Ball of the Opera*, 1896

Gouache on cardboard, 26½ x 20¾ in. (67.3 x 52.7 cm.)
Signed and dated, upper right: *HTLautrec / 96* (*HTL* in monogram)
National Gallery of Art, Washington, Chester Dale Collection 1962
Dortu, no. P 628

In the twenty-three years that separate Manet's picture of a masked ball at the Opera (cat. 39) from this one by Lautrec, the ball itself underwent many changes, becoming less intimate and less exclusive socially in the later, more democratic years of the Republic. But it is clear from images of the ball contemporary with Manet's that even then it had an uninhibited side that he chose to ignore in describing the restrained revelries of his own circle. It was this side, of course, that Lautrec chose to explore, transforming the society ball, whose decorum Forain had still acknowledged in a picture of about 1880 (Browse, pl. 9), into a common cabaret scene like those Lautrec witnessed daily in the night clubs and dance halls of Montmartre.

Maxime Dethomas, one of his most constant companions in the 1890s, was a painter and printmaker who shared Lautrec's fascination with Parisian types and street scenes and with the theater; he was at this time drawing programs and posters for one theatrical company and was later to design décors for another and eventually for the Opera itself. He is shown here seated at a little table, as in a cabaret, while three costumed women stand before him, one of them, dressed in a bright pink body suit, soliciting his attention. Dethomas, who is by contrast soberly dressed in black, reportedly the favorite color of this very large yet timid and self-effacing man, gazes downward sadly and seriously. Lautrec thus shows him in precisely the role in which he most admired his friend: "He liked Maxime Dethomas (whom he never

called anything else than 'le Grosnarbre' [big as a tree]) for the impassiveness he was able to maintain in places of amusement" (Leclercq, 40-41).

It is also likely, however, given Lautrec's fondness for parodying mythological subjects, that he has given Dethomas another role, that of the protagonist in the Judgment of Paris. Like a modern Paris, with a walking stick instead of a shepherd's crook in hand, he sits gravely thoughtful while three women of contrasted appearance parade before him, hinting not only at the three goddesses of the myth but at the familiar temptations of the masked ball. Lautrec had already brought the ancient story up to date two years earlier in his lithograph *The Modern Judgment of Paris* (Delteil, no. 69); published in a humorous supplement to the *Revue blanche*, in which he parodied pictures on view at the Salon, it mocked an academic version of the Judgment of Paris by showing the latter as a Parisian dandy choosing among three prostitutes.

Plate 10. Edouard Manet. *The Races at Longchamp*, c. 1867. Cat 43.

5

Outside Paris: The Racetrack

❧

ALTHOUGH INTEREST in horse racing, along with other customs of English origin, dates from the time of Louis XVI and although the sport was already popular during the July Monarchy, when the aristocratic Jockey Club and the first annual steeplechase were established, its real vogue as a social event occurred during the Second Empire. The Société des Steeplechases de France, founded in 1863; racing journals like *Le Jockey* and *Le Champ de courses*, first published in 1864 and 1866, respectively; and the one-hundred-thousand-franc Grand Prix de Paris, created by the Duc de Morny in 1863, all attest to the greatly increased importance of horse racing in the later years of the Empire. Almost inevitably, in that age of financial speculation, it was accompanied by the establishment of organized betting; the first bookmaking agency, employing a system of *paris mutuels* still in use today, was opened in 1867, and the first newspaper devoted exclusively to betting news, the *Journal des courses*, began to appear in 1869. The physical setting of the race was also transformed: the grandiose track and reviewing stands at Longchamp, in the Bois de Boulogne, were inaugurated in 1857 and those in the Bois de Vincennes in 1863, replacing the small, poorly located Hippodrome on the Champ de Mars, which Flaubert describes in an episode of *L'Education sentimentale* (1869) set in the late 1840s.

From the beginning Longchamp became a center of fashionable life; its elegant crowds, in which aristocratic ladies and wealthy prostitutes mingled, its long processions of carriages, rivaling each other in ostentation, its swarms of bookmakers and bettors, of journalists and adventurers, were the subjects of frequent articles in the popular press and of countless popular prints. The pages not only of the racing publications but of such general illustrated weeklies as *Le Charivari, L'Illustration,* and *Le Monde illustré* regularly contained prints depicting the social ambiance of the tracks at Chantilly and Long-champ either in satirical or in straightforwardly descriptive terms (Grand-Carteret, 5: 203-212). The large wood engraving by Thorigny illustrated here (fig. 64) is an example of their ambitious scope and descriptive detail. Attendance at the tracks and accompanying publicity increased further when the Grand Prix was established in 1863, and still further when it was won by the French entries, Vermouth and Gladiator, in the following years. These are probably the events, long famous in the social annals of the Empire, that Zola vividly evokes in describing the Grand Prix race in *Nana* (1880), which her horse wins. Manet's decision to paint an exceptionally large and complex picture of a race at Longchamp in 1864, and to exhibit it early the next year in a Paris gallery, undoubtedly also reflected this current interest in the subject.

His way of conceiving it, however, was altogether personal. Earlier French artists such as De Dreux had drawn heavily on English sporting prints, long considered the models in this field, in painting portraits of famous thoroughbreds and in recording the colorful ambiance and the various stages of a race. Henri Delamarre's picture of the Grand Prix entries in 1864, popularized in a color engraving (fig. 65), is typical of this genre. Other artists, such as Lami and Doré, in watercolors painted in 1864-1865 (Fleury and Sonolet, 4:266, 274), focused on the picturesqueness of the crowds in the reviewing stands and the carriages along the track, continuing a tradition of social commentary established earlier by printmakers such as De Beaumont and Guérard (Farwell 1977, nos. 67, 68). When French artists depicted the race itself, it was in the extended, lateral view typically seen in English prints and in Géricault's well-known *Races at Epsom*, itself an English subject. And interestingly, when Manet received a commission for such a picture in 1872, he followed the same pattern: his *Races at the Bois de Boulogne* (fig. 66) is based, as he

64. Félix Thorigny. *Spring Races at the Bois de Boulogne*, wood engraving, 1862. Bibliothèque Nationale, Paris.

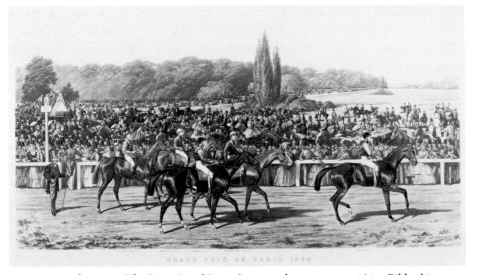

65. Henri Delamarre. *The Paris Grand Prix of 1864*, color engraving, 1864. Bibliothèque Nationale, Paris.

67. Louis Bombled. *The Paris Grand Prix*, reproduction of pen and ink drawing, 1890. Bibliothèque Nationale, Paris.

66. Edouard Manet. *Races at the Bois de Boulogne*, oil on canvas, 1872. Mrs. John Hay Whitney, New York.

himself admitted to Berthe Morisot, on just such sources. So too are Degas' early pictures of jockeys lined up before the start of a race at Epsom (Lemoisne, nos. 76, 101), painted several years before Manet's at Longchamp—a precedence the latter seemed to acknowledge by showing Degas standing at the track in his picture of 1872. Degas, for his part, planned to show Manet attending a race, accompanied by Lydia Cassatt, in an unrealized picture of the same years (Nicolson, 536-537; Wells, 129-134).

What is unusual about Manet's composition of 1864 and its related images is his rejection of the traditional lateral view in favor of a radically foreshortened frontal view, taken from a point at the turning of the track, so that the horses seem to gallop directly toward us. This dramatic perspective with its stop-action effect is sometimes said to have been influenced by contemporary photographs, but no such photographs existed at the time; it was only in 1878-1881 that those of Muybridge, taken in California in 1872-1873, became known in

France. Still later the frontal view became something of a convention in its own right, as seen for example in a drawing of the Grand Prix race of 1890 (fig. 67), which was indeed influenced, if not actually based on, photographs.

Despite his emphasis on the dynamic action of the race, Manet also paid attention to the spectators and carriages lined up at the track and even included a glimpse of the reviewing stand opposite them in his 1864 painting. He thus managed to incorporate all aspects of the colorful spectacle, much like the journalists who were then reporting on the races at Longchamp. As one of them noted in 1864 about his colleagues: "At Longchamp, a good many chroniclers gladly give up the jockey's cap and jacket to see only the dresses and hats of the famous Parisian ladies. They want to be all over the place, and the chronicles show the effect of their authors' divided attention. Horse and dress, jockey and coiffure, petty gossip and big bets—all this swarms confusingly in their paragraphs" (Iffezheim, 284).

Edouard Manet

42 *Women at the Races,* 1865

Oil on canvas, 16⅝ x 12⅝ in. (42.2 x
 32.1 cm.)
Signed and dated, lower right: *Manet / 1865*
The Cincinnati Art Museum, Fanny Bryce
 Lehmer Endowment
R-W 1:95

Like some of his other ambitious compositions of the early 1860s, Manet's *View of a Race in the Bois de Boulogne* has not survived intact. After exhibiting it at the Galerie Martinet in February 1865, he cut the canvas into several pieces, only two of which are now known: this picture and one formerly in the Cognacq collection in Paris (fig. 68). Since both are inscribed 1865, the larger composition cannot be identical with the *Races in the Bois de Boulogne* shown at Manet's retrospective exhibition in May 1867, contrary to what is often stated (e.g., Tabarant 1947, 101-102). What the dismembered picture looked like, we learn from a watercolor study in the Fogg Museum inscribed 1864 (fig. 69), in which the two groups of female spectators standing at the left correspond closely to those in the surviving fragments.

It has been argued that the watercolor is a copy after, rather than a study for, the large painting (Harris 1966, 80), but it is unlikely that Manet would have proceeded directly from his small pencil sketches of spectators and carriages (R-W 2:541-543, 545-547) to the large oil without such an intermediate color study. It was surely in the watercolor, whose harmony is deeper and more intense than that in any of the surviving oils, that he developed the striking sequence of colors—blue, red, blue, yellow, pink, blue—in the jackets of the jockeys, which was preserved in a modified form in the oils (cat. 43, 45). And since the watercolor is painted on two sheets of paper, the second having been added to extend the composition at the left, it is clearly the work in which his ideas evolved and must therefore have come first. In fact, the *verso* of the second sheet contains a faint drawing of the reviewing stand at Longchamp, cut at the right edge (fig. 70); and the first sheet forms a satisfying design in itself, the diagonal of the railing and the women's skirts extending exactly to the lower left corner. When the format was enlarged, it became a long, narrow rectangle whose proportions were two to five. Assuming that these were also the proportions of the painting based on it, and extrapolating from the dimensions of the two fragments, we can determine that it was about 80 x 200 cm., not 102 x 260 cm. as previously proposed (Harris 1966, 79).

Left: 68. Edouard Manet. *The Grounds of the Racetrack at Longchamp*, oil on canvas, 1865. Private collection, France.

Lower right: 70. Edouard Manet. *The Reviewing Stands and Gardens at Longchamp* (*verso* of fig. 69), pencil, 1864. Fogg Art Museum, Harvard University, Grenville L. Winthrop Bequest.

Far right: 69. Edouard Manet. *Races at Longchamp*, watercolor and pencil, 1864. Fogg Art Museum, Harvard University, Grenville L. Winthrop Bequest.

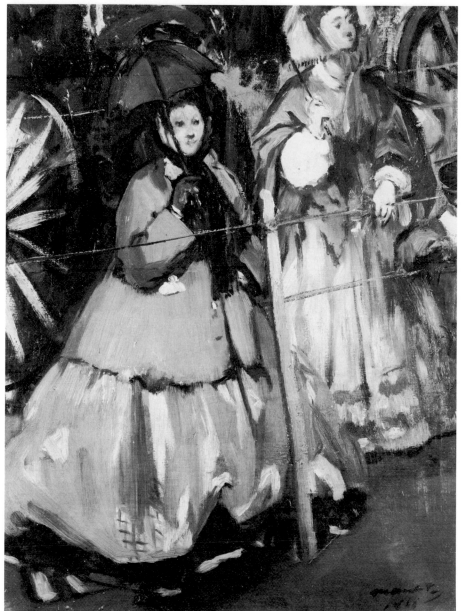

Color plate 2

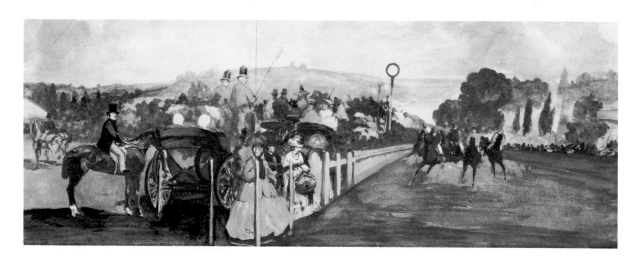

Edouard Manet

43 *The Races at Longchamp,* c. 1867

Oil on canvas, 17¼ x 33¼ in. (43.9 x 84.5 cm.)
Signed and dated, lower right: *Manet 186[?]*
The Art Institute of Chicago, Potter Palmer
 Collection
R-W 1:98

The relation of this picture to the several others, both extant and lost, that Manet painted of the racetrack remains problematic. Although this one shows the most important section of the large composition he exhibited early in 1865 (cf. cat. 42), it cannot actually have belonged to it; it is painted in a more vigorous, sketchy style than the two surviving fragments, and it includes at the lower left two female spectators very similar to those shown in one of the fragments (fig. 68). Nor can it have belonged to the composition exhibited in 1867; for again its style suggests a sketch rather than a finished picture, at least in terms of Manet's art of that decade, and its dimensions are half those of the larger composition, which would, if this one were incorporated, have been even more diffuse than the watercolor study. But since the dimensions of the Chicago picture and the one shown in 1867 are in the same proportion, roughly one to two, one may well have been a study for the other, painted in order to examine how a section of the earlier composition could be isolated to achieve greater compactness of design and intensity of expression. It thus marked a stage in the evolution of Manet's racetrack image toward greater reduction and concentration, which would be carried still further in the following decade.

If this argument is correct, the date of the Chicago picture, previously placed as early as 1864 (Tabarant 1947, 101) and as late as 1872 (Jamot and Wildenstein, no. 202), can be narrowed to c. 1867. In that case, it would be contemporary with the *World's Fair of 1867* (cat. 2), with which it shares the same color harmony dominated by deep green, yellow-green, and beige, with accents of warm brown and light blue, and the same sparkling effect of outdoor light, unprecedented in Manet's work at this time. The last digit of the inscribed date, which is blurred but can be read as a five, a seven, or a nine (Harris 1966, 78, n. 5), would therefore be a seven.

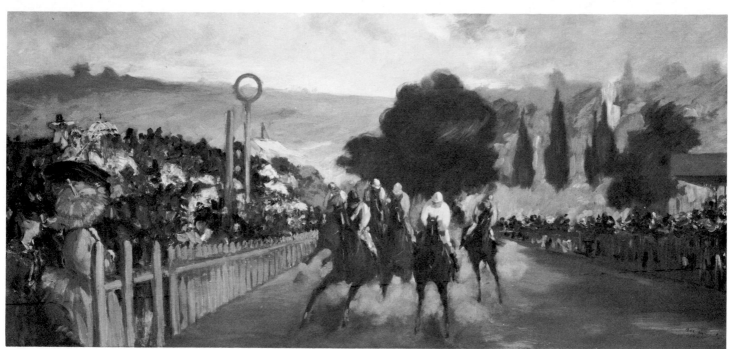

Color plate 10

Edouard Manet

44 *The Races,* 1865-1869

Lithograph, 15¼ x 20⅞ in. (38.8 x 53 cm.)
Not signed or dated
National Gallery of Art, Washington, Rosenwald
 Collection 1943
H 41, only state

The extraordinarily bold handling of the right side of this print, the aspect that appeals most to twentieth-century viewers, would have been unacceptable to most mid-nineteenth-century viewers and perhaps to Manet himself. The furious abandon of the slashed and scribbled strokes has no equivalent in his other lithographs, even in the vigorously drawn *Balloon* (cat. 98), which is sometimes cited in this regard. On closer examination, it becomes apparent that these strokes were superimposed on lighter, more carefully drawn figures and carriages, perhaps to unify them into larger masses of light and dark, perhaps to cancel them entirely. In any event, there is no evidence that Manet considered them his final solution, since this print, even in its first state, was published only posthumously. The putative second state (fig. 71), in which the image is reduced by twenty-eight centimeters at the right, eliminating just this problematic area, might suggest such a solution; but since it too was published after his death, with what is apparently a false signature in the stone, it was not necessarily his own solution. One writer has in fact rejected this version as "a spurious work, concocted after or at the same time as the posthumous printing of 1884" (Harris 1970, 123).

The unique character of this print has led to much disagreement about its date. Suggestions have ranged from 1864 (Guérin, no. 72) to 1877 (Moreau-Nélaton 1906, no. 85), with the latest one spanning both extremes (Wilson, no. 76). The earlier is probably the more correct dating, however, not only because the unresolved handling of the right side should not be given too much weight in relation to the more successful and cautious handling of the rest, but also because the composition with its broad vista and deep perspective corresponds most closely to the racetrack paintings of the mid-1860s and is incompatible with the one of a decade later.

71. Edouard Manet. *The Races* (reduced version of cat. 44), lithograph, 1865-1869. Museum of Fine Arts, Boston, W. G. Russell Allen Collection.

Edouard Manet

45 *The Races at Longchamp,* 1872-1875

Oil on wood, 5 x 8½ in. (12.5 x 21.5 cm.)
Signed, lower right: *Manet*
National Gallery of Art, Washington, Widener
　Collection 1942
R-W 1:97

The final stage in Manet's progressive concentration and simplification of his image of the racetrack is marked by the small, richly painted picture exhibited here. The pack of galloping horses, now five rather than six as in the earlier versions (cat. 42, 43), fills the entire foreground, and the crowds of spectators, merely suggested by dabs of paint, recede swiftly behind the fences at both sides. Even the landscape, which in the previous versions offered a panoramic view of the hillside of Saint-Cloud rising behind the Longchamp track in the Bois de Boulogne, is reduced to a single, densely rendered row of trees, with barely a glimpse of sky at the upper left. All attention is focused now on the horses and riders, who thus achieve a monumental power despite their small size. They differ from the earlier groups not only in number, but also in their more forceful, lunging movements and their wider, more legible spacing; though two of them remain identical with their predecessors, the effect of the whole group is fresh and vigorous. In this later configuration, they first occur in *The Races* (R-W 1:96), an oil sketch of the horses and riders alone, known only in a poor photograph taken in Manet's studio. Thus their repetition in the picture shown here represents the last state in a process of continual reduction that began with the Fogg watercolor and the lost 1865 composition, was carried further in the Chicago painting and the lost 1867 composition, and culminated in the oil sketch and this little picture.

In this form the image is at once at its most concentrated and most vibrantly expressive: its dappled tones of green, blue, and reddish brown, with accents of violet, pink, and mauve, create a vivid effect of movement and of outdoor atmosphere and light. And its execution in small broken touches of pigment, with virtually no linear definition even at the contours of forms, creates a painterly effect more like that in contemporary impressionist works by Monet and Renoir than in any of the pictures Manet painted at Argenteuil while in their company (R-W 1: 218-223, 227). For these reasons, the various dates in the 1870s given in the older oeuvre catalogues (Duret, no. 232; Jamot and Wildenstein, no. 205) and inscribed on an early photograph in the Durand-Ruel archives are preferable to those in the mid-1860s given in the more recent catalogues (Orienti, no. 87d; R-W 1:97).

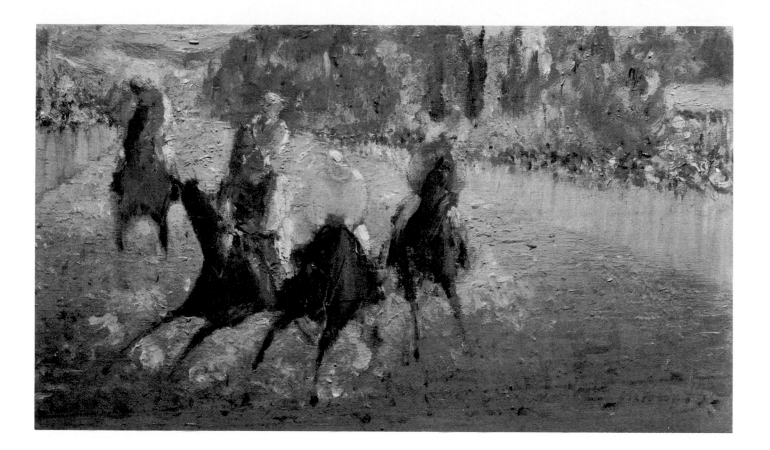

Edouard Manet

46 *The Races at Longchamp,* 1872-1875

Pencil and watercolor, 7¹¹⁄₁₆ x 10⅝ in.
 (19.6 x 27 cm.)
Atelier stamp, lower right: *E. M.*
Cabinet des Dessins, Musée du Louvre, Paris
R-W 2:544

The uniformly thin, uninflected strokes with surprisingly large gaps seen in this drawing suggest that it was traced from another image, either from another drawing in which the forms were first worked out more thoroughly, or from an oil sketch for the 1867 racetrack composition; such a sketch does exist (R-W 1:96), and its dimensions are roughly the same. The facility with which tracings could be used as intermediate steps in the process of transferring a design from one medium to another—often from a watercolor, which in turn reproduced a painting, to an etching or a lithograph—appealed to Manet throughout his career. The etched versions of both the *Spanish Singer* (H 12) and the *Boy with a Sword* (H 24-27) of 1861-1862 are based on tracings, in one case from a watercolor, in the other from a trial proof of the print (De Leiris 1969, 10). The lithograph *The Barricade* (cat. 73) of 1871-1873 is partly based on a tracing from the earlier lithograph of the *Execution of the Emperor Maximilian* (cat. 74). And the etched version of *Jeanne, Spring* (H 88) of 1881 is based on a tracing from a photograph of the painting that was later discovered on the *verso* (Chiarenza, 38-45). It would be surprising, then, if in repeating eight to ten years later the group of galloping jockeys from the first version of the *Races at Longchamp* (cat. 43), Manet did not once again make use of a tracing.

Whatever its own model, this drawing then served as a model for the Washington version of the races at Longchamp (cat. 45), where the five mounted jockeys appear in the same positions and wearing jackets of the same colors—brown, violet, pink, and mauve-blue. Like the painting, but even more clearly because of its limpid execution, the drawing reveals Manet's characteristic way of condensing his sensations. He retains "those elements which convey the action of the entire group and avoids lingering on descriptive passages. The dominant expressive means is a starlike pattern, with no central focus. The viewer cannot apprehend it as a sum of parts but as an integral shape articulated from without by its outer delineating silhouette. Hatchings are introduced within the all-encompassing contour line, but they bridge the entire gap of the blank area within, with little regard for distinctions of individual rider or horse. The drawing gives a telescopic view of the group caught in full motion" (De Leiris 1969, 65).

Eugène Boudin (1824-1898)

47 *The Races at Deauville,* 1866

Pencil and watercolor, 8 x 12¼ in. (20.3 x 31.1 cm.)
Dated, lower right: 66
Mr. and Mrs. Paul Mellon, Upperville, Virginia

To make Deauville a still more fashionable resort, the speculative developers led by the Duc de Morny, who had created it almost overnight on barren sand dunes as a rival to nearby Trouville, built a huge hippodrome near the new casino in 1864. The horse races held there during the summer season soon became world renowned, attracting socially prominent people from Paris and London and of course their unofficial chronicler Boudin. Having already painted countless views of the beach and the jetty lined with elegantly dressed people, as well as a concert in the casino and a regatta with a public celebration (Schmit, nos. 349, 396), he was inevitably drawn to this festive occasion as well. And that is precisely how he saw it—not as a sporting event, for unlike Degas he had little interest in the noble form of the horse, and unlike Manet, little interest in the excitement of the race—but as one more opportunity to record the appearance of the fashionable residents of Deauville on a brilliantly sunny day. In his only painting of a race meeting there (Pickvance 1968, no. 81), his viewpoint is such that the grandstand and spectators almost entirely obscure the track and mounted jockeys.

In the sheet exhibited here of sparkling watercolor sketches, arranged in four horizontal rows rather than a single, spatially coherent design, Boudin likewise captures the social ambiance of the racetrack without focusing on a single event, rather in the style of the vignettes in contemporary journalistic illustrations. It is above all the colorful costumes of the female spectators with their long dresses sweeping on the ground, and those of the jockeys mounted or standing near their mounts, that he depicts. But in the uppermost register, probably the first to be drawn, he does show the general aspect of the track with the grandstand at one side and the field house, the barrier, and a mounted jockey at the other. And in the second register, he includes a tiny sketch of horses clearing a fence in a steeplechase—the closest the gentle Boudin ever comes to representing the excitement of an actual race.

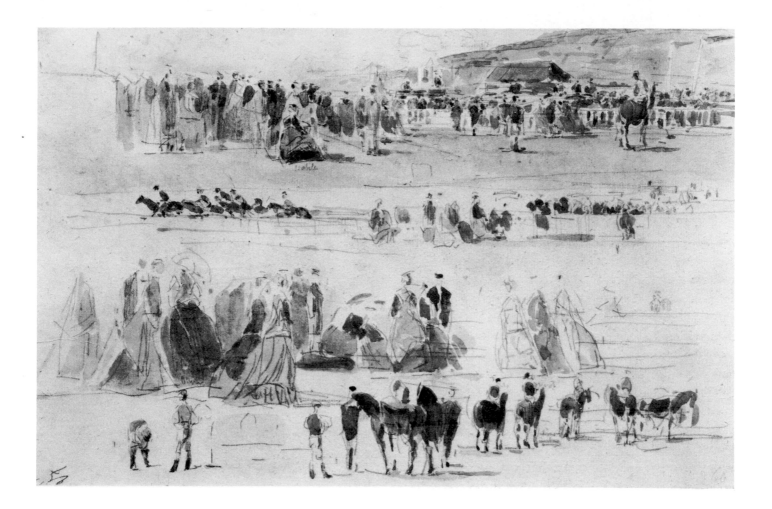

Edgar Degas (1834-1917)

48 *The Races*, c. 1873

Oil on canvas, 10½ x 13¾ in. (26.5 x 35 cm.)
Signed, lower right: *Degas*
National Gallery of Art, Washington, Widener
 Collection 1942
Lemoisne, no. 317

Less worldly and exuberant than Manet, who was drawn to the racetrack as a place of exciting action and elegant crowds, Degas consistently chose quieter, more sober scenes on its periphery: mounted jockeys assembling before the race or lining up at the starting pole, trainers working their mounts or allowing them to graze. Here he could explore at length the horse's noble proportions and graceful movements, which he had come to admire in studying ancient and Renaissance art and sought to reproduce in subjects appropriate for a modern art. With the exception of two unresolved and later reworked pictures (Lemoisne, nos. 76, 101), the *Races* exhibited here and its slightly larger companion, the *Race Horses at Longchamp* (fig. 72), are probably Degas' earliest statements of the first theme, the assembly before the race. They may indeed be among the "little pictures of the racetrack" that Fantin-Latour mentioned seeing in Degas' studio in January 1869 (letter to Whistler, University of Glasgow, Birnie Philip Bequest, L/38); for they are among the smallest of this kind in his oeuvre, and they make use of a shared repertory of oil sketches of mounted jockeys. The two who are seen from behind in both pictures are in fact based on the same sketch (Lemoisne, no. 157), though in one of them one of the jockeys is reversed.

Both pictures were therefore painted in Paris on the basis of such studies and of memories of the field at Longchamp, the one showing Mont Valérien and the slopes of Boulogne in the distance, the other the training ground and stud farm and the town of Puteaux across the Seine. The claim that the *Races*, at least, was painted in New Orleans during Degas' visit in 1872-1873 (cf. Lemoisne, no. 317) is thus unfounded, despite the resemblance that some of his relatives later saw to the local Fairgrounds Race Track and distant cathedrals (Byrnes, 74). It is indeed unlikely that Degas, who was preoccupied with painting the cotton market and family portraits during that visit, would have turned only once to an equestrian subject.

72. Edgar Degas. *Race Horses at Longchamp*, oil on canvas, 1869-1870. Museum of Fine Arts, Boston, S. A. Denio Collection.

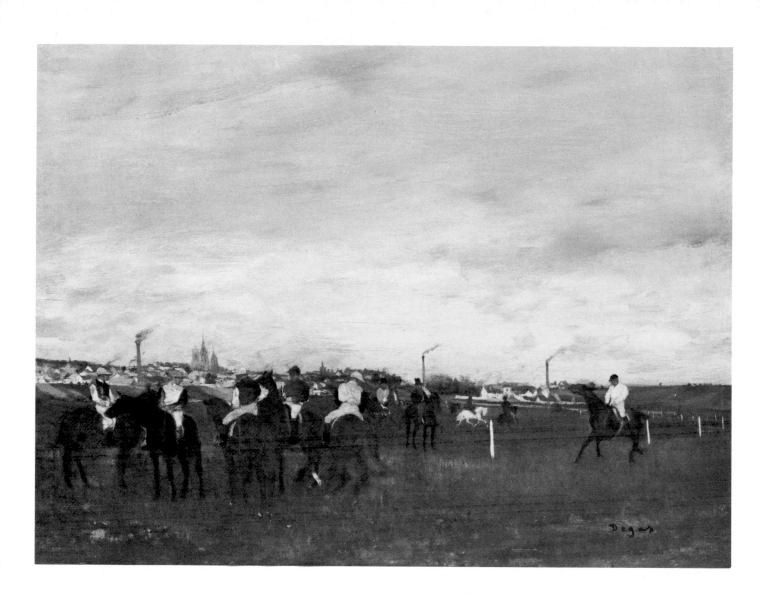

Edgar Degas (1834-1917)

49 *The False Start,* 1869-1871

Oil on canvas, 12⅝ x 15¾ in. (32 x 40 cm.)
Signed, lower right: *E. Degas*
Mrs. John Hay Whitney, New York
Lemoisne, no. 258

It is typical of Degas' indifference to the social aspect of the racetrack that, of all his pictures presumably set at Longchamp, only this and one other, the *Jockeys before the Reviewing Stands* (fig. 73), show the stands and spectators. Both date from 1869-1872, when

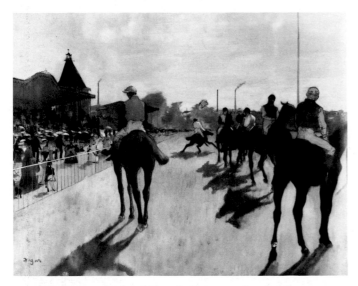

73. Edgar Degas. *Jockeys before the Reviewing Stands,* oil on canvas, 1869-1870. Musée d'Orsay (Galerie du Jeu de Paume), Paris.

he first took up equestrian subjects seriously, and both reveal an initial, passing interest in the kind of panoramic view of horses and spectators that Manet had painted some six years earlier. In preparation, Degas too made a drawing of the reviewing stand (fig. 74), but in much greater detail than Manet had (fig. 70), one in which he described the structure and ornament down to the metalwork filigree; and on it he noted "the narrow edging of light on the railing," a feature omitted from one picture but quite conspicuous in the other. In some respects, however, he freely altered the information he had scrupulously recorded: the railings in the two pictures are of different designs; the fence across the first tier of seats in one is absent from the other; and the straight line of the eaves, clearly shown in contemporary

images of Longchamp, such as Thorigny's wood engraving (fig. 64) and Alphand's official engravings of the stands (Alphand, 2: n.p.), is changed in both pictures to a broken line rising in the center. Surprisingly, it is already altered in the drawing made on the spot: the lines of the eaves, at first drawn lightly straight across, are redrawn the other way, presumably to overcome the sense of monotony Degas must have felt even while standing before the long structure.

How effectively he then used this alteration becomes evident in the *False Start.* The expansive forward leap of the larger horse, perfectly placed in relation to the open space before him and the reviewing stand behind him, is subtly echoed in the rising roof line. And the constrained diagonal position of the smaller horse is repeated in the receding line of the roof above and behind him. Thus the architectural structure, apparently a mere indication of the setting, plays an important part in the expressive force of the image, enhancing its feeling of tension and imminent action.

74. Edgar Degas. Study for *The False Start,* pencil, 1869-1871. Mrs. John Hay Whitney, New York.

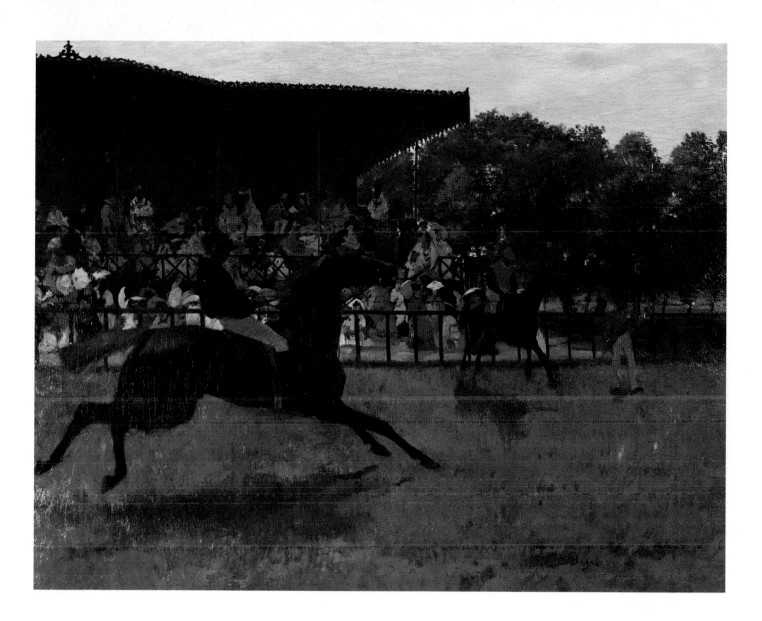

Jean-Louis Forain (1852-1931)

50 *The Good Tip*, c. 1891

Gouache on paperboard, 10⅝ x 13⅞ in.
 (27 x 35.2 cm.)
Not signed or dated (false signature recently
removed)
Mr. and Mrs. Paul Mellon, Upperville, Virginia

Interested primarily in scenes of urban life in which the human figure predominates, Forain rarely painted landscapes and still less often animals. When he did, as in this and a few other pictures of the racetrack around 1891, he focused on the jockeys and spectators rather than the horses, which he relegated to marginal or distant positions. Although a friend and disciple of Degas, whom he may well have accompanied to the track—the *Good Tip* was in fact once considered a work by Degas (Browse, pl. 28)—Forain lacked the latter's experience and skill in representing horses in motion and preferred instead to paint the fashionable people watching a race at Longchamp (Browse, pls. 26, 29) or, as in this case and at least one other (Browse, pl. 27), less savory individuals scheming with jockeys to protect their bets. Like his many scenes of intrigue and corruption backstage and in dressing rooms at the Opera (e.g., cat. 38), these whispered confidences reveal a characteristic interest in the secret and sordid aspects of public entertainments, an interest altogether foreign to Manet's in representing the same subjects.

One of the pictures in this racetrack group is apparently set at Longchamp, but the others describe a more rural track, perhaps the one at Deauville, which Boudin had depicted when it first became popular in the mid-1860s (cat. 47). In any event, Forain's racetracks were painted in the studio and, despite their strong effects of outdoor light, their coloring seems less observed than synthesized from remembered impressions. The large flat areas of yellow-green, gray-green, and greenish blue in the *Good Tip*, accented by a few touches of red, brown, and purple, and enlivened by some passages of agitated brushwork, are clearly products of this studio procedure. Among the impressions Forain summoned up, there must also have been memories of Degas' racing pictures; for some of those he painted in the 1880s (Lemoisne, nos. 503, 889) make very much the same compositional use of a white fence in the foreground, and some of the others (Lemoisne, nos. 767, 878) are set in a similarly deep landscape in which the horses are relatively small, distant forms.

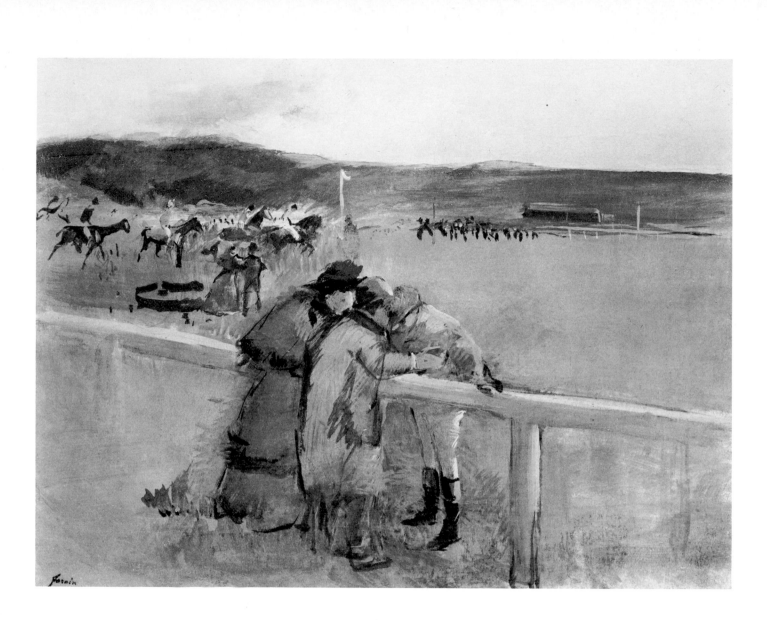

Plate 11. Edouard Manet. *On the Beach at Boulogne,* 1869. Cat. 51.

6

Outside Paris: The Beach

❦

"THROUGHOUT THE SECOND EMPIRE," a contemporary later observed, "the popularity of the Norman beaches was to grow from season to season. Paris, having tasted the sea, could no longer do without it, and every year the number of bathers became larger. Financial speculation taking a part, twenty new resorts were founded and developed. . . . Casinos rose up in the shadow of cliffs, bathing cabins grew like mushrooms, and soon the whole coast, from the dunes of the Pas-de-Calais to the mouth of the Dîves, was during the summer months no more than an immense bathing establishment" (Robiquet). Dominated by Parisian society, which found them increasingly accessible by the new railroads—themselves a product of feverish speculation, in which the Duc de Morny, the emperor's half-brother, played a leading role—the new beaches were the subject of frequent comment in the Parisian press. Illustrated weeklies like *Le Boulevard* and *L'Image* carried regular chronicles and cartoons on the latest social events and personalities; one such cartoon, showing a group of overdressed, obviously loose women on the shore (fig. 75), is captioned "The beach, or the Champs-Elysées at the seashore." The taste for such libertine subjects, further stimulated by a growing freedom in the design of bathing costumes, had already been established in the "pin-up" lithographs of Bettanier, Vernier, and others in the previous decades (Grand-Carteret, 5: 370, 377).

More serious artists and writers also made the trip from Paris in the summer season. In the early 1860s Boudin, who had previously painted Norman farms and Breton fishing villages, discovered a new source of subject matter in the fashionable resorts at Trouville and Deauville and, equally important, a new market in the wealthy collectors who frequented them. A few years later the Goncourt brothers, who vacationed in style at Trouville themselves, set the third act of their play *Henriette Maréchal* (1865) there and also imagined the artist

hero of their novel *Manette Salomon* (1867) as painting a vigorous picture of its beach toward sunset on a fine August day, a picture evidently inspired by one of those Boudin had shown at the Salon. Even Courbet and Daubigny, no lovers of polite society, found themselves at Trouville in 1865, just as Degas did at Boulogne in 1869,

75. Valerie Morland. *Sea Bathing*, wood engraving from *L'Image*, 18 August 1867. General Research Division, The New York Public Library, Astor, Lenox, and Tilden Foundations.

though they were all less interested in sea bathing than in the sea itself, in the vast expanses of sand, water, and sky laid out in broad, flat bands of color muted by the moist atmosphere of the shore. The same was true of Manet when he first stayed at Boulogne in the summer of 1864 and painted its harbor and fishing boats as symphonies of harmonious grays, greens, and blues (R-W 1:78, 79). But

151

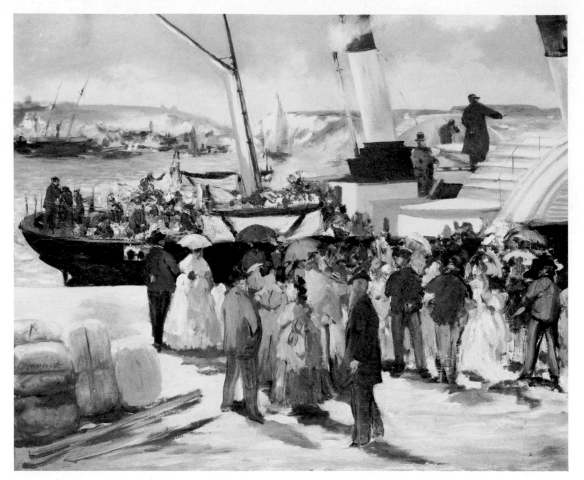

76. Edouard Manet. *The Departure of the Folkestone Ferry*, oil on canvas, 1869. The Philadelphia Museum of Art, Mr. and Mrs. Carroll S. Tyson, Jr., Collection.

when he returned five years later, he chose its public holiday side: the Folkestone ferry, the jetty and the beach, the port on a moonlit night (R-W 1: 143-148). The two pictures of the ferry in particular (e.g., fig. 76), painted from his windows in the Hôtel de Folkestone, directly opposite the quay, capture brilliantly the colorful animation of such a scene through their strong contrasts of light and dark, their patches of vivid color, and their fresh handling of paint.

In the five years separating Manet's two visits to Boulogne, commercial development of its transportation and recreation facilities had made it a more accessible and attractive resort. Although the first bathing establishment and its vogue among Parisians dated from the mid-1820s, the city's real popularity came forty years later. By 1863 the old casino had been replaced by a larger one, which was soon enlarged again; by 1865 the number of bathing cabins had grown from three to one hundred fifty and was growing every season; by 1867 the railroad

line had been extended from Calais to Boulogne, placing the city on the direct line between London and Paris and greatly increasing the number of passengers stopping there (Dutertre, 467-482; Brasseur, 842-843). Within a few years there were eight trains from Paris and seven from Lille daily, as well as two ferries to Folkestone; and the city's easy accessibility, mild climate, and exceptionally fine beach were being cited, at least in municipal publications, as evidence that it was indeed "the City of Bathing *par excellence*" (Boulogne-sur-Mer, n.p.). It was this holiday aspect that Manet, too, now celebrated in his views of the port with its pleasure boats and ferries and of the beach with its fashionable strollers and children, though none of them is shown enjoying the excellent bathing.

What the places Manet represented must have looked like at the time we learn from those other, more banal but more accurate, topographic views drawn by specialists such as Asselineau, whose lithograph in the series *La*

France de nos jours (fig. 77) dates from 1860. The smooth, flat beach, the horse-drawn bathing cabins, the jetty and its strollers, the harbor and its sailboats, even the Folkestone ferry under full steam, all of which are shown in one or another of Manet's paintings, are recorded here. And so, too, are those more traditional and commercial structures, the town hall and cathedral, the warehouses and hotels, which are not shown in his paintings. Clearly his vision is that of the tourist rather than the resident, the tourist who comes to Boulogne assured, as a popular guidebook put it, that "those who like elegant society will rarely find a [bathing] establishment more comfortable or better appointed" (Bardet, 38). But it is also the vision of an artist who discovers in the windswept beach and the vast expanse of sea and sky the stimulus for a new freedom of handling—softer, more fluid and sketchy than before—and a new interest in capturing effects of atmosphere and outdoor light. Both features may owe something to the recent work of Monet and Morisot, but more generally they reflect the emergence at this moment of an early impressionist style in many artists' work, Manet's included.

77. Léon Asselineau. *View of the Baths, Seen from the East Jetty at Boulogne-sur-Mer*, lithograph, 1860. Bibliothèque Nationale, Paris.

Edouard Manet

51 *On the Beach at Boulogne,* 1869

Oil on canvas, 12⅝ x 25⁹⁄₁₆ in. (32 x 65 cm.)
Signed, lower right: *Manet*
Mr. and Mrs. Paul Mellon, Upperville, Virginia
R-W 1:148

Of the six pictures Manet painted at Boulogne in the summer of 1869, only this one shows the beach; the others show the quays, the jetty, and the harbor seen from the windows of his hotel, which appears in two of them. Only this one, then, according to one source, required Manet to "set up his easel on the windy shore, where curious people surrounded him at once" (Tabarant 1947, 166). That he really did so, however, is belied by the synthetic character of the composition and the fact that almost all its figures and groups correspond closely to sketches in the notebook from which he must actually have painted, far from the windy shore. Spontaneous and remarkably vivid, these sketches range from fully shaded, as in the one of a bathing cabin (fig. 78), to swiftly outlined, as in that of the three women at the right in the picture (fig. 79); and their freshness survives in the final work in the graphic quality of the deft brushstrokes. But as a result of this additive procedure, the various figures and groups seem isolated, inconsistent in scale, and strewn indifferently along the beach.

Some writers have in fact criticized this as "one of Manet's most disjointed and disproportionate compositions" (Richardson, 13). In defending him, others have argued that it is "typical of a panoramic view of a crowd on a beach, which is apt to involve such dispersion" (De Leiris 1961, 57), and that it "expresses more intimately the casual enjoyments of the seaside" (Hanson 1977, 201). But since such spatial inconsistencies already appear in the *World's Fair of 1867* (cat. 2), the *Incident in a Bullfight* (cf. cat. 77), and other subjects, their occurrence here cannot be explained solely in terms of Manet's response to this one. Adopting a bolder tactic, another writer has asserted that, to twentieth-century eyes, "it is the oversize man which makes [this] an exciting picture" and that, far from being composed haphazardly, "it must have been carefully constructed on the basis of a double square with right-angled triangles" (Bowness, 277). The picture is indeed twice as wide as it is high—an unusual format, even for a seascape—and is in effect divided in

78. Edouard Manet. *A Bathing Cabin,* pencil, 1869. Cabinet des Dessins, Musée du Louvre, Paris.

79. Edouard Manet. *Three Women on the Beach,* pencil, 1869. Cabinet des Dessins, Musée du Louvre, Paris.

half between the seated woman in the foreground and the standing woman behind her; but as for the triangles, if some can be found among the generally diagonal alignments of the figures, they can be perceived as the "basis" of the design only by choosing arbitrary points to draw them and by ignoring other, equally conspicuous patterns.

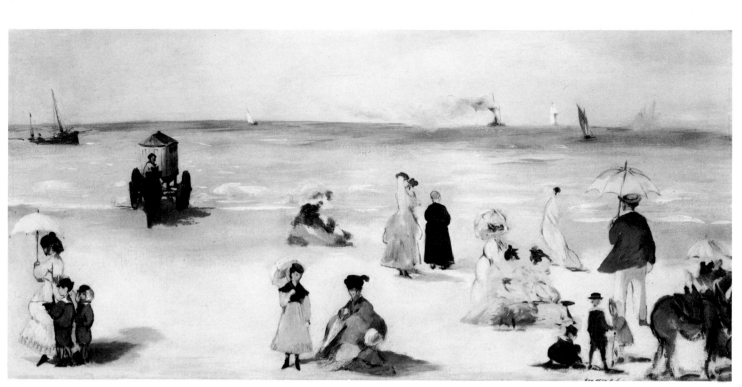

Color plate 11

80. Artist unknown. *The Beach at Boulogne*, color lithograph, 1888-1890. Bibliothèque Nationale, Paris.

In the final analysis, the picture does have an informal, unstructured look, and that is one of its innovative features and one of its charms. Compared to it, the informality of other images of the same beach, such as the color lithograph of the late 1880s illustrated here (fig. 80), seems more contrived and ultimately more predictable. For all their apparently random dispersion, the bathers, ponies, and cabins are organized in little clusters evenly distributed across the picture surface and regularly diminished in size according to their locations in depth. It is in fact a depth constructed by means of conventional perspective, and nowhere in it does a figure stand up with the force and freshness of the oversize man in Manet's picture.

Eugène Boudin (1824-1898)

52 *Bathing Time at Deauville,* 1865

Oil on wood, 13⅝ x 22¾ in. (34.6 x 57.7 cm.)
Signed and dated, lower right: *E. Boudin—65.*
Mr. and Mrs. Paul Mellon, Upperville, Virginia
Schmit, no. 275

Encouraged by the marine painter Isabey to work at Trouville in the early 1860s, when it was becoming the most fashionable summer resort on the Normandy coast, Boudin soon established himself as a specialist in recording the activities of the upper-middle-class, predominantly Parisian society that frequented the beach and its casino and strolled along its jetty and quays. And when the Duc de Morny and fellow entrepreneurs developed the deserted sand dunes at nearby Deauville into a splendid beach within a few years, linking it to Trouville by rail and creating a world-renowned racetrack, Boudin worked there, too. His earliest pictures of Deauville date from 1863 (Schmit, nos. 268, 270, etc.), and he spent part of every summer there for several years thereafter, sometimes in the company of Courbet, Monet, and other artists. Although never a mere chronicler, he painted such notable events of the social season as the opening of the new casino and the start of the annual races (e.g., cat. 47) with a freshness of color and lightness of touch that correspond perfectly to the frivolous nature of the events themselves. His most familiar image, however, is of a subject less eventful than these: simply groups of elegantly dressed vacationers gathered on the beach at one or the other of the two resorts, not to bathe, obviously, but to stroll and converse, to see and be seen.

Bathing Time at Deauville illustrates the compositional formula Boudin gradually developed to represent so large a group in so vast an outdoor space: the figures are aligned horizontally as in a frieze, placed below the already low horizon to allow ample room for the sky he loved most to paint, and arranged in compact groups of varied size, the largest of which is anchored by the taller, more geometric forms of the bathing cabins. Such a formula, with its stress on balance and stability, is far removed from the unconventional, apparently random composition of Manet's *On the Beach at Boulogne.* But that Manet chose in the first place to paint such a scene undoubtedly reflects the influence of Boudin's appealing treatment of it.

James McNeill Whistler (1834-1903)

53 *The Seashore,* 1883-1885

Oil on wood, 3¾ x 6 in. (9.5 x 15.2 cm.)
Signed, lower right, with a butterfly emblem
Dr. John E. Larkin, Jr., White Bear Lake,
 Minnesota
Young, et al., no. 297

If the stylish vacationers in Manet's *On the Beach at Boulogne* are reminiscent of those Boudin painted at Trouville in the mid-1860s, the subtle, low-keyed landscape is equally reminiscent of the ones Whistler painted there in the same years. His *Harmony in Blue and Silver: Trouville* (fig. 81) is one of a series dating from the fall of 1865 (Young, et al., nos. 65-70), which he spent in the company of Courbet, the tiny figure shown at the lower left. Yet this picture has less in common with Courbet's beach scenes than with Manet's, with which it shares its elegantly understated design—wide, parallel bands of sand, sea, and sky, lined up vertically and divided by a high horizon—and its masterful execution in smooth, sweeping strokes, clean and concise in effect. This "minimalism" is of course more apparent in the Whistler, whose single small figure is lost in romantic contemplation of the vastness of nature; but stylistically the two works remain very much alike. Although the two artists had been friendly since the beginning of the decade, and Manet had learned much at that time from Whistler's masterful etchings (cf. cat. 65), in their seascapes nei-

ther one necessarily influenced the other. Manet had in fact already developed his distinctive vision of the sea as a harmony of subtly related tones in the *marines* he painted at Boulogne in the summer of 1864 (Staley, 97-98).

The *Seashore* exhibited here belongs to a later moment in Whistler's career, when he returned to representing the broad expanse of the ocean after having concentrated on more confined bodies of water, the harbor at Valparaiso and the Thames near Chelsea, in the late 1860s and 1870s; yet it reveals the same approach as the Trouville pictures of twenty years earlier. Although unidentified, it was probably painted at Dieppe in the fall of 1884, along with other small and, for Whistler, rather brightly colored panels showing a few figures on an otherwise bare beach (Young, et al., nos. 326-328). In this group he comes as close as he ever does to the more animated and colorful beach scenes of Manet and other French artists he knew.

81. James McNeill Whistler. *Harmony in Blue and Silver: Trouville*, oil on canvas, 1865. Isabella Stewart Gardner Museum, Boston.

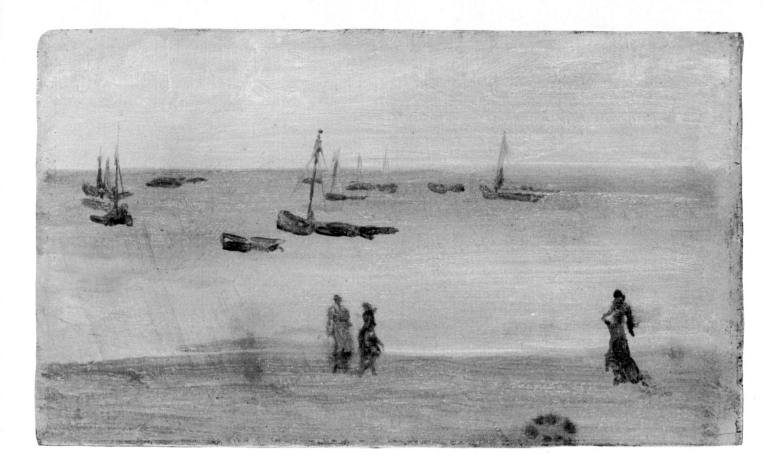

Claude Monet (1840-1926)

54 *Camille on the Beach at Trouville,* 1870

Oil on canvas, 15 x 18½ in. (38 x 47 cm.)
Signed and dated, lower left: *Claude Monet 70*
Mrs. John Hay Whitney, New York
Wildenstein, no. 160

Throughout the 1860s, when his friend and former teacher Boudin was recording the fashionable life on the beaches at Trouville and Deauville (e.g., cat. 52), Monet chose instead a dozen less worldly sites along the same coast, from Honfleur to Fécamp. The most important of these were Sainte-Adresse and Honfleur itself, where he painted the fishing fleets at sea, in the harbor, or tied up on shore and, on one occasion, the sailboats in a regatta, but not the idle life of the holiday resorts. It was in the summer of 1870, in the last months of the Empire, that he first stayed at Trouville, accompanied by Camille, whom he had just married, and for a while by the Boudins. In those two months, however, he explored the place more imaginatively than the older artist had done in several years. Of the nine extant paintings (Wildenstein, nos. 154-162)—there were undoubtedly more, perhaps lost during the war that broke out that summer—one shows the entrance to the port and one the terrace of a large hotel; two are sweeping views of the beach and the hotels lining it; the rest are of Camille on the beach, alone or with Mme Boudin or a cousin. In one or two cases (e.g., fig. 82), the ladies' features are drawn so swiftly and vigorously as to verge on caricature, a mode of expression altogether foreign to the gentle Boudin but very familiar to Monet, who had begun his career by caricaturing acquaintances in Le Havre.

In the version of the beach at Trouville exhibited here, the viewpoint is unusually low: Camille looms up, largely filling the foreground, and the beach recedes rapidly to the right, where two small figures stand. It is a space directly perceived from a specific spot and for a single moment, unlike the space of the beach scene Manet had painted at Boulogne the year before (cat. 51), which he

had reconstructed from memory and peopled with figures whose sizes are incommensurate with their positions in depth. It is also a space more convincingly filled with air than Manet's, suggesting an almost palpable atmosphere that softens the contours of things and gives those in the distance a faintly bluish cast. Yet the coloring throughout is fresh and vivid, and the movement of Monet's brush swift and spontaneous.

82. Claude Monet. *On the Beach at Trouville*, oil on canvas, 1870. Musée Marmottan, Paris.

Edouard Manet

55 *On the Beach*, 1873

Oil on canvas, 23⁷⁄₁₆ x 28¹³⁄₁₆ in. (59.6 x 73.2 cm.)
Signed, lower right: *Manet*
Musée d'Orsay (Galerie du Jeu de Paume), Paris
R-W 1:188

When, after an interval of four years, including the momentous years of foreign invasion and civil war, Manet returned to the Norman coast in the summer of 1873, it was not to Boulogne, whose busy harbor and fashionable beach had attracted him at the end of the Empire, but to Berck-sur-Mer twenty miles south, then little more than a fishing village hidden among the dunes and still undeveloped as a resort. During the three weeks he spent there, a period of calm and confidence following the unprecedented success of his *Bon Bock* at the Salon late that spring, he painted a surprisingly large number of pictures (R-W 1:188-202). The majority are close-up views of fishermen toiling in small boats or repairing them on shore, or more distant views of the boats at sea, very much like those that Boudin was to paint at Berck a few years later (Schmit, nos. 1053-1061), but several are of Manet's relatives and friends on the beach, in the fields, or on the balcony of his rented villa.

The picture exhibited here shows Manet's wife Suzanne and his brother Eugène in a close-up view more intimate than that of the bathers and strollers in the Boulogne beach scene (cat. 51) and more obviously seen by an observer who occupies their space, is indeed seated beside them. The immediacy of this vision is like that of Monet's Trouville beach scenes of 1870 (e.g., cat. 54) and may even have been influenced by them, for it is not Manet's usual way of seeing. But the greater separation of the figures from the landscape and the stronger division of the latter into horizontal bands are altogether characteristic of him. So too is the balanced, classical design of the two figures, conceived as triangular forms of contrasted size and color—the larger one a warm, light gray, the smaller one a very dark gray—and turned toward each other to create a closed, compact group anchored to the frame.

Eugène Manet's pose, it has been noted (Florisoone, xx), resembles his brother Gustave's in the *Déjeuner sur l'herbe* (fig. 83) painted ten years earlier, which in turn was based on that of a river god in a Renaissance print of

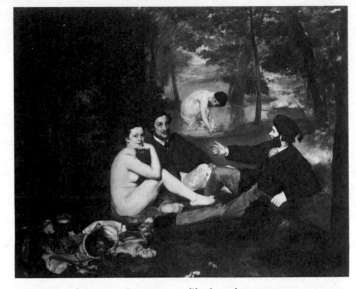

83. Edouard Manet. *Déjeuner sur l'herbe*, oil on canvas, 1862-1863. Musée d'Orsay (Galerie du Jeu de Paume), Paris.

the Judgment of Paris; but whether Manet intended such an allusion in the later work seems doubtful. Certainly there is no resemblance between the massive, introspective figure of his wife and the slender, provocative figure of Victorine Meurent in the earlier work.

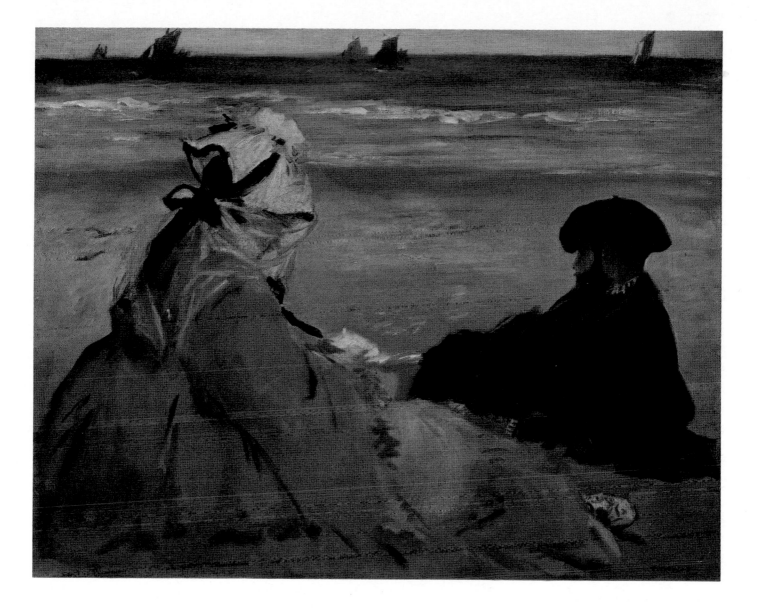

Edouard Manet

56 *Women on the Beach,* 1873

Oil on canvas, 15¾ x 19¼ in. (40 x 48.9 cm.)
Signed, lower right: *Manet*
The Detroit Institute of Arts, Bequest of Robert
 H. Tannahill
R-W 1:189

Painted at Berck-sur-Mer in the summer of 1873, in the same productive three-week period in which the Musée d'Orsay beach scene (cat. 55) was painted, this one too is composed of two large figures placed squarely within the field; but they are treated so broadly as to be unidentifiable, even if friends or relatives of the artist must in fact have posed for them. There is a remarkable breadth and simplicity in the painting of their faces, as indeed of everything else, an elimination of descriptive detail and a concentration on large, strongly illuminated forms that seems truly classical in spirit. The same is true of the composition: against the flat, parallel bands of yellow sand, blue-green sea, and blue sky, as horizontal as in an ancient relief, the two bathers are disposed in a formal balance like ancient statues. One wears a rose-gray costume and is standing and turned toward us, her arms held close to her sides; the other wears a dark blue suit and is reclining and turned away, her arms extended above and below her. The two figures' feet just touch, marking the right angle of the equally classical triangle formed by their perpendicular axes. Behind the reclining bather, several smaller ones immersed in the water serve to counterbalance the greater height of her standing companion. If both figures are reminiscent in their poses and their stability of ancient sculpture, the reclining one resembles a specific type, the Sleeping Faun or Bacchante, who lies in just this way with one arm supporting the body and one encircling the head.

In its remarkably concise and elegant execution, however, in which each deft and darkly accented stroke plays a part in the flowing calligraphy of the whole, this picture looks not backward but forward, even beyond impressionism, to Matisse and other twentieth-century masters. It is clearly the kind of picture that Matisse, an artist equally concerned with the "condensation of his sensations," had in mind when he painted his own beach scenes at Etretat in 1920, using areas of warm gray and yellow-tan and outlining them in black to create a comparable effect of luminosity (Barr, 209, 432-433).

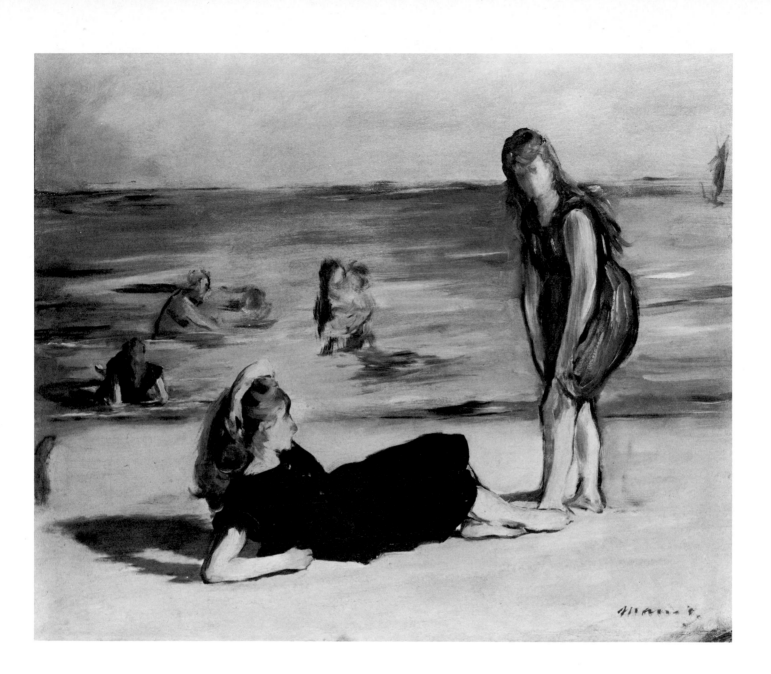

Edgar Degas (1834-1917)

57 *Beach Scene,* 1876-1877

Oil on paper, mounted on canvas, 18½ x 32½ in.
 (47 x 82.5 cm.)
Signed, lower right: *Degas*
The Trustees of The National Gallery, London
Lemoisne, no. 406

A scene of outdoor bathing rare in Degas' work at this early date, this picture may well have been inspired by some of Manet's, especially by *On the Beach at Boulogne* (cat. 51). Both compositions are unusually wide for their height and are divided into flat, smoothly painted bands of sand, sea, and sky, on which figures are dispersed in an apparently random manner. In both they are wittily characterized, though Degas' young girl and her maid form a more monumental, serious group; and in both they stand out as dark or light shapes against the uniformly bland landscape, though Degas captures its misty atmosphere more fully, while also introducing stronger patterns and richer color accents, notably in the play of reddish brown, cool green, and white. Interestingly, he had first explored the atmosphere and vast space of the shore in a series of pastels (e.g., fig. 84) done in 1869 at Boulogne, presumably in Manet's company.

The convincing naturalness of this picture was, as always in Degas' art, less a product of observation than of invention. When asked how he had achieved the *plein-air* effect, he replied: "It's very simple. I spread my flannel vest on the studio floor and had my model sit on it" (Vollard, 112). In this highly synthetic process, the composition was evidently transformed. Initially it must have centered on the foreground group, ending at the tip of the girl's shoe; this part is painted on two sheets of paper of standard size, 32 x 48 cm., joined vertically. The smaller group at the upper left is painted on a narrower sheet, joined along a line touching the girl's shoe and bisecting the lady with an umbrella, who was presumably added, with the gentleman and the dog, when the format was extended.

This picture was shown at the 1877 impressionist exhibition alongside the *Young Peasant Girls Bathing in the Sea at Nightfall* (Lemoisne, no. 377), which is in many

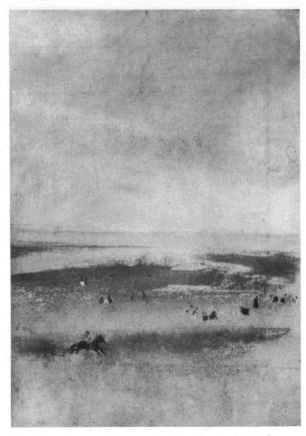

84. Edgar Degas. *Horsemen and Strollers at the Seashore,* pastel, 1869. Private collection.

ways its pendant. The contrast between the naked peasant girls splashing in the water at dusk and the clothed city girl lying on the beach in the sun would have amused Degas, who seems deliberately to have arranged such a juxtaposition by showing the *Young Peasant Girls* a second time in 1877, after it had appeared in the previous impressionist exhibition.

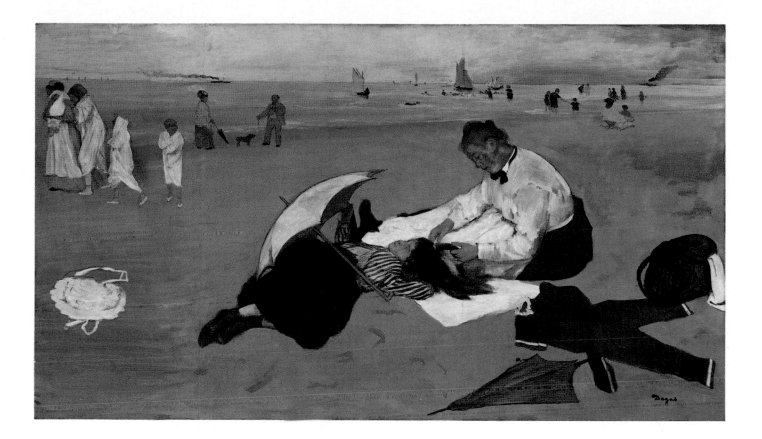

Jean-Baptiste-Camille Corot (1796-1875)

58 A *Beach near Etretat,* 1872

Oil on canvas, 4⅞ x 10 in. (12.5 x 25.5 cm.)
Signed, lower left: *COROT*
National Gallery of Art, Washington, Ailsa
 Mellon Bruce Collection 1970
Robaut 1905, no. 2076

Although Etretat became a popular summer resort in the Second Empire, thanks largely to the publicity provided by the journalist Alphonse Karr, it never attained the vogue of other Norman beaches such as Trouville and Deauville, retaining instead its character as a fishing village. But unlike the other sites, it has a picturesque grandeur due to its huge limestone cliffs, which plunge straight into the sea, forming unusual pillars and *portes,* or openings; and these had appealed to artists since the beginning of the century. The Fielding brothers, Horace Vernet, Isabey, and Jongkind all worked there, as did Delacroix in 1835-1836 and 1848-1849, fascinated by the massive forms of the cliffs rising above the shore; Courbet too painted there in the summer of 1869, producing over a dozen canvases in which the jagged silhouettes, especially of the Porte d'Aval, are contrasted with a few small fishing boats on the beach (Belloncle, 24-31). In the previous winter, and again in the summer of 1873, Monet also made these strikingly silhouetted forms the basis of powerfully evocative pictures (Wildenstein, nos. 127, 258).

When Corot visited Etretat in the summer of 1872, spending two weeks in September with the Stumpf fam-ily (Moreau-Nélaton 1924, 2:55), he characteristically avoided such grandiose and occasionally violent sites and chose instead more tranquil, pastoral ones: small cottages and windmills away from the sea, his friend Dumesnil's country villa, and the racetrack with a glimpse of the shore (Robaut 1905, nos. 2055-2060, 2073). His one important picture of the beach (Robaut 1905, no. 2054) is a serenely human view with a low horizon, in which the Porte d'Amont appears as a relatively small, distant form and the fishing boats and mooring timbers as nearer and more important ones. The smaller picture exhibited here does not show the familiar cliffs at all, but since it was painted in 1872 and was first owned by the Stumpf family, its beach is undoubtedly the one at Etretat and its tiny fishing boats on the horizon those of the Etretat fleet. A larger variant (Robaut 1905, no. 2061) represents very nearly the same site, with one or two fishermen on the shore. Both are broadly painted with sweeping strokes of rather thick, creamy pigment that create a fluid unity of sand, sea, and sky.

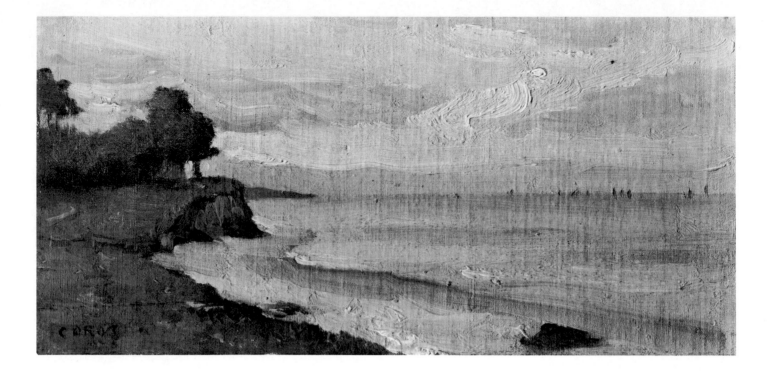

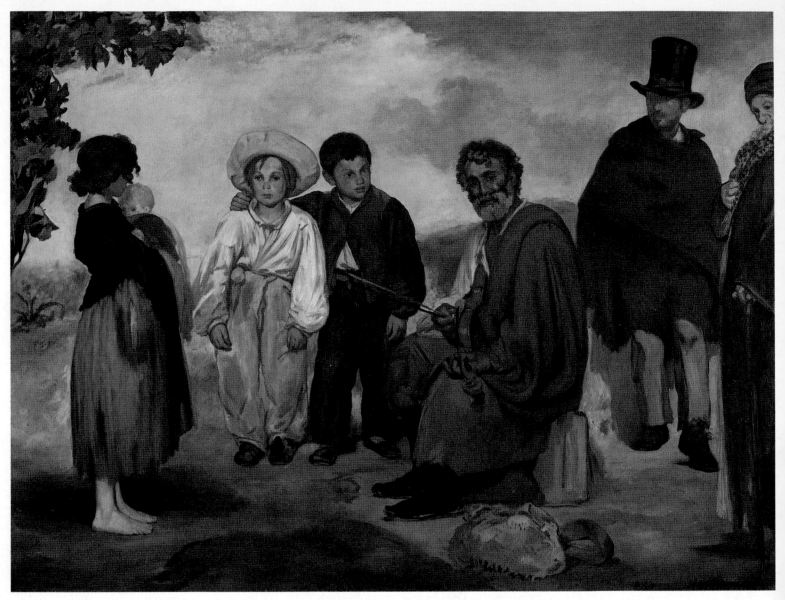

Plate 12. Edouard Manet. *The Old Musician*, 1862. Cat. 59.

7

The Street as Public Theater

❧

IN THE SECOND EMPIRE, the wandering performers and street operators who had long been a traditional part of Parisian life could still be seen in many public squares and streets, despite increasing regulation and harassment by the police. Working alone, in small groups, or in extended families, the strolling singers and musicians, acrobats and jugglers, clowns and charlatans were a familiar daily sight. And no wonder, given the wretched condition of the urban poor: in 1863, some 118,000 of them were officially listed as indigent and 10,000 others were arrested as vagabonds, to say nothing of all those who avoided becoming such statistics (Delvau 1867, 2: 1887-1888). Some of the performers had their favorite spots on the boulevards or the Champs-Elysées; others made the rounds of the cafés and apartment house courtyards. Of the musicians, many had been students and teachers and played conventional instruments or, in the case of one notorious clarinetist, made a living by agreeing not to play; a few attracted crowds with their outlandish instruments, like the singer of popular ballads on the place de la Bastille, who accompanied himself on a "violin" fashioned from a stick, two strings, and a bladder (fig. 85; cf. Texier, 967-968).

Perhaps the most eccentric street musician was the "Homme-Orchestre" whom Yriarte describes: on one leg he had a ring of bells; at each knee, a cymbal; on his back, a large drum that he struck with a stick attached to one hand; fixed to his neck at the level of his mouth, a syrinx; and in his hands, a violin and bow (Yriarte, 199-211). Yriarte's book, *Paris grotesque: Les Célébrités de la rue* (1864), was but one of many published in these years on the colorful and often desperate types to be found in the streets of Paris, living off their wits; among the other books were Fournel's *Les Spectacles populaires et les artistes des rues* (1864), Privat d'Anglemont's *Paris anecdote* (1860), and Vallès' *La Rue* (1866). Most of these writers viewed the so-called "street entertainers" with middle-class irony or detachment; only the socialist Vallès, moved by their degradation and struggle for survival, spoke of them as individuals, whose origins, daily lives, and hardships he recounted.

Although the representation of street performances had a long history in French art, it became more prevalent in the 1830s, when Paris itself and the concurrent interest in depicting its familiar sights both expanded rapidly. The lithographs of saltimbanques and prestidigitators made at that time by Victor Adam, Decamps, and Raffet, and those of side shows and street musicians made slightly later by Daumier, mark the emergence of this newly important iconography. It was developed further in the following decades, and with a more profoundly personal content, in Daumier's paintings of strolling singers and musicians and above all in his watercolors of saltimbanques performing unsuccessfully at fairgrounds or moving through unfriendly streets (e.g., fig. 98). It found an equally gloomy expression in Ribot's tenebrous pictures of ballad singers and guitarists, reminiscent of medieval troubadours (e.g., cat. 71). Manet's numerous acrobats, bear-trainers, organ-grinders, street singers, and gypsy violinists of the early 1860s belong to this tradition of realist imagery, though they are not entirely contained by it. Implicit in his very choice of such subjects was sympathy for the plight of these street artists and criticism of the society that barely tolerated them.

The same attitude determined Manet's interest both earlier and later in rag-pickers—those who posed for the *Absinthe Drinker* (fig. 94) and the *Rag-Picker* (R-W 1:137) itself—in the so-called philosophical beggars (e.g., fig. 9), and in gypsy families who, like Daumier's saltimbanques, were estranged from society and harassed by the police (e.g., fig. 97). The street singer whom Manet noticed emerging from a low cabaret (fig. 86) was more than a picturesque type whose graceful movement he

Edouard Manet

59 *The Old Musician*, 1862

Oil on canvas, 73¾ x 97¾ in. (187.4 x 248.3 cm.)
Signed and dated, lower right: *éd. Manet 1862*
National Gallery of Art, Washington, Chester Dale Collection 1962
R-W 1:52

88. Célestin Nanteuil. *The Drinkers* (after Velázquez), lithograph, 1855. Bibliothèque Nationale, Paris.

🐚 This is the largest and most ambitious picture Manet painted before the *Déjeuner sur l'herbe* and *Olympia* of 1862-1863. It is also his first important picture of modern Paris, in which several themes of his early work—urban vagrants, itinerant performers, wandering gypsies—come together in a monumental image of haunting, melancholy power. The latter feature has been seen as "the result of the placing together of unrelated figures bound to one another by no real iconographic thread, and set in no particular time or place" (Farwell 1973, 94). It is true that the setting is vague, and apparently rural rather than urban; but the figures do belong to a particular place and time, Paris in the early 1860s, and the iconographic thread that binds them is their estrangement from a society that not only rejects them as alien and dangerous, but has literally displaced them from the slums they once occupied. Each of them was a familiar type in the city whose streets Manet, a "perfect *flâneur*" in Baudelaire's sense, loved to explore, and some of them can even be named.

The old musician himself was posed by Jean Lagrène, the leader of a band of gypsies who lived in the Batignolles district and earned his living as an organ-grinder. The model for the brooding figure behind him was Colardet, a rag-picker and iron-monger whom Manet had met in the Louvre and first portrayed in the *Absinthe Drinker* (fig. 94). The bearded old man at the far right was posed by Guéroult, the "old Jew with a white beard" mentioned in Manet's notebook, who thus represents the popular figure of the Wandering Jew. The two street urchins of contrasted appearance are anonymous, though one was perhaps posed by Alexandre, a poor deranged boy who served as Manet's assistant and occasional model (cf. p. 26, above), and the other evokes Watteau's *Gilles*, the very image of the alienated individual. And the orphan girl burdened with an infant is a gypsy whom Manet adapted from a contemporary painting of a bohemian family gathered around a kidnapped child.

Even the setting may evoke more of the Paris of the early 1860s than its rural appearance at first suggests. If it is not Petite Pologne, where Manet found some of his models, it may well be the "remote street" behind the Parc Monceau, surrounded by "huge vacant lots," where he had his studio (Duret, 86), an area still so undeveloped that it could be described at the time as "returning to virgin forest" (Pinkney, 11). If nevertheless the *Old Musician*'s ambiance is often felt to be Spanish, that is probably because it is often seen as alluding to Velázquez' *Drinkers* (fig. 88); and with good reason, since that picture too shows a group of bohemian characters disposed in a shallow, friezelike space, the one at the upper right wearing a cloak and tall hat, the one at the lower left turned in profile toward the others, and it too makes use of a grapevine in one corner to frame the rural landscape. Although it is always assumed that Manet, who first saw the *Drinkers* in Madrid in 1865, was familiar with its composition through Goya's etched copy, he more likely relied on the later lithographed copy by Nanteuil that is illustrated here; in any event, it is the one that appears in the background of his portrait of Zola in 1867 (Reff 1975, 39).

Later paintings of bohemian life in the tradition of both Velázquez and Goya may also have played a part in the development of the *Old Musician*. Such subjects were

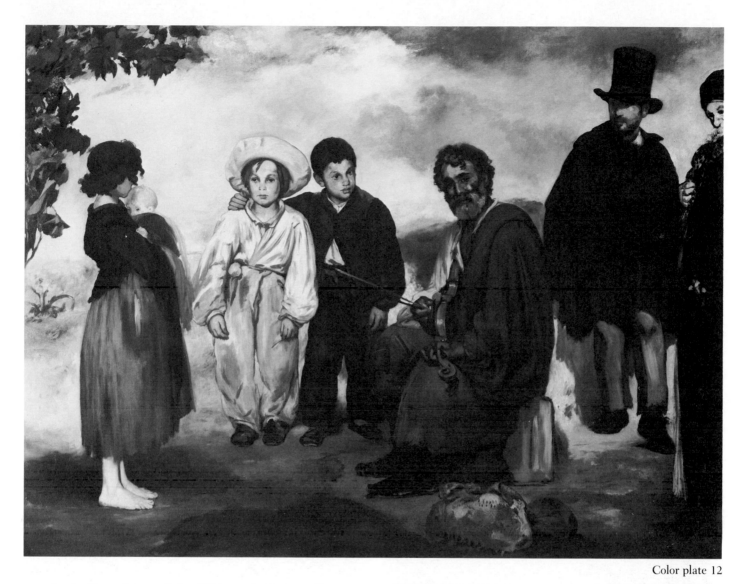

Color plate 12

popular in French art of the 1830s and 1840s, reflecting
an interest in Spanish "local color" that paralleled the
enthusiasm for Spanish art. A striking example, reminis-
cent of Velázquez' *Drinkers* in its design and of Goya's
paintings in its style, is Blanchard's *Indigents from the
Asylum of San Bernardino* (fig. 89). Like Manet's picture,
it shows a small group of poor people, children as well as
adults, among them a top-hatted man similar to the
absinthe drinker, who confront the viewer in a solemn,
self-conscious, and mysterious manner. And like Ma-
net's figures, they are aligned as in a frieze and depicted
as strongly silhouetted forms. There is no evidence that
he knew Blanchard's painting, which remained in Span-
ish collections (Guinard, 382), but he may well have
known others like it by Blanchard himself or by Dauzats
or other French artists who specialized in modern Span-
ish genre subjects.

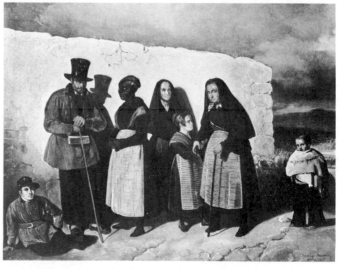

89. Pharamond Blanchard. *Indigents from the Asylum of San
Bernardino, Madrid, Warming Themselves in the Sun*, oil on canvas,
1835. The Marquis de Valdeterrazo, Madrid.

Antoine Le Nain (c. 1588-1648)

60 *The Old Piper,* 1642

Oil on copper, 8⅜ x 11½ in. (21.3 x 29.2 cm.)
Signed and dated, lower right: *Lenain. ft 1642*
The Detroit Institute of Arts, City Appropriation
Thuillier, no. 20

🐛 That the sources of the *Old Musician* include, in addition to Velázquez' *Drinkers,* a painting by one of the Le Nain brothers has long been recognized. The work most frequently cited is Louis Le Nain's *Halt of the Horseman* (fig. 90), which shares with Manet's picture enough features, including the seated posture, direct

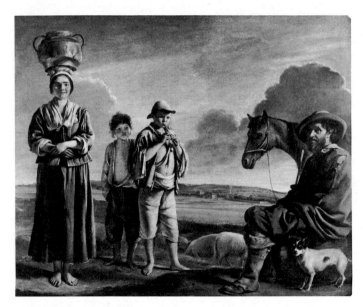

90. Louis Le Nain. *The Halt of the Horseman,* oil on canvas, c. 1640. The Victoria and Albert Museum, London.

91. Antoine Watteau. *Gilles,* oil on canvas, 1721. Musée du Louvre, Paris.

gaze, and heavily folded cloak of the old man, and the stances, gestures, and relationship of the young boys, to make it likely that he knew it in some form, despite the fact that it remained in English collections throughout his lifetime. Another example, more easily accessible and even closer compositionally, is the one exhibited here; it was reproduced in reverse, making it resemble Manet's composition still more, in Saint-Maurice's engraving in the mid-eighteenth century and in Blanc's *Histoire des peintres* in the mid-nineteenth. Blanc was, with Champfleury and Thoré-Bürger, a leader in the revival of interest in the Le Nain, inspired by the democratic ideals of 1848, which saw them as forerunners of contemporary realism in their stress on lower-class subjects and their

naively realistic yet monumental style, a revival whose culmination in 1862 with the publication of Champfleury's *Les Peintres de la réalité sous Louis XIII* coincided with the creation of the *Old Musician.*

Like the sources of Manet's composition, the models for its figures are partly Spanish and partly French. Alongside the dark-haired, swarthy boy based on one of Velázquez' early works—the *Waterseller of Seville* or the *Old Woman Frying Eggs* (Richardson, 13; Feller, 33-34)—stands another boy who, it has long been recognized, is based on Watteau's *Gilles* (fig. 91). Then in a private collection noted for its hospitality to artists, it had also been exhibited at the Galerie Martinet and reproduced in the *Gazette des Beaux-Arts* in 1860. The dreamy, melan-

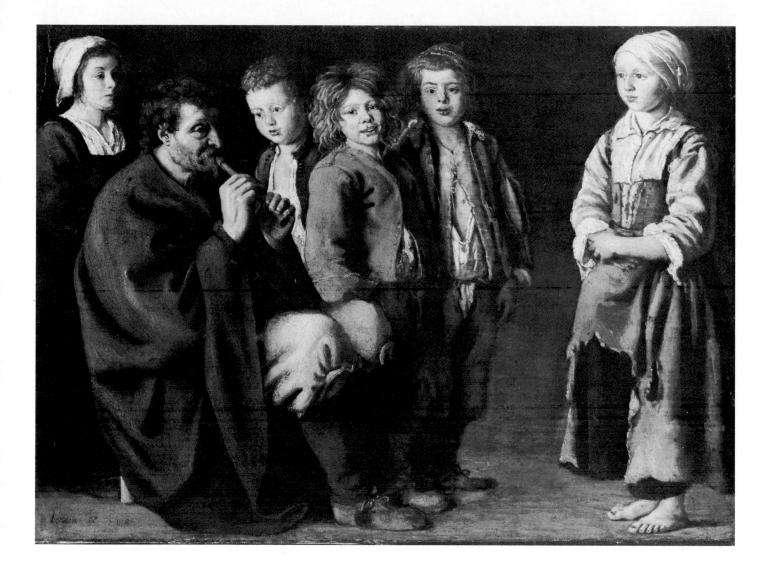

choly Gilles, dressed entirely in white, provided a suitable model for Manet's street beggar, old beyond his years and disillusioned by hardship. But in 1862 Gilles had a more special significance for Manet and his circle: he is identical with Pierrot, the traditional figure of the commedia dell'arte, and closely related to Polichinelle, his Neapolitan counterpart, and both were of current interest: Pierrot as the star of the Théâtre des Funambules, Deburau's pantomime theater, for which Champfleury and others whom Manet knew had written plays, and which at that moment was being destroyed as part of

Haussmann's transformation of the boulevard du Temple (Mauner, 53-55); and Polichinelle as the star of the Théâtre des Marionettes in the Tuileries Gardens, which was directed by Duranty and depicted in prints by Legros, whom Manet also knew, and which inspired him to introduce Polichinelle into a frontispiece etching as a symbol for himself (Fried, 37-40). Nothing would have been more appropriate than to evoke the figure of Pierrot/Polichinelle in the form of Gilles in the *Old Musician*, a picture resonant with overtones of street performers, bohemian life, and Manet's own persona.

Edouard Manet

61 *Chrysippos* (Study for *The Old Musician*), c. 1862

Pencil and red chalk, 8¹⁵⁄₁₆ x 5⅝ in. (22.7 x 14.3 cm.)
Atelier stamp, lower right: *E. M.*
Cabinet des Dessins, Musée du Louvre, Paris
R-W 2:307

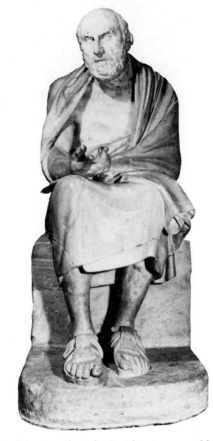

92. Euboulides (attributed to). *Chrysippos*, marble statuette, c. 210 B.C. Musée du Louvre, Paris.

Although the old musician in Manet's picture was painted from a live model, a Parisian gypsy well known at the time, he was also based on an historical model, a Roman replica of a Hellenistic statuette in the Louvre (fig. 92). It is attributed to the sculptor Euboulides and represents the Stoic philosopher Chrysippos, and it was then prominently displayed in the Louvre and widely admired; a copy was also installed in the courtyard of the Ecole des Beaux-Arts (Mauner, 52). From one or the other, and with its eventual use in the *Old Musician* no doubt in mind, Manet made the drawing exhibited here (De Leiris 1969, 401-402). Although swiftly and freely executed, as if done from memory or a live model, it reproduces faithfully enough the statuette's essential features, including the philosopher's seated pose, the cloak folded broadly around him, the block on which he sits, and his conspicuous right hand (drawn in pencil, whereas the rest is drawn in red chalk), whose extended fingers embody his animated gestures as he argues his points. If his head appears somewhat different in Manet's drawing, it is because in his day the statuette was restored with a head of Aristotle, which has subsequently been replaced by one of Chrysippos. In fact the subject was thought to be Poseidonius, another philosopher of the Stoic school (Mauner, 59), but this distinction would hardly have concerned Manet, who in any event represented in the *Old Musician* the features of his live model.

Manet's choice of the statuette was appropriate thematically as well as visually; for a philosopher, especially one who preached indifference to pleasure and patient endurance, was precisely what the other models for the old musician, a gypsy organ-grinder and Le Nain's old piper, were then thought to be. "The itinerant musician," wrote Victor Fournel, "is a philosopher: he knows the vanity of worldly glories" (Fournel 1858, 10); and the "philosophical rag-picker," a related street type whom Traviès had portrayed in a well-known lithograph of the rag-picker Liard, was desribed by Champfleury as "always surrounded by neighborhood children, whom he instructs by his own methods" (Champfleury 1861b, 69). In the same way, the old piper in Le Nain's picture was described, again by Champfleury, as embodying the gravity and wisdom of an ancient teacher: "wrapped in a large cloak, [he] has the air of a philosopher of antiquity" (Champfleury 1850, 31).

47 × 94

Potteau (active 1862-1865)

62 *Jean Lagrène,* 1865

Photograph, 5⅞ x 5⅛ in. (15 x 13 cm.)
Not signed or dated
Bibliothèque du Muséum National d'Histoire
 Naturelle, Paris

🦋 The model for the old musician himself, previously assumed to be the old Jew named Guéroult whom Manet mentions in a notebook, has recently been identified as the gypsy Jean Lagrène on the basis of this photograph and another, showing him in profile, taken in 1865 (Brown, 77, 79). They are among a large series of anthropological portraits of various ethnic groups and national types taken by the photographer Potteau for the Muséum d'Histoire Naturelle in that decade. Although three years older, and now sixty-six, Lagrène is easily recognizable as Manet's subject (fig. 93) by his "high, swarthy cheekbones, aquiline nose, piercing eyes, and curly locks—all distinctive features of gypsy physiognomy" (Brown, 77, 79). The leader of a band of gypsies who lived in the Batignolles district, in which Manet's studio on the rue Guyot was also located, he was undoubtedly a familiar neighborhood figure. Although Lagrène actually earned his living as an organ-grinder and artist's model— he was reputed to have sat for many famous artists— Manet has shown him as a violinist, hence as "the archetypal gypsy musician," since this was the instrument that gypsies, especially those of eastern Europe, were most renowned for playing (Brown, 83-84). But since they were also thought to be direct descendants of ancient peoples, and indeed were compared in their bearing with antique statues, it was appropriate for Manet to represent Lagrène in the form both of a Hellenistic statuette of Chrysippos (cat. 61) and of Le Nain's old piper (cat. 60), who in turn was compared with such statues. All these sources—individual, cultural, and art-historical—reinforced Manet's conception of the itinerant musician as a kind of street philosopher.

Beneath Manet's fascination with gypsies in the early 1860s, which manifested itself in other works besides the *Old Musician,* among them the large picture *The Gypsies* (R-W 1: 41), the smaller one *Gypsy Smoking a Cigarette* (R-W 1: 46), and the etching *The Travelers* (H 4), there undoubtedly lay not only a deep sympathy with these urban nomads who rebelled against conventional society and an artistic interest in their unfamiliar, colorful

93. Edouard Manet. *The Old Musician* (cat. 59), detail.

appearance, but also an identification with the most gifted among them, the itinerant musicians, as consummate artists in their own right. We need not discover "an actual resemblance" between them to realize that the old violinist has become for Manet a symbol of the artist (Mauner, 78).

Edouard Manet

63 Study for *The Absinthe Drinker,* 1858-1859

Watercolor, 11⁷⁄₁₆ x 7½ in. (29 x 19 cm.)
Atelier stamp, bottom center: *E. M.*
National Gallery of Art, Washington, Rosenwald
 Collection 1943
R-W 2:451

The gloomy figure wrapped in an old-fashioned opera cloak, his face shaded by a battered top hat, who half stands and half sits on a low wall at the right side of the *Old Musician* was obviously copied from Manet's earlier picture, *The Absinthe Drinker* (fig. 94). His first important independent work, painted in 1858-1859 while he was still a student in Couture's studio, it reveals a realist interest in portraying bohemian low life on a large scale, stripped of picturesqueness, and a lingering romanticism in the shadowy mystery that envelops the figure. Baudelaire's poem "Le Vin des chiffoniers" in the *Fleurs du mal* (1857) has been cited more than once as a literary parallel and possible source, and with good reason: not only were he and Manet friendly at this time—he was in the artist's studio when news of the picture's rejection at the Salon of 1859 arrived (Proust, 33-35)—but Manet's etched portrait of him strangely resembles that of the absinthe drinker (Wilson, no. 24). And like the poem, the picture is about a rag-picker, a melancholy type named Colardet, whom Manet had met in the galleries of the Louvre and persuaded to pose for him (Moreau-Nélaton 1926, 1: 25-26). For Baudelaire the rag-picker is "like a poet," for Manet, like a philosopher: in drawing up a list of works for sale, he later grouped the *Absinthe Drinker* with the so-called *Philosophers,* in reality beggars, of 1865 (e.g., fig. 9) and the *Rag-Picker* of 1869 (R-W 1:137) as "four philosophers," in the tradition of Velázquez' pictures of the beggar-philosophers Menippus and Aesop. Thus the rag-picker joins the gypsy musician and the Wandering Jew as an embodiment of the streetwise bohemian types shown in the *Old Musician.*

The watercolor exhibited here was evidently made in preparation for the painting, though its color harmony, now somewhat faded, of pale reddish brown and gray tones, with a few accents of deeper brown, hardly foretells either the strong contrasts of light and dark or the

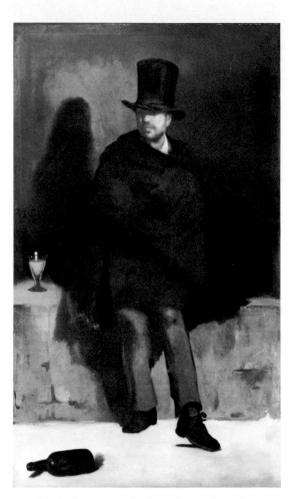

94. Edouard Manet. *The Absinthe Drinker,* oil on canvas, 1858-1859. Ny Carlsberg Glyptotek, Copenhagen.

passages of vivid color in the final work. Another wash drawing, entirely monochromatic (R-W 2:452), was probably a study for the etched reproduction of the painting made a few years later (cat. 64). It corresponds more closely to the latter in the pattern of folds on the cloak, the shape of the cast shadow, and the inclusion of the empty bottle on the ground.

Edouard Manet

64 *The Absinthe Drinker,* 1862

Etching, 11⅜ x 6¼ in. (28.8 x 15.9 cm.)
Signed in the plate, upper right: *éd. Manet*
National Gallery of Art, Washington, Rosenwald
 Collection 1943
H 16, second state

This is one of four states, not three as previously thought (Wilson, no. 24), on which Manet worked over a period of many years, after publishing this state in his *Cahier de huit eaux-fortes* in October 1862. Although the painting it reproduces (fig. 94) dates from 1858-1859, the etching has convincingly been dated 1861-1862 (Harris, 68). The last state, in which most of the plate is covered with two tones of aquatint, largely concealing the earlier line-work and deepening the aura of mystery and gloom enveloping the figure, may date from many years later; a dozen examples were printed posthumously around 1910-1912.

In repeating the theme of the absinthe drinker several times in his early work, Manet was responding to a social problem of current concern. Although absinthe had long been known in France, it first became popular in the

1850s: previously drunk only by lackeys, it was now consumed by everyone, one writer noted in 1862, and there were five hundred establishments in Paris alone that specialized in serving it, among them the famous cabaret "Mère Moreau" (cf. cat. 18); it was in fact so popular that a "Club des Absintheurs" was formed in the rue Saint-Jacques district whose members swore to drink nothing else (Delvau 1862, 247-253). Its debilitating effects were by now equally well known: an allegorical lithograph, also published in 1862, shows a crowd of addicted drinkers around a street fountain from which absinthe pours, described in the accompanying text as a "fountain of death" (Coligny, 4-7). In the following year Daumier devoted two lithographs to the same subject (Delteil, nos. 3255, 3256), stressing the haggard or half-crazed look of the absinthe drinkers in cafés. Manet himself, in copying a *Drinker* attributed to Brouwer (fig. 95), must have assumed that the excessively animated subject was a victim of absinthe poisoning, for he inscribed his canvas "le buveur d'absinthe." That the *Drinker,* now attributed to Van Craesbeeck, was thought to be a self-portrait of Brouwer is also relevant for Manet's self-identification with the absinthe drinker he painted, which paralleled Baudelaire's with the intoxicated rag-picker he described in "Le Vin des chiffoniers" (cf. cat. 63).

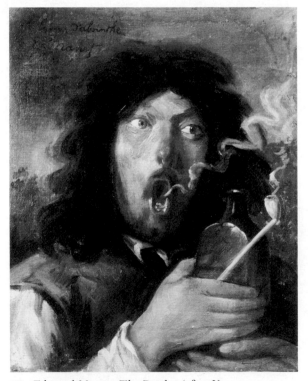

95. Edouard Manet. *The Drinker* (after Van Craesbeeck), oil on canvas, 1858. Private collection, Rome.

Henri-Guillaume Schlesinger (1814-1893)

66 *The Kidnapped Child,* 1861

Wood engraving (after the painting), 4⅝ x 6¹⁄₁₆
 in. (11.8 x 15.3 cm.)
From *Le Magasin pittoresque* 29 (1861), 293
The Library of Congress, Washington

Among the sources still being discovered for the *Old Musician,* the latest and perhaps least expected is a painting by Schlesinger, an artist entirely forgotten today, which appeared at the Salon of 1861: the barefoot girl with an infant in her arms who stands at one side of his *Kidnapped Child* was evidently the model for the one standing in a similar position in Manet's composition (Hanson 1972, 146). As x-ray photographs of the latter reveal (fig. 96), the barefoot girl was originally seen in strict profile and thus resembled Schlesinger's even more closely than she now does. Although treated in an anecdotal and sentimental manner, his subject—a family of gypsies in their camp with a child they have just kidnapped—is consistent with some of Manet's other sources; and Schlesinger's coloristic style—he was praised as "a clever colorist who does not shrink back from using vivacious tones" (Lagrange, 56)—might well have caught Manet's eye. The *Kidnapped Child* must also have achieved considerable renown through the wood engraving exhibited here, which appeared in one of the most popular journals of the period. In the year he painted the *Old Musician,* Manet used an engraving published earlier in the same magazine as a model for the Pulcinella in one of his frontispiece etchings (Reff 1962, 184).

Manet may also have made use of the *Kidnapped Child* in another large painting of 1861-1862, this one explicitly about a family of gypsies in the countryside, entitled *The Gypsies.* After exhibiting it in 1863 and 1867, he cut it into several fragments, of which three survive (R-W 1:42-44); but with the aid of contemporary descriptions and caricatures, an x-ray photograph of one fragment, and his own etching showing the composition reversed (fig. 97), it has been reconstructed (Hanson 1970, 162-165). The motif of the naked infant lying in the lap of a seated figure who looks down at it is the same as in the Schlesinger, and the resemblance would have been more obvious in the painted version of the *Gypsies.*

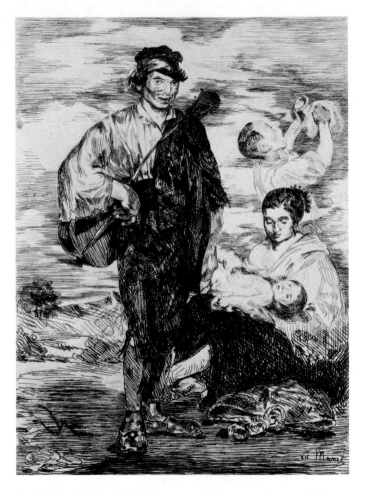

97. Edouard Manet. *The Gypsies,* etching, second state, 1862.
The Metropolitan Museum of Art, New York, Rogers Fund, 1921.

Edouard Manet

67 *The Old Musician*, 1862

Pencil, colored crayon, ink, and wash, 9⁷⁄₁₆ x
 12⅝ in. (24 x 32 cm.)
Atelier stamp (on reverse), lower left: *E. M.*
Private collection, London
R-W 2:308

Usually described as a preliminary study for the *Old Musician*, this drawing is almost certainly a copy after it, made in preparation for an etching. The monochromatic medium would be unique among the drawings clearly intended as compositional studies for paintings, whereas it is common among those made for prints (H 6, 8, 9, and related drawings). The dimensions are those of a standard cooperplate, like the ones Manet used for some early etchings (H 18, 26). And most telling of all, the subject matter corresponds to that of the painting in every respect, even in those that laboratory examination has shown were modified in the course of its development. But the etching was apparently never executed; only the barefoot girl holding an infant appears in a print (cat. 65).

If the young girl at the left was the most extensively revised of the original figures, the old Jew at the right was an altogether new addition: both x-ray and infrared photographs (taken in November 1981) reveal that this figure was painted over part of the absinthe drinker, traces of whose brown cape appear over the stone wall behind him and inside the contour of the old Jew's sleeve.

These photographs also show that the edges of the drinker's cape, completing its original silhouette, are visible beneath the Jew's long robe; that the sky adjacent to the latter's head was heavily repainted; and that, unlike the young girl's well defined feet, his cannot be seen at any level of the paint structure. It is evident, then, that this figure was introduced at a later stage into a composition that originally contained only five full figures.

The iconographic model for the old Jew may well be the one who appears, in a similarly marginal position, in Courbet's picture *The Painter's Studio* (fig. 12), which Manet reportedly had in mind in painting his own (Bazire, 15; cf. Mauner, 74-76). But the formal model seems to have been Velázquez' *Menippus*, which Manet knew in Goya's etching and had already relied on in painting the *Absinthe Drinker* (Feller, 32). Two of his early academies of draped figures are indeed in the same poses as *Menippus* and its pendant *Aesop* (De Leiris 1969, nos. 135, 136). From Velázquez' image of a philosopher-beggar, an appropriate model thematically, he evidently derived the turning posture and especially the twisted head and bent arm of his similarly cloaked and bearded old Jew.

Edouard Manet

68 *The Street Singer,* 1862

Etching, 8¼ x 11 in. (21 x 28 cm.)
Not signed or dated
S. P. Avery Collection, Art, Prints and Photo-
graphs Division, The New York Public Library,
Astor, Lenox, and Tilden Foundations
H 22, only state

Manet's interest in and sympathy with the itin-
erant musicians who were a familiar sight in the streets
of Paris in the 1860s is evident not only in his large,
carefully developed paintings of an old violinist (cat. 59)
and a street singer (fig. 86), but also in this smaller, more
immediate, and more naively rendered etching contem-
porary with them. It is the only one of the three works
that represents the performer standing before an audi-
ence and actually performing. It is also the most explicit
in describing the urban milieu and its characteristic
types—the laundress with her basket, the schoolboy
with his satchel, the old gentleman, the young woman,
the delivery boy, the policeman—all crowded around the
singer who accompanies himself on the guitar. He is
perhaps one of those "celebrated itinerant singers," such
as "Bouvard, the famous Bouvard, who still parades in
public places with his black coat, his gray hat, and his red
face," whom Vallès evokes a few years later in his
sketches of Parisian street life (Vallès, 174-175). Such
subjects were also treated in popular prints, both in the
truly popular *images d'Epinal* and in more sophisticated
political cartoons (Farwell 1973, 132-133, 158-159),
types of imagery with which Manet's print shares not
only its subject matter, but also its simple, symmetrical
composition, its stiffly immobile figures, and its awk-
ward, almost naive rendering.

These features have been explained as products of
Manet's practice, followed also by Whistler, Fantin-
Latour, and Legros, of drawing directly on the plate,
without a preliminary study (Harris 1970, 80), but since
they do not appear in his other early prints, presumably
executed in the same way, they were probably intended
deliberately to convey an effect of simplicity and naiveté.
The specific character of this form of realism becomes
clearer when the *Street Singer* shown here is compared to
one of Daumier's pictures of the same subject, painted at
almost the same time (Maison, 1: nos. 107, 125), but in a
more complex and sophisticated realist style.

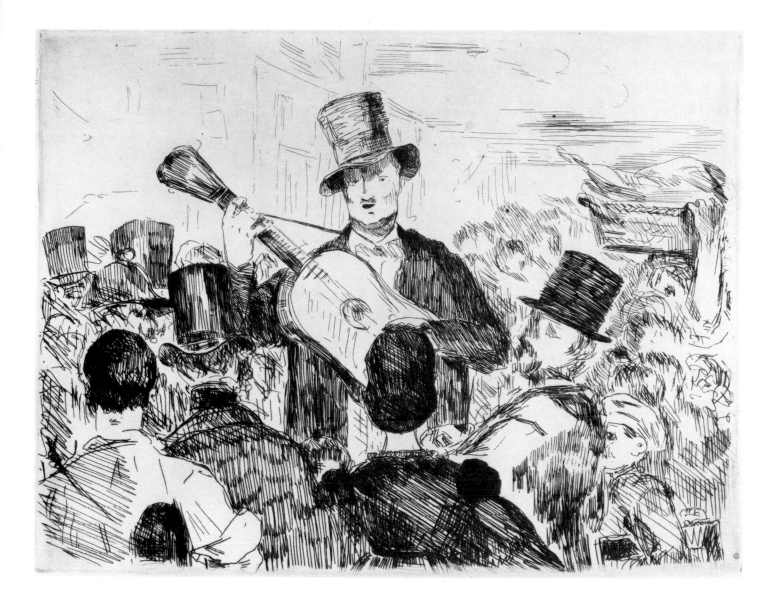

Honoré Daumier (1808-1879)

69 *The Barbary Organ*, c. 1860

Pencil, ink, and watercolor, 13⅜ x 10¼ in. (34 x
 26 cm.)
Signed, lower left: *h. Daumier*
Musée du Petit Palais, Paris
Maison, 2: no. 350

Contemporary with the *Old Musician* and similar in
subject matter, this watercolor is nevertheless more in-
teresting as a foil than as a pendant. It shows how such a
subject might actually have looked around 1860, treated
with comparable power but without the romantic evoca-
tions of Spain, of Spanish art, of gypsies and Pierrots,
that suffuse Manet's image. Daumier portrays as directly
as possible a group of poor people in Paris standing on a
street corner at twilight, wearing nondescript smocks
and shawls, absorbed in the singing or hearing of a simple
refrain. But despite its atmosphere of grim poverty, his
image demonstrates a kind of collective strength in the
size of the audience and its closeness to the performers, a
solidarity that is echoed in the massive stone blocks that
form an arch embracing them all. Manet's picture, for all
its sympathy with the gypsy violinist, the absinthe drink-
er, the old Jew, the street urchins, and the orphan girl, is
more concerned with endowing each of these types with
its own aura of sadness or suffering; Daumier's, for all its
indifference to the individuality of its impassive figures,
half of whom disappear into the shadow of the archway,
more with establishing the social fact of their existence.

Barrel organ players were a common sight on the
streets of mid-nineteenth-century Paris; so much so, we
are told, that their insistent, mechanical music began to
grate on peoples' nerves and they were prohibited in 1860
from playing on the streets (Allemand, 169). Given the
Second Empire's hostility toward itinerant performers,
all of whom were considered dangerous to established
order and morality, and especially its suspicion of singers
and musicians, whose songs were feared as potentially
subversive (Clark 1973, 120-123; Harper, 32), it is more
likely that the ban on barrel organ playing was meant to
soothe the government's nerves.

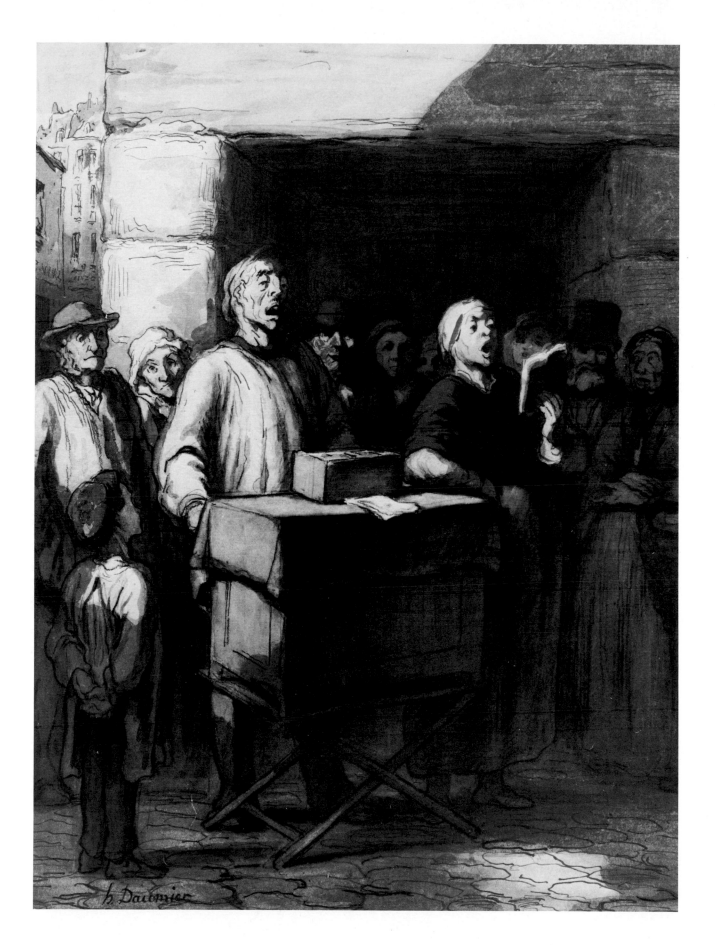

Honoré Daumier (1808-1879)

70 *The Wandering Saltimbanques*, 1847-1850

Oil on wood, 12⅞ x 9¾ in. (32.6 x 24.8 cm.)
Not signed or dated
National Gallery of Art, Washington, Chester
 Dale Collection 1962
Maison, 1: no. I-25

❧ Quite apart from official efforts to control street performances, which had been going on since the late eighteenth century, the wandering saltimbanques' lives had long seemed to epitomize hardship and sorrow. Always on the move from one fairground or street corner to another, always dependent on the taste and mood of a fickle public, they became for the romantic artists and writers obvious symbols of their own marginal and precarious existence. The saltimbanques' costumes, patched-together imitations of those of Harlequin and Pierrot, also linked them with the type of the sad clown, which found its fullest expression in Deburau's performances at the Théâtre des Funambules (Haskell, 7-14). All these meanings of the wandering saltimbanques are developed further in the great series of paintings and drawings that Daumier devoted to them in the 1850s and 1860s, of which Henry James later said, "The whole thing is symbolic and full of grimness, imagination, and pity" (Haskell, 12).

These qualities are already present in the earliest example, the small painting begun in the late 1840s and reworked much later, which is exhibited here. That Daumier thought highly of it, despite its small size and unfinished condition, is shown by his decision to include it in his retrospective exhibition in 1878 (Harper, 110-111). Although it was evidently based on two of Victor Adam's lithographs of a family of saltimbanques moving wearily through the city streets (Harper, 101-108), Daumier's picture conveys a far greater sense of alienation and sadness, an effect heightened by the whiteness of the Pierrot-like father's downcast face and the isolation of the three figures from one another.

After repressive measures were decreed in 1849 and 1853, the wandering saltimbanques' existence became still more difficult (Clark 1973, 120-121); and in Daumier's later pictures they seem to move through the ominous, shadowy streets as though harried, one step

98. Honoré Daumier. *A Saltimbanque Playing a Drum*, ink and watercolor, c. 1863. The British Museum, London.

ahead of the police. But in at least one work, *A Saltimbanque Playing a Drum* (fig. 98), probably painted in 1863, the old drummer stops to perform with an almost desperate resolution, despite the evident indifference of the crowd. This poignant image has recently been interpreted as a veiled attack on the government's manipulation of elections—for the manipulator's, or prestidigitator's, tools are displayed on the table, but he himself is strangely absent—and as a symbolic self-portrait of the aging artist, no longer in favor with the public but still stubbornly performing his role (Harper, 175-183).

Théodule Ribot (1823-1891)

71 *The Musicians,* c. 1862

Oil on canvas, 52⅜ x 39⅛ in. (133 x 99.4 cm.)
Signed, lower right: *t. Ribot*
Mr. and Mrs. Joseph M. Tanenbaum, Toronto

Whereas Daumier's street musicians (e.g., cat. 69) clearly belong to a certain time, place, and class, those of Ribot, although inspired by the same realist interest in Parisian lower-class life, are more ambiguous in all these respects. As in his other pictures of itinerant performers of the early 1860s—among them, the *Guitar Player,* the *Receipts,* and the *Singers* (Weisberg 1981, nos. 10-12)—their setting is either a dark tavern or a shadowy street, or it is simply the artist's dimly lit studio. Their costumes, sometimes described as "street clothes," are hardly adequate as such and, with their long capes and plumed hats, suggest instead a troupe of actors or a band of troubadours. Their instruments, too, are oddly matched and evoke, on the one hand, a brass band—the cymbals and drum played by the two girls—and, on the other, a chamber orchestra—the oboe and mandolin played by the two men. Even their pet monkey can be understood either as a natural companion of such wandering minstrels, a tradition that goes back to the Middle Ages (Janson, 145-146, 170-171), or as a symbol of the worldly pleasures to which the music-making itself may allude. Thus what is for Daumier a straightforward, though richly suggestive, genre scene becomes for Ribot a more ambiguous image evocative of the theater and older art, one which is in that respect closer to Manet's image of bohemian street life in the *Old Musician.*

In its composition and style, Ribot's *Musicians* is even more obviously reminiscent of earlier art. There are echoes of Brouwer's tavern scenes in the compact grouping of the figures, some half hidden by others; of the Le Nain brothers' peasant interiors in the centralized yet isolated arrangement of the figures, each facing in a different direction; and above all of Courbet's early genre scenes and portraits, themselves based on older French and Flemish art, in the monumental scale of the figures and in the strong lighting that makes them stand forth against the dark background. And as Ribot's contemporaries observed, there is more than an echo of seventeenth-century Spanish art, of Velázquez and especially of Ribera, in the sober color harmony composed of black, white, gray, earth, and flesh tones and in the dramatic chiaroscuro, which with the figures' soulful expressions give the simple genre scene an atmosphere of spiritual intensity.

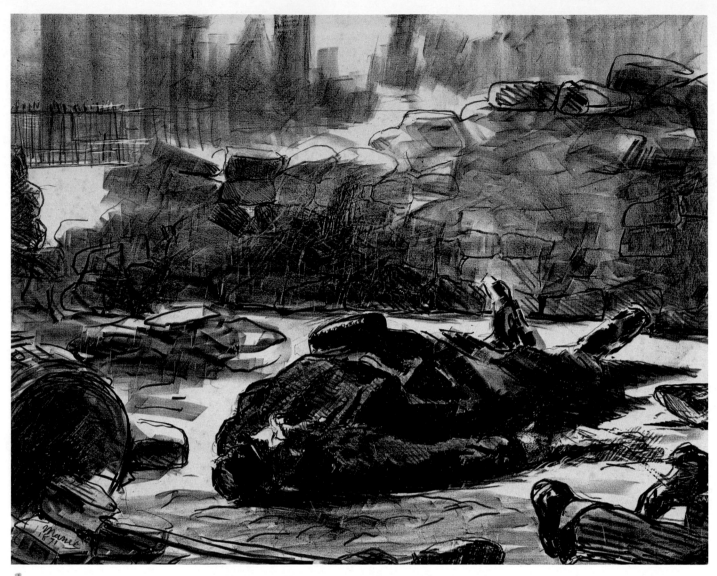

Plate 13. Edouard Manet. *Civil War*, 1871. Cat. 76.

8

The Street as Battleground

❦

FOR THE HISTORY of art, the most remarkable fact about the Paris Commune of 1871 is that it inspired no work of art comparable in symbolic power to David's *Death of Marat* in 1793, Delacroix's *Liberty Leading the People* in 1830, or Daumier's *Uprising* in 1848. Yet it was a revolution more momentous than the last two in its effect on European politics and more terrible in its destruction of life and property: between twenty and twenty-five thousand government soldiers, national guardsmen, and civilians were killed in the violent street fighting and ruthless executions; and a great many buildings, some of great historical importance, were burned down or blown up. Due to the broader scope of these events and to recent developments in photography, the Commune did unleash a larger flood of imagery than any previous revolution (Rifkin, 201; Lacambre, 68-71). Caricatures, photographs, and prints of all kinds abounded, but these were largely ephemeral, serving the political or journalistic needs of the moment. And even the paintings produced at the time tended to be blatantly partisan or banal, regardless of their ideological content: on the one side, indictments of the barbarism of the Commune, in both allegorical and realistic styles (Lévy's *Commune*, Meissonier's *Ruins of the Tuileries*); on the other, tributes to the heroism of its martyrs and leaders, in similarly diverse styles (Picchio's *Wall of the Fédérés at Père-Lachaise*, Girardet's *Arrest of Louise Michel*).

Significantly, some of the most powerfully expressive pictures of the Commune were painted many years later by artists actively involved in the radical movements that emerged in its wake and drew inspiration from it: Steinlen's *Louise Michel on the Barricades* of c. 1885 (fig. 99) is one example, dramatic and defiant; Luce's *A Paris Street in 1871*, painted in 1904 (cat. 85), is another, more sober but still vibrant. In the same way, some of the most moving fictional accounts—Maupassant's stories, Vallès' *L'Insurgé*, Zola's *La Débâcle*—were written fifteen to twenty years later, and like the pictures were partly pessimistic, partly affirmative in tone. Conversely, what were perhaps the most impressive works created at the time—Rimbaud's visionary poems of conflict and conflagration and Courbet's brooding portrait of himself in prison (Fernier, no. 760)—are so wholly absorbed in projecting a personal vision or an image of personal defeat that they make no effective public statement.

Courbet had at least fully expressed his radical convictions through energetic action: as a delegate to the governing body of the Commune, as a member of its committee on public education, and above all as a leading force in its commission on artists, involved in reorganizing along democratic lines the museums, exhibitions, and art schools of Paris. None of the other artists of his generation played so active a part; nor did they respond to the momentous events through their art. Daumier, who had projected the spirit of 1848 so powerfully in his paintings and attacked the reaction against it so effectively in his prints, now remained almost totally silent. Millet's only

99. Théophile-Alexandre Steinlen. *Louise Michel on the Barricades*, oil on canvas, c. 1885. Petit Palais, Geneva.

100. Ernest Meissonier. *The Ruins of the Tuileries*, oil on canvas, 1871. Musée Nationale du Château de Compiègne.

response was an angry resignation from the Commission Fédérale des Artistes, to which he had been elected *in absentia*. Couture, who had been inspired by the patriotic fervor of 1848 to paint that of 1792—the ambitious, ultimately unresolved *Enrollment of the Volunteers*—was singularly uninspired by that of 1871. Only Meissonier, among the major artists of his generation, reacted strongly; his *Ruins of the Tuileries* (fig. 100), brutally conceived and brilliantly executed, sums up the revulsion many felt at the alleged barbarism of the Communards (conveniently forgotten, as Marx pointed out, was the devastation wrought by the Versailles army's bombardment and the effect of high winds in spreading fires).

Of the younger artists, those of the impressionist group, Manet was one of the very few to depict the civil war or even to witness it; most of the others had fled Paris earlier to avoid involvement in the Second Empire's disastrous war against Germany. Pissarro, whose political convictions might have led him to support the Commune, was in England (cf. fig. 29). Monet, whose single recorded comment on it concerned the reported execution of Courbet, was also in England. Cézanne, who had gone into hiding in the South of France, fearful of any political involvement, continued to work there alone. Degas, who had served in the National Guard during the siege of Paris, fled when it was over, and returned in time to witness the Commune, left no artistic record of either event. Renoir, who had lived through the revolution and had almost been shot as a government spy, went on painting landscapes along the Seine, though he did sketch a Communard being executed (Soria, 3: 345). Guillaumin and Caillebotte, who had both served in the National Guard, one having enlisted, the other having been drafted, seem not to have participated in the Commune in any way. Among the impressionists' contemporaries, even Tissot and Dalou, who did participate or were accused of having done so and had to flee France to avoid prosecution, did not paint or sculpt what they had seen.

The reasons for this almost universal silence are partly personal, partly ideological, but largely historical: the relation between art and politics had changed drastically since 1848, or rather, since 1851, when Napoleon's *coup d'état* extinguished republican hopes and caused many disaffected artists and writers to turn from public to private themes and to consolation in nature. Flaubert's *Education sentimentale*, although set in the 1840s and richly evocative of its democratic aspirations, was written in the 1860s and embodied that era's deep disillusionment with all political action, peaceful or revolutionary. Looking back at the June Days, he concludes ironically: "Equality—as if to punish its defenders and ridicule its enemies—asserted itself triumphantly: an equality of brute beasts, a common level of bloody atrocities" (Flaubert, 334). The novel was published in 1869; two years later Flaubert, like his friends Gautier, Goncourt, and Daudet, and many others, including Hugo and George Sand, was equally disgusted by the atrocities and "heartily sick of the Parisian insurrection" (Psichari, 95-96).

Manet, long considered the leading exponent of "pure painting," thus emerges as the most important artist to represent the Commune at the time it occurred; not

because he painted it on a large scale, as he had the *Execution of the Emperor Maximilian* (fig. 103), but because he witnessed and chose to record it at all. Deeply patriotic and radically republican, he had fought in the National Guard during the siege—at one point, ironically enough, under Meissonier—and after rejoining his family in southwest France, had tried to return to Paris as soon as the Commune was declared; after this proved too dangerous, he tried again and succeeded, three days before the Versailles army invaded (Ruggiero, 28-31). And although he produced only one watercolor and two lithographs, they are among the most memorable images of that bitterly fought war—powerful yet utterly unrhetorical, free of both the partisan exaggeration and the banal literalness of much contemporary imagery, and deeply resonant with his own political convictions.

Edouard Manet

72 *The Barricade*, 1871

Ink and watercolor, 18³⁄₁₆ x 12¹³⁄₁₆ in. (46.2 x
 32.5 cm.)
Signed, lower right: *E.M.*
Szépmüvézeti Múzeum, Budapest
R-W 2:319

Throughout the "semaine sanglante" at the end of
May 1871, and well beyond it to the middle of June,
scenes such as this one took place all over Paris. So
ruthless was the massacre, not only of those who surren-
dered at the barricades, but of those merely suspected of
having aided them, that the London *Times*, hardly a
radical paper, informed its readers, "The French are
now writing the saddest page of their history and of that
of the world" (Soria, 4:294). Manet would thus have had
ample opportunity to witness such an execution; yet for
all its apparent spontaneity in recording something
directly seen, this picture is based on another. The firing
squad and even the victims are taken from his *Execution
of the Emperor Maximilian* (fig. 103) and more specifically
from the lithographed version (cat. 74), in which they are
exactly the same size; a tracing of their outlines, no doubt
made from the lithograph, is on the *verso* of this water-
color (R-W 2:319 *verso*).

This was for Manet more than a mere expediency:
there was an intimate connection between his image of
the Parisian rebels, cynically abandoned by Thiers to
their fate at the hands of the vindictive army, and that of
the doomed Maximilian, abandoned by the equally cyni-
cal Napoleon to his fate at the hands of the Mexican
army. But that image was in turn based on another, the
model of all such scenes of ruthless execution by a firing
squad conceived as a brutally impersonal mechanism,
Goya's famous *Third of May, 1808* (fig. 101). In some
respects, the *Barricade* is even closer to this work than to
the *Maximilian*; for here too the design "is based on a
two-part balance of oppressor and oppressed and it is not
possible to determine the number of either the soldiers or
their victims" (Hanson 1977, 119).

Despite this visual confusion—the product of an un-
usually agitated handling, which heightens the effect of
violence—the *Barricade* clearly reflects Manet's sym-
pathy with the Communards. This was well known to his
friends: in a letter of 5 June 1871, Berthe Morisot's

mother informed her that her brother Tiburce, an officer
in the Versailles army (to whom Manet inscribed a proof
of the lithograph based on this watercolor, cf. Harris
1970, 190), had "met two Communards, at this moment
when they are all being shot. . . . Manet and Degas!
Even at this stage they are condemning the drastic mea-
sures used to repress them" (Morisot, 63). This sym-
pathetic attitude is confirmed by the unbroken condition
of the barricade in Manet's image, a unique instance in
the representation of the overrun barricade in
nineteenth-century art, where it is invariably shown as a
pile of rubble (Clark 1973, 16).

101. Francisco de Goya. *The Third of May, 1808*, oil on canvas,
1814. Museo del Prado, Madrid.

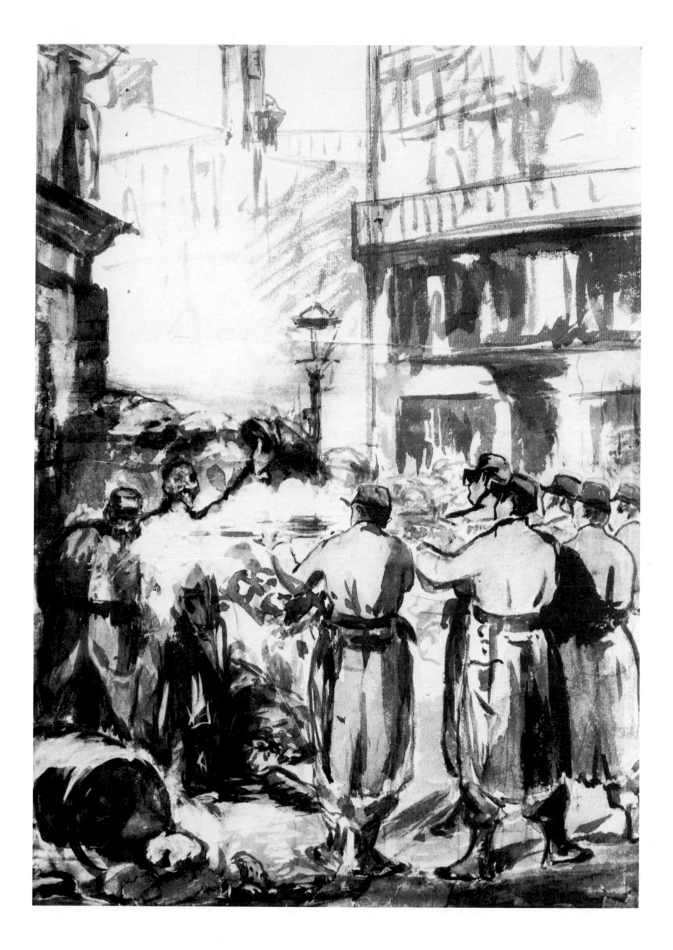

Edouard Manet

73 *The Barricade*, 1871-1873

Lithograph, 18⅜ x 13⅛ in. (46.8 x 33.3 cm.)
Not signed or dated
S. P. Avery Collection, Art, Prints and
 Photographs Division, The New York Public
 Library, Astor, Lenox, and Tilden Foundations
H 71, second state

Although this print shows essentially the same image as the watercolor study (cat. 72) and is almost exactly the same size, Manet could not have "used a tracing to transfer the main shapes onto the lithographic stone" (Harris 1970, 190), since they are considerably smaller here in relation to the whole. In reducing their size, he also attentuated the forms of the soldiers as well as the building behind them, while strengthening those of the

102. Gustave Courbet. *The Execution*, black chalk, 1871. Cabinet des Dessins, Musée du Louvre, Paris.

civilians and the building and barricade behind them; and as a result, he altered the watercolor's "two-part balance of oppressor and oppressed" in favor of the latter. The taller of the two victims in particular is now shown more clearly, holding himself erect and shouting defiance with a dignity and courage that leave no doubt about Manet's sympathies. Yet his image remains remarkably objective, a record of something he must have seen many times in the last days of the Commune, and one whose familiar atmosphere of battered buildings and heavy smoke he seems to have been equally intent on capturing. Certainly his print has none of the rhetorical implications of the sketch Courbet made under similar circumstances (fig. 102), where the female Communard

is isolated, centered in the field, and allegorized through her Phrygian bonnet and clenched-fist salute.

Twenty years earlier, Manet had witnessed other incidents of the brutality of soldiers against civilians which had undoubtedly strengthened his radical convictions. Wandering the streets of Paris during the *coup d'état* of December 1851, he was arrested while observing the bombardment by half-crazed artillery men of an innocent merchant's house; and after his release he visited the Montmartre cemetery, where the victims of the *coup* were laid out for identification; his drawing of that scene has unfortunately not survived (Bazire, 6-9; Proust, 25-26). He had also been on the streets during the June Days in 1848, assisting in the return of the Archbishop Affre's body to the Faubourg Saint-Antoine, though there is no record of his having responded artistically (Proust, 11-12). In the *Barricade* he did respond, but in a form too highly charged politically to be published during his lifetime; it first appeared in a posthumous edition in 1884.

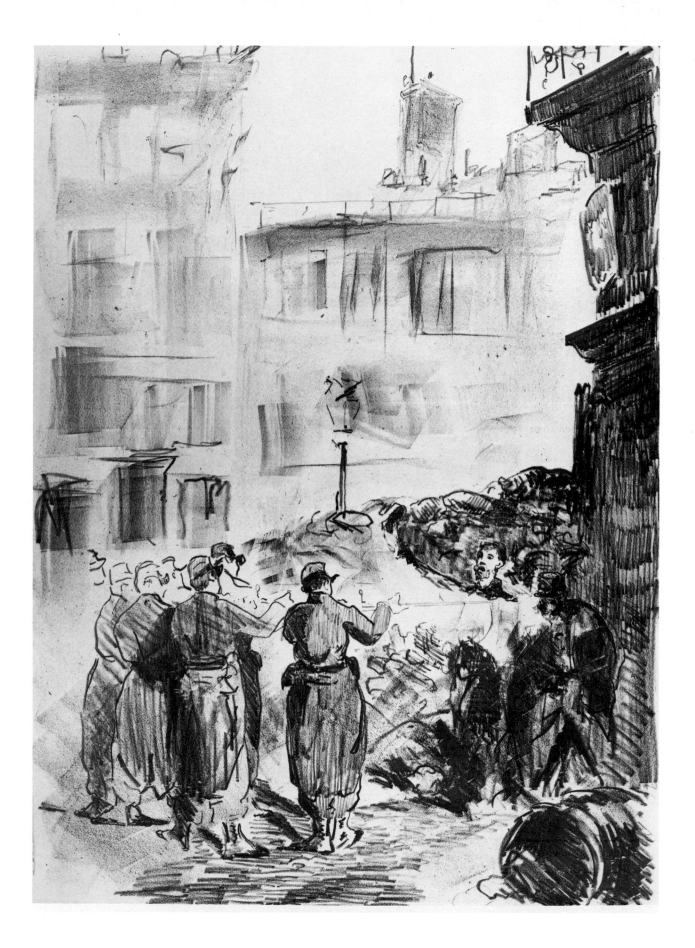

Edouard Manet

74 *The Execution of the Emperor Maximilian*, 1868-1869

Lithograph, 13¼ x 17⅛ in. (33.7 x 43.6 cm.)
Signed in the stone, lower left: *Manet*
National Gallery of Art, Washington, Rosenwald
 Collection 1947
H 54, first state

Like the *Barricade* (cat. 73), this lithograph was for all its apparent detachment considered too much a political statement to be published during Manet's lifetime: it was suppressed by the officials of the Dépôt Légal when his printer submitted it in February 1869, and it did not appear until the posthumous edition of 1884 (Griffiths, 777). Only after much difficulty was Manet able even to obtain the return of his lithographic stone (Guérin, no. 73). The officials were not wrong, for he had undoubtedly chosen lithography, long associated in France with political criticism and protest, precisely in order to make such a statement, as he would do again in the case of the *Barricade,* of *Civil War* (cat. 76), and of *Polichinelle* (cat. 40). He may in fact have chosen it when he learned that other authorities, in charge of the Salon of 1869, would reject his painting of the same subject if he submitted it as planned (Griffiths, 777). Which of the four painted versions this was, we do not know; presum-

ably the final one, now at Mannheim (fig. 103). But since the design of the print is in some respects closer to what is generally considered the second version, of which only fragments survive (R-W 1:126), and in other respects closer to the third version, a small oil sketch (R-W 1:125), Manet may have worked on it concurrently with these, incorporating his evolving ideas for the definitive composition; there are indications of scraping and revision on the ground behind the victims and around the officer's raised sword (Jones, 17-19).

What made the *Execution of the Emperor Maximilian* politically provocative was its implicit criticism of Napoleon III's ill-advised attempt to establish a French protectorate over Mexico and his cynical abandonment under foreign pressure of the ruler he had chosen, his half-brother Maximilian of Austria. Whether Manet intended such criticism when he painted the first version (R-W 1:124) is not certain; but it became increasingly

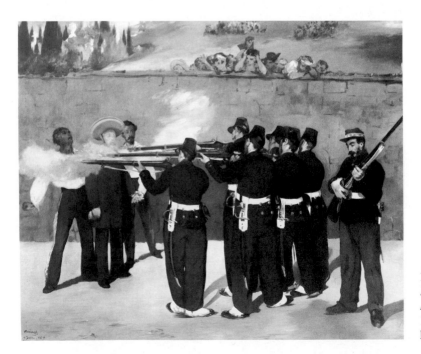

103. Edouard Manet. *The Execution of the Emperor Maximilian*, oil on canvas, 1867-1868. Städtische Kunsthalle, Mannheim.

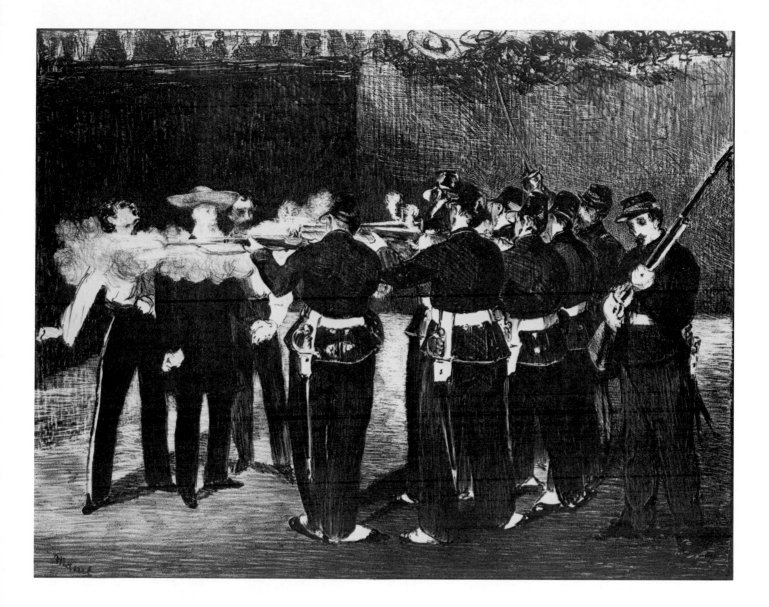

apparent in the later ones, where the uniforms of the firing squad are those of the French army and the ultimate responsibility for Maximilian's death is clearly Napoleon's. Since the execution took place in a country of Spanish culture, in an enclosed, arenalike space, with spectators in the background, it must also have been associated in Manet's mind with another kind of ritual death, that of the bullfight. One of the bullfight pictures he had painted two years earlier (cat. 81) is indeed similar in composition; and those of Goya and Dehodencq (fig. 112), which Manet is known to have admired and learned from, show very similar groups of spectators in the background (Sandblad, 146-147; Isaacson, no. 29).

Edouard Manet (attributed to)

75 *The Execution,* c. 1871(?)

Oil on canvas, 14¾ x 17⅞ in. (37.5 x 45.5 cm.)
Signed and dated, lower right, in another
 hand: *Manet 1871*
Folkwang Museum, Essen
Not in R-W

Both the subject and the attribution of this boldly conceived and swiftly painted oil sketch have long been problematic. First identified as a study for the *Execution of the Emperor Maximilian* (fig. 103), then as a battle scene in the Franco-Prussian War (*The Artillery Shell, The Grenade*), it was recognized as an image of Communards being executed when a cleaning revealed the small firing squad just visible at the left edge (Held, no. 112). Similarly, it was first published as an autograph work by Manet, then as one of questionable authenticity, and is now rejected by most scholars and omitted from the oeuvre catalogues; its provenance in fact goes back no further than 1905, when the founder of the Essen Museum acquired it (Osthaus, 147). Stylistically, it should be dated only a decade earlier than that: both the flattening of the forms within a shallow space and their reduction to a striking pattern of dark and light suggest a French painter of the mid-1890s. And since that was also a period of renewed interest in the Commune among artists sympathetic to the anarchist movement, such as Steinlen, Luce, and Vallotton, this picture is very likely one of the many retrospective images of the civil war produced then.

Of the artists mentioned, and the others like Signac and Pissarro who contributed to anarchist publications, Vallotton is the only one whose style resembles that of the Essen picture. In his woodcuts of 1892-1894, some of which (e.g., fig. 104) treat a comparable subject, police brutality against anarchist demonstrators, the simplified, interlocking shapes of black and white create a very similar pattern. In his color lithographs of 1902, violent denunciations of repression and sadism in bourgeois society (Vallotton and Goerg, nos. 56-78), the same style is used in a more painterly manner, though the bold patterning is still apparent. In his paintings of these years, the subjects are usually tranquil scenes of middle-class Parisian life, and the treatment is more impersonally realistic, with harder outlines and smoother textures. But in some small pictures of the mid-1890s, such as the

104. Félix Vallotton. *The Charge,* woodcut, 1893. The Museum of Modern Art, New York, Larry Aldrich Fund.

105. Félix Vallotton. *The Bistro,* oil on canvas, 1893-1895. Mr. and Mrs. Arthur G. Altschul, New York.

Bistro (fig. 105), Vallotton adopts the flattened, strongly foreshortened and silhouetted forms and the looser handling that characterize the Essen picture. Even if the latter lacks his usual refinement in adjusting the shapes to each other, it should probably be attributed to him or to someone working very close to him.

THE STREET AS BATTLEGROUND 211

Edouard Manet

76 *Civil War*, 1871

Lithograph, 15¾ x 19¹⁵⁄₁₆ in. (40 x 50.7 cm.)
Signed and dated in the stone, lower left: *Manet /
 1871*
National Gallery of Art, Washington, Rosenwald
 Collection 1943
H 72, second state

Like its counterpart *The Barricade* (cat. 73), this print represents a scene Manet actually observed in the last days of the Commune. It occurred at the intersection of the boulevard Malesherbes and the rue de l'Arcade, near the Madeleine, whose columned portico is visible in the background; he reportedly made a sketch on the spot, though it has not survived (Duret, 166). Given that precise location, the incident can be given a precise date: 23 May 1871, the day the advancing Versailles troops occupied the area between the place de la Concorde and the place Vendôme in which the Madeleine is situated (Soria, 4: 166-167). But exactly when Manet transformed what must have been a hasty sketch into this carefully composed and vigorously executed print is not known. It may have been shortly afterward, when the visual impression and the emotions it aroused, both broadly human and narrowly partisan, were still vivid in his mind and able to inspire the extraordinarily vehement handling of this work. Or it may have been much later, since the print was not published until 1874—and then in a limited edition—for fear of the political passions it might arouse; in that case the inscribed date would be commemorative (Wilson, no. 79).

In any event, it is clear that in the process of transforming his sketch Manet relied, as he so often did, on other works of art. Since the 1920s it has been recognized that the most important of these was his own painting *The Dead Toreador* (cat. 77) or perhaps his etched copy of it (cat. 80), an image of a fallen warrior lying in exactly the same diagonal position; fallen in another kind of combat, it is true, but one that we have already seen was

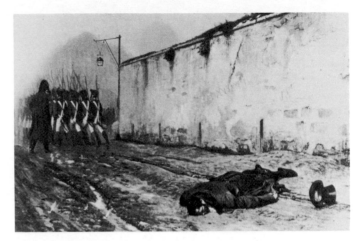

106. Jean-Léon Gérôme. *The Execution of Marshal Ney*, oil on canvas, 1868. The Graves Art Gallery, Sheffield.

linked in Manet's memory with the scenes of civil war he had just witnessed (cf. cat. 74). More recently, it has been suggested that he also had in mind works by two other nineteenth-century artists. One is Gérôme's *Execution of Marshal Ney* (fig. 106), which was shown at the Salon of 1868, perhaps in response to Manet's *Execution of the Emperor Maximilian* (fig. 103), and which he in turn appears to have drawn on in relating the foreshortened, diagonal figure to the strongly textured wall behind him (Ackerman, 170-171). The other work is Daumier's *Rue Transnonain* (cat. 84), the archetype of all such images of the victims of political repression in nineteenth-century art, which seems to have influenced the placement of the dead soldier in the center and the drastic cutting of the dead civilian at the lower right (Fried, 76, n. 167).

Color plate 13

Edouard Manet

77 *The Dead Toreador,* 1864

Oil on canvas, 29⅞ x 60⅜ in. (75.9 x 153.3 cm.)
Signed, lower right: *Manet*
National Gallery of Art, Washington, Widener
 Collection 1942
R-W 1:72

🐚 Manet could easily adapt his dead toreador for the dead soldier in his *Civil War* (cat. 76) because the toreador, too, was a fallen warrior, stretched out lifeless in his handsome uniform. Manet had indeed already removed him from the special context of the bullfight several years earlier and given him a more universal tragic meaning: he had become, as Manet specified in exhibiting the *Dead Toreador* in 1867, simply the *Dead Man.* Originally this picture had been part of a larger one, an *Incident in a Bullfight,* which he had shown at the Salon of 1864 and shortly afterward had cut up, either in response to reviewers' criticisms of its faulty perspective or in the realization that this figure alone, in its isolation, prone position, and stark coloring, could express the terrible pathos he had tried to convey in the larger work (Hanson 1970, 158-161). Both explanations have been given, and both may be correct.

In any event, Manet had already destroyed the *Incident* by February 1865, when he exhibited the *Dead Toreador* alone; and for many years thereafter it was assumed to be the only surviving fragment (Zola 1867, 96; Bazire, 42). Around 1900, however, a smaller picture of three bullfighters standing before the barrier, with spectators behind them and a bull just visible at the bottom edge (fig. 107), was listed as a second fragment (Duret, no. 52); and since then it has generally been accepted as such. But since x-ray photographs subsequently revealed the existence in this picture of an earlier state, showing a mounted picador and two bullfighters seen from behind, smaller than those in the final state, it was thought not to have been part of the original composition after all (R-W 1:71).

Only when those photographs and the ones recently taken of the *Dead Toreador* at the same scale are juxtaposed, as they are here for the first time (fig. 108), does it become clear that the two fragments can indeed be matched: together they complete the form of the bull and those of the two bullfighters seen from behind, which overlap his. What this composite image reveals, however,

remains confusing. Clearly the bull, eliminated when the larger fragment containing the dead toreador was detached and its yellow tan background (the arena's sand) was repainted an olive green, was in the position shown in the photographs and in contemporary caricatures of the *Incident* by Bertall, Cham, and Oullevay. But whether the picador and the two small bullfighters were painted before or after the smaller fragment was detached—as a first idea for the background of the large work or as a revised idea for the now much smaller work—neither laboratory examination nor historical reconstruction can determine. We can only be sure of the general appearance and impressive size of the *Incident* shown in 1864: assuming that the upper right and lower left corners coincided with those in the composite photograph, it was a canvas about 126 x 168 cm., the largest of all Manet's bullfight pictures, as well as the most profoundly moving.

107. Edouard Manet. *The Bullfight,* oil on canvas, 1864. Copyright The Frick Collection, New York.

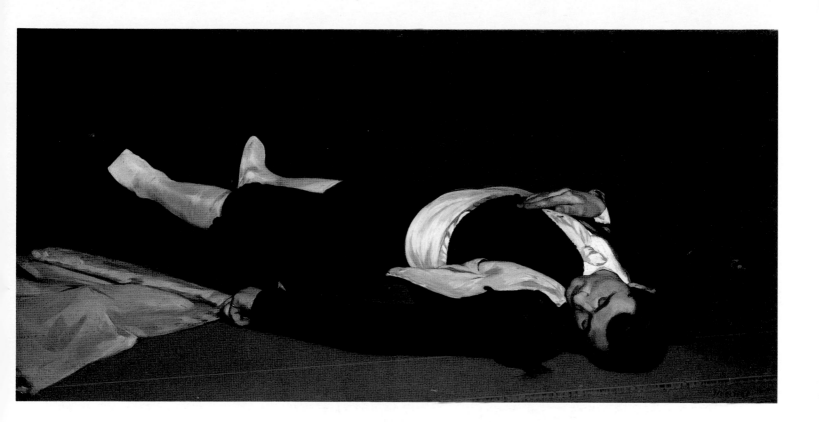

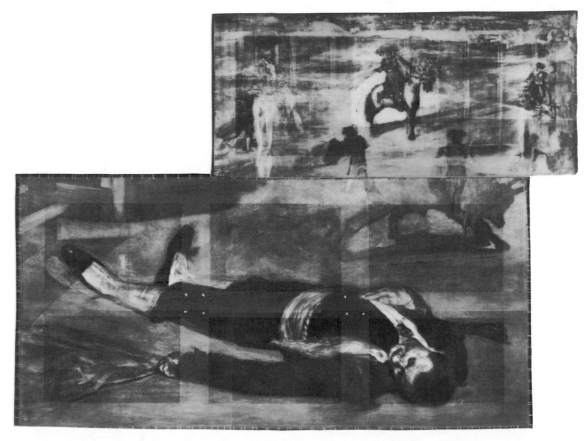

108. Composite x-ray photograph of Manet's *Dead Toreador* (cat. 77) and *Bullfight* (fig. 107).

Jean-Léon Gérôme (1824-1904)

78 *Caesar Assassinated,* c. 1868

Pen and black ink, 5¹³⁄₁₆ x 12 in. (14.7 x 30.5 cm.)
Signed, lower right: *J L Gerome*
David Daniels, New York

Just as the dead soldier in Manet's *Civil War* (cat. 76) had its source in his earlier *Dead Toreador* (cat. 77), so the latter had its sources in still earlier pictures. One model, already recognized at the time, is the *Dead Soldier* then attributed to Velázquez (fig. 110); the other, discovered in the 1960s, is the *Dead Caesar* by Gérôme (fig. 109). Shown at the Salon of 1859 and photographed the following year, it was undoubtedly familiar to Manet, as was Gérôme himself through such mutual acquaintances as Degas and Gautier (Ackerman, 167). Gérôme in his turn depended on the *Dead Soldier,* which was then in a Parisian collection to which he would have had access; but his transformation of it into the dead Caesar, lying abandoned on the marble floor of the Curia, the inert body seen in a drastically foreshortened position, the head fallen to one side and the feet turned up in the air, made it a more suitable source for the dead toreador lying equally alone on the sand of the arena. Although both figures were painted from live models, each must have been posed with its respective artistic model in mind (Ackerman, 165-166).

The drawing exhibited here is not a study for the painting of 1859 but rather a copy after it, made a decade later in preparation for an etching published in a deluxe volume of prints and poems entitled *Sonnets et eauxfortes,* to which Manet also contributed an etching (H 57). Gérôme's was printed opposite Anatole France's poem "Le Sénateur romain," which in turn was evidently inspired by Gérôme's second, much enlarged version of the *Dead Caesar,* exhibited two years earlier (Ackerman, 165-168). In extracting from that theatrical, deeply spatial scene the single prostrate figure and in closely circumscribing it by the frame, Gérôme was recalling not only the seventeenth-century *Dead Soldier,* which had

109. Jean-Léon Gérôme. *The Dead Caesar,* oil on canvas, 1859. Formerly, Corcoran Gallery of Art, Washington; present location unknown.

been its primary source, but also Manet's *Dead Toreador,* which may well have been a secondary source—precisely for that uncharacteristically strong surface pattern and shallow space (Ackerman, 168-169). Perhaps Gérôme was also recalling the principal point Baudelaire had made in praising his simpler 1859 version, a point Manet too may have had in mind in cutting out the *Dead Toreador* from his own more theatrical and deeply spatial scene. "It was indeed a happy moment," wrote Baudelaire, when he conceived his Caesar *alone,* stretched out in front of his overturned throne—when he imagined the corpse of his Roman, who was pontiff, warrior, orator, historian, and master of the world, filling an immense and deserted hall. This way of showing the subject has been criticized, but to my mind it could not be too highly praised. Its effect is truly great" (Baudelaire 1859, 176).

Léopold Flameng (1831-1911)

79 Roland Dead (The Dead Soldier), 1865

Etching, 6 x 9⅛ in. (15.3 x 23.2 cm.)
From *Gazette des Beaux-Arts* 18 (1865),
 opposite 98
Library, National Gallery of Art, Washington

The painting reproduced in this etching (fig. 110), although now of uncertain attribution—it is not Spanish, perhaps not Italian, perhaps not even seventeenth century (Levey, 148)—was in Manet's time considered a masterpiece by Velázquez. The article accompanying the etching in the *Gazette des Beaux-Arts* describes it as "a work of capital importance, . . . displaying all the qualities of force and harmony that one admires in Velázquez (Mantz, 98-99). As such it was bound to interest Manet, a great admirer of Spanish art and especially of Velázquez, as indeed it had already interested Gérôme, who based his *Dead Caesar* (fig. 109) on it. But if the officially acclaimed Gérôme could gain access to the exclusive Pourtalès Collection, where the picture hung until 1865, it is doubtful that the relatively unknown Manet could. He would surely have seen the large photograph of it published by Goupil in 1863 (Hanson 1977, 83-84); but it has been argued that, before painting his *Incident in a Bullfight* later that year, he must also have seen the original, since his dead toreador is "an actual copy of its

coloring, tonal values, lighting, and brushwork" (Peladan, cf. Isaacson 1969, no. 25).

In any event, in posing the model for the toreador Manet did imitate the prone diagonal posture of the dead soldier and the placement of his hands; and when he detached the toreador from the larger composition, he also imitated the soldier's position relative to the frame, though the Baroque work characteristically shows the figure in a broader, deeper space. It also employs an elaborate symbolism of skulls and bones—the skull at the right is omitted from the print—of bubbles rising in the water, and of a lamp of eternal light suspended from a branch, which spelled out a Christian allegory altogether foreign to Manet's starkly realistic depiction of death in a bullring (cf. Mauner, 138-140).

110. Italian school, 17th century. *A Dead Soldier,* oil on canvas. The National Gallery, London.

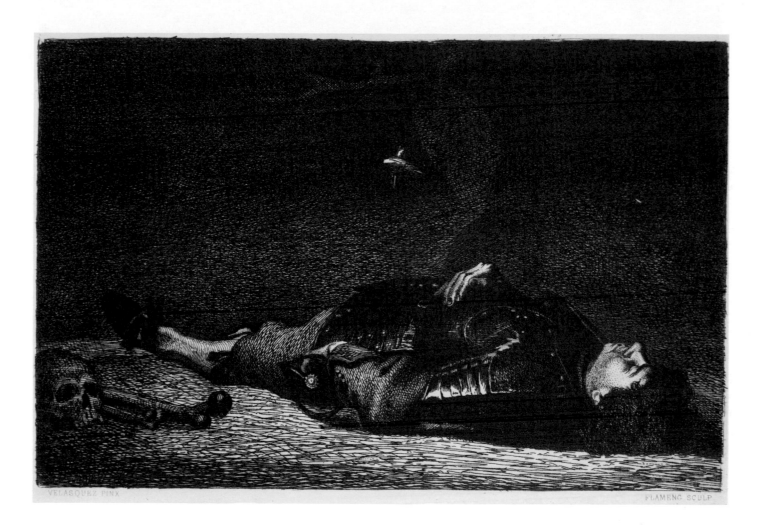

Edouard Manet

80 *The Dead Toreador*, 1868

Etching and aquatint, 6¹⁄₁₆ x 8¹¹⁄₁₆ in. (15.4 x 22.1 cm.)
Signed in the plate, lower left: *Manet*
National Gallery of Art, Washington, Rosenwald Collection 1943
H 55, third state

🐦 Previously dated 1864, the year of the painting it reproduces (cat. 77), this carefully developed etching has been convincingly redated 1868 on both stylistic and circumstantial grounds. In its bold patterning of light and dark, reinforced by extensive use of aquatint, it resembles other prints of that period, especially the *Exotic Flower* (H 57), Manet's contribution to the volume *Sonnets et eaux-fortes* published in 1868; the two prints were in fact shown together at the Salon the following year (Harris 1970, 157). And since the painting of the dead toreador won a silver medal at an exhibition in 1868, Manet may well have been motivated by this success to reproduce it then (Isaacson 1969, no. 25).

In its composition, the print goes beyond the painting of four years earlier—even in its revised state, after having been detached from the *Incident in a Bullfight*—in the extent to which the figure and setting are integrated in a strong two-dimensional pattern. For the atmospheric background of the painting, a continuously graded olive green painted over the original yellow tan and merging with it at the bottom (laboratory examination, November 1981), the print substitutes a flatter background consisting of sharply contrasted light and dark grays, the one produced by dusting with fine grains of aquatint resin, the other by applying it in liquefied form with a brush. Their juncture is marked by a horizontal line that intersects the contour of the prostrate figure; and interestingly, at the very point at which the horizon in Flameng's etching of the "Velázquez" *Dead Soldier* (cat. 79) intersects its figure. If that print, published in February 1865, probably appeared too late to influence Manet's detachment from the *Incident* of the *Dead Toreador*,

111. Edouard Manet. *The Dead Toreador,* etching, sixth state, 1868. S. P. Avery Collection, Art, Prints and Photographs Division, The New York Public Library, Astor, Lenox, and Tilden Foundations.

which was shown in its present form in that month, it may well have influenced his reproduction of the *Toreador* three years later, working in the same medium and on a similar scale.

If Manet did have Flameng's etching in mind, it was only in developing the earlier states of his own, of which the third is exhibited here; for in the last three, and most effectively in the sixth (fig. 111), he obliterated the horizontal division of the background and established instead a diagonal line extending from lower right to upper left, along the axis of the outstretched figure. He also strengthened the upper zone, working over the aquatint grains in long zigzag lines which deepen the atmosphere of oppressive darkness around the dead man.

Edouard Manet

81 *The Bullfight,* 1865-1866

Oil on canvas, 18⅞ x 23¾ in. (48 x 60.3 cm.)
Signed, lower right: *Manet*
The Art Institute of Chicago, Mr. and Mrs.
 Martin A. Ryerson Collection
R-W 1:108

🐚 Unlike Manet's first bullfight picture (cf. cat. 77), created with the aid of artistic and literary sources, the three he painted after his trip to Spain in August 1865 recorded his impressions of an actual bullfight. Recounting his experiences to Zacharie Astruc, who had helped him plan the trip, he wrote enthusiastically about the "superb" bullfight he had seen in Madrid and of his intention to "put down on canvas a swift sketch of that motley gathering of people, without forgetting the dramatic part, the picador and horse overthrown and gored by the bull's horns and the army of bullfighters

112. Alfred Dehodencq, A *Bullfight in Spain,* oil on canvas, 1849. Musée des Beaux-Arts, Pau.

trying to draw the furious animal away" (Manet, 1). Since the largest of the three pictures (R-W 1:107) corresponds closely to this description, it was presumably painted first. The next in size (R-W 1:109) was probably also the next in date; it retains from the first version the mounted picador and the effect of small forms scattered in a large space. The smallest, the one exhibited here, would thus be the last; constructed in parallel planes— the schema of Manet's most definitive compositions—it achieves a remarkable compactness and concision, especially in the focal area, where the interlocking forms of

the bull, the four bullfighters, and their deep shadows create a striking pattern of dark and light. The concentrated shadows and the strongly contrasted colors—deep blue, reddish brown, yellow-white, and black—reinforce the effect of brilliant sunlight that Manet had experienced in Spain.

For all his emphasis on color and light, he has hardly ignored the "dramatic part"; unlike the other versions, this one shows the moment of truth, the toreador with raised sword confronting the defeated bull. The composition thus recalls that of Dehodencq's *Bullfight in Spain* (fig. 112), which Manet had admired at the Salon of 1850 and then at the Musée du Luxembourg, and which had first fired his enthusiasm for bullfighting and for Spain (Proust, 36). Dehodencq's description of the spectators perched on the wall may also have influenced Manet's treatment of those standing behind the bullring barrier in his painting, as well as the crowd shown behind the wall in his *Execution of the Emperor Maximilian* (fig. 103) two years later (Isaacson 1969, no. 20). But more important than their common source in Dehodencq are the thematic affinities between the *Execution* and this *Bullfight*: both are scenes of solemn, ritualized death; both are set in remote places of Spanish culture—Querétaro and Madrid—and in both the executioner stands with his back to us, holding his weapon horizontally, while his victim stands facing him impassively and with dignity (Mauner, 123).

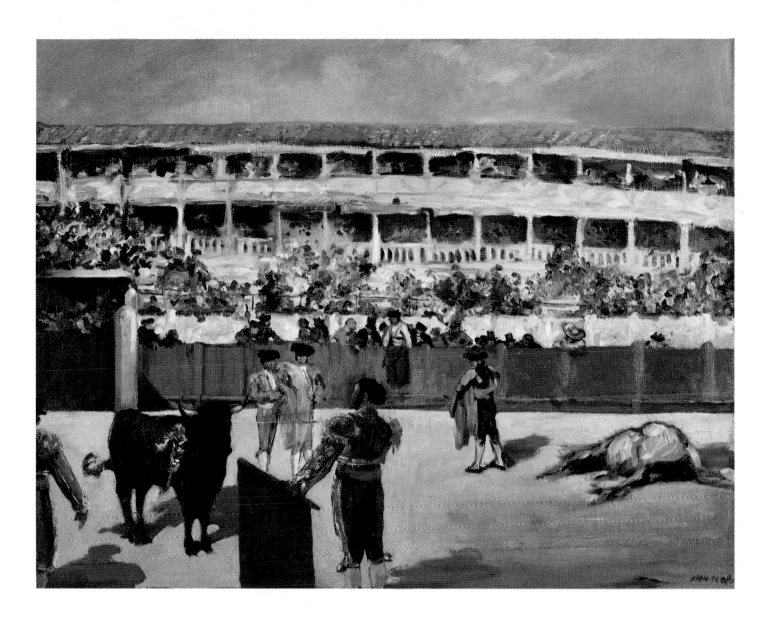

André Disdéri (1819-1890)

82 *Dead Communards,* 1871

Photograph, 8¼ x 11⅛ in. (21 x 28.3 cm.)
Not signed or dated
Musée Carnavalet, Paris

Through frequent reproduction, this small picture has come to symbolize more than any other the full horror of the civil war of 1871 and the brutal reprisals that occurred for weeks afterward. It is estimated that between twenty and twenty-five thousand men and women who fought on the barricades, or sympathized with those who did, or merely happened to be in the way, were killed in the fighting or summarily executed by government troops during and after the "semaine sanglante." This photograph shows twelve of them stuffed into plain wooden coffins, tagged for identification, and laid out at one of the temporary morgues set up all over the city. The subject was hardly unusual in the public imagery of the time: all the illustrated journals published wood engravings like the one from *L'Illustration* reproduced here (fig. 113), showing the bodies of Communards piled up at a field-hospital on the rue Oudinot. But the photographer's close-up view, looking almost directly down at the twelve corpses, whose postures and features and expressions at the very moment of death are recorded in an intensely direct, unforgettable way, has no equivalent in those journalistic illustrations, which instead take a longer, more distant view that aims at suggesting the extent (and fascination) of the tragedy through sheer numbers and grimly multiplied details.

Even the other photographs—and the Commune was the first such event to be photographed on a large scale in France—were generally more distant and detached, whichever side they represented ideologically. The numerous pictures of insurgents posing atop their barricades or beside the overturned Vendôme Column, like those of the Palais des Tuileries and the Hôtel de Ville in flames or in ruins, the former taken before the battles by supporters of the Commune, the latter afterward by its enemies, have in general a posed or static quality altogether different from the startling immediacy of this one (Soria, vol. 4; Feld, passim). Yet the irony is that it was taken by Disdéri, the most famous portrait photographer of the Second Empire, an entrepreneur who had made a fortune from small, inexpensive portraits of visiting-card format and a celebrity at whose studio Napoleon III had stopped for a picture before leading his army to Italy (Newhall, 49-50). Perhaps it was that very interest in the appearance of the individual that led Disdéri to take this exceptionally close-up view, this series of twelve uncut visiting-card portraits of the dead.

113. Alfred-Henri Darjou. *Corpses of Executed Communards in a Field Hospital,* wood engraving from *L'Illustration,* 3 June 1871. General Research Division, The New York Public Library, Astor, Lenox, and Tilden Foundations.

Honoré Daumier (1808-1879)

83 *And All This Time . . .*, 1872

Lithograph, 9⅜ x 8⁷⁄₁₆ in. (23.8 x 21.5 cm.)
Signed in the stone, lower left: *h. D.*
Museum of Fine Arts, Boston, W. G. Russell
 Allen Bequest 1963
Delteil, no. 3937

Although Daumier must have considered the Commune a progressive experiment, he refrained from depicting either its struggle for survival or its final defeat; at most he commented wryly on the political tension between Paris and Versailles, poked fun at the Communards' attempts to decentralize culture, and applauded their destruction of the hated guillotine (Dollinger, 24). Afterward, however, he resumed his vigorous defense of the new Republic against the campaigns of the Orleanists and Legitimists, then in the majority in the National Assembly, to reestablish a monarchy in France. In the print exhibited here, his last on a political subject, he predicts that the monarchist cause, badly divided between the two factions, is doomed to failure: against a stark black background Monarchy lies rigidly dead in her coffin; yet "all this time," the caption states, "they have continued to affirm that she was never better."

Like Disdéri in his photograph of dead Communards in their coffins (cat. 82), which was published the year before and was perhaps known to him, Daumier chooses a close-up view that heightens the dramatic impact of his macabre subject, but one not quite as close as Disdéri's or as charged with immediacy; his slightly more distant and horizontal view enables Daumier to show the entire coffin in a more conventional manner. He increases its pathos, however, by setting it at an angle to the picture plane, employing the "common and ages-old device by which a prone body can serve to express the suffering, surrender, and passivity in general of the defenseless, the dying, and the dead" (Heckscher, 35-36). The device recurs repeatedly in Daumier's frequently gloomy prints of these years. In the *Assembly of Bordeaux* (Delteil, no. 3848), the reactionary representatives stand ominously behind a table, on which the Republic is stretched out diagonally with a large knife beside her, to which the caption draws attention. In *Other Candidates* (Delteil, no. 3844), she lies in virtually the same position on a deserted battlefield, above which a flock of vultures, the other candidates, hovers. That the device was still more widespread in nineteenth-century art is evident from Manet's image of the dead toreador (cat. 77) and Gérôme's of the dead Caesar (cat. 78), though in these cases the head rather than the feet is close to the picture plane.

Honoré Daumier (1808-1879)

84 *Rue Transnonain, 15 April 1834,* 1834

Lithograph, 11¼ x 17⅜ in. (28.6 x 44.1 cm.)
Signed in the stone, lower left: *h. D.*
National Gallery of Art, Washington, Rosenwald
 Collection 1943
Delteil, no. 135

The event Daumier commemorates in this powerful print, one of the most memorable in his graphic oeuvre, is well known. On 13-14 April 1834, a violent but unsuccessful uprising against the repressive regime of Louis Philippe broke out in the working-class district around the present rue Beaubourg in Paris. About five o'clock the following morning, an army officer was rumored to have been killed by a sniper firing from a tenement at 12, rue Transnonain, in the heart of this district. Other officers and soldiers of his regiment, known for its brutality, forced their way into the building and in retaliation shot, stabbed, and clubbed to death most of its innocent and defenseless inhabitants. Eyewitness accounts by the few survivors, published by the republican politician Ledru-Rollin early in August in an impassioned pamphlet demanding a government investigation, filled in the horrible details of the picture already outlined by oral reports (Bechtel, 33-34). When Daumier set to work later that month, he could base his own picture on this factual account. What he produced, as his editor Philipon observed, is as "frightful as the ghastly event which it relates. . . . This indeed is not a caricature; it is not a *charge*; it is a page of our modern history bespattered with blood, a page drawn with a powerful hand and dictated by noble anger" (Bechtel, opposite pl. xxiv).

Immensely popular as soon as it was published—crowds formed outside the printseller Aubert's shop to see it—the *Rue Transnonain* was considered inflammatory by the police, who seized the stone and destroyed all available examples. Its suppression foretells that of Manet's lithographs *The Execution of the Emperor Maximilian* (cat. 74) and *Polichinelle* (cat. 40), and helps to explain his reluctance to publish *The Barricade* (cat. 73) and the *Civil War* (cat. 76) while memories of the Commune were still vivid. But Daumier's print also anticipates the *Civil War* in other respects—in its condemnation of military brutality and in its composition with one body lying diagonally in the center and another drastically cut by the frame at the lower right—and may indeed have been in his mind when he created his own print (Fried, 76, n. 167).

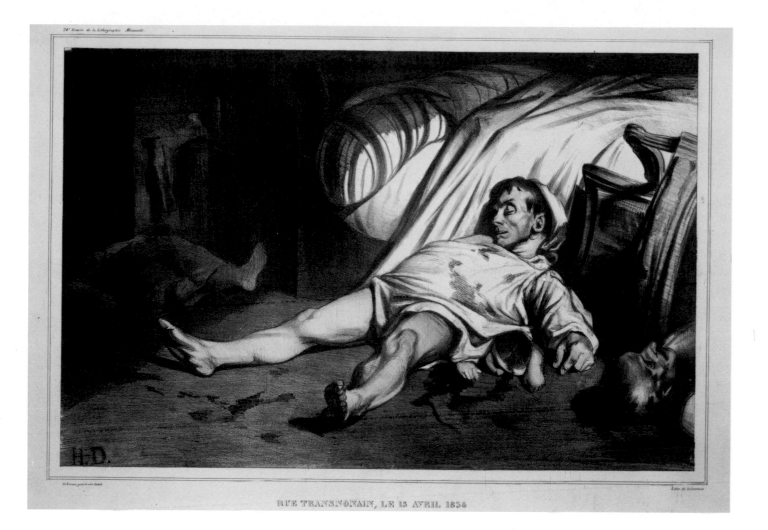

RUE TRANSNONAIN, LE 15 AVRIL 1834

Maximilien Luce (1858-1941)

85 A Paris Street in 1871, 1904-1905

Oil on canvas, 59 x 88⁹⁄₁₆ in. (150 x 225 cm.)
Signed and dated, lower right: *Luce/1904-1905*
Musée d'Orsay, Paris

The most impressive of the pictures painted long after the Commune by artists with radical political views who wished to exalt its memory for later generations of workers is the one by Luce exhibited here. Shown at the Salon des Indépendants in 1905 and later lent to the Confédération Général du Travail, it was clearly conceived as a kind of secular altarpiece for a new cult of proletarian revolution; hence its monumental size, over five by seven feet. It is hardly surprising that Luce undertook to paint it on such a scale; for among the largely radicalized neo-impressionists, he was the most active contributor to the proletarian anarchist newspapers and the one "closest to the masses in temper and outlook" (Herbert 1961, 187). Nor was it the last of his tributes to the martyrs of the Commune: in 1915 he depicted the famous Wall of the Fédérés, its most hallowed burial ground, and in 1918 the execution of Varlin, one of its legendary leaders (Tabarant 1928, 51-52). It was surely A Paris Street in 1871, however, that had the greatest significance for Luce; he had dreamed of painting it ever since, as a boy of thirteen, he had simultaneously begun his artistic training in a course offered during the Commune and had witnessed brutal reprisals in the working-class district behind the Gare Montparnasse where his family lived (Tabarant 1928, 9-12). But it was only in 1904, after moving to a larger studio earlier in the year, that he attempted to represent in art what had remained indelible in memory.

To achieve the look of terrible reality he sought, Luce made many studies of male and female corpses; but he must also have found a pictorial model in Meissonier's *Barricade* (fig. 114), itself a "souvenir of civil war." Although then in private hands, it had been exhibited in Paris and reproduced in a monograph in the 1890s. From this source Luce apparently derived both his composition, with its dead bodies strewn on the pavement beside a fallen barricade, and his perspective, with its long view down a deserted street lined with shuttered store-fronts,

114. Ernest Meissonier. *The Barricade (Souvenir of Civil War)*, oil on canvas, 1848. Musée du Louvre, Paris.

whose emptiness and lack of any signs confer an eerie silence and anonymity on the tragic event. But if Luce's monumental canvas was meant to commemorate the heroism of the revolutionary martyrs, the tiny one by Meissonier, an artist of reactionary political views, was intended as "a sober warning to the rebels of the future" (Clark 1973, 27). Hence its somber tonality and inhumanly precise rendering of the fallen insurgents, in contrast to which the more strongly illuminated and vividly colored picture by Luce seems an affirmation of life and the will to resist even in death.

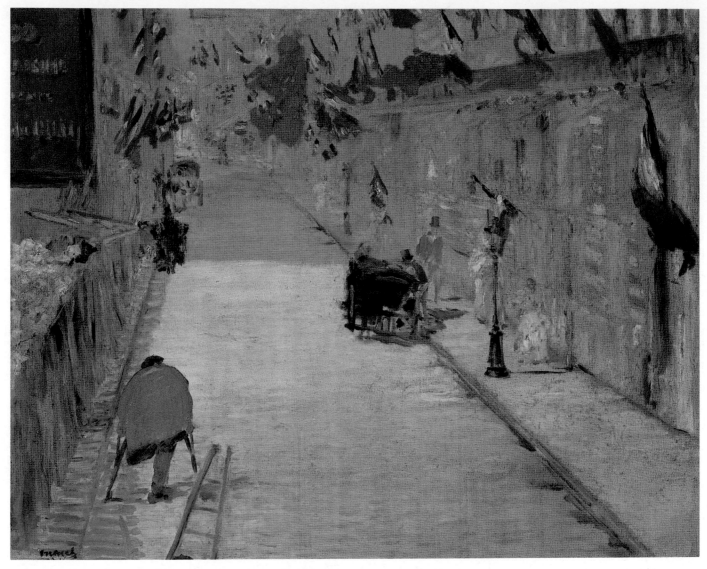

Plate 14. Edouard Manet. *The Rue Mosnier Decorated with Flags*, 1878. Cat. 86.

9

The Public Holiday

ᘔ

DESPITE THE INCREASING atomization of French society in the second half of the nineteenth century, public festivities remained an important part of both religious and secular life. In addition to the fixed and movable feasts of the ecclesiastical calendar, there were many occasions for public celebration in the large cities as well as the small towns and villages; and throughout this period, French artists found inspiration in them. In the Pas-de-Calais region in the late 1850s, Jules Breton painted the solemn processions of clergymen and populace formed for the traditional ceremonies of blessing the wheat and dedicating a new calvary (Weisberg 1981, 113-114, 121-122). In the still more conservative villages of Brittany, Boudin in the same years and Maurice Denis forty years later painted the centuries-old *pardons*, or pilgrimages, in which peasants and fishermen in traditional costume participated. In the towns of Argenteuil and Marly-le-Roi in the 1870s, Monet and Sisley painted the annual festivals (fig. 115) which, having begun as church holidays, had assumed a more civic and commercial character and included fairs, fireworks, public balls, and at Argenteuil a regatta (Tucker, 32-33). For all their picturesqueness, however, these local festivities could not match the splendor of those held in the large cities, and above all in the capital.

In Paris the celebration of carnival on Shrove Tuesday, long an occasion for extravagant merrymaking, included an elaborate costume ball at the Opera which Gavarni depicted in the 1840s and Manet thirty years later (cat. 39), as well as a colorful parade along the boulevards which Pissarro represented in the late 1890s (cat. 97). There too the popular *Foire aux Pains d'Epice* was held every year at the place du Trône, drawing huge crowds to its side shows, games of skill, and gingerbread stall, a festive ambiance that is vividly described in Daudet's novel *Les Rois en exil* (1879). And there also were held the five world's fairs of this period, accompanied by

prodigious displays, both official and popular: the opening of the 1878 fair, after seven years of political instability and disillusionment, was greeted spontaneously with street decorations and dancing throughout the city (fig. 116); and two months later the more formally organized *Fête de la Paix*, which Monet (cat. 90) and Manet (cat. 86) and, as we now know, Sisley all painted (Thomson, 686), was celebrated no less joyously. As the traditional religious holidays gradually lost their appeal, civic and

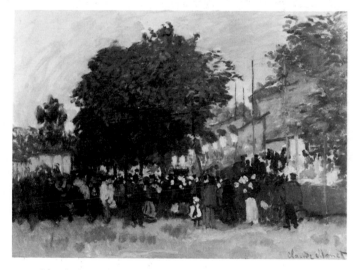

115. Claude Monet. *Festival at Argenteuil*, oil on canvas, 1872. Private collection, United States.

patriotic ones such as these gained in popularity, and none more so than the annual celebrations intended to glorify or strengthen the present regime. Napoleon III had made August 15th, his patron saint's day, an occasion for well-organized festivities and free theater admissions, as numerous prints of the Second Empire testify. But it was only when the Third Republic revived the celebration of Bastille Day on July 14th that the nation had a truly popular political holiday and artists a truly inspiring subject.

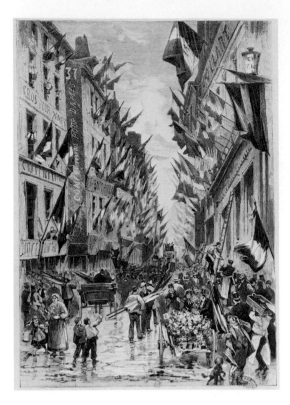

Left: 116. M. Scott. *The First of May in Paris*, wood engraving from *Le Monde illustré*, 11 May 1878. Bibliothèque Nationale, Paris.
Right: 117. Artist unknown. *The Republic Triumphant*, lithograph, 1880. Bibliothèque Nationale, Paris.

The political implications of the *fête* of 30 June 1878 were not lost on Monet, who in one of his paintings (fig. 123) included a large banner inscribed "Vive la République." The first such official celebration since the "année terrible" of 1870-1871, it was meant to demonstrate the republican government's newly consolidated strength, as well as the country's newly restored pride; but it was merely a prelude to what soon followed. Two weeks later, the centenary of the death of Rousseau, one of the Republic's intellectual forefathers, was celebrated on July 14th; and one year after that, a glittering reception at the Palais Bourbon for prominent figures in all branches of public life, among them Manet, was again held on the 14th; it was given by Gambetta, who rightly declared it "the triumph of the Republic" (Proust, 93-94). But it was only in 1880 that the fall of the Bastille, already celebrated once before in one of the most extraordinary festivals of the Revolution, was declared a national holiday. To achieve its goal of creating a similar "ritual of civic solidarity" (Sanson, 40), the government organized a great military review at Longchamp, an impressive parade and fireworks display in Paris, and other festivities throughout the country, though the conservative rural communities were at first less than enthusiastic. At the same time, complete amnesty for prisoners

and exiles of the Commune, long sought by leftist deputies and partly granted in 1879, healed the last wounds of that bitter conflict. All these themes, together with a colossal figure of the Republic wearing the radical Phrygian bonnet, are summed up in a popular print of the day (fig. 117).

The government also commissioned huge paintings to commemorate the military review and the parade through Paris, the latter subject given to Roll (cat. 91). And in the last decades of the century, many other artists treated the colorful, animated festivities of their own accord; among them, Van Gogh in Montmartre in 1887 and again in Auvers in 1890, Bonnard in a bourgeois district of Paris in 1890 (cat. 92), and Steinlen in a working-class district around 1895 (cat. 93). This was also the period in which the *Fête Nationale* was most enthusiastically celebrated in the provinces as well as the capital, and by the middle as well as the lower classes; but by the end of the century it had begun to lose this broad appeal, and by the First World War it had become almost exclusively a working-man's holiday. In his novel *L'Apprentie* (1904), set in Montmartre, Gustave Geffroy could note that "among the inhabitants of the slums, there was a *Fête Nationale*. On the humid, gray stones, in the casements without curtains, broke forth the tricolors"

(Geffroy, 379). The same was true in provincial towns like Saint-Tropez and Le Havre, where the fauve painters Manguin, Marquet, and Dufy found inspiration for some of their most exuberant pictures around 1905 (e.g., cat. 94).

Deeply patriotic and ardently republican, Manet responded with enthusiasm to the celebration of the 14th in 1880, anticipating the fireworks display in one letter and decorating two others with watercolors of French flags (cat. 89), in which he naturally stressed the themes of amnesty and the Republic. Two years earlier, he had painted the street opposite his studio decked with flags for the *Fête de la Paix* of June 30th (cat. 86). His interest in such celebrations was, however, by no means exclusively political. It was indeed inseparable from that broader interest in all aspects of the public life of modern Paris which had led him still earlier to paint the thoroughly bourgeois ball at the Opera at carnival time (cat. 39), the world's fair that Napoleon III had arranged as a colossal imperial showcase (cat. 2), and a crowd witnessing a balloon ascent on a public holiday in the no less imperial Tuileries Gardens (cat. 98).

Edouard Manet

86 *The Rue Mosnier Decorated with Flags,* 1878

Oil on canvas, 25½ x 31½ in. (64.8 x 80 cm.)
Signed and dated, lower left: *Manet 1878*
Mr. and Mrs. Paul Mellon, Upperville, Virginia
R-W 1:270

Opened with some misgivings on 1 May 1878, seven years after the devastating Franco-Prussian War and the Commune, the world's fair had already proved itself a popular and political success two months later. The *Fête de la Paix* on June 30th was thus, like the fair itself, an affirmation of the country's complete recovery, international acceptance, and material and cultural progress, and was conceived on a larger scale than any during the previous regime, itself a continual *fête impériale*. The newspapers and illustrated weeklies were ecstatic that

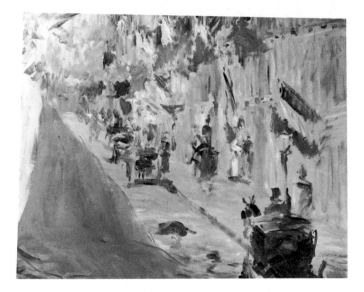

118. Edouard Manet. *The Rue Mosnier Decorated with Flags,* oil on canvas, 1878. Private collection, Switzerland.

June in describing "the joy on every face, exuberant and sincere," and the festive decoration of every street, which in some quarters caused "the houses to disappear completely behind the bundles of flags" (*Univers illustré,* 426). Manet, who had already painted a panoramic view of the 1867 fair and its visitors (cat. 2), responded no less enthusiastically on this occasion: from the windows of his studio on the rue Saint-Pétersbourg, he painted the rue Mosnier decked with flags twice on June 30th.

What must be the first version, judging from the

shorter shadows shown (Collins, 710, n. 3), is by far the more exuberant of the two (fig. 118): its design, built on a series of diagonals, is more dynamic and its execution more spontaneous and energetic, though that aspect would have been modified if Manet had worked on it further; it is clear that he abandoned it, unsigned, in the state of a bold oil sketch. The red, white, and blue strokes at the top are put down swiftly, with no preliminary drawing, and the huge red triangle at the left—a flag flying beside his studio window, but perhaps also a reminder of the red banners he had seen during the Commune—fills the entire corner. The second version, exhibited here, is more deliberately worked out and more restrained in mood; indeed, remarkably so, in contrast to the first one, to Monet's paintings of the same holiday (cat. 90), and to contemporary images of the streets and festivities (fig. 119). The composition is based on a classical system of central perspective, the paint is applied in smooth, regular strokes, and the tonality is cool and blond, with small accents of red and blue. Only a handful of people are on the street, the most conspicuous of them a crippled man (cf. cat. 88). The two poles of Manet's sensibility, the engaged and the detached, are thus illustrated in works painted on the same day.

119. Vicente Oms. *The National Holiday,* wood engravings from *Le Monde illustré,* 13 July 1878. Bibliothèque Nationale, Paris.

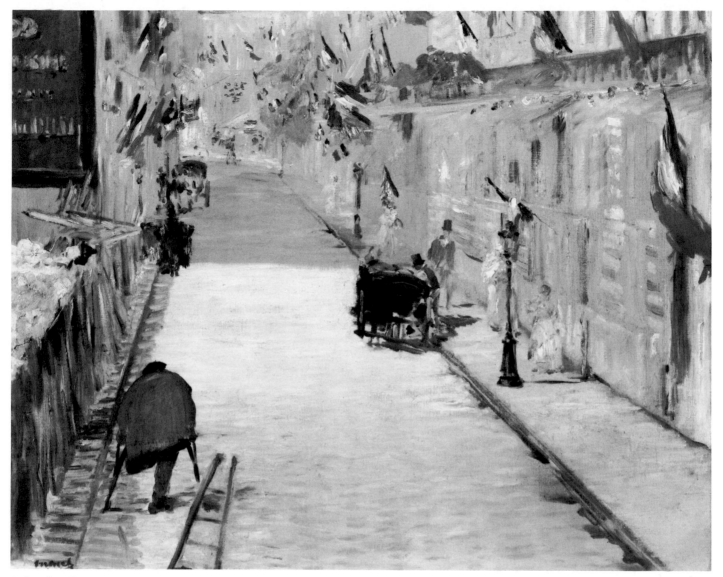

Color plate 14

Edouard Manet

87 *The Rue Mosnier,* 1878

Pencil, brush, and ink, 10¹⁵⁄₁₆ x 17⁵⁄₁₆ in. (27.8 x
44 cm.)
Atelier stamp, lower right: *E.M.*
The Art Institute of Chicago, Gift of Mrs. Alice
H. Patterson in memory of Tiffany Blake
R-W 2:327

The celebrations on 30 June 1878 coincided with
Manet's departure from the studio on the rue Saint-
Pétersbourg that he had occupied for the past six years;
his lease having expired, he moved to another studio early
in July (Tabarant 1947, 319). As if wishing to preserve an
image of the street he had seen almost daily in those
years, he made several drawings and a painting of it—
probably also in the late spring—in addition to pictures
of the holiday itself (cat. 86). There are indeed clear
signs of spring, bright sunlight and bright green foliage,
in the third painting (R-W 1:272), which shows a group of
road menders working on the pavement in the foreground
and a fence blocking the sidewalk to the left; the work
was still in progress on the 30th, to judge from the same
fence in one of the other paintings.

The drawing exhibited here is one of two of the rue
Mosnier executed with a brush and diluted Chinese ink.
The other (R-W 2:328) shows the street from the same
angle as the paintings, with both sidewalks visible,
whereas this one showing it from a distinctly different
angle must have been drawn from another window.
Neither drawing, however, is a study in the strict sense
for any of the paintings; at most they are a kind of
reconnaissance of the motif made in preparation for the
final assault, but in a much freer, more calligraphic
style. It is a style of remarkable verve and spontaneity, in
which representation is reduced to the notation of a few
salient features—the buildings and lampposts, the car-
riages and pedestrians, the sweepers and their brooms—
and recorded with a few swift strokes of the brush. The
effect is that of Oriental calligraphy and especially of
Japanese *sumi* drawings, both of which appear in or are
imitated in a sheet of studies Manet had made a few years
earlier, while illustrating Poe's "The Raven" (Wilson,
no. 88). Among the other drawings of the rue Mosnier,

however, there are more precise descriptions of coaches
and coachmen (R-W 2:323-326) that can be considered
studies for one or the other of the paintings, even if
rendered in a similarly spontaneous style. One of these,
of a coach seen from behind (fig. 120), corresponds
closely enough to the first of the paintings of June 30th
(fig. 118) to suggest that, for all its exuberant freedom,
the latter was prepared by means of such drawings.

120. Edouard Manet. *A Coach Seen from Behind,*
pencil, 1878. Cabinet des Dessins, Musée du
Louvre, Paris.

Edouard Manet

88 *A Man with Crutches*, 1878

Brush and ink, 10¹¹⁄₁₆ x 7¾ in. (27.1 x 19.7 cm.)
Signed, bottom center: *M.*
The Metropolitan Museum of Art, New York,
 Harris Brisbane Dick Fund, 1948
R-W 2:479

The one-legged man wearing a smock and walking with the aid of crutches in this drawing is undoubtedly the one who is seen from behind in the second of Manet's paintings of the rue Mosnier decorated with flags (cat. 86). Given a monumental stature here through the large-ness of form and simplicity of line, he appears there as an insignificant genre element, indeed as the familiar neighborhood figure he is said to have been (Moreau-Nélaton 1926, 2:46). At the most, his pictorial role seems purely formal—to strengthen the composition at the lower left and prevent too rapid a thrust into depth—and as such he is the first in a series of forms placed on alternate sides of the street at progressively deeper inter-vals. But given the date of the drawing and the painting, seven years after the Franco-Prussian War, he is almost certainly a war veteran, a type long familiar in nineteenth-century art, especially in prints, and is thus an expression of a more humane view of war and its consequences than can be found in contemporary mili-tary pictures by Meissonier, Detaille, De Neuville, and others (Collins, 710-711; Grand-Carteret, 5:64, 66). More specifically, he is a reminder of the horrors of the recent war and of the civil war that followed it, intro-duced here with bitter irony at the very moment when Paris was celebrating a *Fête de la Paix*. In that retrospec-tive sense, the cripple in this version of the rue Mosnier is comparable to the huge red flag in the other version (fig. 118).

The same figure, seen from behind as in the painting, appears in another wash drawing of 1878 (fig. 121), which Manet made in preparation for a lithograph that was to serve as the cover for an album of music published in that year (Wilson, no. 14). Composed by Cabaner, an eccentric musician in the circle of artists, writers, and left-wing politicians whom Manet had met in the salon of Nina de Villard, the music was set to poems from Jean

121. Edouard Manet. *The Beggars,* brush and ink, 1878. Private collection, Paris.

Richepin's book *La Chanson des gueux*, about Parisian vagabonds and beggars. Since one of the poems, "Le Vieux," describes a "poor old cripple" begging outside a church (Richepin, 12), it is likely that Manet's image was inspired by it, and therefore has a social as well as a political significance. This is especially clear in the painting, where the one-legged man in his worker's blue smock is contrasted to the fashionable people on the opposite sidewalk.

Edouard Manet

89 A *Cluster of Flags,* 1880

Ink and watercolor, 5¹¹⁄₁₆ x 4⁵⁄₁₆ in. (14.5 x
 11 cm.)
Signed, lower right: *Ed Manet,* and inscribed:
 Bellevue / 14 Juillet 1880 / Vive la République
Private collection, Zürich
R-W 2:596

Obliged by his failing health to spend the summer
of 1880 in a villa at Bellevue, on the Seine near Sèvres,
Manet sought escape from his isolation and the fatigue of
his daily hydrotherapy in the forty or so letters he wrote
to friends and illustrated with small watercolor sketches
(Tabarant 1947, 390-394). Among them are two directly
concerned with the first celebration of July 14th under
the Third Republic, the watercolor exhibited here and
another, now in the Louvre (fig. 122). Both as a patriot
and as an ardent republican, Manet was enthusiastic
about this great public demonstration of the govern-
ment's recently consolidated power and popularity, and
as an artist he was equally excited by the splendid forms
the festivities would take, at least those he could observe
in his confined position. Writing to Isabelle Lemonnier
on the 13th, he surmised, "I am sure you are dreaming of
flags and the fall of the Bastille. We are, it seems, in the
best spot for watching the fireworks" (R-W 2:573). On its
hill above the Seine valley, just outside Paris, Bellevue
was indeed such a spot.

The watercolors Manet made the following day both
depict clusters of French flags, by far the most popular
motif in the decoration of the streets, not only in Paris
but throughout the country. The slogan he wrote on the
one shown here, "Vive la République," was of course
heard everywhere that day; but the other slogan, "Vive
l'Amnestie," made a more personal statement. Amnesty
for the imprisoned and exiled Communards had been
proposed by leftist legislators as early as 1873, and more
strenuously by Clemenceau in the Chamber and by Hugo
in the Senate in 1876; a partial amnesty had been voted in
March 1879, but a complete one only in July 1880, three
days before the celebration of the 14th (Bruhat, Dautry,
and Tersen, 354-360). It was this final gesture of recon-
ciliation toward the survivors of the Commune, which
Manet had witnessed in 1871 (cat. 72, 76), that he
celebrated.

122. Edouard Manet. *A Cluster of Flags,* ink and
watercolor, 1880. Cabinet des Dessins, Musée du Louvre,
Paris.

Claude Monet (1840-1926)

90 *The Rue Montorgeuil, Festival of 30 June 1878*, 1878

Oil on canvas, 31½ x 19⅛ in. (80 x 48.5 cm.)
Signed, lower right: *Claude Monet*
Musée d'Orsay (Galerie du Jeu de Paume), Paris
Wildenstein, no. 469

🦢 If the *Fête de la Paix* on 30 June 1878 was not, as is usually said, the first public festivity held in Paris since the last *fête impériale* in 1869—the spontaneous celebration of the opening of the world's fair on May 1st, hailed as "a new *Fête de la Fédération*" (Simond, 3:164-165), was in fact the first—it was nevertheless the one most elaborately organized and enthusiastically received throughout the city. Like Manet on that June day, Monet was so deeply stirred by the emotional outpouring and so strongly stimulated by the sight of the brilliantly decorated streets that he painted them twice. But unlike his friend, who remained in his studio in the middle-class Quartier de l'Europe and depicted the relatively tranquil celebration on the rue Mosnier, Monet wandered the streets of the working-class district near Les Halles and chose to depict two of its most crowded and animated thoroughfares, the rue Montorgeuil and the rue Saint-Denis. The former street is shown in the painting exhibited here, the latter in the one now at Rouen (fig. 123); but the two streets are only a few blocks apart, and both are viewed toward the north; so that, judging from the treatment of light and shadow, Monet must have painted this one first. Both are panoramic views taken from a balcony several stories above the street, for as he later recalled, "The street was decked with flags but swarming with people. I spied a balcony, mounted the stairs, and asked permission to paint" (Seitz, 108). Which street that was he did not specify, but presumably he repeated the process on the other one.

As a result, both pictures convey not only the vast scope of the celebration—something that the drawings in the illustrated weeklies (fig. 119), based on photographs taken from the ground, capture less successfully—but also its animated and exalted spirit. The agitated strokes of red, white, and blue suggest, more than they describe, the fluttering of hundreds of flags on both sides of the street, and the repetition of these colors creates a rhythmic beat down its entire length, like that of marching music—a slightly different beat on each side, depending on the size of the flags and the degree of sunlight or shadow. The darker, more vertical strokes that represent the crowd establish still another rhythm; and the smoothly painted, pale blue sky, the fourth zone in this design based on a pair of crossed diagonals, provides an area of contrasting tranquillity.

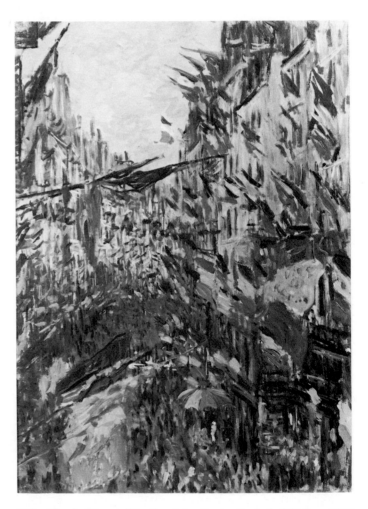

123. Claude Monet. *The Rue Saint-Denis, Festival of 30 June 1878*, oil on canvas, 1878. Musée des Beaux-Arts, Rouen.

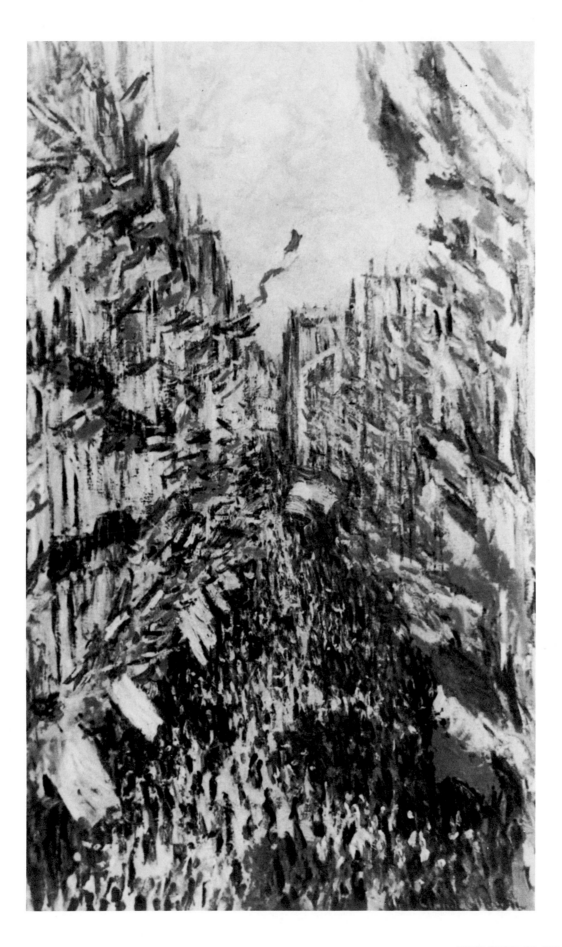

Alfred-Philippe Roll (1846-1919)

91 *The Fourteenth of July, 1880,* 1882

Oil on canvas, 69 x 145½ in. (175.3 x 370 cm.)
Not signed or dated
Musée du Petit Palais, Paris

Despite its huge size, this picture is merely the sketch for a still larger one, some twenty-one by thirty-two feet (fig. 124), which was meant to commemorate on a monumental scale the first celebration of July 14th as a national holiday in 1880. Originally commissioned by the government to represent another aspect of the festivities, the military review at Longchamp, Roll was asked at the last minute to depict instead the popular parade through the streets of Paris. "For an entire day and night," his biographer relates, "he mingled with the crowd, participated in the popular rejoicing, heard the acclamations that greeted the soldiers returning from the review, and, imbued with all this patriotic joy, set to work" (Valmy-Baysse, 11). The last-minute change was a happy one, for Roll's temperament and talent were much more suited to such a spectacle than to the official one at Longchamp.

Roll's deep identification with the working class, which had already led him to paint the plight of the flood victims in the countryside near Toulouse (*The Flood,* Salon of 1877) and that of the hard-hit miners in the coal fields at Charleroi (*The Miners' Strike,* Salon of 1880), enabled him to describe the parade as a truly popular event, in which street urchins, workers in blouses, and an old woman in an apron mingle with the more elegantly dressed couples in and around the carriage. And his vividly realistic style, which elicited much criticism of vulgarity when the definitive version was shown at the Salon of 1882, made it possible for him to project a panoramic view of a city square teeming with soldiers, musicians, and spectators in a convincing, if somewhat tedious, manner. (The more broadly executed sketch is for that reason more congenial to twentieth-century taste; the finished picture, at first rejected by the government, then shunted from one public building to another, is now kept in storage, rolled up.)

Given his strongly populist sympathies and his intense patriotism, it was perhaps inevitable that Roll would choose as a setting for his panoramic picture the vast, recently renamed place de la République in the predominately working-class eastern part of Paris. Yet for all his commitment to realism, he did not represent it exactly as it appeared in 1880: the colossal statue of the Republic, which he shows looming up against the sky, was erected in June 1883 and inaugurated on July 14th (Hillairet, 2:336). Roll must have seen a model of it, perhaps in the studio of Dalou, who sculpted the figures of Liberty, Equality, and Fraternity on its pedestal.

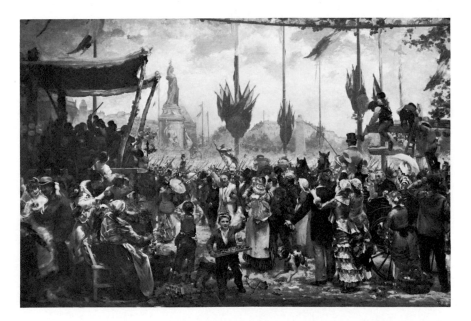

124. Alfred-Philippe Roll. *The Fourteenth of July, 1880,* oil on canvas, 1882. Musée du Petit Palais, Paris.

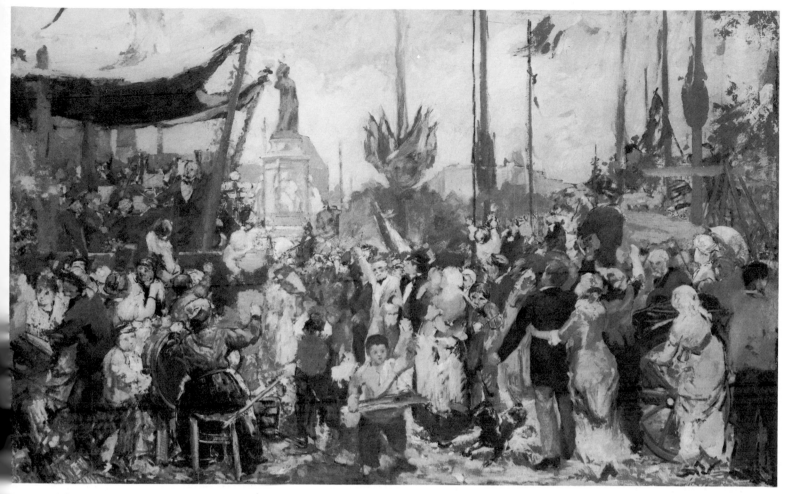

Not in exhibition.

Pierre Bonnard (1867-1947)

92 *The Rue de Parme on Bastille Day,* 1890

Oil on canvas, 31¼ x 15¾ in. (79.4 x 40 cm.)
Not signed or dated
Mr. and Mrs. Paul Mellon, Upperville, Virginia
Not in Dauberville

🦋 The sophisticated urban imagery, the oblique composition, and the clever drawing of this charming picture immediately call to mind Bonnard's work of the 1890s. His well-known *Screen* of 1897, of which the right half is illustrated here (fig. 125), reveals precisely the same features, though in a more mature, confident form. But the very smooth, flat surface of the *Rue de Parme* and the fine, dark outlining of its shapes are unusual in his work; and since the picture is unsigned, has virtually no provenance, and is absent from the standard oeuvre catalogue, one might question the attribution. Ultimately it is confirmed not only by the presence of similar features in a few unquestioned early works—notably the *Military Review* and the *Snowball Blossoms* (Dauberville, 1: nos. 10, 30), where the execution is just as flat and the outlining just as sharp—but by the very high quality of *Rue de Parme*. Although painted by a young artist who was not yet twenty-three, it shows a mastery of the compositional devices perfected by Degas and before him by Japanese printmakers and a remarkable ability to use them in a personal manner.

By the early 1890s, the *Fête Nationale* decreed only a decade earlier had begun to lose some of its appeal, at least in the more prosperous quarters of Paris, whose inhabitants celebrated only perfunctorily or left the city entirely. In 1892 Jules Lemaître deplored "that brutal contrast between a poor Paris that celebrates and a wealthy Paris that abstains and disdains" (Sanson, 103). The rue de Parme, a short street in the Batignolles district between the rue de Clichy and the rue d'Amsterdam, where Bonnard was living with his grandmother when he painted this picture, was somewhere between those two extremes both socially and geographically. But it was close enough to Montmartre for the holiday to have been celebrated more enthusiastically than he suggests; the sedate bourgeois tone is one he projects, and it contrasts strikingly with the emphatically populist tone of Steinlen's picture later in the decade (cat. 93). For Bon-

nard the occasion was festive—and he makes much of the brilliantly colored flags—but hardly very animated; the cleverly foreshortened street and carriages, the wittily silhouetted and patterned figures are like those he observed every other day.

125. Pierre Bonnard. *Screen* (right half), color lithograph, 1897. The Museum of Modern Art, New York, Abby Aldrich Rockefeller Fund.

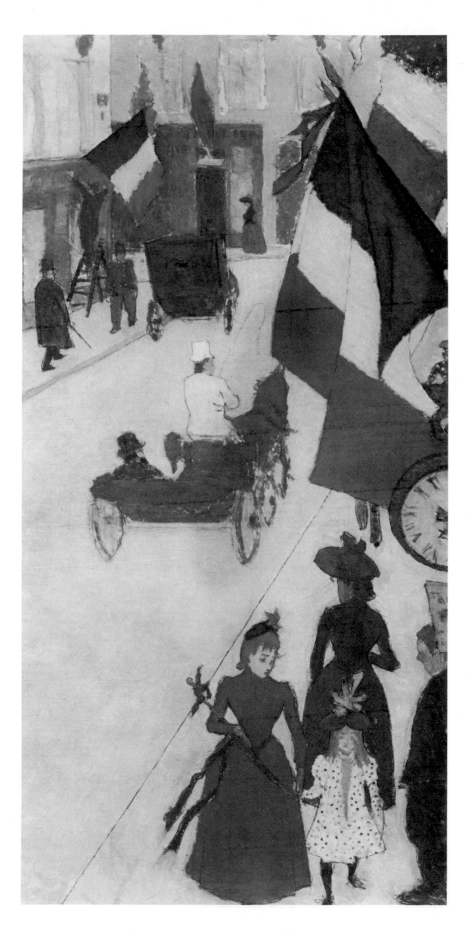

Théophile-Alexandre Steinlen (1859-1923)

93 *The Fourteenth of July,* 1895

Oil on canvas, 14¹⁵⁄₁₆ x 18⅛ in. (38 x 46 cm.)
Not signed or dated
Petit-Palais, Geneva

For the socialist artist Steinlen, whose work was largely devoted to describing the labors and pleasures of the working-class inhabitants of northern and eastern Paris, the 14th of July was above all their holiday. Like his fellow socialist Vallès, he was obviously "all for a truly Republican day in the city given over to its inhabitants, in the midst of the streets, whose free and familiar way of life will put a check on the official way, always solemn and declamatory" (Bancquart, 47). Stressing this populist aspect of the celebration, Steinlen painted a group of six working men and women, some in their Sunday clothes and some not, striding arm in arm through the streets of Montmartre and singing lustily; and unlike Manet (cat. 86), Monet (cat. 90), and Bonnard (cat. 92), all of whom looked down on the street from above, he chose a low viewpoint that caused his figures to stand large against the colorful banners and lanterns behind them. Heroic in stature, united and determined, they are like the more militant marchers in Steinlen's images of political protest, such as those who stride forward arm in arm in a lithograph he published in 1894 to commemorate the establishment of the Commune twenty-three years earlier (fig. 126). In the print, however, the figures are half realistic and half symbolic, whereas his achievement in the painting is to convey that sense of proletarian strength and determination without recourse to allegorical figures like that of the radical Republic, and to do so in a language of powerful form and boldly contrasted color. The red, white, and black of the younger woman's costume and the glowing red and yellow of the lanterns exemplify this dramatic coloring.

In the same socialist newspaper in which his print commemorating the Commune had appeared, Steinlen published another a few months later, presenting a bitterly ironic view of Bastille Day (Crauzat, no. 158). It shows a worker walking with his children on the night of the 14th—again there are lanterns in the background—and its legend sums up the disillusionment with their fettered condition that many workers felt: "Why—Papa—did they take the Bastille?"

126. Théophile-Alexandre Steinlen. *The Eighteenth of March,* lithograph, 1894. Bibliothèque Nationale, Paris.

Raoul Dufy (1877-1953)

94 *A Street Decked with Flags*, 1906

Oil on canvas, 25⁹⁄₁₆ x 31⅞ in. (81 x 65 cm.)
Signed and dated, lower right: *Raoul Dufy 1906*
Musée National d'Art Moderne, Centre Georges
 Pompidou, Paris, Bequest of Mme R. Dufy
Laffaille, no. 214

Around 1905, long after the painting of crowds celebrating on flag-decked streets had ceased to attract most advanced artists, the young fauves turned to Bastille Day subjects with enthusiasm. Given their general interest in choosing "intrinsically colorful subjects" as "a way of brightening and intensifying their pictures without losing their attachment to natural appearances" (Elderfield, 79), this was a natural and perhaps inevitable attraction. The brilliant flags and banners hanging over the streets, the bright lanterns shining at night were pictorial equivalents of the colorful billboards and posters, the glittering rivers and ships that also appealed to them, and likewise expressed their sense of the dynamism and vitality of the modern city and harbor. But their interest in the *Fête Nationale* may not have been purely artistic: it was precisely in 1905-1906 that the wave of intense nationalism which had been swelling since the political disorders of the previous decade, and above all since the Dreyfus Affair, crested under the growing threat of war caused by the Russo-Japanese War and German colonialism in Africa (Oppler, 215-231); and the fauves may well have been affected by the fiercely patriotic celebrations of those years, especially in the provincial towns where they were working.

In July 1906, while staying in Le Havre with Marquet, Dufy painted eleven versions of the street decked with flags on Bastille Day (Laffaille, nos. 211-221), of which the one exhibited here is the largest and by far the most familiar. In all of them he was evidently more attracted by the colorfulness of the huge flags and banners than by the animation of the crowds. Unlike Monet, whose pictures of an earlier holiday (cat. 90) were his closest pictorial precedents, Dufy included relatively few people, and as single figures rather than a throng; but unlike Steinlen (cat. 93), he saw them as anonymous types rather than as

127. Albert Marquet. *The Fourteenth of July at Le Havre*, oil on canvas, 1906. Musée de Bagnols-sur-Cèze.

individuals. It was above all the flags that interested Dufy—not as small colorful forms fluttering in the breeze, but as large stable blocks of color, whose autonomous nature he stressed by placing some of them parallel to the picture plane or by outlining them heavily. Whereas Marquet, in a picture painted on the same occasion (fig. 127), remained interested in describing particular flags hanging at particular angles over the street, Dufy raised them to the level of general signs, which could function simultaneously in the realms of pure sensation and of patriotic sentiment.

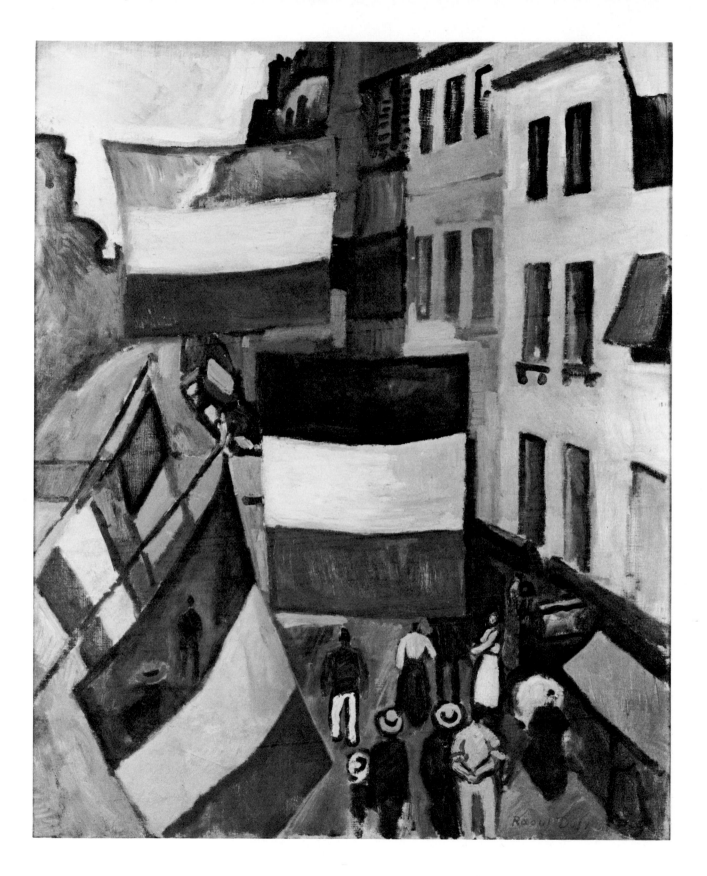

Eugène Boudin (1824-1898)

95 *Festival in the Harbor of Honfleur,* 1858

Oil on wood, 15⅞ x 23⅛ in. (40.3 x 58.7 cm.)
Signed, lower left: *Boudin* 58[?] and inscribed,
 lower right: *Honfleur*
Mr. and Mrs. Paul Mellon, Upperville, Virginia
Schmit, no. 191

Among the many occasions for festivity besides the *Fête Nationale*, none was more popular in the cities and towns situated on rivers or streams or on the northern coast of France than the annual regatta. From the time the first one was held at Le Havre in 1840, these colorful sporting events attracted thousands of participants and spectators to all the port-cities along the coast from Dunkerque to Cherbourg. At Honfleur, which had been slower than some of its neighbors in organizing regattas, the first ones took place in September 1854, amid much pomp and ceremony; the next ones in September 1855 and August 1857 (Karr, et al., 234-236). It must therefore have been in the same season in 1858 that Boudin painted the picture exhibited here, not of the regattas themselves—those he depicted in a smaller work (Schmit, no. 189), showing the shore crowded with spectators and ornamented with pennants, while dozens of sailing boats maneuver at sea—but of the port splendidly decked out in honor of them. From the rigging of every vessel at anchor, including the large naval bark no doubt sent for the occasion and the steamboat that also appears in the regatta picture, flags and pennants of every color fly in the breeze; and around the bark, equally colorful boatloads of women row out to sea. (The Honfleur regattas were unique in including women boaters—cf. Karr, et al., 236—but the ones shown here are presumably spectators.)

This picture is the first of many in pre-impressionist and impressionist art to treat regattas. Four years later, Boudin painted a replica of it (Schmit, no. 256), larger in scale but less festive in spirit; and four years after that the *Regattas and Celebration on the Beach at Trouville* (Schmit, no. 396), his new source of subject matter in the mid-1860s, and *Argenteuil: The Regattas* (Schmit, no. 391), his first representation of a subject the impressionists would soon make famous. In 1874 Monet, who had previously painted the regattas of Sainte-Adresse, on the Norman coast (Wildenstein, no. 91), twice painted those at Argenteuil, by far the most popular ones in the region around Paris (Wildenstein, nos. 339, 340), and Renoir did the same. In the same year Sisley depicted their English counterpart, the regattas at Molesey, near Hampton Court, on the Thames (Daulte, nos. 125, 126). For all these artists, the combination of white sails, blue skies, and colorful pennants, doubled in the mirror of the water, was as irresistible as it had been for Boudin.

Emile Bernard (1868-1941)

96 *Fireworks on the River,* 1888

Oil on wood, 34½ x 23¼ in. (87.6 x 59.1 cm.)
Signed and dated, lower left: *Emile Bernard 1888*
Yale University Art Gallery, Gift of Arthur G.
Altschul, B.A. 1943

It is hard to be sure what public holiday Bernard had in mind in painting this boldly conceived picture of a nocturnal fireworks display at Pont-Aven in the summer of 1888. It may have been Bastille Day, when fireworks were a traditional feature of the closing festivities, but that republican holiday was not celebrated very enthusiastically in the conservative, royalist villages of Brittany (Sanson, 97, 102); nor was Bernard in Pont-Aven on the 14th, having arrived there from Saint-Briac only in the middle of August. It may instead have been one of the local *pardons* held in late August and early September on the banks of the Aven, such as the Pardon des Ajoncs d'Or (Robson, 177, 227); but there is no evidence that these religious ceremonies culminated in a fireworks display. It may not have been any event Bernard actually witnessed that summer, for it was precisely at Pont-Aven in 1888 that he and Gauguin and others in their circle were developing a style in which memory and imagination played a larger role than observation. This symbolist style is still more apparent in the panel *Woman with a Red Umbrella* (Welsh-Ovcharov, fig. 108), which Bernard painted at the same time as the *Fireworks on the River*—both were intended to decorate the door of the old post office at Pont-Aven—and which shows a still more arbitrary and suggestive juxtaposition of figure and landscape.

Whatever part memories of an actual holiday may have had in determining the subject matter of this picture, it is clear that memories of works of art had a large part in shaping its form. Each of the elements of its curiously disjunctive design—the glittering river scene with its tiny boats and points of light in the distance, and the three figures with oddly bloated and distorted faces in the extreme foreground—has its source in a distinct type of advanced art of the 1870s, the former in Whistler's nocturnes with fireworks, the latter in Degas' *café-concert* scenes (Herbert 1965, no. 19). Bernard had un-

128. James McNeill Whistler. *Nocturne in Black and Gold: The Falling Rocket,* oil on canvas, 1875. The Detroit Institute of Arts, Gift of Dexter M. Ferry, Jr.

doubtedly seen examples of both types; for the nocturnes, including the famous *Falling Rocket* (fig. 128), the centerpiece of Whistler's lawsuit against Ruskin, were shown at the Galerie Georges Petit in 1887, and the *cafés-concerts,* of which there is one in this exhibition (cat. 25), had long been known through Degas' treatment of the theme in prints.

Camille Pissarro (1830-1903)

97 *The Boulevard Montmartre, Mardi Gras,* 1897

Oil on canvas, 25 x 30½ in. (63.5 x 77.5 cm.)
Signed and dated, lower left: *C. Pissarro '97*
The Armand Hammer Collection, Los Angeles
Pissarro and Venturi, no. 995

What the regatta was to the Norman port-cities and the *pardon* to the Breton villages (cat. 95, 96), the carnival procession was to Paris—the most festive celebration of the year, apart from the *Fête Nationale*. The parade of the Fatted Ox, garlanded and surrounded by merrymakers, which had long been a traditional feature of the mid-Lent festivities on Shrove Tuesday, was replaced in the late nineteenth century by a parade of floats and elaborately decorated chariots. But until the First World War, one observer recalled, "you could still see the crowd joining in the gaiety which is the essence of Carnival, running about the streets in some bizarre costume, either antiquated or ridiculous, and with the face masked" (Robson, 29). And the procession still followed its established route through the center of the city, from the Latin Quarter through the place de la Concorde to the Opera and the Madeleine, then down the boulevards to the Porte Saint-Denis.

Moving slowly along the boulevard des Italiens and the boulevard Montmartre on Shrove Tuesday, which fell on March 2nd in 1897, it passed directly below the windows of the room Pissarro had rented in the Grand Hôtel de Russie early in February. Already engaged in painting what eventually became a series of sixteen views of the boulevards, he had decided "to get one or two [canvases] ready to paint the crowd" on that day, though he was afraid the serpentines tangled in the plane trees would hamper him (Pissarro, 307). Three days after the parade, he reported that he had "painted the boulevards with the crowd and the march of the Boeuf-Gras, with effects of sun on the serpentines and the trees, the crowd in shadow" (Pissarro, 308). Despite his fears, he succeeded in capturing those effects in the three pictures he began that day, the ones at Cambridge and Winterthur (Pissarro and Venturi, nos. 996, 997) and above all the one exhibited here, which is considered the finest of the three (Coe, 107).

If he did so, it was partly because he had a pictorial model in the views Monet had painted of the nearby boulevard des Capucines twenty-four years earlier (e.g., fig. 129). Not only in its urban subject and high viewpoint, but in its use of heavily encrusted strokes to create a dense web of pigment suggestive of the procession, the large crowd, and the tangled streamers, Pissarro's picture is distinctly reminiscent of Monet's, though it has its own more uniform and tranquil rhythms.

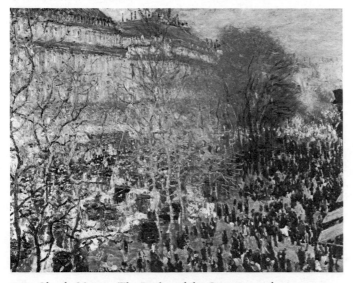

129. Claude Monet. *The Boulevard des Capucines,* oil on canvas, 1873. Pushkin Museum, Moscow.

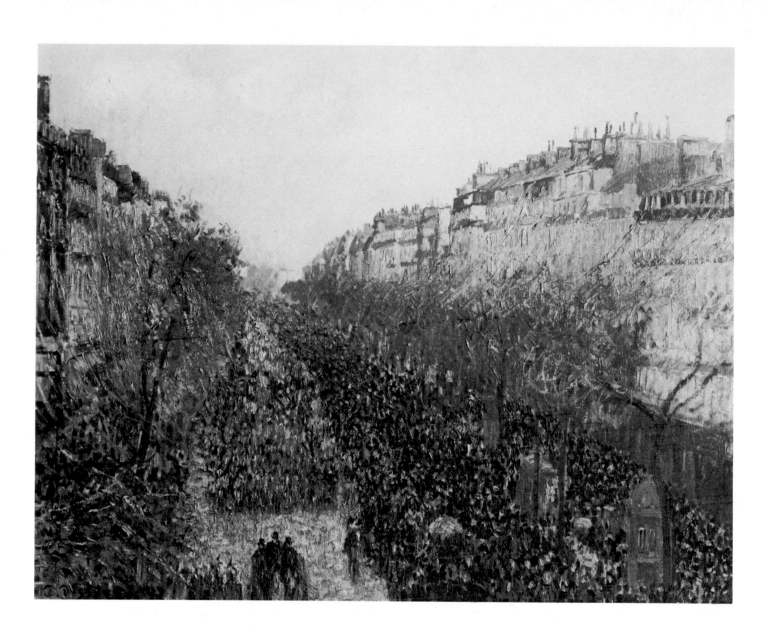

Edouard Manet

98 *The Balloon,* 1862

Lithograph, 15⁹⁄₁₆ x 20¹⁄₁₆ in. (39.5 x 51 cm.)
Signed and dated in the stone, lower right: *éd.*
 Manet 1862
Mr. and Mrs. Paul Mellon, Upperville, Virginia
H 23, only state

This masterful lithograph, the more impressive in that it is the first Manet attempted, was supposedly inspired by a balloon ascent at a public celebration in the Tuileries Gardens in the summer or fall of 1862 (Moreau-Nélaton 1926, 1: 40-41), perhaps the one held on August 15th to celebrate the *Fête Nationale.* The presence at the right side of a small puppet theater, similar to the one the writer Duranty operated in the Tuileries in 1861-1862, confirms this identification of the site (Fried, 38). Yet none of the illustrated weeklies of those months mentions a balloon ascent—still a noteworthy event at the time—as occurring there, whereas they do discuss those of Godard's balloon "La Gloire" at Compiègne in November (cat. 99) and at the Pré-Catalan in the Bois de Boulogne on several Sundays in September and October (Farwell 1973, 305, n. 80). The Pré-Catalan, too, had a puppet theater and other small buildings, and the ascents that took place there after the weekly concerts of military music attracted large crowds like the one in Manet's print. But the Tuileries remains the more likely setting, despite the absence of further documentation, since it is also the one he chose earlier in 1862 for another important image of modern Paris, the *Concert in the Tuileries* (fig. 3).

A pendant to the lithograph in conception, if not in medium and size, the *Concert* likewise shows a large number of people gathered in a park for a public entertainment, arranged in a roughly symmetrical, friezelike design. But they are seen as individuals, and in sufficient detail to be identified as artists, writers, musicians, and society ladies in Manet's circle (Davies, 91-92), whereas in the print they are seen as a motley crowd composed of workers and bourgeois, national guardsmen and street vendors, boys climbing poles, and a conspicuously placed beggar. Moreover, the composition of the painting is formal and relatively static, whereas that of the print is more lively and varied, though still surprisingly symmetrical. The balloon is in fact on the central axis, flanked by the puppet theater and another building of equal size, and directly below the balloon is the crippled beggar on his cart. The juxtaposition of the two motifs, which can hardly be accidental in so hieratic a design, intimates several oppositions without specifying any. One motif is a metaphor of frustrating immobility, the other of effortless super-mobility; one is an obvious symbol of despair, the other a well-known symbol of hope and progress (Mainardi, 112); and one implicitly criticizes the regime's indifference to suffering, while the other acknowledges its search for grandeur.

Félix Thorigny (1824-1870)

99 *The Ascent of the Balloon "La Gloire,"*
1862

Wood engraving, 12¹¹⁄₁₆ x 8 in. (32.3 x 22.8 cm.)
Signed, lower right, in the block: *F. Thorigny*
From *Le Monde illustré* 11 (1862), 341
General Research Division, The New York Public
 Library, Astor, Lenox, and Tilden Foundations

Since the days of the Montgolfier brothers and of
Blanchard in the late eighteenth century, the balloon had
made the greatest progress in France and had quickly
become a regular feature of public celebrations. In 1862
Manet made a balloon ascent at a celebration in the
Tuileries Gardens the subject of one of his first impor-
tant images of modern Paris (cat. 98); and in the same
year he imitated a popular type of balloon print, this one
showing a flight over Paris with the windmills of Mont-
martre in the distance, in a frontispiece intended for an
album of his etchings (H 38). Five years later he depicted
his friend Nadar's colossal balloon "Le Géant" hovering
over the grounds of the world's fair of 1867 (cat. 2) as a
symbol of its ideals of hope, progress, and universality
(Mainardi, 112). But since "Le Géant" was constructed
in 1863, it is likely that the balloon shown in Manet's
lithograph is its great predecessor, Eugène Godard's "La
Gloire." Godard had been Napoleon III's chief balloonist
during his Italian campaign in 1859 and afterward had
toured Europe and America (*Boulevard*, 8). On his re-
turn he had made several ascents in "La Gloire" at the
Pré-Catalan in the Bois de Boulogne in September and
October of 1862 (cf. cat. 98).

In the full-page wood engraving from *Le Monde illus-
tré,* one of the most popular illustrated weeklies of the
period, that is exhibited here, Godard is shown preparing
to ascend one month later at Compiègne, the imperial
country residence, in the presence of the emperor, the
empress, and members of the court. "La Gloire" has been
fitted with a kind of parachute around its circumference,
in order to increase its maneuverability and thus to make
it more useful for observation of enemy forces during
war. The experiment, according to the accompanying
text, was apparently successful.

Séjour de la cour à Compiègne. — Ascension du ballon la Gloire, en présence de LL. MM. — Visite à Pierrefonds.

Nous avons assisté samedi dernier, à la résidence impériale de Compiègne, à une expérience faite par Godard, l'aéronaute, en présence de LL. MM. l'Empereur, l'Impératrice, le Prince impérial et leurs nobles invités.

L'aéronaute avait intéressé Sa Majesté à certaines études aérostatiques faites dans le but d'observer, en cas de guerre, la position des armées. L'Empereur a donc autorisé l'aéronaute à dresser son ballon dans le parc du château. Cet aérostat cube 4300 mètres; à son équateur se développe un immense parchute affectant la forme d'un lambrequin qui mesure une circonférence de 80 mètres.

Dans la nacelle, disposée comme celle des aérostats déjà connus, se dresse l'appareil spécial qui permet de s'élever dans les airs sans gaz ni leste, de descendre et de remonter à volonté.

Les chances d'incendie sont combattues par une disposition ingénieuse; le foyer enfermé dans un triple cylindre que séparent des matières isolantes, ne permet pas à la flamme de s'égarer.

A trois heures, par un vent assez violent, les cables de la *mongolfière* étaient coupés et l'aéronaute s'élevait dans les airs. M. Godard avait annoncé son intention de descendre à Pierrefonds, se flattant de pouvoir diriger à son gré son aérostat.

Le soir même, un de nos voisins de table d'hôte, à l'hôtel de la Cloche, nous assurait avoir vu à quatre heures moins vingt la *Gloire* planer au-dessus de Pierrefonds. Nous nous assurerons de ce résultat qui serait assez concluant.

Le lendemain, on a fait une excursion à Pierrefonds; nous avons donné, dans notre avant-dernier numéro, une vue du Manoir restauré par M. Viollet-Leduc; nous donnons aujourd'hui un nouvel aspect des ruines. Au premier plan l'église Saint-Sulpice avec son architecture élégante et fine.

Trois époques bien distinctes ont laissé trace de leur passage.

L'arc surbaissé de la Renaissance se voit à côté de l'ogive, les sculptures charmantes de la transition grimpent autour des portails, tandis qu'en certains endroits la rigide moulure du moyen-âge donne aux contreforts un aspect solide et indestructible.

Au dernier plan, dans le lointain, se détache la belle silhouette du château du sire de Coucy. C'est l'un des dix aspects sous lesquels apparaît ce manoir célèbre, et ce n'est certes pas le moins pittoresque.

CHARLES YRIARTE.

Séjour de LL. MM. à Compiègne. — Ascension du ballon la *Gloire*, muni d'une machine motrice, en présence de LL. MM.

Jean-Louis Forain (1852-1931)

100 *The National Holiday,* 1918

Brush and ink, 14¾ x 20⅞ in. (37.5 x 53 cm.)
Signed, lower right: *forain*
National Gallery of Art, Washington, Rosenwald
 Collection 1943

This remarkably elliptical image of the celebration of Bastille Day merely hints at the elements traditionally shown, indicating with a few lines the public square, the military parade, and the dense crowd, and instead focuses on the boy who has climbed a pole to get a better view. He too is a traditional motif in the representation of festivals, and he appears as such in Manet's print of a balloon ascent in the Tuileries Gardens (cat. 98), in Victor Adam's print of a royal holiday on the Champs-Elysées (Farwell 1977, no. 74), and in Renaissance paintings of the entry of Christ into Jerusalem, such as Giotto's in the Arena Chapel. In Forain's drawing, however, the pole climber has a more specific function, which becomes clearer in the lithograph based on it (fig. 130). Published in the politically conservative newspaper *Oui* on 16 July 1918, it bears the caption: "Whom are they cheering? The Americans... and the others." Its irony is perhaps best explained by a retrospective account of the Bastille Day parade, written by a journalist who had been present: "After the review of Independence Day (July 4th), in which the Americans had made—it must be admitted—a strong impression on the Parisians, came that of July 14th, with its detachments of French, British, American, Belgian, Italian, Portuguese, Polish, Czechoslovakian, Serbian, and Greek troops" (Manevy, 83).

For Forain, an intensely patriotic artist who had already published scores of prints on the progress of the war in other chauvinistic newspapers, such as *Le Figaro* and *L'Opinion,* and who had in 1915 at the age of sixty-

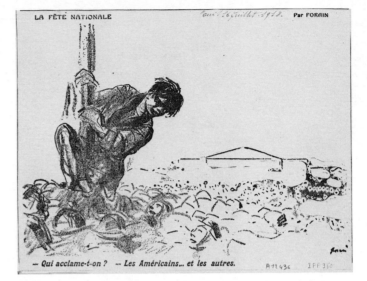

130. Jean-Louis Forain. *The National Holiday,* lithograph from *Oui,* 16 July 1918. Bibliothèque Nationale, Paris.

two enlisted in the army and served in a camouflage section, the presence of so many foreign troops, welcome though they were, could only detract from the glory of the French troops. It was only on the following Bastille Day, when the war had been won and the allied armies had returned home, that fiercely patriotic figures such as Forain and Maurice Barrès could participate with pride in the immense, deeply moving celebration, in which the French army, led by Foche and Joffre, marched through the Arc de Triomphe and down the Champs-Elysées (Sanson, 108-112).

La Fête Nationale 'Qui acclame-t-on? Les Américains et les autres'

Imp. Lemercier & C.ᵉ Paris

(Tiré à 25.)

N.º 19

Féroce & rose avec du feu dans sa prunelle,
Effronté, saoul, divin, c'est lui Polichinelle!

Théodore de Banville.

Plate 15. Edouard Manet. *Polichinelle,* 1874. Cat. 40.

Chronology: Manet and His Time

Manet's Life & Works*	Other Works of Art & Literature	Political & Urban History
1850 Enters Couture's studio with Antonin Proust; also studies at Académie Suisse	Daumier, *Wandering Saltimbanques* (cat. 70)	Laws passed strengthening Louis-Napoleon's hand against republican opposition
1851 Witnesses insurrection provoked by *coup d'état;* observes and draws victims in Montmartre Cemetery	Jongkind, *Pont de la Tournelle* (fig. 25) Daumier, *Hamlet* (fig. 51)	Louis-Napoleon's *coup d'état;* becomes Napoleon III
1852 Copies after Boucher in Louvre Léon-Edouard Leenhoff born to Suzanne Leenhoff, Manet's music teacher, whom he later marries	Daumier, *At the Champs-Elysées* (fig. 47) Gautier, *Emaux et camées*	Gare de Lyon and Gare Montparnasse completed; link between Louvre and Tuileries Palace begun; half of rue des Ecoles opened
1853 Travels to Florence and Venice, perhaps also to Cassel, Prague, Vienna, and Munich	Hugo, *Les Châtiments* Michelet, *Histoire de la révolution française* completed	Haussmann appointed Prefect of the Seine Boulevard de Strasbourg and rue Soufflot opened; half of rue de Rennes opened; Petit Pont reconstructed
1854 Copies Tintoretto's *Self-Portrait* in Louvre; copies Delacroix's *Bark of Dante* in Musée du Luxembourg		Place du Louvre created; area around Hôtel de Ville cleared and boulevard Victoria begun
1855 Copies after Titian and other old masters in Louvre	Courbet, *Painter's Studio* (fig. 12); his retrospective exhibition on avenue Montaigne Nanteuil, after Velázquez, *Drinkers* (fig. 88)	World's Fair of 1855 on Champs-Elysées Rue de Rivoli and rue des Ecoles completed; Pont de l'Alma completed
1856 Leaves Couture's studio; rents own studio on rue Lavoisier Travels to Belgium, Holland, Germany, Austria, and Italy	Guérard, *Boulevard des Italiens* (fig. 2) Hugo, *Les Contemplations* Duranty, ed., *Le Réalisme*	Avenue de l'Impératrice opened; Pré-Catalan in Bois de Boulogne opened; workers' housing built on boulevard Mazas
1857 Copies after Rubens and other old masters in Louvre; meets Fantin-Latour there	Baudelaire, *Les Fleurs du mal* Flaubert, *Madame Bovary*	New pavillions at Les Halles completed; Louvre completed; avenues around place de l'Etoile opened Longchamp racetrack inaugurated New Hippodrome opened on avenue Victor Hugo

*NOTE: *Works by Manet and his contemporaries listed here are largely restricted to those illustrated or discussed in this catalogue. The years covered are confined to those of greatest importance for the material in* Manet and Modern Paris.

Manet's Life & Works	Other Works of Art & Literature	Political & Urban History
1858 Copies Van Craesbeek's *Drinker* in Louvre (fig. 95); meets Colardet there and begins *Absinthe Drinker*, using him as model (cf. cat. 63)	Boudin, *Festival in the Harbor of Honfleur* (cat. 95) Gautier, *Le Roman de la momie* Offenbach, *Orphée aux enfers* Baudelaire becomes friendly with Manet	Orsini attempts to assassinate Napoleon III Boulevard de Sébastopol and Bois de Boulogne opened Bill passed authorizing new public works program for Paris
1859 Copies after Velázquez in Louvre; meets Degas there Moves to studio on rue de la Victoire *Absinthe Drinker* (fig. 94) is rejected by Salon	Gérôme, *Dead Caesar* (fig. 109) Baudelaire, *Salon de 1859*	Boulevard Saint-Michel completed; Pont Solférino inaugurated; reconstruction of Pont au Change begun
1860 *Fishing* (fig. 5) Moves to studio on rue de Douai and to apartment on rue de l'Hôtel-de-Ville, Batignolles	Daumier, *Barbary Organ* (cat. 69) Daumier, *Gare Saint-Lazare* (fig. 33) Meissonier, *Polichinelle* (fig. 63) Martial, *Area of Petite Pologne* (fig. 87)	Annexation by Paris of suburban towns Pont au Change inaugurated; rue Guyot opened; boulevard du Prince-Eugène begun
1861 *Spanish Singer* and *Portrait of M. and Mme Manet* shown at Salon Begins to show paintings at Galerie Martinet, boulevard des Italiens Moves to studio on rue Guyot	Schlesinger, *Kidnapped Child* (cf. cat. 66) shown at Salon Martial, *Petite Pologne* (fig. 8) Baudelaire, *Les Fleurs du mal* (2nd ed.)	French expedition to Mexico Demolition of Petite Pologne completed; boulevard Malesherbes opened; Parc Monceau created; rue Soufflot extended; Pont Saint-Louis constructed
1862 *Spanish Ballet* (cat. 32); *Don Mariano Camprubi* (cat. 33); *Lola de Valence* (cat. 34); *Old Musician* (cat. 59); *Chrysippos* (cat. 61); *Absinthe Drinker* (cat. 64); *Little Girl* (cat. 65); *Old Musician* (cat. 67); *Street Singer* (cat. 68); *Balloon* (cat. 98); *Concert in the Tuileries* (fig. 3); *Street Singer* (fig. 86); *Gypsies* (fig. 97)	Lépine, *Pont de la Tournelle* (cat. 7) Ribot, *Musicians* (cat. 71) Champfleury, *Les Peintres de la réalité sous Louis XIII* Camprubi's troupe of Spanish dancers and musicians performs at Hippodrome	Demolition of Funambules and other theaters on boulevard du Temple; construction of new opera house begun; boulevard du Prince-Eugène inaugurated
1863 *Déjeuner sur l'herbe* (fig. 83) and other pictures shown at Salon des Refusés Holds one-man exhibition at Galerie Martinet Marries Suzanne Leenhoff in Holland	Daumier, *Laundress* (fig. 26) and *Saltimbanque Playing a Drum* (fig. 98) Baudelaire, "Le Peintre de la vie moderne" Audiganne, *Paris dans sa splendeur*	New Gare du Nord completed; restored cathedral of Notre-Dame reopened for worship Société des Steeplechases de France founded; Grand Prix de Paris racing prize established
1864 *Dead Toreador* (cat. 77); *Races at Longchamp* (fig. 69); *Bullfight* (fig. 107) *Dead Christ* and *Incident in a Bullfight* shown at Salon Moves to apartment on boulevard des Batignolles	Flameng, *Dead Soldier* (79) Delamarre, *Paris Grand Prix of 1864* (fig. 65) Fournel, *Les Spectacles populaires* Yriarte, *Paris grotesque* Fantin-Latour, *Homage to Delacroix*	Boulevard Arago, boulevard Berthier, and rue Auber opened; church of Notre-Dame-de-Clignancourt inaugurated French entry wins Grand Prix at Longchamp
1865 Copy of Velázquez' *Pablillos de Valladolid* (cat. 31); *Women at the Races* (cat. 42); *Philosopher* (fig. 9);	Boudin, *Bathing Time at Deauville* (cat. 52) Potteau, *Jean Lagrène* (cat. 62)	United States demands recall of French troops from Mexico Bois de Vincennes opened; Luxem-

Manet's Life & Works	Other Works of Art & Literature	Political & Urban History
1865 (cont.) *Grounds of the Racetrack at Long-champ* (fig. 68) *Olympia* (fig. 7) and *Christ Mocked* shown at Salon Travels to Spain; meets Duret there	Whistler, *Harmony in Blue and Silver: Trouville* (fig. 81) Goncourt, *Henriette Maréchal* Death of Philibert Rouvière	bourg Gardens reduced by creation of new streets French entry wins Grand Prix at Longchamp
1866 *Tragic Actor* (cat. 27) and *Fifer* shown at Salon *Tragic Actor* (cat. 30); *Bullfight* (cat. 81)	Boudin, *Races at Deauville* (cat. 47) Vallès, *La Rue* Zola writes first articles on Manet, becomes friendly with him	Boulevard Saint-Germain and rue de Rennes completed; Point-du-Jour constructed
1867 *World's Fair of 1867* (cat. 2); *Funeral* (cat. 4); *Races at Longchamp* (cat. 43) Holds private exhibition on place de l'Alma, near Courbet's exhibition Moves to apartment on rue de Saint-Pétersbourg	Bonvin, *Flemish Tavern* (cat. 19) Fantin-Latour, *Portrait of Edouard Manet* (fig. 1) Monet, *Garden of the Princess* (fig. 23) Zola, *Edouard Manet* Goncourt, *Manette Salomon* Death of Baudelaire	French troops leave Mexico; Maximilian's army is defeated; he is executed World's Fair of 1867 on Champ de Mars Gare Saint-Lazare enlarged; Pont de l'Europe and place du Théâtre-Français constructed
1868 *Dead Toreador* (cat. 80) *Portrait of Zola* and *Woman with a Parrot* shown at Salon Visits Boulogne-sur-Mer and London	Gérôme, *Caesar Assassinated* (cat. 78) Gérôme, *Execution of Marshal Ney* (fig. 106) *Sonnets et eaux-fortes*, ed. Burty	Liberal press laws passed; limited rights of public meeting granted Church of Saint-Augustin inaugurated; restoration of Palais de Justice completed
1869 *On the Beach at Boulogne* (cat. 51); *Execution of the Emperor Maximilian* (cat. 74); *Portrait of Baudelaire* (fig. 13); *At the Café* (fig. 45); *Departure of the Folkestone Ferry* (fig. 76) *Balcony* (fig. 10) and *Luncheon in the Studio* shown at Salon	Degas, *Horsemen and Strollers at the Seashore* (fig. 84) Baudelaire, *Petits Poëmes en prose* Flaubert, *L'Education sentimentale* Duranty, "La Double Vue de Louis Séguin" Laurence, *Les Restes du vieux Paris*	Folies-Bergère and Théâtre du Vaudeville inaugurated; rue Mosnier opened; Hippodrome destroyed by fire
1870 *Portrait of Eva Gonzalès* and *Music Lesson* shown at Salon Fights duel with Duranty; they soon become friends again	Monet, *Camille on the Beach at Trouville* (cat. 54) Fantin-Latour, *Studio in the Batignolles* (fig. 16) Degas, *Race Horses at Longchamp* (fig. 72) and *Jockeys before the Reviewing Stand* (fig. 73) Monet, *On the Beach at Trouville* (fig. 82)	Napoleon III and his army capitulate to German army at Sédan, shortly after declaring war on Germany; Third Republic proclaimed in Paris; siege of Paris by German army begins
1871 *Barricade* (cat. 72); *Civil War* (cat. 76) Begins selling his work to Durand-Ruel Visits Boulogne-sur-Mer	Degas, *False Start* (cat. 49) Disdéri, *Dead Communards* (cat. 82) Pissarro, *Lordship Lane Station* (fig. 29) Meissonier, *Ruins of the Tuileries* (fig. 100) Courbet, *Execution* (fig. 102)	Peace treaty with Germany ends war, but German army continues to occupy France Paris Commune founded, fights civil war with government troops and is crushed Thiers elected president of Third Republic

Manet's Life & Works	Other Works of Art & Literature	Political & Urban History
1872 *Pont de l'Europe* (fig. 30); *Races at the Bois de Boulogne* (fig. 66) *Battle of the Kearsarge and the Alabama* shown at Salon Large sales to Durand-Ruel Moves to studio on rue de Saint-Pétersbourg	Morisot, *View of Paris from the Trocadéro* (cat. 3) Renoir, *Pont Neuf* (cat. 5) Monet, *Pont Neuf* (cat. 6) Corot, *Beach near Etretat* (cat. 58) Daumier, *And All This Time . . .* (cat. 83) Morisot, *Balcony* (fig. 22) Degas, *Dancers Backstage* (fig. 61) Monet, *Festival at Argenteuil* (fig. 115) Zola, *La Curée*	German indemnity paid and German army leaves France Reconstruction of Palais de Justice and Hôtel de Ville begun
1873 *Gare Saint-Lazare* (cat. 10); *Ball of the Opera* (cat. 39); *On the Beach* (cat. 55); *Women on the Beach* (cat. 56); *Barricade* (cat. 73) probably completed *Bon Bock* and *Repose* shown at Salon	Degas, *Races* (cat. 48) Grévin, *Ball of the Opera* (fig. 62) Monet, *Boulevard des Capucines* (fig. 129) Mallarmé becomes friendly with Manet	Marshal MacMahon elected president of Republic; Marshal Bazaine tried and found guilty Opera house on rue Lepeletier destroyed by fire
1874 *At the Café* (cat. 23); *Polichinelle* (cat. 40) *Gare Saint-Lazare* (cat. 10) shown at Salon; *Ball of the Opera* (cat. 39) and *Swallows* rejected	Renoir, *Dancer* (cat. 35) Degas, *Dancers at the Old Opera House* (cat. 36) Degas, *Rehearsal of a Ballet on Stage* (fig. 60) First impressionist exhibition (Manet declines to participate)	Vendôme Column, pulled down during Commune, is reerected Statue of Jeanne d'Arc erected in place des Pyramides
1875 *Races at Longchamp* (cat. 45, 46) probably completed *Argenteuil* shown at Salon Travels to Venice, paints Grand Canal	Guillaumin, *Pont Louis Philippe* (cat. 8) Renoir, *Grands Boulevards* (fig. 19) Whistler, *Nocturne in Black and Gold* (fig. 128) Huysmans, *Drageoir aux épices*	Constitution of 1875 approved New opera house inaugurated; construction of Sacré-Coeur begun; reconstruction of Pavillon de Marsan of Louvre begun
1876 *Artist* and *Laundry* rejected at Salon and shown in Manet's studio, with *Olympia* (fig. 7) Paints portrait of Mallarmé	Caillebotte, *Pont de l'Europe* (fig. 34) Degas, *Absinthe* (fig. 40) shown at second impressionist exhibition Huysmans, *Marthe* Claretie, *Le Train 17*	New Senate and Chamber meet Half of rue des Pyramides opened; reconstruction of Palais-Royal completed; Pont Sully and avenue de l'Opéra opened
1877 *Waitress Serving Beer* (cat. 20); *Nana* (fig. 11); *Suicide* (fig. 14); *Waitress Serving Beer* (fig. 43); *At the Café* (fig. 44); *Hamlet and His Father's Ghost* (fig. 54) *Portrait of Faure as Hamlet* (fig. 53) shown at Salon; *Nana* rejected and shown at Galerie Giroux on boulevard des Capucines	Caillebotte, *Pont de l'Europe* (cat. 13) Monet, *Gare Saint-Lazare* (cat. 14) Degas, *Ballet Dancers* (cat. 37) Monet, *Pont de l'Europe* (fig. 36) Degas, *Young Woman in a Café* (cat. 24), *Café-Concert* (cat. 25), *Beach Scene* (cat. 57), *At the Café-Concert* (fig. 38), and *Women before a Café* (fig. 46) shown at third impressionist exhibition Zola, *L'Assommoir*	Ministry of War building and town halls of four *arrondissements* completed Musée des Arts Décoratifs founded

Manet's Life & Works	Other Works of Art & Literature	Political & Urban History
1878 *Plum* (cat. 18); *Café-Concert* (cat. 21); *Rue Mosnier Decorated with Flags* (cat. 86, fig. 118); *Rue Mosnier* (cat. 87); *Man with Crutches* (cat. 88); *At the Café* (fig. 44) Moves to studio on rue d'Amsterdam	Monet, *Rue Montorgeuil* (cat. 90) Monet, *Rue Saint-Denis* (fig. 123) Forain, *Café Scene* (fig. 50) Zola, *Une Page d'amour* Retrospective exhibition of Daumier at Galerie Durand-Ruel	World's Fair of 1878 in Palais du Trocadéro; its success celebrated with *Fête de la Paix* New Hôtel-Dieu and Parc de Montsouris completed
1879 *Self-Portrait* (cat. 1); *Woman Reading in a Café* (cat. 22); *Valtesse de la Bigne* (fig. 6); *Café-Concert* (fig. 39) *Boating* and *In the Conservatory* shown at Salon Proposes to decorate new Hôtel de Ville with murals on modern Paris	Huysmans, *Les Soeurs Vatard* Daudet, *Les Rois en exil* Fourth impressionist exhibition	Partial amnesty for Communards granted Jules Grévy elected president of Republic Place de la République named; avenue Ledru-Rollin opened
1880 *Cluster of Flags* (cat. 89, fig. 122) *Portrait of Antonin Proust* and *At the Père Lathuille's* shown at Salon Holds exhibition of recent works at gallery of "La Vie Moderne"	Forain, *Behind the Scenes* (cat. 38) Huysmans, *Croquis parisiens* Zola, *Nana* Fifth impressionist exhibition	July 14th celebrated as national holiday for first time since 1794 Full amnesty granted to Communards Place de la Nation named; rue de l'Ambigu opened
1881 *Café in the Place du Théâtre-Français* (fig. 15) Portraits of Rochefort and Pertuiset shown at Salon Begins to suffer from locomotor ataxia	Huysmans, *En Ménage* Zola, *Le Naturalisme au théâtre* Sixth impressionist exhibition	Part of boulevard Raspail opened; Bibliothèque Nationale expanded; Entrepôt de Bercy constructed
1882 *Bar at the Folies-Bergère* (fig. 49) and *Spring* shown at Salon Is named Chevalier du Légion d'Honneur Becomes seriously ill	Roll, *14th of July 1880* (cat. 91) Seventh impressionist exhibition Posthumous exhibition of Courbet at Ecole des Beaux-Arts	Law passed making primary education compulsory Reconstructed Hôtel de Ville inaugurated; Bibliothèque de l'Opéra opened
1883 Becomes incapacitated, plans to learn miniature painting; dies April 30th; is buried May 3rd	Huysmans, *L'Art moderne* Zola, *Au bonheur des dames*	Funeral of Gambetta (died 1882) Anarchist demonstrations and workers' riots Statue of Republic in place de la République inaugurated
1884 Posthumous exhibition at Ecole des Beaux-Arts Sale of contents of his studio at Hôtel Drouot	Forain, *Study of Fog in a Station* (cat. 15) Zola, Preface to catalogue of Manet exhibition Huysmans, *A rebours*	Laws passed reestablishing marital divorce and legalizing trade unions Eiffel proposes to erect tower for 1889 world's fair.

BIBLIOGRAPHY

HARRIS (cited as H)

Jean C. Harris. *Edouard Manet: Graphic Works*. New York, 1970.

ROUART AND WILDENSTEIN (cited as R-W)

Denis Rouart and Daniel Wildenstein. *Manet: Catalogue raisonné*. 2 vols. Paris, 1975.

ACKERMAN

Gerald M. Ackerman. "Gérôme and Manet." *Gazette des Beaux-Arts* 70 (1967), 163-176.

ALLEMAND

Maurice Allemand. *La Vie quotidienne sous le Second Empire*. Paris, 1948.

ALPHAND

Alphonse Alphand. *Les Promenades de Paris*. 2 vols. Paris, 1867-1873.

ARIÈS

Philippe Ariès. "The Family and the City." *Daedalus* 106 (1977), 227-235.

BABELON

Paris, Archives Nationales. *Le Parisien chez lui au XIXᵉ siècle*. Exh. cat., edited by Jean-Pierre Babelon. 1976.

BALZAC

Honoré de Balzac. *La Cousine Bette* (1846). Translated by Kathleen Raine. New York, 1958.

BANCQUART

Marie-Claire Bancquart. *Images littéraires du Paris "fin-de-siècle."* Paris, 1979.

BARDET

Godefroy Bardet. *Plages de la Manche*. Guides Dentu. Paris, 1888.

BARR

Alfred H. Barr, Jr. *Matisse: His Art and His Public*. New York, 1951.

BATAILLE AND WILDENSTEIN

Marie-Louise Bataille and Georges Wildenstein. *Berthe Morisot: Catalogue des peintures, pastels et aquarelles*. Paris, 1961.

BAUDELAIRE 1846

Charles Baudelaire. "Salon de 1846." In *Art in Paris, 1845-1862*. Translated by Jonathan Mayne. London, 1965.

BAUDELAIRE 1857

Charles Baudelaire. "Quelques Caricaturistes français" (1857). In *The Painter of Modern Life and Other Essays*. Translated by Jonathan Mayne. London, 1964.

BAUDELAIRE 1859

Charles Baudelaire. "Salon de 1859." In *Art in Paris, 1845-1862*. Translated by Jonathan Mayne. London, 1965.

BAUDELAIRE 1861

Charles Baudelaire. *Les Fleurs du mal* (2nd ed., 1861). Edited by Jacques Crépet and Georges Blin. Paris, 1942.

BAUDELAIRE 1862

Charles Baudelaire. "Peintres et aqua-fortistes" (1862). In *Art in Paris, 1845-1862*. Translated by Jonathan Mayne. London, 1965.

BAUDELAIRE 1863

Charles Baudelaire. "Le Peintre de la vie moderne" (1863). In *The Painter of Modern Life and Other Essays*. Translated by Jonathan Mayne. London, 1964.

BAUDELAIRE 1869

Charles Baudelaire. *Petits Poëmes en prose* (1869). Translated by Louise Varèse. New York, 1970.

BAZIRE

Edmond Bazire. *Manet*. Paris, 1884.

BECHTEL

Edwin de T. Bechtel. *Freedom of the Press and L'Association Mensuelle: Philipon versus Louis-Philippe*. New York, 1952.

BELLONCLE

Michel Belloncle. "Les Peintres d'Etretat." *Jardin des Arts*, no. 148 (March 1967), 24-33.

BENJAMIN 1968

Walter Benjamin. "Paris—Capital of the Nineteenth Century." *New Left Review*, no. 48 (March-April 1968), 77-88.

BENJAMIN 1973

Walter Benjamin. *Charles Baudelaire: A Lyric Poet in the Era of High Capitalism*. Translated by Harry Zohn. London, 1973.

BERHAUT

Marie Berhaut. *Caillebotte, sa vie et son oeuvre: Catalogue raisonné des peintures et pastels.* Paris, 1978.

BERMAN

Marshall Berman. *All That Is Solid Melts into Air: The Experience of Modernity.* New York, 1982.

BLANCHE

Jacques-Emile Blanche. *Manet.* Translated by F. C. de Sumichrast. London, 1925.

BOGGS

St. Louis, City Art Museum. *Drawings by Degas.* Exh. cat., edited by Jean Sutherland Boggs, 1966.

BOULEVARD

Le Boulevard, no. 37 (14 September 1862), 8.

BOULOGNE-SUR-MER

Boulogne-sur-Mer, Etablissement Municipal des Bains. *Programme sommaire.* 1874.

BOWNESS

Alan Bowness. "A Note on 'Manet's Compositional Difficulties.'" *The Burlington Magazine* 103 (1961), 276-277.

BRASSEUR

Charles Brasseur. "La Chambre de Commerce de Boulogne." In *Boulogne-sur-Mer et la région boulonnaise.* 2 vols. Boulogne-sur-Mer, 1899.

BROWN

Marilyn R. Brown. "Manet's *Old Musician:* Portrait of a Gypsy and Naturalist Allegory." *Studies in the History of Art* 8 (1978), 77-87.

BROWSE

Lillian Browse. *Forain the Painter, 1852-1931.* London, 1978.

BRUHAT, DAUTRY, AND TERSEN

Jean Bruhat, Jean Dautry, and Emile Tersen. *La Commune de 1871.* 2nd ed. Paris, 1970.

BYRNES

James B. Byrnes. "Edgar Degas: His Paintings of New Orleanians Here and Abroad." In New Orleans, Isaac Delgado Museum of Art. *Edgar Degas: His Family and Friends in New Orleans.* Exh. cat., edited by James B. Byrnes. 1965.

CALINESCU

Matei Calinescu. *Faces of Modernity: Avant-Garde, Decadence, Kitsch.* Bloomington and London, 1977.

CALLEN

Anthea Callen. "Faure and Manet." *Gazette des Beaux-Arts* 83 (1974), 157-178.

CHAMPFLEURY 1850

Champfleury [Jules Husson]. *Essai sur la vie et l'oeuvre des Le Nain.* Paris, 1850.

CHAMPFLEURY 1861a

Champfleury [Jules Husson]. "Courbet en 1860" (1861). In *Le Réalisme.* Edited by Geneviève Lacambre and Jean Lacambre. Paris, 1973.

CHAMPFLEURY 1861b

Champfleury [Jules Husson]. *La Mascarade de la vie parisienne.* Paris, 1861.

CHAN

Georges Chan. "Les Peintres impressionnistes et le chemin de fer." *La Vie du Rail,* no. 476 (1976), 19-27.

CHIARENZA

Carl Chiarenza. "Manet's Use of Photography in the Creation of a Drawing." *Master Drawings* 7, no. 1 (Spring 1969), 38-45.

CHU

Petra ten-Doesschate Chu. *French Realism and the Dutch Masters.* Utrecht, 1974.

CLARK 1973

T[imothy] J. Clark. *The Absolute Bourgeois: Artists and Politics in France, 1848-1851.* London, 1973.

CLARK 1977

Timothy J. Clark. "The Bar at the Folies-Bergère." In *The Wolf and the Lamb: Popular Culture in France.* Edited by Jacques Beauroy, Marc Bertrand, and Edward Gargan. Saratoga, Calif., 1977.

COE

Ralph T. Coe. "Camille Pissarro in Paris." *Gazette des Beaux-Arts* 43 (1954), 93-118.

COLIGNY

Charles Coligny. "L'Absinthe." *Le Boulevard,* no. 3 (19 January 1862), 6-7.

COLLINS

Bradford R. Collins. "Manet's *Rue Mosnier Decked with Flags* and the Flâneur Concept." *The Burlington Magazine* 117 (1975), 709-714.

COUTURE

Thomas Couture. *Méthode et entretiens d'atelier.* Paris, 1867.

CRAUZAT

Ernest de Crauzat. *L'Oeuvre gravé et lithographié de Steinlen.* Paris, 1913.

CUNNINGHAM

Northampton, Mass., Smith College Museum of Art. *Jongkind and the Pre-Impressionists.* Exh. cat., edited by Charles C. Cunningham. 1976.

DAUBERVILLE

Jean and Henry Dauberville. *Bonnard: Catalogue raisonné de l'oeuvre peint.* 4 vols. Paris, 1965-1974.

DAULTE 1959

François Daulte. *Alfred Sisley: Catalogue raisonné de l'oeuvre peint.* Lausanne, 1959.

DAULTE 1971
François Daulte. *Auguste Renoir: Catalogue raisonné de l'oeuvre peint.* 1 vol. to date. Lausanne, 1971.

DAUZAT AND BOURNON
Albert Dauzat and Fernand Bournon. *Paris et ses environs.* Paris, 1925.

DAVIES
Martin Davies. *French School.* Revised by Cecil Gould. National Gallery Catalogues. London, 1970.

DE LEIRIS 1961
Alain De Leiris. "Manet: *Sur la plage de Boulogne.*" *Gazette des Beaux-Arts* 57 (1961), 53-62.

DE LEIRIS 1969
Alain De Leiris. *The Drawings of Edouard Manet.* Berkeley and Los Angeles, 1969.

DE LEIRIS 1980
Alain De Leiris. "Manet and El Greco: 'The Opera Ball.'" *Arts Magazine* 55, no. 1 (September 1980), 95-99.

DELTEIL
Loys Delteil. *Le Peintre-Graveur illustré (XIXe et XXe siècles).* 32 vols. Paris, 1906-1926.

DELVAU 1862
Alfred Delvau. *Histoire anecdotique des cafés et cabarets de Paris.* Paris, 1862.

DELVAU 1864
Alfred Delvau. *Dictionnaire érotique moderne.* Capetown, n. d. [1864].

DELVAU 1867
Alfred Delvau. "L'Assistance publique à Paris." In *Paris-Guide, par les principaux écrivains et artistes de la France.* 2 vols. Paris, 1867.

DOLLINGER
Heinz Dollinger. "Daumier und die Politik." In Hamburg, Hamburger Kunsthalle. *Honoré Daumier, 1808-1879: Bildwitz und Zeitkritik.* Exh. cat., edited by Gerhard Langemeyer, 1979.

DORIVAL
Bernard Dorival. "Meissonier et Manet." *Art de France* 2 (1962), 222-226.

DORTU
M. G. Dortu. *Toulouse-Lautrec et son oeuvre.* 6 vols. New York, 1971.

DURET
Théodore Duret. *Manet* (1902). Paris, 1926.

DUTERTRE
Dr. Dutertre. "Les Bains de mer de Boulogne." In *Boulogne-sur-Mer et la région boulonnaise.* 2 vols. Boulogne-sur-Mer, 1899.

ELDERFIELD
John Elderfield. *The "Wild Beasts": Fauvism and Its Affinities.* New York, 1976.

EXPOSITION GOENEUTTE
Paris, Ecole Nationale des Beaux-Arts. *Exposition de tableaux, dessins, pastels, eaux-fortes de Norbert Goeneutte.* Exh. cat., preface by Antonin Proust. 1895.

FARWELL 1973
Beatrice Farwell. "Manet and the Nude: A Study in Iconography in the Second Empire." Ph.D. dissertation, University of California, Los Angeles, 1973.

FARWELL 1977
Santa Barbara, University of California. *The Cult of Images.* Exh. cat., edited by Beatrice Farwell. 1977.

FELD
Charles Feld. *Paris au front d'insurgé: La Commune en images.* Paris, 1971.

FELLER
Glorionna Colton Feller. "A Study of the Sources for Manet's *The Old Musician.*" Master's thesis, Columbia University, 1966.

FERNIER
Robert Fernier. *La Vie et l'oeuvre de Gustave Courbet.* 2 vols. Lausanne and Paris, 1977.

FLAUBERT
Gustave Flaubert. *L'Education sentimentale* (1869). Translated by Robert Baldick. Harmondsworth, 1964.

FLEURY AND SONOLET
Comte Fleury and L[ouis] Sonolet. *La Société du Second Empire.* 4 vols. Paris, n. d. [1917].

FLORISOONE
Michel Florisoone. *Manet.* Monaco, 1947.

FOURNEL 1858
Victor Fournel. *Ce qu'on voit dans les rues de Paris.* Paris, 1858.

FOURNEL 1865
Victor Fournel. *Paris nouveau et Paris futur.* Paris, 1865.

FRIED
Michael Fried. "Manet's Sources: Aspects of His Art, 1859-1865." *Artforum* 7, no. 7 (March 1969), 1-82.

GEFFROY
Gustave Geffroy. *L'Apprentie* (1904). Paris, 1920.

GERSTEIN
Marc Gerstein. "Degas's Fans." *The Art Bulletin* 64 (1982), 105-118.

GETSCHER
Oberlin, Ohio, Allen Memorial Art Museum. *The Stamp of Whistler*. Exh. cat., edited by Robert H. Getscher. 1977.

GRAND-CARTERET
John Grand-Carteret. *L'Histoire, la vie, les moeurs, et la curiosité par l'image, le pamphlet et le document*. 5 vols. Paris, 1927-1928.

GRIFFITHS
Antony Griffiths. "Execution of Maximilian." Letter in *The Burlington Magazine* 119 (1977), 777.

GUÉRIN
Marcel Guérin. *L'Oeuvre gravé de Manet*. Paris, 1944.

GUINARD
Paul Guinard. *Dauzats et Blanchard, peintres de l'Espagne romantique*. Paris, 1967.

HAMBOURG
New York, Alliance Française. *Charles Marville: Photographs of Paris, 1852-1878*. Exh. cat., edited by Maria Morris Hambourg. 1981.

HAMILTON
George Heard Hamilton. *Manet and His Critics*. New Haven, 1954.

HANCOUR
Louis d'Hancour. *L'Hôtel de Ville de Paris à travers les siècles*. Paris, 1900.

HANSON 1970
Anne Coffin Hanson. "Edouard Manet, *Les Gitanos*, and the Cut Canvas." *The Burlington Magazine* 112 (1970), 158-166.

HANSON 1972
Anne Coffin Hanson. "Popular Imagery and the Work of Edouard Manet." In *French 19th Century Painting and Literature*. Edited by Ulrich Finke. Manchester, 1972.

HANSON 1977
Anne Coffin Hanson. *Manet and the Modern Tradition*. New Haven and London, 1977.

HARPER
Paula Harper. "Daumier's Clowns: Les Saltimbanques et les Parades." Ph.D. dissertation, Stanford University, 1976.

HARRIS 1966
Jean C. Harris. "Manet's Racetrack Paintings." *The Art Bulletin* 48 (1966), 78-82.

HASKELL
Francis Haskell. "The Sad Clown: Some Notes on a 19th Century Myth." In *French 19th Century Painting and Literature*. Edited by Ulrich Finke. Manchester, 1972.

HAUPTMAN
William Hauptman. "Manet's Portrait of Baudelaire: An Emblem of Melancholy." *The Art Quarterly*, n.s., 1 (1978), 214-243.

HAVEMEYER
Louisine Havemeyer. *Sixteen to Sixty: Memoirs of a Collector*. New York, 1961.

HECKSCHER
William S. Heckscher. *Rembrandt's "Anatomy of Dr. Nicolaes Tulp."* New York, 1958.

HELD
Essen, Museum Folkwang. *Katalog der Gemälde des 19. Jahrhunderts*. Edited by Jutta Held. Essen, 1971.

HERBERT 1961
Eugenia W. Herbert. *The Artist and Social Reform: France and Belgium, 1885-1898*. New Haven, 1961.

HERBERT 1965
New Haven, Yale University Art Gallery. *Neo-Impressionists and Nabis in the Collection of Arthur G. Altschul*. Exh. cat., edited by Robert L. Herbert. 1965.

HILLAIRET
Jacques Hillairet. *Dictionnaire historique des rues de Paris*. 2 vols. Paris, 1963.

HOFMANN 1973a
Werner Hofmann. *Nana: Mythos und Wirklichkeit*. Cologne, 1973.

HOFMANN 1973b
Werner Hofmann. "Poesie und Prosa: Rangfragen in der neueren Kunst." *Jahrbuch der Hamburger Kunstsammlungen* 18 (1973), 173-192.

HUYSMANS 1879
Joris-Karl Huysmans. *Les Soeurs Vatard* (1879). In *Oeuvres complètes*. Edited by Lucien Descaves. 18 vols. Paris, 1928-1934.

HUYSMANS 1880
Joris-Karl Huysmans. "Les Folies-Bergère en 1879" (1880). In *Croquis parisiens. Oeuvres complètes*. Edited by Lucien Descaves. 18 vols. Paris, 1928-1934.

HUYSMANS 1884
Joris-Karl Huysmans. *A rebours* (1884). Translated by Robert Baldick. Baltimore, 1959.

HYSLOP AND HYSLOP
Lois Boe Hyslop and Francis E. Hyslop. "Baudelaire and Manet: A Re-Appraisal." In *Baudelaire as a Love Poet and Other Essays*. Edited by Lois Boe Hyslop. University Park, Pa., and London, 1969.

IFFEZHEIM
Iffezheim. "Les Courses." *La Vie parisienne*, 21 May 1864, 284.

ISAACSON 1969
Ann Arbor, University of Michigan Museum of Art. *Manet and Spain*. Exh. cat., edited by Joel Isaacson. 1969.

ISAACSON 1980
Ann Arbor, University of Michigan Museum of Art. *The Crisis of Impressionism, 1878-1882*. Exh. cat., edited by Joel Isaacson. 1979-1980.

ISAACSON 1982
Joel Isaacson. "Impressionism and Journalistic Illustration." *Arts Magazine* 56, no. 10 (June 1982), 95-115.

JAMOT AND WILDENSTEIN
Paul Jamot and Georges Wildenstein. *Manet*. 2 vols. Paris, 1932.

JANIS
Cambridge, Fogg Art Museum. *Degas Monotypes*. Exh. cat., edited by Eugenia Parry Janis. 1968.

JANSON
H. W. Janson. *Apes and Ape Lore in the Middle Ages and the Renaissance*. London, 1952.

JEANNIOT
Georges Jeanniot. "En Souvenir de Manet." *La Grande Revue* 46 (1907), 844-860.

JOLLIVET
Gaston Jollivet. *Souvenirs de la vie de plaisir sous le Second Empire*. Paris, n.d. [1927].

JONES
Pamela M. Jones. "Structure and Meaning in the *Execution* Series." In Providence, R.I., Brown University. *Edouard Manet and the "Execution of Maximilian."* Exh. cat., edited by Kermit S. Champa. 1981.

KARR, ET AL.
Alphonse Karr. Léon Gatayes, et al. *Le Canotage en France*. Paris, 1858.

KNYFF
Gilbert de Knyff. *L'Art libre au XIXᵉ siècle, ou La Vie de Norbert Goeneutte*. Paris, 1979.

KRACAUER
Siegfried Kracauer. *Orpheus in Paris: Offenbach and the Paris of His Time*. Translated by Gwenda David and Eric Mosbacher. New York, 1938.

LACAMBRE
Jean Lacambre. "Les Expositions à l'occasion du centenaire de la Commune de Paris." *Revue de l'Art*, no. 18 (1972), 68-71.

LAFFAILLE
Maurice Laffaille. *Raoul Dufy: Catalogue raisonné de l'oeuvre peint*. 4 vols. Geneva, 1972-1977.

LAGRANGE
Léon Lagrange. "Salon de 1861—VII." *Gazette des Beaux-Arts* 11 (1861), 49-73.

LECLERCQ
Paul Leclercq. *Autour de Toulouse-Lautrec*. Paris, 1921.

LEMOISNE
P.-A. Lemoisne. *Degas et son oeuvre*. 4 vols. Paris, 1946-1949.

LEVEY
Michael Levey. *The Seventeenth and Eighteenth Century Italian Schools*. National Gallery Catalogues. London, 1971.

LUCAS
George A. Lucas. *The Diary of George A. Lucas: An American Art Agent in Paris, 1857-1909*. 2 vols. Edited by Lillian M. C. Randall. Princeton, 1979.

MCCABE
James D. McCabe. *Paris by Sunlight and Gaslight*. Boston, 1870.

MACK
Gerstle Mack. *Toulouse-Lautrec*. New York, 1952.

MAINARDI
Patricia Mainardi. "Edouard Manet's *View of the Universal Exposition of 1867*." *Arts Magazine* 54, no. 5 (January 1980), 108-115.

MAISON
K. E. Maison. *Honoré Daumier: Catalogue Raisonné of the Paintings, Watercolors, and Drawings*. 2 vols. Greenwich, Conn., 1968.

MANET
"Lettres d'Edouard Manet sur sa voyage en Espagne." *Arts*, 16 March 1945, 1.

MANEVY
Raymond Manevy. *Histoire de la presse, 1914 à 1939*. Paris, 1945.

MANTZ
Paul Mantz. "La Galerie Pourtalès—IV." *Gazette des Beaux-Arts* 18 (1865), 97-117.

MAUNER
George Mauner. *Manet, Peintre-Philosophe: A Study of the Painter's Themes*. University Park, Pa., and London, 1975.

MAUPASSANT
Guy de Maupassant. *Bel-Ami* (1885). *Oeuvres complètes*. 28 vols. Paris, 1908-1928.

MOORE
Lillian Moore. "Edouard Manet: Painter of Spanish Dance." *Dance Magazine* 28, no. 2 (February 1954), 24-26.

MOREAU-NÉLATON 1906
Etienne Moreau-Nélaton. *Manet, graveur et lithographe*. Paris, 1906.

MOREAU-NÉLATON 1924
Etienne Moreau-Nélaton. *Corot raconté par lui-même*. 2 vols. Paris, 1924.

MOREAU-NÉLATON 1926
Etienne Moreau-Nélaton. *Manet raconté par lui-même*. 2 vols. Paris, 1926.

MORISOT
Berthe Morisot. *The Correspondence of Berthe Morisot.* Edited by Denis Rouart, translated by Betty W. Hubbard. New York, 1959.

MURRAY
Gale B. Murray. "Problems in the Chronology and Evolution of Style and Subject Matter in the Art of Henri de Toulouse-Lautrec." Ph.D. dissertation, Columbia University, 1978.

NEWHALL
Beaumont Newhall. *The History of Photography.* Rev. ed. New York, 1964.

NICOLSON
Benedict Nicolson. "The Recovery of a Degas Race Course Scene." *The Burlington Magazine* 102 (1960), 536-537.

NOCHLIN
Linda Nochlin. *Realism.* Baltimore, 1971.

OPPLER
Ellen C. Oppler. *Fauvism Reexamined.* New York, 1976.

ORIENTI
Sandra Orienti. *L'Opera pittorica di Edouard Manet.* Milan, 1971.

OSTHAUS
Karl Ernst Osthaus: Leben und Werk. Edited by Herta Hesse-Frielinghaus, et al. Recklinghausen, 1971.

PARIS-GUIDE
Paris-Guide, par les principaux écrivains et artistes de la France. 2 vols. Paris, 1867.

PETRONE
Mario Petrone. *"La Double Vue de Louis Séguin,* de Duranty." *Gazette des Beaux-Arts* 88 (1976), 236-239.

PICKVANCE 1963
Ronald Pickvance. "Degas's Dancers: 1872-1876." *The Burlington Magazine* 105 (1963), 256-266.

PICKVANCE 1968
New York, Wildenstein. *Degas's Racing World.* Exh. cat., introduction by Ronald Pickvance. 1968.

PIERROT
Alfred Pierrot. *Essai d'étude sur l'attenuation de l'alcoolisme et de la prostitution.* Montmedy, 1895.

PINKNEY
David Pinkney. *Napoleon III and the Rebuilding of Paris.* Princeton, 1958.

PISSARRO
Camille Pissarro. *Letters to His Son Lucien.* Edited and translated by John Rewald. 3rd rev. ed. Mamaroneck, N.Y., 1972.

PISSARRO AND VENTURI
Ludovic Pissarro and Lionello Venturi. *Camille Pissarro, son art, son oeuvre.* 2 vols. Paris, 1939.

PRIVAT D'ANGLEMONT
Alexandre Privat d'Anglemont. *Paris anecdote.* 2nd ed. Paris, 1864.

PROUST
Antonin Proust. *Edouard Manet: Souvenirs.* Paris, 1913.

PSICHARI
Henriette Psichari. "Aveuglement des écrivains." *Europe,* nos. 499-500 (1970), 90-100.

REFF 1962
Theodore Reff. "The Symbolism of Manet's Frontispiece Etchings." *The Burlington Magazine* 104 (1962), 182-186.

REFF 1975
Theodore Reff. "Manet's Portrait of Zola." *The Burlington Magazine* 117 (1975), 35-44.

REFF 1976a
Theodore Reff. *Degas: The Artist's Mind.* New York, 1976.

REFF 1976b
Theodore Reff. *The Notebooks of Edgar Degas.* 2 vols. Oxford, 1976.

REFF 1981
Theodore Reff. "Degas and De Valernes in 1872." *Arts Magazine* 56, no. 1 (September 1981), 126-127.

REWALD
John Rewald. *The History of Impressionism.* 4th ed. New York, 1973.

RICHARDSON
John Richardson. *Edouard Manet.* New York, 1958.

RICHEPIN
Jean Richepin. *La Chanson des gueux* (1876). Paris, 1909.

RIFKIN
Adrian Rifkin. "Cultural Movement and the Paris Commune." *Art History* 2 (1979), 201-221.

ROBAUT 1885
Alfred Robaut. *L'Oeuvre complète d'Eugène Delacroix.* Paris, 1885.

ROBAUT 1905
Alfred Robaut. *L'Oeuvre de Corot.* 4 vols. Paris, 1905.

ROBIQUET
Jean Robiquet. "Les Bains de mer d'autrefois et d'aujourd'hui." *Le Gaulois du Dimanche,* 20-21 August 1904.

ROBSON
E. I. Robson. *A Guide to French Fêtes.* London, 1930.

ROGER-MARX
Claude Roger-Marx. *L'Oeuvre gravé de Vuillard.* Monte-Carlo, 1948.

ROZ
Firmin Roz. *La Lumière de Paris.* Paris, 1933.

RUGGIERO

Marianne Ruggiero. "Manet and the Image of War and Revolution: 1851-1871." In Providence, R.I., Brown University. *Edouard Manet and the "Execution of Maximilian."* Exh. cat., edited by Kermit S. Champa. 1981.

SAALMAN

Howard Saalman. *Haussmann: Paris Transformed.* New York, 1971.

SANDBLAD

Nils Gösta Sandblad. *Manet: Three Studies in Artistic Conception.* Lund, 1954.

SANSOŇ

Rosemonde Sanson. *Les 14 Juillet (1789-1975).* Paris, 1976.

SAY

Léon Say. "Les Chemins de fer." In *Paris-Guide, par les principaux écrivains et artistes de la France.* 2 vols. Paris, 1867.

SCHAPIRO

Meyer Schapiro. "Mondrian: Order and Randomness in Abstract Painting." In *Modern Art, 19th and 20th Centuries: Selected Papers.* New York, 1978.

SCHARF

Aaron Scharf. *Art and Photography.* Harmondsworth, 1968.

SCHMIT

Robert Schmit. *Eugène Boudin, 1824-1898.* 3 vols. Paris, 1973.

SCHNEIDER

Pierre Schneider. *The World of Manet.* New York, 1968.

SEITZ

William C. Seitz. *Claude Monet: Seasons and Moments.* New York, 1960.

SERRET AND FABIANI

Georges Serret and Dominique Fabiani. *Armand Guillaumin, 1841-1927: Catalogue raisonné de l'oeuvre peint.* Paris, 1971.

SHAPIRO

Michael Shapiro. "Degas and the Siamese Twins of the Café-Concert: The Ambassadeurs and the Alcazar d'Eté." *Gazette des Beaux-Arts* 95 (1980), 153-164.

SIMOND

Charles Simond [Paul Adolphe van Cleemputte], ed. *La Vie parisienne à travers le XIXᵉ siècle: Paris de 1800 à 1900.* 3 vols. Paris, 1900-1901.

SOLKIN

David H. Solkin. "Philibert Rouvière: Edouard Manet's *L'Acteur Tragique.*" *The Burlington Magazine* 117 (1975), 702-709.

SORIA

Georges Soria. *Grande Histoire de la Commune.* 5 vols. Paris, 1971.

STALEY

New York, Wildenstein, and Philadelphia Museum of Art. *From Realism to Symbolism: Whistler and His World.* Exh. cat., edited by Allen Staley. 1971.

SUE

Eugène Sue. *Mystères de Paris* (1842-1843). 2 vols. New York, 1844.

TABARANT 1923

Adolphe Tabarant. "Une Histoire inconnue du 'Polichinelle.'" *Bulletin de la Vie Artistique,* 1 September 1923, 365-369.

TABARANT 1928

Adolphe Tabarant. *Maximilien Luce.* Paris, 1928.

TABARANT 1931

Adolphe Tabarant. *Manet: Histoire catalographique.* Paris, 1931.

TABARANT 1947

Adolphe Tabarant. *Manet et ses oeuvres.* Paris, 1947.

TEXIER

Edmond Texier. "Les Petits Industries." In *Paris-Guide, par les principaux écrivains et artistes de la France.* 2 vols. Paris, 1867.

THOMSON

Richard Thomson. "A Sisley Problem." Letter in *The Burlington Magazine* 123 (1981), 686.

THUILLIER

Paris, Grand Palais. *Les Frères Le Nain.* Exh. cat., edited by Jacques Thuillier. 1978.

TRAPP

Frank Anderson Trapp. *The Attainment of Delacroix.* Baltimore, 1971.

TUCKER

Paul Hayes Tucker. *Monet at Argenteuil.* New Haven and London, 1982.

UNIVERS ILLUSTRÉ

"La Fête Nationale du 30 Juin." *L'Univers illustré* 21, no. 1215 (6 July 1878), 424-426.

VACHON

Marius Vachon. *L'Hôtel de Ville de Paris,* Paris, 1905.

VALLÈS

Jules Vallès. *La Rue* (1866). Edited by Pierre Pillu. Paris, 1969.

VALLOTTON AND GOERG

Maxime Vallotton and Charles Goerg. *Félix Vallotton: Catalogue raisonné de l'oeuvre gravé et lithographié.* Geneva, 1972.

VALMY-BAYSSE
Jean Valmy-Baysse. *Les Peintres d'aujourd'hui*. Paris, 1910.

VARNEDOE
J. Kirk T. Varnedoe. "Caillebotte's Pont de l'Europe: A New Slant." *Art International* 18, no. 4 (April 1974), 28-29 ff.

VOLLARD
Ambroise Vollard. *En écoutant Cézanne, Degas, Renoir*. Paris, 1938.

WALTER
Rodolphe Walter. "Saint Lazare impressionniste." *L'Oeil*, no. 292 (November 1979), 48-55.

WEISBERG 1979
Gabriel P. Weisberg. *Bonvin, la vie et l'oeuvre*. Paris, 1979.

WEISBERG 1981
Cleveland, The Cleveland Museum of Art. *The Realist Tradition: French Painting and Drawing, 1830-1900*. Exh. cat., edited by Gabriel P. Weisberg. 1981.

WELLS
William Wells. "Who Was Degas's Lyda?" *Apollo* 95 (1972), 129-134.

WELSH-OVCHAROV
Toronto, Art Gallery of Ontario. *Vincent Van Gogh and the Birth of Cloisonism*. Exh. cat., edited by Bogomila Welsh-Ovcharov. 1981.

WILDENSTEIN
Daniel Wildenstein. *Claude Monet: Biographie et catalogue raisonné*. 3 vols. to date. Paris and Lausanne, 1974-1978.

WILHELM
Jacques Wilhelm. *La Vie à Paris*, Paris, 1947.

WILLOCH
Sigurd Willoch. "Edouard Manets *Fra Verdensutstillingen i Paris 1867*." *Konsthistorisk Tidskrift* 45 (1976), 101-108.

WILSON
Paris, Huguette Berès. *Manet: Dessins, aquarelles, eaux-fortes, lithographies, correspondance*. Exh. cat., edited by Juliet Wilson. 1978.

YOUNG, ET AL.
Andrew McLaren Young, Margaret MacDonald, Robin Spencer, and Hamish Miles. *The Paintings of James McNeill Whistler*. 2 vols. New Haven and London, 1980.

YRIARTE
Charles Yriarte. *Paris grotesque: Les Célébrités de la rue*. Paris, 1864.

ZOLA 1867
Emile Zola. "Une Nouvelle Manière en peinture: Edouard Manet" (1867). In *Salons*. Edited by F. W. J. Hemmings and Robert Niess. Geneva and Paris, 1959.

ZOLA 1872
Emile Zola. "Lettre parisienne." *La Cloche*, 8 June 1972. In *Oeuvres complètes*. Edited by Henri Mitterand. 15 vols. Paris, 1966-1970.

ZOLA 1877
Emile Zola. *L'Assommoir* (1877). Translated by Leonard Tancock. Baltimore, 1970.

ZOLA 1884
Emile Zola. "Edouard Manet" (preface to *Exposition des oeuvres d'Edouard Manet*, 1884). In *Salons*. Edited by F. W. J. Hemmings and Robert Niess. Geneva and Paris, 1959.

PHOTOGRAPHIC CREDITS

N 6853 .M233 A4 1982
Reff, Theodore.
Manet and modern Paris

Unless noted here, photographs reproduced in this book were provided by the owners of the works. For their assistance and cooperation, we are most grateful.

Arts Graphiques de la Cité, Paris: cat. 55, fig. 83

Huguette Berès, Paris: fig. 121

Brenwasser, New York: cat. 15

Caisse Nationale des Monuments Historiques, Paris: fig. 60, fig. 73, fig. 92, fig. 112

Davidoff Studios, Palm Beach, Florida: cat. 13

Durand-Ruel, Paris: fig. 84, fig. 95

Foto Liselotte Witzel, Heidehang: cat. 75

Ralph Kleinhempel, Hamburg: cat. 28 (color)

M. Knoedler & Co., Inc., New York: fig. 66

Photo Hutin, Compiègne: fig. 100

Photo Routhier, Paris: fig. 82

Photographie Bulloz, Paris: cat. 69, cat. 91, fig. 13, fig. 18, fig. 53, fig. 124

Photographie Giraudon, Paris: cat. 82, fig. 12, fig. 36, fig. 38, fig. 39, fig. 49, fig. 90, fig. 123

Eric Pollitzer, Hempstead, New York: cat. 49, cat. 54

Réunion des Musées Nationaux, Paris: cat. 20 (color), cat. 46, cat. 49 (color), cat. 55 (color), cat. 61, cat. 85, fig. 10, fig. 16, fig. 40, fig. 42, fig. 46, fig. 78, fig. 79, fig. 102, fig. 114, fig. 120, fig. 122, fig. 127

Sam Salz: fig. 115

Joseph Szaszfai, New Haven, Connecticut: cat. 96

Taylor & Dull, Inc., New York: fig. 105

RITTER LIBRARY
BALDWIN-WALLACE COLLEGE

7 156CO 6065
 PS
04/95 01-062-00 GBC